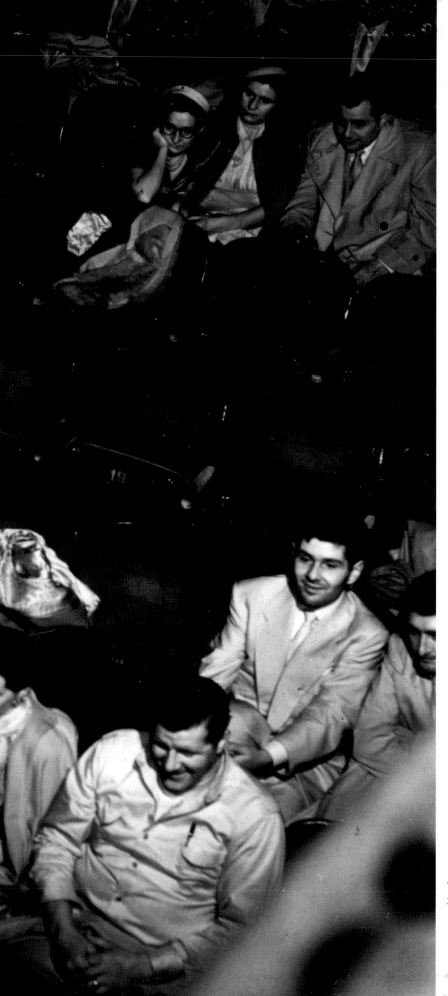

Weegee
At the Palace Theatre (5), 1945
The J. Paul Getty Museum, Malibu, California

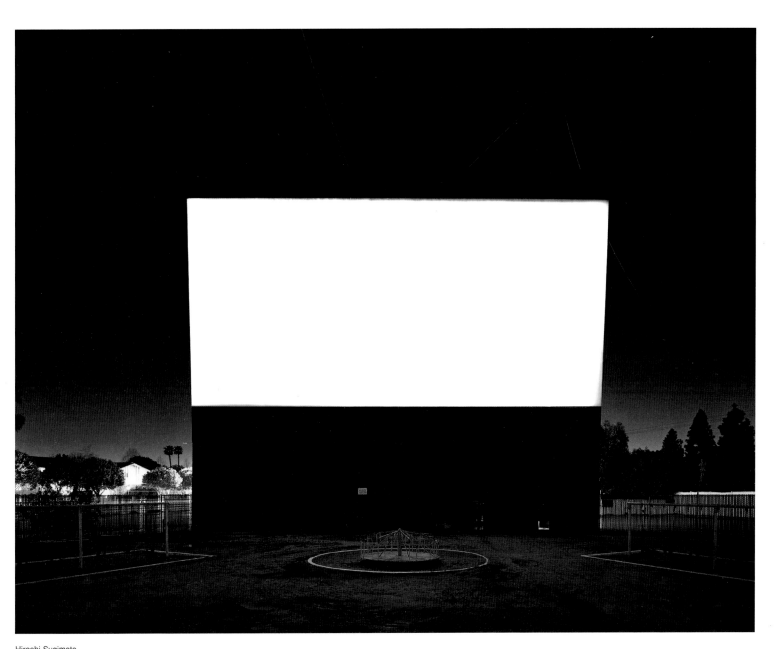

Hiroshi Sugimoto
Studio Drive-In, Culver City, 1993
The Museum of Contemporary Art, Los Angeles

Edward Ruscha
Western, 1991
Castelli Gallery, New York

Art and Film Since 1945: Hall of Mirrors

Organized by
Kerry Brougher

With essays by
Kerry Brougher
Jonathan Crary
Russell Ferguson
Bruce Jenkins
Kate Linker
Molly Nesbit
Robert Rosen

Edited by Russell Ferguson

The Museum of Contemporary Art, Los Angeles
The Monacelli Press, New York

This publication accompanies the exhibition "Hall of Mirrors: Art and Film Since 1945," organized by Kerry Brougher and presented at The Museum of Contemporary Art, Los Angeles.

"Hall of Mirrors: Art and Film Since 1945" has been made possible by **Time Warner Inc.**

Additional support has been generously provided by MCA/Universal, Fox Filmed Entertainment, Mr. Steve Tisch, Paramount Pictures, The Andy Warhol Foundation for the Visual Arts, Inc., New Line Cinema Corporation, Ronnie and Vidal Sassoon, The Japan Foundation, Mr. Gordon Hampton, the Canadian Consulate General at Los Angeles, The New Otani Hotel & Garden, and the National Endowment for the Arts, a federal agency.

Co-published by The Museum of Contemporary Art, Los Angeles and The Monacelli Press.
ISBN 1-885-254-21-0

Edited by Russell Ferguson
Assistant Editors: Stephanie Emerson and John Alan Farmer
Design: Bruce Mau Design Inc., Bruce Mau with Chris Rowat
Production by Dr. Cantz'sche Druckerei, Ostfildern, Germany

Cover: Richard Hamilton, *Ghosts of Ufa,* 1995
Back Cover: Cindy Bernard, *Ask the Dust: Vertigo (1958/1990),* 1990

LIBRARY OF CONGRESS CATALOGUING-IN-PUBLICATION DATA

Brougher, Kerry.
 Art and Film Since 1945: Hall of mirrors / Kerry Brougher ; with
 essays by Jonathan Crary, [et al.].
 p. cm.
Exhibition: Museum of Contemporary Art at the Temporary Contemporary,
Los Angeles, Mar. 17, 1996 – July 28, 1996.
 Includes bibliographical references.
 ISBN 1-885-254-21-0 (cloth)
 1. Art and motion pictures–Exhibitions. I. Crary, Jonathan.
 II. Museum of Contemporary Art (Los Angeles, Calif.) III. Title.
 PN1995.25.B76 1996
 791.43′657– dc20 95-52679
 CIP

Exhibition Tour

The Museum of Contemporary Art
Los Angeles
17 March 1996 – 28 July 1996

The Wexner Center for the Arts
Columbus, Ohio
21 September 1996 – 5 January 1997

Palazzo delle Esposizioni
Rome
June 1997 – September 1997

The Museum of Contemporary Art
Chicago
11 October 1997 – 21 January 1998

Sponsor's Statement

As the world celebrates the hundredth anniversary of the birth of cinema, Time Warner is proud to be the lead sponsor of "Hall of Mirrors: Art and Film Since 1945," the only museum exhibition chosen for the International Motion Picture Centennial. Exploring the relationship between film and the other visual arts, this landmark show illuminates the revolutionary power of the cinema anew, and captures the fascination of film during the past half-century of unprecedented social and political change.

Along with the late Steve Ross, whose support and commitment helped turn the idea for this exhibition into a reality, the women and men of Time Warner share a profound belief in the importance of creativity and imagination. The filmmakers and artists represented in "Hall of Mirrors: Art and Film Since 1945" have given us works of individual power and vision and, together, forever altered our way of seeing the world. Time Warner salutes their artistry and their achievement.

Gerald M. Levin
Chairman and Chief Executive Officer

Andy Warhol
Double Marlon, 1966
Private Collection

Contents

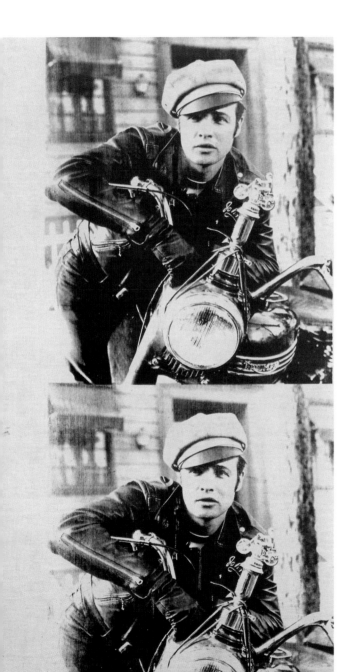

Akira Kurosawa
Akira Kurosawa's Dreams, 1990

Director's Foreword

In celebration of the hundredth anniversary of the birth of cinema, The Museum of Contemporary Art is proud to present "Hall of Mirrors: Art and Film Since 1945." This major exhibition pays tribute to the creative contributions of artists and filmmakers from around the world and explores the subtle, fascinating, and ever-changing relationship between film and the visual arts — a relationship also directly germane to the cultural, artistic, and historical issues represented by MOCA's collection and programs overall.

An exhibition and publication as complex as "Hall of Mirrors: Art and Film Since 1945" involves the commitment and concentrated efforts of many individuals over a considerable period of time. We are particularly grateful to MOCA's Board of Trustees, led by Chairman David Laventhol, President John C. Cushman III, and Vice Chairpersons Douglas S. Cramer, Audrey M. Irmas, Richard Brawerman and Betye Monell Burton, and Program and Exhibition Committee Chairman Gilbert B. Friesen, for their indomitable spirit and remarkable commitment to the Museum. Most importantly, we also thank Curator Kerry Brougher, who proposed the concept for the exhibition, selected the artists and individual works included, and provided the exemplary curatorial leadership that brought this major project to fruition. "Hall of Mirrors" attests to his unique curatorial interests, skills, and extraordinary dedication.

For their generous contribution of time, advice, and special assistance, the Trustees and staff of the Museum are also deeply grateful to the Honorary Committee for the exhibition. Originally chaired by the late Steven J. Ross, the committee includes Peter Chernin, Jonathan Dolgen, Sherry Lansing, Gerald Levin, Michael Lynne, Kerry McCluggage, Ron Meyer, Rupert Murdoch, Terry Semel, Robert Shaye, and Peter Wolff.

Initial funding for "Hall of Mirrors: Art and Film Since 1945" was generously provided by Time Warner, for which we give particular thanks to the late Steven J. Ross, as well as to Gerald B. Levin and Peter Wolff. Major funding has also been contributed by MCA/Universal, with special thanks to Ron Meyer; Paramount Pictures, with special thanks to Jon Dolgen; Fox Filmed Entertainment, with special thanks to Rupert Murdoch and Peter Chernin; New Line Cinema Corporation, with special thanks to Michael Lynne; The Japan Foundation, with thanks to Shin'ichiro Asao in Japan and Satoshi Nakamura in Los Angeles; The Andy Warhol Foundation for the Visual Arts, Inc., with appreciation to Pamela Clapp; and Gordon Hampton, Ronnie and Vidal Sassoon, Steve Tisch, and the National Endowment for the Arts, a federal agency.

Here's to the next hundred years of film and the visual arts!

Richard Koshalek

Lenders to the Exhibition

Patrick and Abby Adams, Santa Monica, California

Angles Gallery, Santa Monica, California

The Estate of Diane Arbus

Judith Barry

The Bergman Family, Chicago

Galerie Berinson, Berlin

Cindy Bernard

Douglas Blau

Christian Boltanski

Rena Bransten Gallery, San Francisco

The Eli Broad Family Foundation Collection, Santa Monica, California

The Capital Group Companies, Inc., Los Angeles

Castelli Gallery, New York

Elisabetta Catalano

John Cheim, New York

James Coleman

Eileen and Michael Cohen, New York

Francis and Eleanor Coppola

Cecilia and Michael A. K. Dan, Malibu, California

Dr. Lieven Declerk-Verstraete, Belgium

Anthony d'Offay Gallery, London

Rita Donagh, London

Cliff and Mandy Einstein, Los Angeles

F.R.A.C. Franche-Comté, Dole, France

Les Impenitents, F.R.A.C. de Haute Normandie, Rouen, France

Richard L. Feigen, New York

Richard L. Feigen and Company, New York and Chicago

Gilbert B. Friesen, Los Angeles

The Foundation To-Life, Inc. Collection

Richard Gere, New York

Beatrice and Philip Gersh, Los Angeles

The J. Paul Getty Museum, Malibu, California

Marian Goodman Gallery, New York

The Solomon R. Guggenheim Museum, New York

Richard Hamilton

Hayward Gallery, South Bank Centre, London

Ydessa Hendeles Art Foundation, Toronto

Hirshhorn Museum and Sculpture Garden, Smithsonian Institution, Washington, D.C.

Dennis Hopper

Pontus Hulten

Jedermann Collection, N.A.

Jasper Johns

Herbert F. Johnson Museum of Art, Cornell University, Ithaca, New York

Miani Johnson, New York

The Estate of Ray Johnson

Nicole Klagsbrun, New York

Peter Kubelka

Lannan Foundation, Los Angeles

Lisson Gallery, London

Sharon Lockhart

Los Angeles County Museum of Art

Ludwig Collection, Ludwig Forum for International Art, Aachen, Germany

Christian Marclay

Giò Marconi Gallery, Milan

Chris Marker

Mr. and Mrs. Henry Martin, Bolzano, Italy

Fabio Mauri

Annette Messager

Metro Pictures, New York

Robert Miller Gallery, New York

Modern Art Museum of Fort Worth, Texas

Robert Morton, New York

Musée d'Art Contemporain de Lyon

Musée National d'Art Moderne, Centre Georges Pompidou, Paris

Museum of Contemporary Art, Chicago

The Museum of Contemporary Art, Los Angeles

Museum of Fine Arts, Boston

Museum Ludwig, Cologne

The Museum of Modern Art, New York

National Gallery of Canada, Ottawa

The National Swedish Art Museums, Moderna Museet, Stockholm

neugerriemschneider, Berlin

Marius Olbrychowski, Los Angeles

Collection Onnasch, Berlin

Friedrich Petzel Gallery, New York

Projeto Hélio Oiticica, Rio de Janeiro

Raúl Ruiz

Galerie Reckermann, Cologne

Galerie Rolfe Ricke, Cologne

Mimmo Rotella

Edward Ruscha

San Francisco Museum of Modern Art

The Sandor Family Collection, New York

Carolee Schneemann

Artists and Filmmakers in the Exhibition

Cindy Sherman
Norton Simon Museum, Pasadena, California
Sonnabend Gallery, New York
Martin and Toni Sosnoff, New York
Stuart and Judy Spence, South Pasadena, California
Stanford University Museum of Art, Stanford, California
Tate Gallery, London
Galerie Patrice Trigano, Paris
Vision Gallery, San Franicisco
Walker Art Center, Minneapolis
Wexner Center for the Arts, The Ohio State University,
 Columbus, Ohio
William S. Wilson, New York
David Zwirner, New York
and anonymous lenders

Robert Aldrich
Kenneth Anger
Michelangelo Antonioni
Diane Arbus
John Baldessari
Judith Barry
Saul Bass
Ingmar Bergman
Cindy Bernard
Bernardo Bertolucci
Joseph Beuys
Douglas Blau
Barbara Bloom
Christian Boltanski
Stan Brakhage
Luis Buñuel
Victor Burgin
Jean Cocteau
James Coleman
Bruce Conner
Tony Conrad
Joseph Cornell
David Cronenberg
Salvador Dalí
Brian De Palma
Stan Douglas
Carl-Theodor Dreyer
Federico Fellini
Hollis Frampton and
 Marion Faller
Robert Frank
Jean-Luc Godard
Douglas Gordon
Dan Graham
Peter Greenaway
Richard Hamilton
Alfred Hitchcock
Dennis Hopper
Edward Hopper
Ken Jacobs
Derek Jarman
Ray Johnson
Peter Kubelka
Stanley Kubrick

Akira Kurosawa
Suzanne Lafont
Fritz Lang
Sharon Lockhart
David Lynch
Christian Marclay
Chris Marker
Fabio Mauri
Annette Messager
Pat O'Neill
Hélio Oiticica and
 Neville D'Almeida
Pier Paolo Pasolini
Roman Polanski
Michael Powell
Alain Resnais
Nicolas Roeg
Mimmo Rotella
Raúl Ruiz
Allen Ruppersberg
Edward Ruscha
Carolee Schneemann
Martin Scorsese
Ridley Scott
Paul Sharits
Cindy Sherman
Michael Snow
Hiroshi Sugimoto
Andrei Tarkovsky
Frank Tashlin
François Truffaut
Jeff Wall
Andy Warhol
Weegee
Orson Welles
Wim Wenders
James Whitney
John Whitney
Billy Wilder

Introduction and Acknowledgments

In 1934 the art historian Erwin Panofsky proposed that if all poets, composers, painters, and sculptors then working were forced to stop their activities, only a small fraction of the general public would regret it; if, on the other hand, filmmakers were to cease production, the "social consequences would be catastrophic."[1]

In the early years of cinema, filmmakers made self-conscious reference to "high art" in order to validate their medium and underscore its roots in nineteenth-century "grand machine" painting. Pastrone drew from Alma-Tadema, Griffith from Millet, Lang from Friedrich, while theater architects mass produced plaster copies of Botticelli's Venus to adorn the proscenium arch. Such references sought to veil the cinema's bloodlines stretching back into the less desirable but equally influential realm of popular entertainments, to the "low" art forms of vaudeville, phantasmagoria light shows, and wax museums. But by the time Panofsky wrote his lecture during the golden age of cinema, film had succeeded in establishing itself as an art form — *the* art form of the twentieth century; and by doing so, it had by its very dual nature, helped to break down the barriers between art and entertainment, high and low. By the thirties, cinema was no longer merely borrowing from art, it was converting modern art into popular culture; in the hands of Busby Berkeley, Walt Disney, and Josef von Sternberg, Surrealism, German Expressionism, and abstraction were being converted into languages for mass consumption, their original radical, vanguard, and subversive undercurrents along with their decidedly anti-bourgeois sentiments having been neutralized. If the cinema is, as Raymond Durgnat has termed it, a "mongrel muse," an amalgamation of many other art forms,[2] it is also a medium with tremendous powers of absorption and transformation, with the ability to soak up culture, alter it, and then re-present it to a degree never seen before the first film projections one hundred years ago at the Grand Café in Paris.

Although this is an exhibition about the interactions of art and film, it is the shadow of cinema itself that looms over the project just as it

towers over twentieth-century culture in general. What binds all the artists and filmmakers included in this catalogue and the exhibition it accompanies, is the question: What is — or was — cinema? This is an inquiry that could not be posed in the first half of this century as film itself was evolving, but could only be asked from a historical perspective, one that comes after the first fifty years of cinema's evolution and after the pinnacle of its achievement. Thus this exhibition begins around 1945, a loose but convenient marker indicating that moment when the modern era slipped past the innocence of its utopian dreams, and when both the cinema and modern art entered states of crisis, decline, and self-examination, a "post-modern," "post-Hollywood" era that has seen the separations between high art and mass culture, art and kitsch, art and film, even further blurred.

This exhibition and publication do not strive for didactic comparisons of art and film, the juxtaposition of painting against film for formal and stylistic comparisons, nor do they attempt to trace specific links between the visual arts and cinema, such as an artist's influence on a cinematographer or production designer; this is not a project about drawing lines between points. Rather it is an attempt to uncover affinities between the two media and shared responses to social and cultural pressures by looking at common thematic tendencies and similarities in approaches, particularly the desire to dismantle, deconstruct, and re-present the cinema in order to better grasp film's immense influence and potency. The desire here is to map the social and aesthetic issues that have shifted painting toward cinema, film toward the visual arts, and have fused the two together into new hybrid forms. This trajectory involves both artists and filmmakers, the artists often utilizing images from cinema (which, by the forties, had an immense image bank from which to draw); cinematic techniques of montage, seriality, and sequence, among others; and the use of film itself, while the filmmakers, also in an attempt to probe their own medium, often shift that medium toward the static work of art, a state from which cinema originally emerged. To present such a refracted history, it has been necessary to do away with the usual divisions between the histories of narrative film, experimental cinema, and

the visual arts, and instead to visualize a synthesized history brought together by the shared problems of deconstructing the cinematic. The exhibition has been divided into three broad and roughly chronological sections, the first focusing on the self-reflexive tendencies of immediate postwar Hollywood and the dismantling of the cinematic experience; the second on the severely reductivist strategies of the sixties and early seventies that focus primarily on the film apparatus and its origins in optical devices and the static image (and in so doing test the very limits of both art and film); and the third on the more recent nostalgia for the cinema in the face of its absence. Several themes emerge as common threads: the use and reconfiguration of Hollywood models of stardom; the return to the origins of film in an attempt to locate its fundamental relationship to the visual arts and to underscore the cinema's curious position between optics and illusion, science and secular mysticism, high art and popular culture; psychoanalytic and voyeuristic issues that shed light on gender, visual pleasure, surveillance, and spectacle; the meeting of film, painting, and photography within the concept of the tableau vivant; and the fragmentation of classic theater-based cinema within a culture dominated by the cinematic.

★ ★ ★

All historical or thematic exhibitions are complicated undertakings, but *Hall of Mirrors*, which intertwines two disciplines, has been more complex than most, requiring the contributions and expertise of a great number of individuals.

First I would like to thank all the artists and filmmakers who enthusiastically agreed to participate in the exhibition and to single out several of these individuals who gave freely of their time to offer invaluable insight into the relationship between art and cinema thereby deeping and enriching the project as a whole: Michelangelo Antonioni, John Baldessari, Judith Barry, Saul Bass, Cindy Bernard, Bernardo Bertolucci, Douglas Blau, Barbara Bloom, Christian Boltanski, Stan Brakhage, Victor Burgin, James Coleman, Bruce Conner, Tony Conrad, Richard

Hamilton, Dennis Hopper, Ken Jacobs, Peter Kubelka, David Lynch, Chris Marker, Fabio Mauri, Annette Messager, Pat O'Neill, Mimmo Rotella, Raúl Ruiz, Allen Ruppersberg, Edward Ruscha, Carolee Schneemann, Martin Scorsese, Cindy Sherman, Michael Snow, Hiroshi Sugimoto, Jeff Wall, and the late John Whitney. The same debt of gratitude must be extended to those individuals who acted as consultants on the project including, in its initial phases, Annette Michelson and Peter Wollen, and throughout the entire project, Michael Friend, who was always there with enthusiastic and thoughtful advice. The publication — as well as the exhibition itself — was enriched and shaped by guest authors Jonathan Crary, Russell Ferguson, Bruce Jenkins, Kate Linker, Molly Nesbit, and Robert Rosen.

This exhibition would not have been possible without the support of MOCA's Board of Trustees and staff who enthusiastically supported the project throughout its various stages of development. MOCA Director Richard Koshalek offered steadfast support throughout its entire evolution; his indefatigable efforts truly made this exhibition possible. Although the entire board of trustees embraced this project, special thanks are due to Gil Friesen, Gordon Hampton, Daniel Melnick, and Ron Meyer. Others who never wavered in their enthusiasm for *Hall of Mirrors* include Chief Curator Paul Schimmel, who not only supported the idea but was a constant source of encouragement; Director of Administration Kathleen S. Bartels whose extraordinary efforts in publicity and administration greatly enhanced the project; Chief Financial Officer Jack Wiant whose fiscal guidance was an important factor in realizing the exhibition; and Director of Development Erica Clark, who, along with Campaign Manager Margaret Steele and Grants Manager June Scott, energetically met the daunting challenge of funding this enormous undertaking.

In any major exhibition, there are always certain individuals who must be singled out for their extraordinary commitment, skill, and motivation. Both Curatorial Assistant Stacia Payne and Research Assistant Mariana Amatullo, who also compiled the rich and thought-provoking chronology for the catalogue, through their expertise, resourcefulness,

and initiative, were, along with Curatorial Intern Angelene Taccini, instrumental in the realization of this exhibition and catalogue in every phase of development; the project would simply not have come to fruition without their dedication and scholarship.

This catalogue not only documents the exhibition, but through the enthusiasm and intelligence of MOCA Editor Russell Ferguson, whose advice and counsel were invaluable in shaping the exhibition as well as the book, extends the theme of art and film far beyond that possible in the physical manifestation of the exhibition. Bruce Mau, who has so beautifully designed this publication, was, along with Chris Rowat, a close collaborator throughout the various stages of the development of this publication; their talent has made it possible to set cinema and art comfortably side by side. The publication and the exhibition were enhanced greatly by the contributions of Assistant Editor Stephanie Emerson, who diligently addressed a myriad of details and research issues, and of Sue Henger and former Assistant Editor John Alan Farmer, who thoughtfully compiled the extensive bibliography and brought his adept skills to other aspects of this project as well, and by Erin Mohr, Joshua Hirsch, Kathleen Johnson, Patrick Keady and Shayna Ritenour. Thanks are also due to other staff members and interns who so diligently worked on the project in its early stages, including Susan Colletta, Eric Freedman, Birgit Plinke, and Sherri Schottlaender.

This exhibition was designed by Craig Hodgetts and Ming Fung of Hodgetts + Fung Design Associates who, along with Selwyn Ting, addressed the complex problems of placing still images alongside those that move and shifted a whole medium meant to be seen in the black box of theatrical space into a museum environment. Achieving these goals by patiently applying their talents and graciously addressing every detail was critical to the development and successful realization of this project. John Bowsher, Exhibition Production Manager, who worked closely with Hodgetts + Fung as well as all the artists involved in creating projects for the exhibition, was a crucial collaborator; he brought his considerable expertise to a very demanding installation. The interpretation of art and film would also not have been possible without the expertise of Media Arts

Technical Manager David Bradshaw, Preparator Jay Dunn, Chief Preparator Eric Magnuson, and Staff Preparators Jeremy Goff, Barry Grady, Jim Jahto, Jang Park and Valerie West. Assistant Registrar Portland McCormick, along with Registrar Robert Hollister, expertly handled, as always, the numerous and diverse loans of this exhibition. Througout the evolution of this exhibition, many other members of MOCA's staff have offered invaluable suggestions and advice, among them Curators Ann Goldstein, Julie Lazar, and Elizabeth Smith, and Exhibitions Coordinator Alma Ruiz, who was also instrumental in organizing its tour.

Bringing film into the gallery spaces of MOCA has presented challenges met at each turn by Peter Kirby and Media Art Services. Throughout the process of gathering and editing films, as well as organizing the artists' and filmmakers' installations, Peter has been a calm, stablizing influence, meeting each new problem with the appropriate creative solution. The presentation of films at the Temporary Contemporary would also not have been possible without the technical skills of Robert Miniaci, whose knowledge of the film mechanism is fast becoming a lost art. Despite the presentation of film in the museum, nothing can take the place of film in the theater; thoughtfully organized by Robert Rosen and Andrea Alsberg and developed jointly by MOCA and the UCLA Film and Television Archive, the film series is not simply an auxiliary component, but an integral part of the exhibition that sheds new light on the relationship between narrative cinema and the visual arts.

Director of Education Kim Kanatani and Art Talks Coordinator Caroline Blackburn worked closely with artists, filmmakers, and scholars to provide an extraordinary array of educational programming for this project. I would also like to thank other members of MOCA's staff for their support, including Assistant Director of Communications, Media Relations Dawn Setzer, former Grants Associate Pam Gregg, Associate Director of Development Ed Patuto, Designer Cindy Estes, and former Chief Curator Mary Jane Jacobs, under whose tenure the idea for this exhibition was generated.

In the spirit of collaboration that this exhibition has demanded, I would also like to thank those individuals at the institutions who are par-

Hall of Mirrors

Kerry Brougher

Art is not the reflection of reality, it is the reality of that reflection.
—Jean-Luc Godard, 1967[1]

The Machine-as-photographed.... The Machine-as-pictured through the means of machinery — something like a 'hall of mirrors' reflecting mirrors, *ad infinitum*, to confound all material sense and punch a hole in the whole of universal space.
—Stan Brakhage, 1972[2]

The cinema is a mechanical mirror that has a memory.
—Raúl Ruiz, 1992[3]

Overture

Through a scratched and washed-out celluloid window we survey a scene which transforms us into a train moving slowly along the winding tracks of a mountain pass toward an inevitable encounter with the darkness of a tunnel. A voice hovers around us: "These shifting and confused gusts of memory never lasted more than a few seconds; it often happened that in my brief spell of uncertainty as to where I was, I did not distinguish the various suppositions of which it was composed any more than, when we watch a horse running we isolate the successive positions of its body as they appear upon a bioscope."[4] We plunge into the tunnel, blackness and silence consuming us, until finally we emerge into the daylight only to start the process once more with a different passage of text that draws us onward toward the next tunnel.

A meditation on the state between sleep and consciousness, illusion and reality, Stan Douglas's film installation *Overture* (1986) is a prime example of the dialogue between art and cinema that has occupied artists and filmmakers since mid-century. Using a film loop of archival footage

Orson Welles
The Lady from Shanghai, 1948

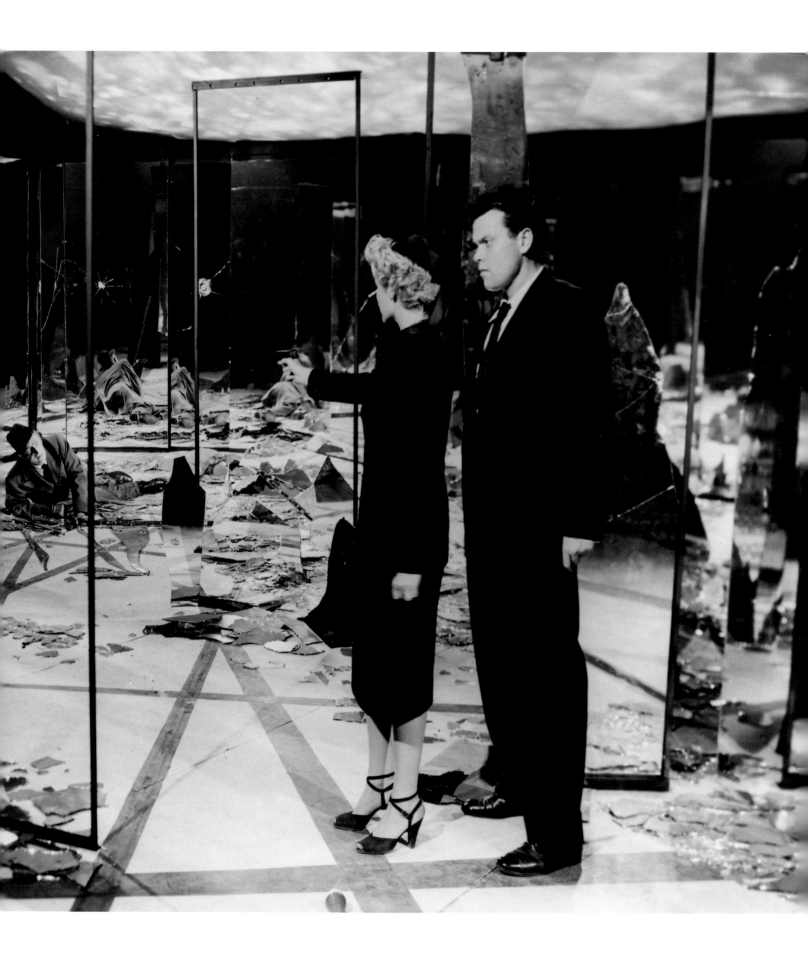

shot by the Edison Film Company in 1899 and 1901 combined with passages from Proust's "Overture" to *Remembrance of Things Past*, Douglas uses the cinema itself as a vehicle to explore issues of visual and psychological perception and modern temporality. Like many other artists of the last several decades, Douglas finds a correlation between the cinematic experience, the film apparatus, and the fragmentation of time — those leaps from present to past and back again — that are part of the discontinuity of modern life described early in the century by Proust. As the narrator of *Remembrance* is awakened by the thought that it is time to sleep, he hears "the whistling of trains," which, in his dark chamber, punctuates the psychic spaces of his mind and elicits thoughts of a modern traveller whose path "will be engraved in his memory." Proust's era was one in which Lumière's train had already arrived at the station, carrying with it greater persuasive illusionary powers than either painting or photography. It was an age of the cinematic time machine, of the crossbreeding of past, present, and future, of art and life.

The cinema can be seen from our perspective today as one of the most important forces that defined modern aesthetics and culture; for some historians, the twentieth century, or at least the first half of it, has even been designated "the film age."[5] It is a mechanism that had a long evolutionary history. It can be traced back far beyond 1895, the year that the Lumières's *actualitées* were first screened in the Grand Café in Paris, to at least 1646, when the German-born Jesuit priest Athanasius Kircher published *Ars magna lucis et umbrae*, in which he outlined plans for using mirrors and projected light to create luminous apparitions.[6] In this forerunner of the magic lantern and the phantasmagoria performance, Kircher would use a dark room and place the light source behind a wall, hidden from the audience. By projecting light onto etched and painted mirrors, Kircher could create startling apparitions on the opposite wall. Kircher's placement of his mirrors behind a wall, out of sight, suggests that even in its "primordial" state, the cinema had already defined itself as spectacle and had placed the desire for secular mysticism and illusion over the display of its optical foundations, magic over reason.[7]

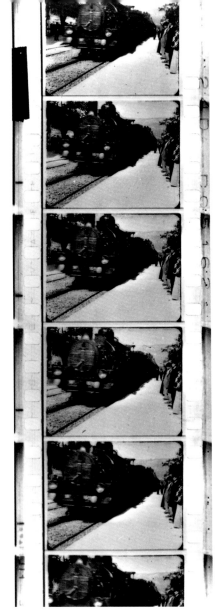

Lumière Brothers
L'Arrivee d'un Train en Gare de la Ciotat
(Arrival of a Train at La Ciotat), 1896

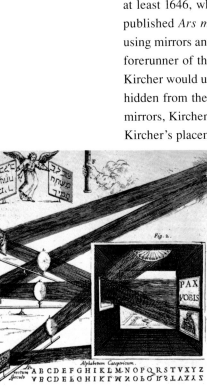

Athanasius Kircher's Room for Projected Images, 1646

Stan Douglas
Overture, 1986
Collection of Eileen and Michael Cohen,
New York

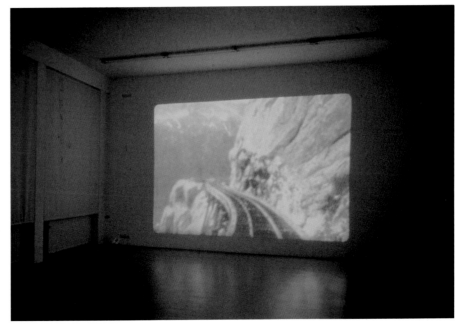

However, somewhere near the mid-twentieth century, film's evolutionary history seems to have crested. A medium that by the late forties had given culture an immense image bank, a collective cinematic memory, film began to turn back in on itself, to examine its own inner working, a process that inspired artists to do the same. From the opposite side of this evolution, from the perspective of postwar, post-classic film, post-Holly-wood culture, film can be investigated and deconstructed in ways that would have been inconceivable in the midst of its evolutionary stages in the first half of the century.

To deconstruct cinema is to investigate a culture defined to a large degree by the cinematic experience. In Stan Douglas's piece, we have entered into the moving picture, approaching it from the other side of the screen and from the other side of film's history. As Douglas demonstrates, ours is a culture that has a grounding in trance-like states, persistence of vision, virtual images, illusionistic transportation, disorienting effects, dreamy states of consciousness, popular iconography, and secular religion.

Since mid-century, artists have created work which often allows us to "enter" the film apparatus, to take a walk through Kircher's mirrored chamber. By taking the cinema as subject matter, by creating situations in which the viewer becomes engaged with the entire cinematic apparatus, artists and filmmakers have taken us behind the screen to better understand the cinematic aspects of our culture. It is a journey that takes us from the decline of Hollywood and the dismantling of its language into an arena of reductive tendencies that tests the limits of the film mechanism to such extremes that it eventually explodes back outward into the contemporary fragmented reflections of a cinema past.

The climax of Orson Welles's *The Lady from Shanghai* (1948) takes place in a hall of mirrors. The protagonist, played by Welles, looks on as the villains attempt to shoot one another but cannot distinguish the real from the reflection. They fire into the mirrors, destroying one another over and over in a tempest of shattered glass. The dialogue between art

and film in the postwar period is a little like this hall of mirrors, a passageway in which the two media not only reflect one another and get confused in the multiple refractions, but in which reality and illusion often co-mingle. This is also a dialogue that returns time and time again to the cinema's origins, holding the past up to the present, cinematic spectacle up to the mirror of contemporary culture, splintering and re-arranging it into new, self-reflexive experiences that highlight and subvert screen practice.

Part I
Lost Illusions: Dismantling the Dream Factory

Hollywood's like Egypt. Full of crumbling pyramids. It'll never come back. It'll just keep on crumbling until finally the wind blows the last studio prop across the sands.

—David O. Selznick, 1951[8]

Hollywood should be dismantled.

—Kenneth Anger, 1965[9]

The Beginning of The End

Up through the war years, Hollywood was one of the great American success stories. Synonymous with its main industry of movies, Hollywood had grown from a few citrus farms to a city that created a product that held the world spellbound. The business of moviemaking was driven not only by quantity but also by quality controls unparalleled by most other American industries. In 1939, a year often mentioned as the pinnacle of Hollywood's achievement, such classic films as *Gone with the Wind*, *Stagecoach*, *Ninotchka*, *Wuthering Heights*, *Mr. Smith Goes to Washington*, and *The Wizard of Oz* were all released. By the late thirties, Hollywood found itself the eleventh-largest American industry and was producing four hundred movies every year that drew some fifty million viewers to the theater—every week. Making nearly 700 million dollars

Orson Welles
Citizen Kane, 1941

every year, the film industry was a bright beacon for American capitalism in the dark days of the Depression.[10] It was clearly a place that believed in itself, in its ability to withstand economic downturns, and perhaps even in its own flickering dreams.

Hollywood's fall came about through a swift series of events. In 1941, the United States entered the Second World War, forever altering the studio system. Stars and directors headed off to Europe and the Pacific, draining the industry of some of its top talent; feature film production fell forty percent by 1945; and the Office of War Information (OWI) was set up to "suggest" to the industry appropriate war-related themes. Nor did governmental intervention cease after the war. In 1948, the anti-trust suit, *United States v. Paramount Pictures, Inc. et. al.*, filed in 1938, finally reached the U.S. Supreme Court. Known as the "Paramount case," the suit charged all the major film studios with violating anti-trust laws with their control of production, distribution and, through the ownership of theaters, exhibition. The studios lost the case and were forced to give up theater ownership, a major-blow to their source of revenues. Between 1947 and 1951, the House Un-American Activities Committee attacked Hollywood with zeal, calling witnesses, charging with contempt those who refused to answer questions about their political affiliations, forcing major Hollywood figures to name names or be banished from the industry. The blacklist that resulted from the hearings ruined lives and forced individuals lucky enough to have opportunities to work to adopt pseudonyms and head underground. What's more, movie attendance began to sharply decline around 1947, the result of demographic shifts to the suburbs and the growing accessibility of television.[11]

Hollywood's support structure had been badly damaged and the result was that the film industry began to take a closer look at its own internal mechanisms. Perhaps the earliest evidence of this shift comes some seven years before *The Lady from Shanghai* in Orson Welles's *Citizen Kane* (1941). Indeed, Welles was one of the first Hollywood directors to emerge after the birth of film rather than before it, so it is not surprising that his approach to cinema would be fundamentally different and more reflexive than those directors born before the turn of the century.

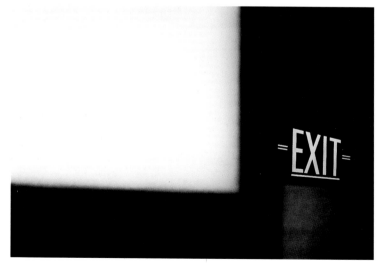

Edward Ruscha
Exit, 1990
Collection of Gilbert B. Friesen,
Los Angeles

Welles had a history of cinema available to him; there are accounts, for example, that he had John Ford's *Stagecoach* (1939) screened thirty-five times before beginning *Kane*.[12] Near the beginning of *Citizen Kane*, there is a moment that could serve as a symbolic rupture between the classic cinema and the self-reflexive film to come. Following "News on the March," a newsreel documentary focusing on Kane's life, we cut to the bright light of a film projector, are presented with the illuminated words "The End" seen at an angle from within the cramped, dark space of a screening room, and hear the optical track grind to a halt. We realize the newsreel, which had filled our theater screen, was actually within the fictive room "inside" the film. The shift is startling, the film within a film suddenly disrupting our suspended disbelief. (Incidentally, this technique is not unlike the way that Jasper Johns would later confuse representation and reality by painting the American flag to the edge of the canvas, providing no fictive space in which the flag could exist.) Next the producers of the film discuss the merits of their product and how they can improve on it while remaining all the while mere shadows against the illuminated blank screen.

For Welles, who had studied magic, the entire film apparatus — theater, projection, light, camera, sound — was something that could be "experienced" within the film's frame; part of the pleasure of the cinema was the excitement derived by the audience as self-aware observers of filmic pyrotechnics, the highlighting of what had before been primarily invisible. In *Kane*, the camera is self-referential, a device capable of flying under billboards and through glass skylights, of capturing the farthest corners of deep space and the closest foreground object within the same frame. Welles begins with the end, the end of Kane and the end of the documentary on Kane, signaling a reversal of convention and bringing the viewer's attention to the cinematic spectacle. This foregrounding of the apparatus foreshadows much of the concerns that artists and independent filmmakers would bring to the dialogue between cinema and the visual arts. The use of "the end" and the glowing white screen as a means of flipping a medium on its head would continue in work as diverse as that of Bruce Conner, Edward Ruscha, and Hiroshi Sugimoto, and in the "clear leader"

Orson Welles
Citizen Kane, 1941

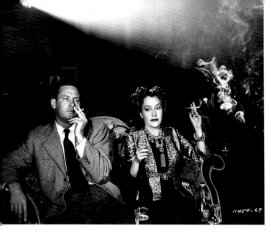

Billy Wilder
Sunset Boulevard, 1950

films of George Maciunas and Nam June Paik, as well as the "flicker" films of Peter Kubelka and Tony Conrad, all of which focus on the cinematic experience and film as a material.

Before *Kane*'s release, Welles had been seen as a rising star of Hollywood directors, a wunderkind of the cinematic. His fall from grace after *Kane* and *The Magnificent Ambersons* (1942), can be attributed in part to his attempts to subvert the cinematic system that relied heavily on the suspension of disbelief. Welles's desire to foreground the apparatus, sometimes at the expense of the narrative, was a radical departure from conventional filmmaking practice. As a shooting star who burned out through his own interest in the cinematic, Welles stands as a metaphor for the transition from the first half of film's history, a history of growth and experimentation, to the second half, after the growth had peaked. The new postwar history would be built out of film's own image — a history derived from history, film reflecting film.

Welles's films anticipate a strain of self-reflexive positioning that emerged more forcefully in mainstream narrative film in the fifties. Standing in the light from a projector, Gloria Swanson as the demented Norma Desmond in Billy Wilder's *Sunset Boulevard* (1950) laments that "We had faces then." The "then" is the silent era, when, indeed, the face was an object of desire. In *Sunset Boulevard*, we are expected to see Swanson not only as a deranged has-been, but to bring to the film our own knowledge of her as a legendary actress whose credits stretch back to the silent era and whose close-ups linger in our memory. There is a confusion of character and star, a blurring of the boarders between fiction and reality. Wilder exposes the dream factory as a place where a "star" might continue "sleepwalking along the giddy heights of a lost career," and aspiring writers sell their souls for a swimming pool.

With films such as *Sunset Boulevard* Hollywood began to re-present its past, to eat its own tail. *Sunset Boulevard* would be followed by other films which sought to expose the underbelly of the film industry or highlight the film apparatus, from Vincente Minnelli's *The Bad and the Beautiful* (1952) to Peter Bogdanovich's *Targets* (1968) or, from a European perspective, Jean-Luc Godard's *Le Mépris* (Contempt, 1963)

and Federico Fellini's *8½* (1963). A more humorous strain emerged in films such as Minnelli's *The Band Wagon* (1953), in which Fred Astaire plays Tony Hunter, a famous Hollywood dancer now past his prime, and Frank Tashlin's *Will Success Spoil Rock Hunter?* (1957), in which Jayne Mansfield portrays actress Rita Marlowe, a clear parody of Marilyn Monroe. Each in their own way linked the unveiling of the film apparatus with the decline of Hollywood itself, and by doing so indicated that "the end" of classic cinema had arrived.

In a short essay of 1955, Roland Barthes considers the face of Greta Garbo, suggesting that it belonged "to that moment in cinema when capturing the human face still plunged audiences into the deepest ecstasy, when one literally lost oneself in a human image as one would in a philtre, when the face represented a kind of absolute state of the flesh, which could be neither reached nor renounced."[13] Describing Garbo as an archetype of the human face and a Platonic Ideal of the human creature, Barthes underscores the transformative power of the classic American cinema, and the close-up in particular, for its ability to turn flesh and blood into a deified mask, into a "face-object." Almost alchemical, the metamorphosis is brought about by scientific means, by photo-emulsions, celluloid, light, gears, and lenses, that magically transform a living being into a star—into "The Divine." Barthes suggests that the seeds of change were already apparent in the face of Garbo, that by the thirties the star was beginning to be perceived differently, the goddess was giving way to a more lyrical face of a mere mortal, and the power of the cinematic image was breaking down. In referring to the face of Audrey Hepburn, he sees the advent of a new iconographic age, one based not on absolutes and archetypes as had been the case in the classic cinema, but on specificity and substance, a "passage from awe to charm."

The difference between these two ages is the difference between a pre-war Hollywood at its height, a golden age in which the factory of dreams was working at top speed, and a postwar Hollywood collapsing under the weight of a series of social and political upheavals. The cinema of the late twenties and

Frank Tashlin
Will Success Spoil Rock Hunter?, 1957

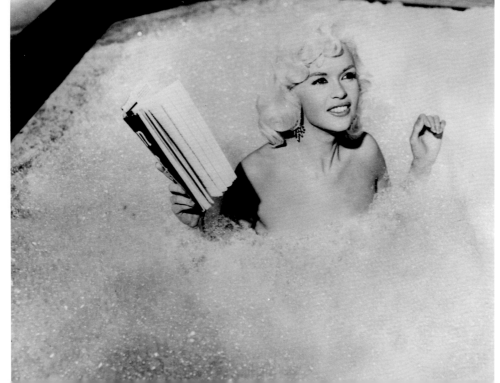

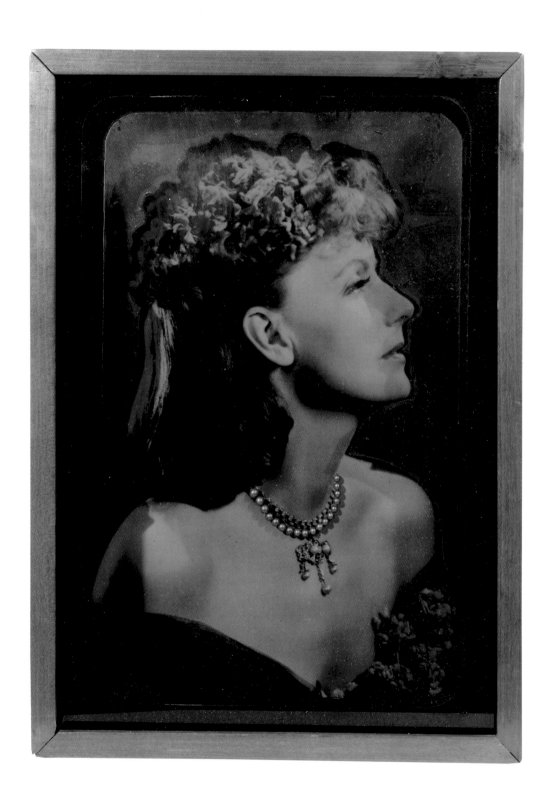

thirties was a well-oiled machine that intertwined promotion, publicity, high production values, the star system, and mise-en-scène that, for the most part, successfully created a world in which the audience could escape and in which the medium itself was essentially invisible. This was a world inhabited by larger than life characters, untouchable, unknowable, distantly perceived in the modern cathedral that was reshaping culture. But by the fifties, the cinema had become a self-conscious entity, its own half century of history now weighing down its sense of progress, its evolution having crested, its power to create myths exposed and mimicked in other forms such as television. It had moved from a sense of awe to one of familiarity, from the cathedral to the living room.

This transition can be perceived in the work of Joseph Cornell. In the thirties and forties, the reclusive Cornell began turning out boxes, collages, "dossiers," films, and magazine articles often revolving around cinematic themes. In *Greta Garbo* (c. 1939), Cornell incorporates a publicity still of the actress in costume silhouetted by iridescent blue glass. In this homage to "the Sphinx of the twentieth century," Cornell succeeded in translating from screen to reality that sense of the "face-object," as Barthes later called it, an antique mask of undetermined sex animated by the magic of moving pictures. Yet Cornell does not capitalize on the power of the then golden age of cinema; rather he attempts to return Garbo to an earlier stage of film history. Cornell was a fan of early film and proto-cinematic devices, a devotee of shadow boxes, optical toys, chronophotography, and the trick films of magician Georges Méliès. By placing Garbo's image in an antique box, "tinting" it blue like the nocturnal scenes in silent film, Cornell creates a relic, a fetish from a bygone era when the cinema was new, magical, and awe-inspiring, and when the creatures that haunted the screens were less marble icons and more enchanted fairies. He did the same a few years later in *Untitled (Penny Arcade Portrait of Lauren Bacall)* (1945–46). This time Cornell used the the penny arcade seen in his youth as a leitmotif. Although an avid filmgoer, Cornell clearly felt that something was missing in the golden age of cinema, that the sense of wonder had been tempered by the cool, highly crafted Hollywood productions.

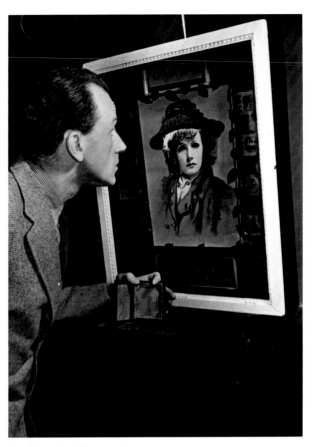

Joseph Cornell with his construction, "Legendary Portrait of Greta Garbo," during its presentation at Julien Levy Gallery, New York, in 1939 or 1940

Joseph Cornell
Greta Garbo, c. 1939
Richard L. Feigen,
New York

Georges Méliès
La Voyage dans la lune
(A Trip to the Moon), 1902

In his homage to Hedy Lamarr, printed in *View* in 1942, Cornell extols the virtues of silent film:

> Among the barren wastes of the talking films there occasionally occur passages to remind one again of the profound and suggestive power of the silent film to evoke an ideal world of beauty, to release unsuspected floods of music from the gaze of a human countenance in its prison of silver light. But aside from evanescent fragments unexpectedly encountered, how often is there created a superb and magnificent imagery such as brought to life the portraits of Falconetti in "Joan of Arc," Lillian Gish in "Broken Blossoms," Sibirskaya in "Menilmontant," and Carola Nehrer in "Dreigroschenoper."
>
> And so we are grateful to Hedy Lamarr, the enchanted wanderer, who again speaks the poetic and evocative language of the silent film, if only in whispers at times, beside the empty roar of the sound track....[14]

If one compares Cornell's vision of film stars with that of George Hurrell, Hollywood's most successful portrait photographer working at about the same time, it becomes clear how Cornell was trying to undercut the aesthetic vision of contemporary Hollywood and supplant what by the thirties had become the dominant studio style. Hurrell had himself altered the course of star portraiture by displacing the soft focus, painterly style of earlier star portrait photographers with dramatic "Rembrandt" lighting. His portraits emphasize contour and plasticity, giving dramatic impact to the portrait genre and suggesting a sense of the temporal drama within the confines of the still image. To an extent, Hurrell's style is an extension of the cinematography of the era, particularly the vision of director Josef von Sternberg who relied on heavy chiaroscuro and rich textures to give his images an effect that lies somewhere between expressionism and cubism (Sternberg collected both expressionist and cubist art). Hurrell was concerned with capturing drama, with extending the dramatic impact of the film and its power to envelop the viewer into production stills, to capture the grandeur and monumentality of the icon within the still format. Crystal clear, sharply modeled, dramatically lit, Hurrell's stars are cool, distant, untouchable.

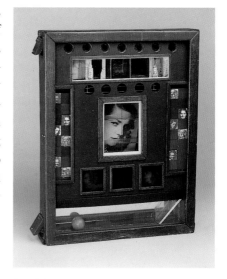

Joseph Cornell
Untitled (Penny Arcade Portrait of Lauren Bacall), 1945–46
Collection of the Bergman Family, Chicago

Joseph Cornell
Penny Arcade Portrait of Lauren Bacall (Dossier), 1946
(added to after 1946)
Collection of the Bergman Family, Chicago

His photographs promoted and extended the myths as conceived and manufactured by the studios.

Cornell, however, was not interested in the studio style of Sternberg or Hurrell, for this was a pictorialism in the service of the silver screen, a seamless extension of the narrative escapism of Hollywood. Rather, as a late follower of Surrealism, the cinema offered Cornell a vehicle for the creation of a netherworld of dreams, of the unconscious, of a spirituality based upon a modern apparatus and its worshippers in the dark. For Cornell, the star was an extension of the search for a spiritual resonance in art, and as such, had to be removed from the context of Hollywood which had become legitimate and common, and re-situated within a different, more mysterious context. Ironically, by creating art works out of film images, Cornell was in fact removing cinema from its high pedestal and lowering it back into the world of popular distractions, into the realm of the phantasmagoria, penny arcade, and wax museum.

Cornell's desire to send the cinema reeling back into its past can also be seen in the films he made himself, particularly his first, *Rose Hobart* (c. 1936). Cornell cut up and reassembled a 1931 B-film, *East of Borneo*, extending his collage and assemblage techniques into film montage. Cornell realized the possibilities that montage offered: the creation of a seamless world where great jumps in distance, time, and space were commonplace, where the strangest juxtapositions would flow quite naturally, where both presence and absence could be brought together within a few frames, and where, as in Proust's narrative, the present could be reshaped by the past.[15] But Cornell's objective was not to recreate the montage of Sergei Eisenstein or the more seamless editing style of Hollywood; it was not to create narrative out of a dialectic of images or out of an orderly set of building blocks. Rather, Cornell reworks existing material into a quasi-surrealist journey, where temporal structures are shaken to create a sense of linearity outside of strict narrativity. The film produces a sense of expectation and impending resolution that never occurs; Rose Hobart glances this way and that, but we are not allowed to see at whom or what. Narrative convention has been reworked to form a frame, like that of Cornell's boxes, to pay homage to an actress. *East of Borneo*

Joseph Cornell
Rose Hobart, c. 1936

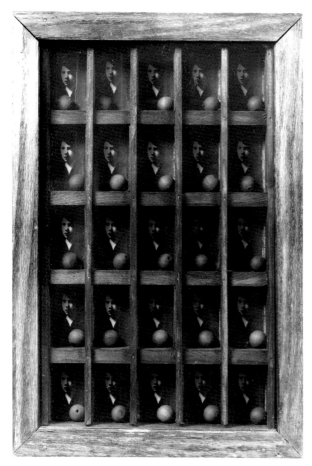

Joseph Cornell
Untitled (Compartmented Box), 1954–56
The National Swedish Art Museums, Moderna Museet, Stockholm

has revealed itself as film, and that material has been reshaped into a frame displaying the actress Rose Hobart.

Cornell acts as a link between the two ages described by Barthes, between the time when cinema was an awe-inspiring, progressive medium, and a new age when it was past its zenith and in decline. Unlike the artists and filmmakers who preceded him, Cornell did not embrace the cinema as a validating stamp for modernism; rather Cornell chose to recast film in a different light. In this, he prefigures the approach of many artists to follow. Like many artists of the postwar period he was profoundly nostalgic for the cinema past. He was moved not only by iconography, but by all aspects of cinema, by film language and by the very apparatus itself — the screen, projection, editing, celluloid — and he sought ways to incorporate these cinematic aspects into his work. Cornell even seems to instill many of his non-Hollywood related works, such as *Untitled (Compartmented Box)* (1954–56), with a sense of the cinematic, with issues of iconography, montage, and seriality, while his use of film iconography moves in the opposite direction, taking on the aura of Western traditions of portrait painting.

Cornell represents what Barthes recognized in the late thirties as a moment of transition for Hollywood. The gods and goddesses were giving way to something more corporeal, and the factory of dreams was giving way to the factory of nightmares. Cornell's response was to turn cinema backward, to send it reeling into its past. But it was too late. The star was shifting to a flesh and blood being with morphological functions. No longer were stars untouchable; rather, they were readily identifiable and reflective of ourselves, and their images were available for use and reconfiguration. Stars had ceased to come from inside the screen; now they belonged to the audience. Somewhere in the forties a layer of gloss had been rubbed off and the divine face of Edward Steichen's Garbo had passed into the "funny face" of Richard Avedon's Audrey Hepburn.

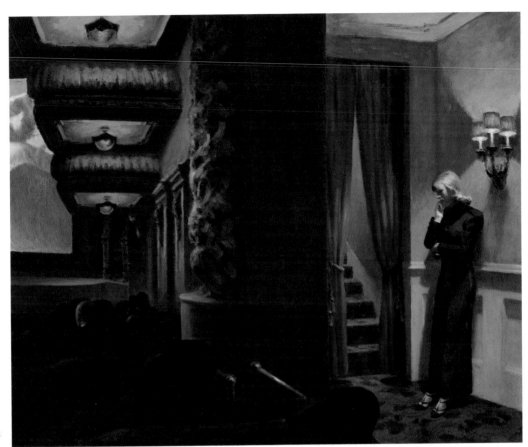

Edward Hopper
New York Movie, 1939
The Museum of Modern Art, New York
Given Anonymously

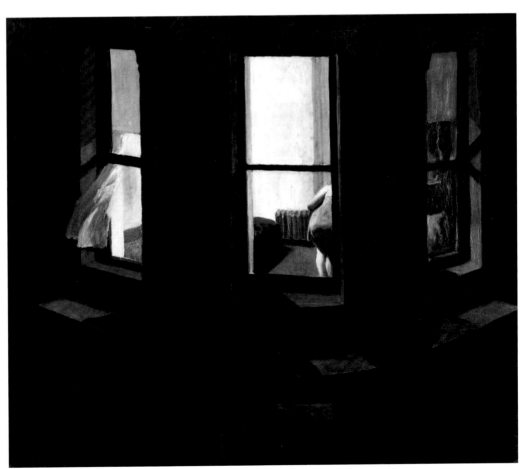

Edward Hopper
Night Windows, 1928
Oil on canvas, 29 x 34 in.
The Museum of Modern Art, New York
Gift of John Hay Whitney

Naked Hollywood

In the postwar era, the relationship between art and film turned more confrontational, sometimes hostile, with artists attempting to break the spell of cinema, turn it inside out, then construct a new but perhaps no less spellbinding relationship.

Edward Hopper's 1939 painting *New York Movie* foreshadows this approach. Hopper was not so much interested in the attributes of filmmaking — editing, space, time, motion — but in the vernacular language of the cinema, and in the "cinematic" aspects of life. In *New York Movie*, Hopper shifts the big screen to the side, focusing instead on the audience and the usherette illuminated by the flicker of the screen. In so doing, he places the film apparatus and the experience of watching at the core of the work. Isolated from one another by the power of the silver screen, the audience slips into a dream state while the usherette, having seen this dream over and over and unable to fully re-enter the daylight of reality, slips into her own silent revery. The alienating effect of cinema is carried over to much of Hopper's other work. Although he does not depict the cinema itself in such works as *Night Windows* (1928) or *Nighthawks* (1942), he does suggest the cinema in the lighting, composition, and voyeuristic characteristics that cry out to be presented as a form of "mise-en-scène," that rather undefinable filmic expression for the individual style of a director. As an avid moviegoer, Hopper injected into his work a sense of the cinematic; his paintings could easily be mistaken as film stills from the noir melodramas of such directors as Jules Dassin and Robert Siodmak. Hopper's work suggests that life itself has become a movie and that we — and the artist — are the audience peering in on the private lives of America now made public spectacle. Little wonder then that from the forties on, filmmakers as diverse as Alfred Hitchcock, Vincente Minnelli, Terrence Malick, Herbert Ross, and Wim Wenders have been, in return, inspired by Hopper's canvases, the original source of the cinematic imagery having become forever confused in the back and forth dialogue between Hopper and cinema.[16]

Hopper's interest in the spectator and the structure of movie gazing is echoed in the photographs of Weegee, but where Hopper's voyeurism

Weegee
Lovers at the Movies, Times Square, N.Y., c. 1940
Collection of the J. Paul Getty Museum, Malibu, California

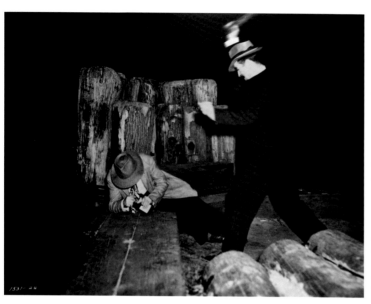

Jules Dassin
The Naked City, 1948

is humanistic, Weegee's often seems parodic and contentious. Garbo might be "the divine" but Weegee was self-proclaimed "the famous," a photojournalist who had established a reputation with violent and vulgar subjects. While Hopper was interested in the experience of filmgoing and in incorporating a cinematic look into his work, Weegee went for the jugular by singling out spectators in theaters during the screening of a film and photographing them with infrared film. In these photographs from the forties, Weegee catches people unaware of the photographer's presence. In one photograph of the audience at a 3-D movie, Weegee captures the comical embrace between the two lovers who, ironically, try to use the dark of the theater and the spectacle on the screen as a shield from the gaze of prying eyes.

But like most masters of the exposé, Weegee was as much fascinated as repelled by his subject. In 1947 he sold the rights to the title of his book about New York life, *Naked City*, to the film director Jules Dassin. At least on the surface the film version of *Naked City* bears little resemblance to Weegee's book. They are related, however, through their dark style, raw cynicism, and violent themes, and perhaps most of all through the use of the city as star (a theme Andy Warhol would bring to its ultimate conclusion in his film, *Empire*). Weegee's "picture" book is itself a fusing of *roman noir* and *film noir*, both of which relied heavily on the big city as protagonist. In both forms, the city becomes a familiar if foreboding place, an extension of the characters and author: Dashiell Hammett's San Francisco, Cornell Woolrich's New York, Raymond Chandler's Los Angeles.

The city as protagonist provided a point of intersection for noir and abstract expressionism. Echoing the night walks of Brassaï in the Paris of the thirties, Willem de Kooning, dance critic Edwin Denby, and photographer-filmmaker Rudolph Burckhardt often wandered through the streets of New York, or "Byzantine City" as de Kooning called it.[17] De Kooning's black-and-white works of 1946, Aaron Siskind's wallscape photographs, Franz Kline's black-and-white abstractions, and of course Weegee's journalistic photographs all parallel the urban environments of such films as Robert Siodmak's *Phantom Lady* (1944) and Sam

Robert Wiene
Das Kabinett des Dr. Caligari
(The Cabinet of Dr. Caligari), 1919

Fuller's *Pick Up on South Street* (1953), where black and white are in opposition and the remains of Caligariesque expressionism are transposed into a metaphor for an anxious atomic society in which the streets are inhabited by existentially unhinged heroes and the powers that be are obsessed with weeding out and destroying the unhealthy and degenerate elements in society. In Raymond Chandler's words, where "The streets were dark with something more than night."[18]

Indeed, it is perhaps in Chandler's Los Angeles that the city and noir become inextricably entangled. In Hollywood a number of social and cultural factors converged to create the quintessential film noir genre: the influx of German artists and filmmakers steeped in Expressionism, an interest by production designers in Edward Hopper's nightscapes, the jazz scene on Central Avenue, James M. Cain's pessimism, Chandler's cynicism, the Hollywood Ten, and the need to hide from a conservative government any sense of social commitment left over from the Depression.[19] In Edward Dmytryk's *Murder, My Sweet* (1944), Billy Wilder's *Double Indemnity* (1944) and *Sunset Boulevard*, Howard Hawks's *The Big Sleep* (1946), Robert Aldrich's *Kiss Me Deadly* (1955), and Orson Welles's *Touch of Evil* (1958) (where a barely disguised Venice Beach covers for a Mexican border town), character and narrative are equated with the city itself.

In 1947, Weegee himself headed to the noir capital in search of work. The publication of his book *Naked Hollywood* (1953), signaled a new approach to documenting the film industry. Unlike the photographers of the twenties and thirties such as Edward Steichen, Clarence Sinclair Bull, and George Hurrell, who had underscored the status of the star as god and goddess, Weegee and his collaborator, the writer Mel Harris, went after something quite different. *Naked Hollywood* is a comical exposé of the dream factory and the lives of the people in front of and behind the lens. Weegee cracked the glossy shell covering Hollywood and found beneath it a decadent world of absurd contradictions and frustrated desires. The images are sometimes naughty, sometimes ludicrous, but in several of the shots of movie stars (a puffy Errol Flynn, a weary Clark Gable) we sense the twilight of the gods.

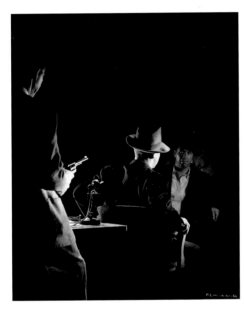

Edward Dmytryk
Murder, My Sweet, 1944

Orson Welles
Touch of Evil, 1958

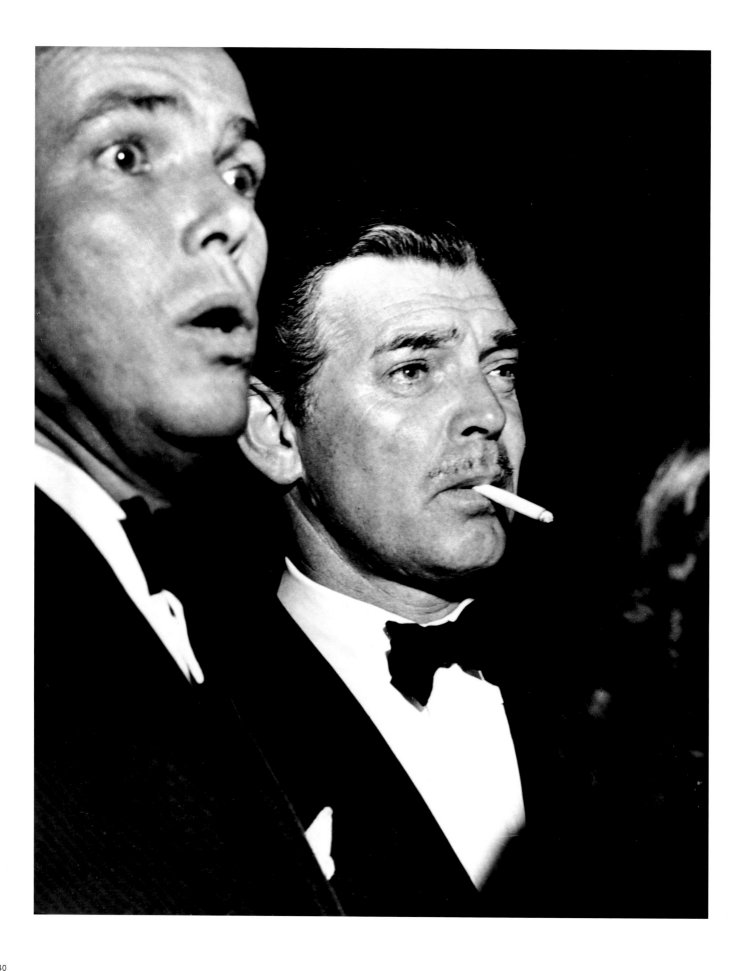

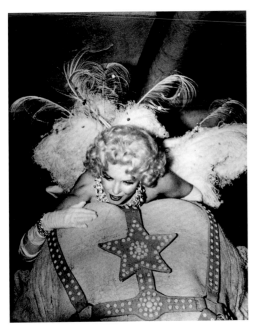

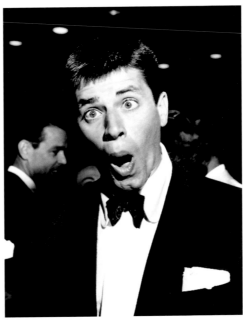

Weegee
Marilyn Monroe on an Elephant, c. 1953
Vision Gallery, San Francisco

Weegee
Jerry Lewis, 1953
Collection Galerie Berinson, Berlin

The raw, spontaneous quality found in Weegee's photographs is paralleled in other photographers' work that dismantled Hollywood with equal, if more lyrical, precision. Diane Arbus's photographs taken in film theaters in the fifties such as *Audience in the Loge and Balcony, N.Y.C.* (1958), capture bizarre spatial relationships between screen and spectator and uncover the hypnotic power of the cinematic event by revealing its reliance on the physical characteristics of the movie palace: the frontal positioning of the screen, the hidden cone of light from the projector, the darkness required for the illusion. At times, Arbus even confuses the real world and the illusionary; in *Kiss from "Baby Doll"* (1958), Arbus fills the frame with the cinema screen, confusing, as Welles had done in *Citizen Kane*, real space and dream space. If Arbus concentrates on the experience of film watching, Robert Frank is more interested in the dissemination of Hollywood iconography into the American landscape in such photographs as *Drive-in Movie, Detroit* (1955–56). Like Edward Ruscha's rendition of the Hollywood sign seen against the fading sunlight from the "wrong" side of the desolate Hollywood hills, Frank's *H for Hollywood Sign* (1956) suggests that even though Hollywood was in decline, its remains were redefining American postwar culture.

Bruce Conner's works demonstrate his discontent with Cold War America by taking society's refuse and reassembling it into works of art. Of course this debris included the movies. In his assemblages and collages, Conner combined images of pin-up girls and horror movie stills with reproductions of famous works of art. Film images are seen in this context as merely part of the onslaught of images assaulting society and a certain equation is set up between the motion picture, sex, and high art. In works such as *Homage to Mae West* (1961) or *Son of the Sheik* (1963), Conner seems to suggest that underneath every movie star is a seething quagmire of shocking revelations and decomposing remnants of humanity. In this sense, the star is a metaphor standing in for the warped disposition of society. Conner's vision finds a correspondence in Hollywood's own self-referential, self-incriminating films, such as Robert Aldrich's

Weegee
H Fonda and Friend, 1953
Collection Galerie Berinson, Berlin

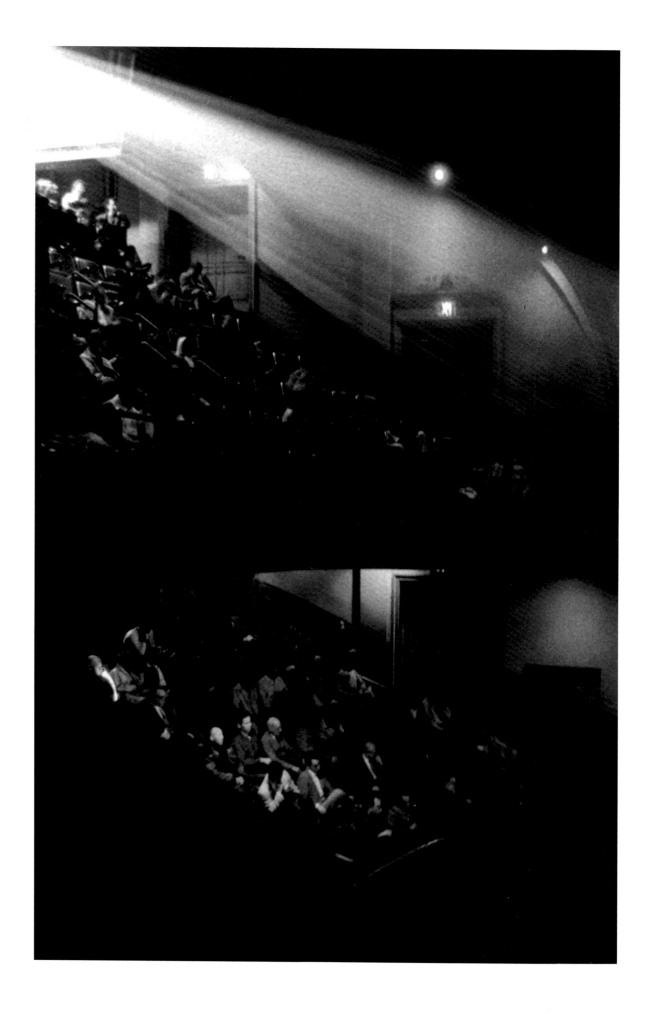

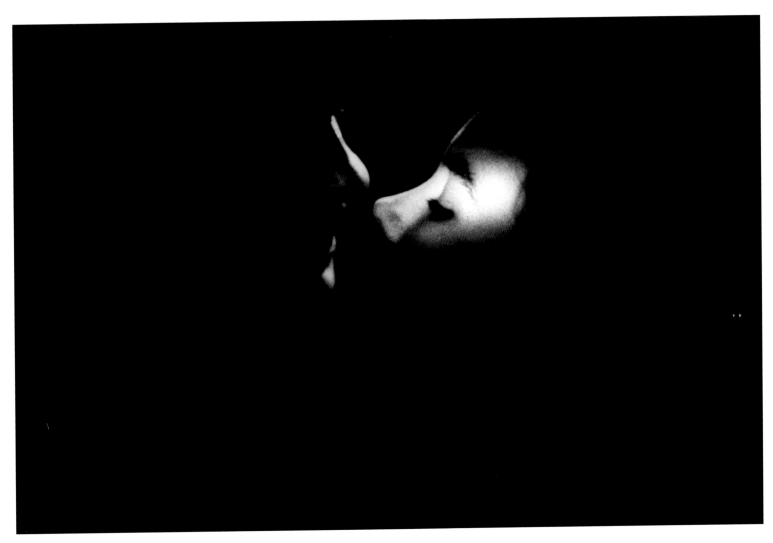

Diane Arbus
Kiss from "Baby Doll," 1958
Collection of John Cheim, New York
© Estate of Diane Arbus

Diane Arbus
Audience in the Loge and Balcony, N.Y.C. 1958
Robert Miller Gallery, New York
© Estate of Diane Arbus

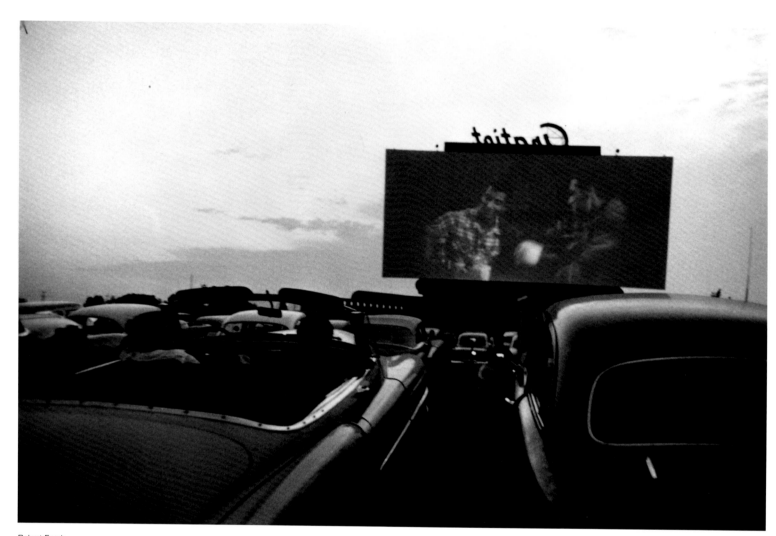

Robert Frank
Drive-in Movie, Detroit, 1955–56
The Museum of Contemporary Art, Los Angeles
Purchased with funds provided in part by the
Collectors Committee

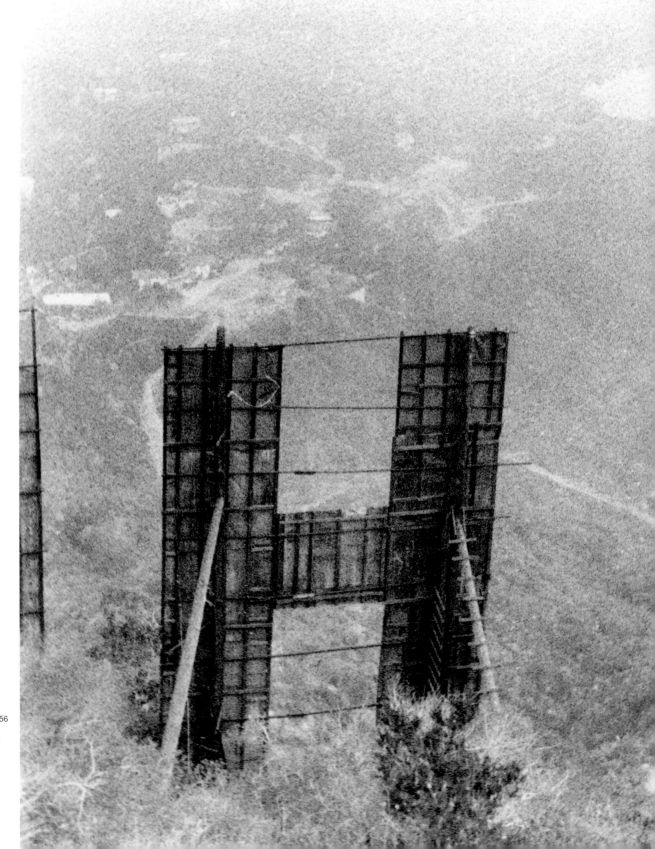

Robert Frank
H for Hollywood Sign, 1956
Stanford Museum of Art
Gift of Raymond B. Gary

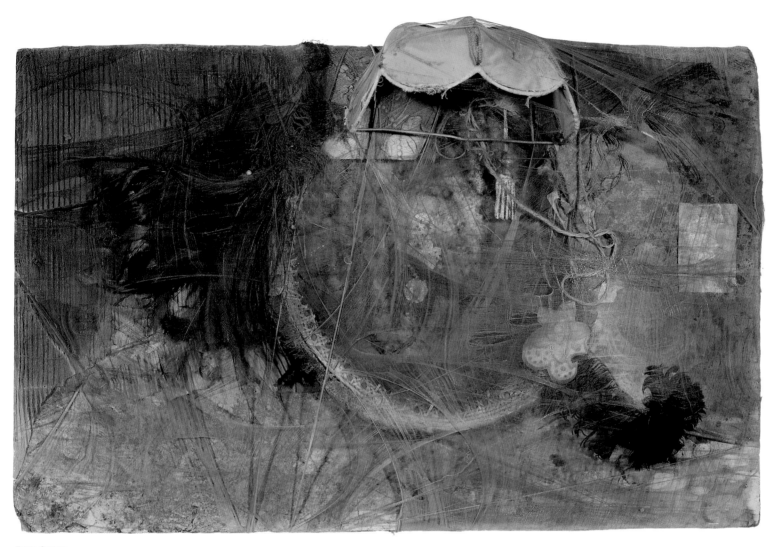

Bruce Conner
Homage to Mae West, 1961
Galerie Patrice Trigano, Paris

Bruce Conner
Son of the Sheik, 1963
Lannan Foundation, Los Angeles

Robert Aldrich
Whatever Happened to Baby Jane?, 1962

Bruce Conner
Homage to Minnie Mouse, 1959
Norton Simon Museum, Pasadena, California

Bruce Conner
A Movie, 1958

Dennis Hopper
Paul Newman, 1964
Collection of the artist, Los Angeles

Dennis Hopper
Peter Fonda (with Robinson Billboard), 1965
Collection the artist, Los Angeles

Dennis Hopper
John Wayne and Dean Martin, 1962
Collection of the artist, Los Angeles

Dennis Hopper
The Last Movie, 1971

51

Whatever Happened to Baby Jane? (1962), with its gothic one-upmanship of *Sunset Boulevard*, and Dennis Hopper's photographs that opt for a "behind-the-camera" take on stardom and straddle underground and industrial cinema. Hopper's film, *The Last Movie* (1971), as a consideration of genre and film production, could be seen as the culmination of Hollywood's self-examination process.

Conner's *A Movie* (1958) extended his interest in assemblage into film itself. *A Movie* uses found footage, taken from documentaries, newsreels, and features, and synthesizes these disparate elements into a new form in which the context of the original images is twisted and distorted. The juxtaposition of shots, arranged in a logical sequence and following the rules of direction and parallel cutting, results in the association and linkage of a cacophony of images ranging from Indians on the warpath to the burning Hindenburg Zeppelin to an atomic explosion. Like the finale to the Marx Brothers's *Duck Soup* (1933), which Conner greatly admires, many of these juxtapositions are absurdly comical, but in *A Movie*, the humorous quickly degenerates into the ominous. By imposing the editing techniques of feature film on footage from a variety of sources, Conner creates a film which deconstructs cinematic language and uses this disruption of convention to anticipate the destructive nature of conditioned behavior in postwar society.

Conner's counterculture position, his referencing of Hollywood and his concerns with the structure of the Hollywood mechanism, and his need to expose the trickery of the system, is paralleled in the work of underground filmmaker Kenneth Anger. Anger's films, from the sexual visions of *Fireworks* (1947), made when he was a teenager, to the mass cultural references of *Invocation of My Demon Brother* (1969), have been concerned with the celebration and interlacing of subcultures — homosexual, occult, Hell's Angel, customized car builders — with the repressive, antagonistic society pathetically attempting to hold them in check. Unlike Conner, who mostly used found footage, Anger shot his own film in a style that, unlike much underground and experimental cinema, is quite grounded in industrial filmmaking techniques: smooth dollies, careful pans, neatly arranged compositions, professional lighting.

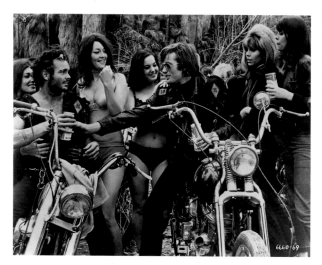

Kenneth Anger
Scorpio Rising, 1963

Roger Corman
The Wild Angels, 1966

By combining the professional production values of Hollywood with his subversive themes, Anger creates a disjointed vision that jars the viewer's expectations.

A collector of Hollywood memorabilia and a chronicler of the sordid side of tinseltown in his book *Hollywood Babylon* (1965, first published in France in 1959), Anger also uses the images of Hollywood in his films to underscore the way that cinema has shaped modern culture. Like Cornell, Anger particularly loved the silent cinema; he has said that silent cinema "has a kind of magic. You don't hear people's voices. A silent image is more like a ghost or a dream."[20] *Scorpio Rising* (1963) is a montage of associative and colliding images revolving around a "motorcycle man" (played by real life "Midnight Cowboy," Bruce Byron) and his dream machine, backgrounded by pictures of James Dean and Marlon Brando, comic books, Nazi swastikas, footage of Mickey Rooney as Puck from Max Rheinhardt's *A Midsummer Night's Dream* (1935) (in which Anger appeared at age eight), and footage from a low-budget film on Jesus, *The Road to Jerusalem*, all of which are counterpointed against such popular songs as "Fools Rush In," "Wipe Out," "My Boyfriend's Back" and "Blue Velvet." Anger sees *Scorpio Rising* as "a death mirror held up to American culture . . . Thanatos in chrome, black leather, and bursting jeans."[21] Anger's films went full circle as *Scorpio Rising, Inauguration of the Pleasure Dome* (1954), and *Kustom Kar Kommandos* (1964), among others, eventually influenced Hollywood through their presentation on the "nudie" circuit. Russ Meyer's *Faster Pussycat! Kill! Kill!* (1965), Roger Corman's *The Wild Angels* (1966), and Dennis Hopper's *Easy Rider* (1969) all owe a debt to Anger's interpretations of American iconography and the "Hollywoodization" of American culture.

Conner and Anger's subversive use of Hollywood iconography finds a correlation in Ray Johnson's collages and Mimmo Rotella's "décollages." In the mid-fifties, Johnson began creating small works made up of fragments of mechanically reproduced images. In the decline of Hollywood and the changing nature of the star image, Johnson found a means of expressing the alienation and rebellious spirit lying just

Ray Johnson
Shirley Temple, 1958
Collection of Mr. and Mrs. Henry Martin,
Bolzano, Italy

Ray Johnson
Hand Marilyn Monroe, 1958
Richard L. Feigen Gallery & Co.,
New York and Chicago

Mimmo Rotella
Eastmancolor, 1962
Galerie Reckermann, Cologne

Mimmo Rotella
La dolce vita, 1962
Private Collection, Rome

Mimmo Rotella
Cinecittà, 1963
Private Collection, Rome

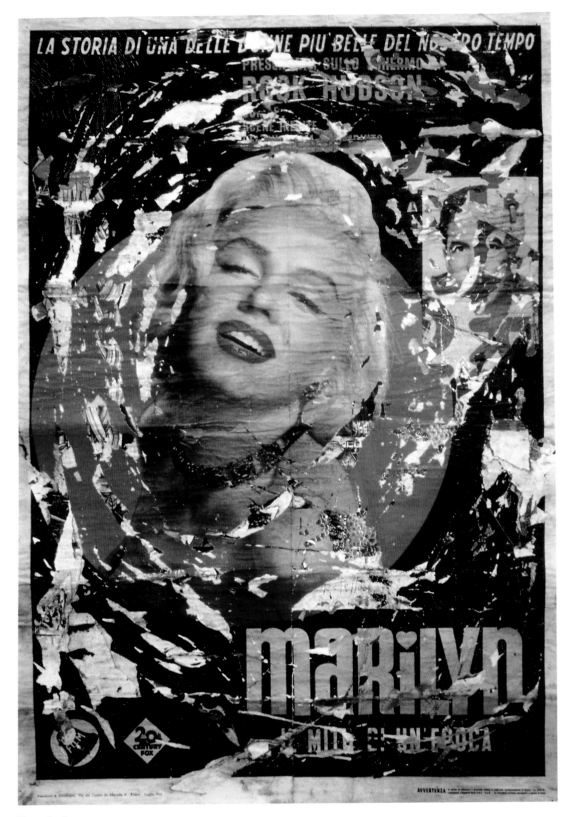

Mimmo Rotella
Marilyn Monroe, 1963
Galerie Reckermann, Cologne

beneath the surface calm of the Eisenhower fifties. Scraping off layer upon layer of film posters to create his décollages, Rotella not only comments on the marketing and consumption of dreams, but also on the ephemeral nature of the cinematic experience. His works are visual signs of the simultaneous breaking away of Hollywood (and Cubist lineages of modern art) and the recognition of the power inherent in mass production.

Glorious Technicolor, Breathtaking CinemaScope

If 16mm film was one of the catalysts for the rise of the American Independent Film movement in the thirties and forties, then surely the increased use of 8mm film in the fifties and sixties led to even more radical changes in the perception of what cinema could be. Even though Eastman Kodak had made 8mm home movie equipment available as early as 1932, it was not until the fifties that it became affordable and convenient. By the fifties, anyone could be a filmmaker. Not only were home movies a growing cultural phenomenon, adults and children could also produce and direct their own films in 8mm (and such productions have indeed altered the course of film history by producing a crop of filmmakers who got their start in their backyards). In addition, the non-professional could, through such companies as Blackhawk Films, also possess a Hollywood movie. In this way, film was disseminated, albeit cut up and reduced to 8mm, to the masses while simultaneously old films began to be strained through the television set on Million Dollar Movie-type showcases. The result was the rise of a generation of film fans who came to cinema as a once removed art form. In turn, this gave rise to such campy magazines as Forrest J. Ackerman's *Famous Monsters of Filmland*. These new publications dwelt as much on past films as new releases, creating whole histories of particular genres; somehow they were able to parody the very subject they were supposedly honoring without degrading it.

But if film practice was becoming simpler and more intimate on the amateur level, on the professional level it was doing quite the contrary.

Publicity for *This is Cinerama*, 1952

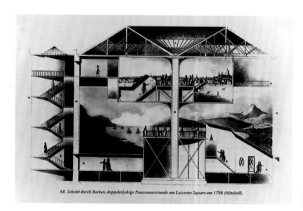

68. Schnitt durch Barkers doppelstöckige Panoramarotunde am Leicester Square um 1798 (Mitchell).

Cross-section of Robert Barker's panorama, London, constructed in 1792.

While 8mm was shifting film into a personal enterprise that, in some ways, more closely emulated the act of making and viewing visual art, the feature film industry was moving in the opposite direction, toward widescreen spectacle. Confronted in the fifties with the threat of television, the studios began to exaggerate the elements they then saw as essential to the cinematic experience, particularly scale. Returning to cinema's origins in the panorama and diorama, Cinerama's three-screen process was introduced in 1952 as a means of enveloping the spectator as never before, while in 1953, CinemaScope attempted to engulf the audience in slightly more conventional, but nevertheless panoramic screen and multi-directional sounds.[22] At about the same time, film expanded into three-dimensions, first with *Bwana Devil* (1952) and *House of Wax* (1953), and then, with the opening of Disneyland in 1955, with dark rides based on Disney films and designed by film animators. Underscoring the nature of film as a device that could transport the spectator, special effects became more and more prominent in films such as George Pal's *Destination Moon* (1950) and *When Worlds Collide* (1951), which utilized the hyperreal, panoramic matte paintings of Chesley Bonestell. What these tactics had in common was not only the desire to make the moviegoing experience more spectacular and monumental in an attempt to differentiate it from television, but also the wish to capitalize on the innate ability of film to transport the viewer; widescreen and other devices shifted the cinema closer to reality, supplanting artifice with the virtual, and further blurring the lines between fiction and reality, art and life — something that Pop art would also soon strive for.

As early as 1933, Rudolph Arnheim, contemplating the advent of sound and the increased use of color film, had argued that film could only remain art if it retained a sense of its basic properties, an argument not unlike Clement Greenberg's for painting. Arnheim feared that the development of a "complete" film — color, enhanced sound, stereoscopic vision, widescreen — would render useless such cinematic devices as montage, camera movement, and dynamic composition, thus destroying the art of film. He predicted that the "camera will have to become an immobile recording machine, every cut in the film strip will be mutilation."[23]

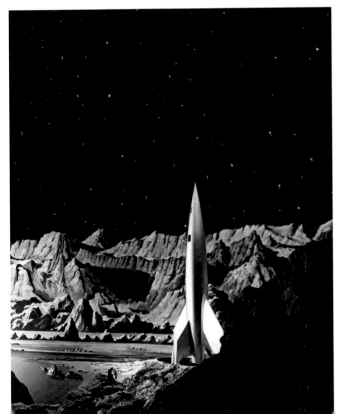

Chesley Bonestell
Painting for Destination Moon, 1950

Jean-Luc Godard
A bout de souffle (Breathless), 1960

Arnheim's anxious vision was prescient; by the mid-fifties, not only had composition and editing radically changed, but with the advent of Disneyland and the development of dark rides, the cinema was beginning to leave behind celluloid and the movie theater altogether.

One of the reasons for the decline of the mythic status of the movie star around this same time might be attributed to this "evolution," or rather this "inversion" of cinema back to its origins in the panorama and diorama. Widescreen and theme parks were a far cry from the artifices of classic cinema, the nearly square 1 x 1.33 ratio screen, rich black and whites, and high key lighting. The square screen had given way to ratios of 1 x 1.85 or even 1 x 2.66 which were not so well suited to the close-up. The potent one-shot, the singular, gigantic image of the actor tightly framed by the dark of the theater, gave way to compositions leaving great plains of space on one or both sides of the screen and the increasing use of shots in which the actor became a part of the landscape, reduced to a mere element in the composition. No longer the dominant image, often playing second fiddle to a technical "advancement" such as 3-D, and presented in a neighborhood movie "theater" rather than the movie "palace," the mythic power of the face-object declined.

But if the star no longer dominated the cinema, if artists and film-makers such as Weegee and Wilder had undercut their iconic power, if stars were no longer precious and untouchable, there still remained a desire, clearly grounded in commoditization, to manufacture new stars. But the stars that appeared in the fifties often represented a darker side of American culture. While Marilyn Monroe, James Dean, and Elvis Presley recharged the cinematic icon, they also introduced a new sense of sex, rebelliousness, and cult worship. This crisis can be seen in directors' work that spans the golden age and the tarnished postwar era. Alfred Hitchcock's *Vertigo* (1958), for example, with its theme of the double, the real and illusionary woman, could be read on one level as a metaphor for the crisis of the star. Hitchcock's biographer, Donald Spoto, has discussed *Vertigo* from the point of view of the director himself.

Hitchcock's conflicting feelings about women were perhaps the single most dramatic and painful realization of his own experience of a divided personality. On the one hand, Woman was an abstraction, almost a remote goddess in her purity and coolness. But — "in the back of a taxi," as he liked to say — what such a woman might do was really what he *wished* she would do.[24]

Later, when Hitchcock needed to "manufacture" a new female star to replace Grace Kelly and Kim Novak, he would take on aspects of James Stewart's character in *Vertigo* in his attempt to mold Tippi Hedren into a classic icon; it was a doomed project, not only for its rather perverse, patriarchal overtones, but also because Hitchcock was trying to create an anachronism. In the world of Marilyn Monroe and Jayne Mansfield, the woman in the back of the taxi had already supplanted Hitchcock's cool, Janus-faced blonde fantasy.

By the fifties, certain Hollywood directors were focusing on the world of popular culture and marketing. In *Will Success Spoil Rock Hunter?* (1957) Frank Tashlin takes a wry look at the worlds of advertising, fashion, and stardom, while also foreshadowing pop styles with his reliance on bright primary colors, the re-presentation of classic modern paintings floating in the minimal spaces of corporate walls, and the presence of Jayne Mansfield who plays Rita Marlowe who is clearly representing Marilyn Monroe, a device that Jean-Luc Godard, a fan of Tashlin's, would use a few years later in *Breathless* (1960) as Jean-Paul Belmondo plays Michel who mimics Humphrey Bogart. Tashlin takes a jab at television, too; partway through the film, Tony Randall addresses the audience and tells them that there will be a break to accommodate those members of the audience who are used to interruptions for messages on their "big 21-inch screens." As he addresses them the CinemaScope screen shrinks to a small square image, turns black and white, and goes out of control.

Yet widescreen itself could be parodied. In Edward Ruscha's early works such as *Large Trademark with Eight Spotlights* (1962), or his images of the Hollywood sign, the artist walks a fine line between homage and pastische. The well-known images, seen from the wrong-side or shoved just a little toward hard-edge abstraction, are painted in

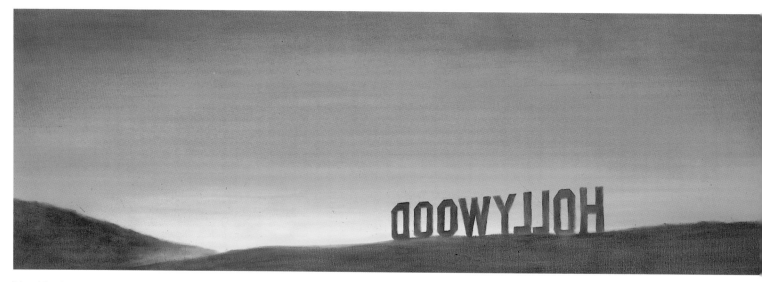

Edward Ruscha
The Back of Hollywood, 1977
Collection Musée d'Art Contemporain de Lyon

a widescreen format and are exaggerated just enough to turn the most common of signs into a complex commentary — without moralizing — on contemporary culture and aesthetics. In other works, such as *The Los Angeles County Museum of Art on Fire* (1965–68), Ruscha uses cinematic spectacle, widescreen composition and other film-related techniques, including what critic Peter Plagens has described as a "crane shot" view that can be equated with the Atlanta railroad station sequence in *Gone with the Wind*, to suggest the spectacle of the modern museum.[25]

The beginnings of the so-called Pop movement are generally traced to London and the Independent Group's interest in movies, advertising, and popular music. These artists, including Richard Hamilton and Eduardo Paolozzi, embraced commercial culture and attempted to ease it into the realm of "serious" art. They were not, however, merely interested in lifting images from popular culture, but in providing a new context for them, in finding out, as Lawrence Alloway put it, "How close to its source can a work of art be and preserve its identity? How many kinds of signs can a work of art be at once."[26] But despite this recontextualization of the mass culture image in art, it is difficult to separate Pop art as an art historical movement from the rise in mass marketing and mass consumption overall. As Peter Wollen has pointed out "the arrival of Pop Art in the early sixties was just one element in a much more general cultural shift ... Artists had to come to terms with the new images, whether through irony, celebration, aesthetic enhancement, or détournement."[27] The seeds of Pop sensibility can be found first in the merchandising machines of the media industries, in movies and television.

Issues revolving around the remaking of Hollywood, including mass marketing, consumption, the evolution of the star, fashion, and the new visionary aspect ratios are all superimposed and interwoven in the work of Hamilton. He interlaced seemingly unlike or even oppositional elements into tightly structured, coherent views of a world reformed by popular culture, particularly the cinema. In an early work such as *Hers is a lush situation* (1958), Hamilton intermingles the sensual lines of a 1957 Buick with the human figure and collaged lips of Sophia Loren, creating a new type of cinematic space that allows for the fusion of popular

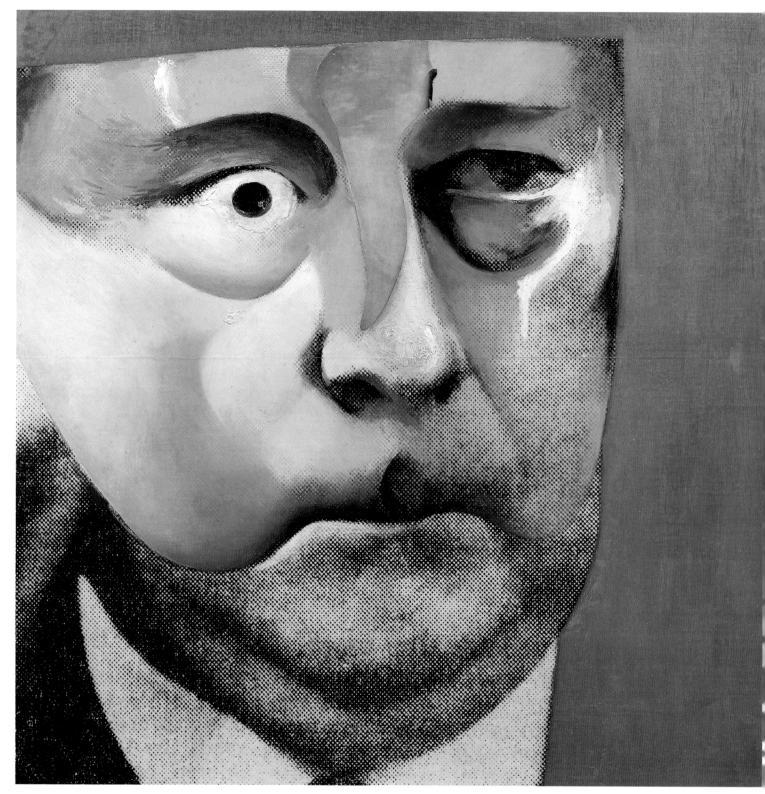

Richard Hamilton
Portrait of Hugh Gaitskell as a Famous Monster of Filmland, 1964
Hayward Gallery, Arts Council Collection, South Bank Centre, London

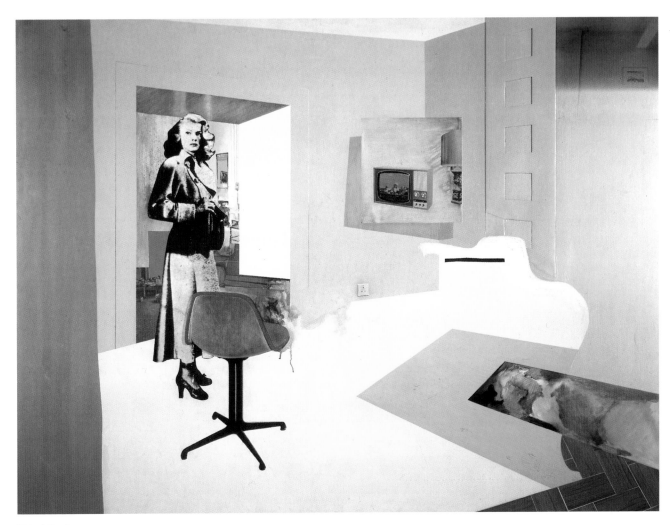

Richard Hamilton
Interior II, 1964
Tate Gallery, London

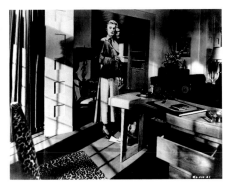

Douglas Sirk
Shockproof, 1949

culture, high art, and industrial design. In *Portrait of Hugh Gaitskell as a Famous Monster of Filmland* (1964), Hamilton overlays Hollywood special effects, genre, and fandom onto a portrait of a British politician, creating a parody of a parody: Claude Rains as the Phantom of the Opera from the forties into the cover on a fanzine from the fifties combined with the title character in *The Creature with the Atom Brain* from the fifties combined with the leader of the Labour Party.

In 1959, Hamilton delivered a lecture with slides and pop music entitled *Glorious Technicolor, Breathtaking Cinemascope and Stereophonic Sound*.[28] On the surface this piece is a fairly straightforward description of widescreen technologies, but on a deeper level is symptomatic of Hamilton's profound interest in the contemporary observer and the way cinema had shaped his or her vision. It has been noted that Hamilton's works are often constructed in relief and yet simultaneously plunge the viewer into the center of the composition, folding a variety of fields together, zooming inward and dollying sideways, creating flying saucer like shapes that bulge, distort, and spread space.[29] Not only is the viewer sucked into a vortex of undulating rhythmic space, but once inside is repelled back outward by a piece of chrome or a mirror, echoing the cinema audience's desire to look at something other, to be a voyeur, and yet simultaneously to find oneself there being looked at. An example can be found in his *Interior I* and *Interior II* (both 1964). Always intrigued by modern interior spaces, Hamilton came upon a publicity still for Douglas Sirk's film *Shockproof* (1949) in which Patricia Knight stands amidst a noirishly lit room. Hamilton was amazed at the way a publicity still could convey so much of the film's plot and atmosphere. He analyzed the still: "A very wide angle lens must have been used because the perspective seemed distorted.... Since the scale of the room had not become unreasonably enlarged, as one might expect from the use of a wide angle lens, it could be assumed that false perspective had been introduced to counteract its effect — yet the foreground remained emphatically close and the recession extreme. All this contributed more to the foreboding atmosphere than the casually observed body on the floor, partially concealed by a desk."[30] In *Interior I*, the mirror behind Knight is real, placing

Michelangelo Antonioni
Il deserto rosso (Red Desert), 1964

the spectator in the midst of the painting. Hamilton further blurs the real and the fictive by introducing found elements such as a real pencil and printed material. In the *Interior* works, Hamilton has subsumed the essence of film — its iconography, its mise-en-scène, its reduction into a still, even part of its narrative — into an art work that reprocesses photography, printing, and filmmaking into a wholly new, mixed-media form.

In some respects, Hamilton's work in art parallels Michelangelo Antonioni's in film. Both, for example, are interested in articulating the space and design of contemporary cinematic culture while simultaneously transmuting the medium in which they work. In *Blow-Up* (1966), Antonioni is interested in the specularity of the cinema and in cinematic technique: in zooms, dollies, close-ups, color, sound; and in the relationship of art to popular culture, painting to design, and representation to abstraction. What Hamilton and Antonioni have in common is the desire to bewilder the viewer with a multiplicity of views, to explore contemporary perception which combines flatness and deep focus, time and stillness, tableau and movement. Like Hamilton, Antonioni is interested in color and abstraction; in *Il deserto rosso* (Red Desert, 1964), for example, Antonioni "misuses" film language — focal-length lenses that are too long, rhythms that are too slow, shots just out of focus, shots that are a little too close, too far away, too grainy, too saturated — to create a world between representation and abstraction. In *Il deserto rosso* the landscape no longer functions as a backdrop to the stars, but, as in much of Hamilton's work, is integrated with the figures, the landscape and architecture taking on aspects of the characters, and the characters metaphorically represented in the landscape. Cinema is pushed to the point of abstraction, an arena where conventional narrative, character, and linearity become confused with color, composition, and rhythm.

Godard/Warhol

Acting as mirror images of one another, Jean-Luc Godard and Andy Warhol find common ground within the realm of popular culture and the deconstruction of the cinema. Although the two artists had no personal

relationship, their work addresses similar issues of Hollywood and stardom, genre, the periphery and the underground, reality and fiction, tableau, voyeurism, repetition, disaster, prostitution, and consumerism, while the form their work takes is also often analogous in its use of time, color, public images, abstraction, and the replay of traditional forms of history painting, portraiture, and still life.

Both Godard and Warhol's relationship with Hollywood is ambivalent. Godard's background as a critic for various magazines, including the influential *Cahiers du Cinéma* and his presence at numerous screenings at the Cinémathèque Française in the fifties establishes his relationship with Hollywood as that of cinephile and fan; it was, after all, the French critics of the fifties who helped uncover numerous Hollywood "B" directors such as Sam Fuller and Frank Tashlin and gave them their place in a pantheon of American directors headed by Hitchcock, Welles, John Ford, and Howard Hawks. Yet Godard and his fellow critics François Truffaut, Eric Rohmer, and Jacques Rivette were not content simply to write a history of cinema, nor even to establish a cinema theory, but went on to apply this history to filmmaking and the creation of a new cinema that would in some manner move beyond what had gone before. Indeed, their position was not unlike that of painters in the fifties who were working under the shadow of Abstract Expressionism and had to decide to work within that tradition or to dismantle the established myths and remix conventions. Popular culture provided both Godard and Warhol with a means of refuting established canons of cinema history and modernism, and their reductivist strategies allowed each to subvert previously established forms such as montage and the long take into a self-reflexive meta-language that created new signifiers such as the jump cut, the overly-long take, the one-shot/one reel movie, the use of text, and the repetition of images and sequences. In addition, each sought to break down the purity of their respective mediums, Godard by consistently referring to other media such as painting and literature and by incorporating written language into film imagery, and Warhol by literally moving into filmmaking and rejecting, at least for several years, painting altogether.

Jean-Luc Godard
Le Mépris (Contempt), 1963

Jean-Luc Godard
La Chinoise, 1967

If there is a primary theme in Godard's early work, it is the desire to obtain a space between reality and fiction, between documentary and imagination. It is, of course, the established dichotomy of Lumière and Méliès, the opposite poles of the cinema: the Lumière brothers and their early *actualitée* that captured "reality" and Méliès's use of camera tricks and artificially painted sets to manufacture fiction and fantasy. Godard, however, decided early on to find a passage between the two, to create a new form in which reality and fiction converge. Godard wrote: "Beauty and truth have two poles: documentary and fiction. You can start with either one. My starting point is documentary to which I try to give the truth of fiction."[31] The eventual form that Godard adapted to accommodate these poles was the film essay, which in part came out of his own background as a critic. "Instead of writing criticism, I make a film, but the critical dimension is subsumed. I think of myself as an essayist producing essays in novel form, or novels in essay form: only instead of writing, I film them."[32] This crossing of documentary and fiction is a position shared by Warhol. In his "Disaster" series, the repetition and general aestheticization of car crashes, suicides, electric chairs, and race riots shift the focus from the unwatchable reality to the rhythms of fiction, while in films such as *Kiss* and *Sleep* (both 1963), Hollywood is plunged into the realm of Lumière's recording mechanism.

Warhol is probably the clearest example of an artist who shifts painting toward cinema and cinema toward painting. Warhol's use of movie stars such as Marilyn Monroe, Elizabeth Taylor, and Marlon Brando capitalizes on immediate recognition with all its built-in publicity value to blur the distinction between the work itself, what it represents, and that representation's history. This is somewhat analogous to the use of stars as a marketing strategy, the built-in name power acting as part of the content of the work as much as the narrative, resulting in a blurring of reality, hype, and fiction. Warhol's use of the silkscreen process to replicate over and over again these iconographic images is, of course, part of Pop's strategy to draw attention to the public imagery and its role as consumer item — Marilyn as coke bottle. Yet tied into this formula is the desire to emulate the cinema, to find a means of making

Andy Warhol
Marilyn Monroe's Lips, 1962
Hirshhorn Museum and Sculpture Garden,
Smithsonian Institution, Washington, D.C.

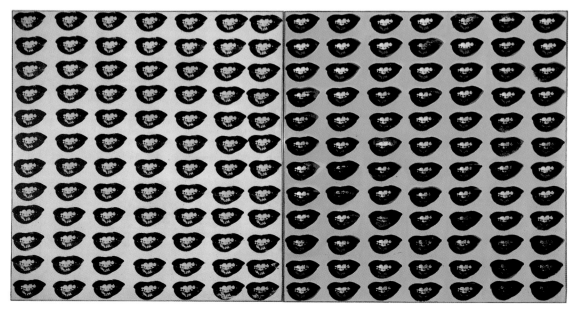

these portraits, or disaster images, "move," to give them a lifeless life, a deadpan personality — to bring the dead back to life. In his films, Warhol uses the same approach, only in reverse. Warhol traps the Empire State Building or his superstars into prison-like tableaux, the image repeating over and over at sixteen frames a second (silent speed), to create a more or less motionless but time-based anti-cinema that suggests painting in a world that has moved, in part from the impact of cinema, past painting.

Throughout his career, Godard has also been concerned with public imagery and the validity of art and cinema in contemporary culture. In *A bout de souffle* (Breathless, 1960), when Godard emulates the low-rent gangster genre, or in *Le Mépris* (Contempt, 1963), when Fritz Lang plays himself and Jack Palance and Brigitte Bardot play a producer and actress, or in *Alphaville* (1965) as detective Lemmy Caution a.k.a. Spade/ Bogart/Marlowe moves through the noirish moderne future that is contemporary Paris, Godard's retrieval of film history and iconography not only relates to his own role as a critic in the fifties but, like Warhol's work, raises issues regarding the dissemination of mechanically reproduced images in mass culture, most importantly those from the cinema. As a cinephile, Godard is both enveloped by the cinema and distanced by its history. Like Warhol, Godard's content cannot be separated from his use of form; from the jump cuts to his use of extremely long takes, he shares with Warhol's cinema the desire to create film about film (fiction in the realm of Lumière), film after the age of film. In a short piece titled "My Approach in Four Movements" published in 1967, Godard concludes by asking: "Is this cinema? Am I right to go on trying?"[33] Rather than use "fin" at the end of his film *Week-end* (1968), Godard substitutes "Fin du cinéma," foretelling his disappearance from narrative feature film production in the late sixties and early seventies.

Like Warhol, Godard's work is also about painting after the age of painting. Richard Roud has suggested that perhaps the most basic theme of Godard's work is his interest in the fleeting or passing moment.[34] Godard himself praises Ingmar Bergman's films for his interest in "the precise instant."

Bergman, in effect, is the filmmaker of the instant. Each of his films is born of the hero's reflection on the present moment, and deepens that reflection by a sort of dislocation of time — rather in the manner of Proust but more powerfully, as though Proust were multiplied by both Joyce and Rousseau — to become a vast, limitless meditation upon the *instantaneous*. An Ingmar Bergman film is, if you like, one twenty-forth of a second metamorphosed and expanded over an hour and a half. It is the world between two blinks of the eyelids, the sadness between two heart-beats, the gaiety between two handclaps."[35]

Jan Vermeer is one of the artists who comes to mind when viewing much of Godard's work. Although Godard rarely quotes a specific painting in his early films, he nevertheless suggests the poses, light, and sense of extended time of Vermeer, an artist who was also intimately focused on capturing the fleeting moment for eternity. More broadly, Godard's interest in art appears as posters on the wall, reproductions in books, poses recalling the masters, yet it is high art interwoven with images of billboards, magazine advertisements, comics, and film posters.

Warhol and Godard have both been concerned with the means of production and the meaning that this process has on the finished work. The Factory was an environment, at least for those halcyon days before 1968 when Warhol was shot, in which people from all walks of life came and went with considerable freedom; and yet it was also a *factory*, a place to manufacture a product. Warhol embraced capitalist structures while simultaneously turning them on their head. The Factory was both a business and a send up of a capitalist venture, a parody of systems of mass production, particularly Hollywood's industrial systems. The Factory distanced the artist from the work and raised questions of authenticity much as the images themselves seem to raise questions about the originality of stars depicted.

Warhol's interest in modes of production and his tightrope walk between painterly authenticity and mechanical reproduction find parallels in Godard's work. Throughout his career, Godard has struggled to find an appropriate means of film production. Godard's interest in consumer culture and modes of production also influenced his filmmaking habits and

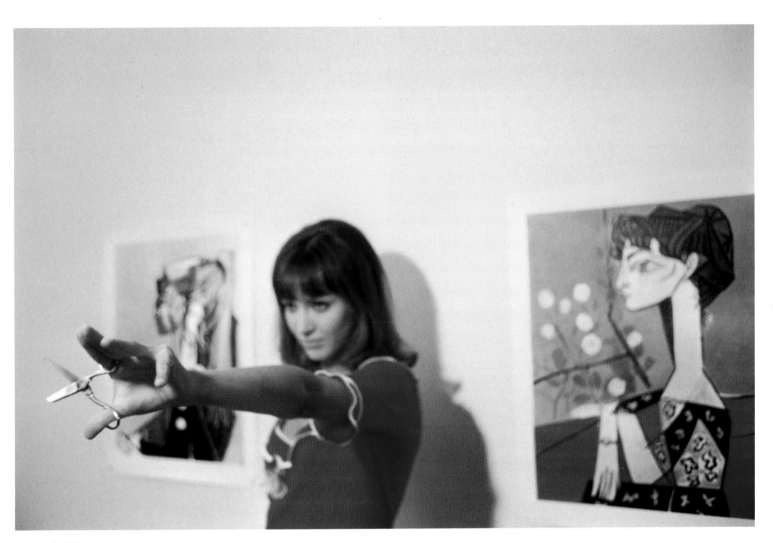

Jean-Luc Godard
Pierrot le Fou, 1965

Andy Warhol
Frame sequence from *Sleep*, 1963

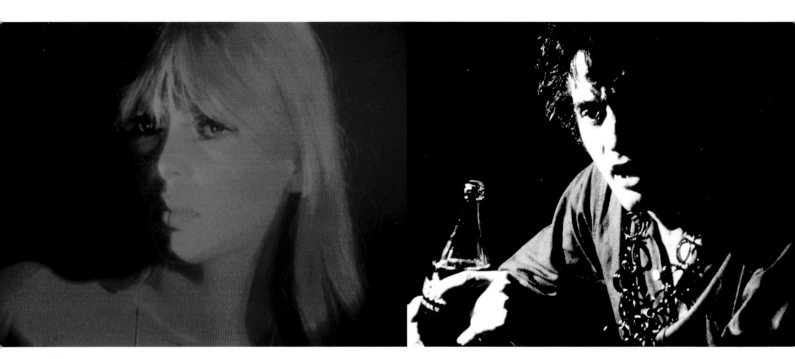

Andy Warhol
The Chelsea Girls, 1966

goes hand in hand with his despair about the state of cinema in general. Even in his early films Godard, like other members of the Nouvelle Vague, worked with relatively small crews right in the streets of Paris. The result was a type of filmmaking which, through hand-held camerawork, jump cuts, and natural light, shifted narrative film closer to the documentary, and revealed the process of filmmaking. In the late sixties, Godard pushed this further and attempted to find a new model for critiquing filmmaking by doing away almost completely with the film crew and narrative and adopting minimal aesthetics in *Le Gai Savoir* (1968) and *One Plus One* (1968); then, shortly after, establishing, with Jean-Pierre Gorin, the "authorless" Dziga Vertov Group; and eventually turning to videotape in collaborations with Anne-Marie Miéville on works such as *Numéro deux* (1975). Like Warhol, Godard has always relied on spontaneity and flexibility, improvising on location and using ideas brought to the set by others. This way of creating shifts Godard's work, including his feature films, toward the underground cinema, while Warhol's interest in Hollywood production techniques and his use, and abuse, of narrative, stars, and genre along with his indifference to contemporary experimental film and filmmakers, shifts his film work toward mainstream cinema.

David James has suggested that Warhol's films can be divided into three stages: investigations into the process of being photographed and of becoming an object (*Sleep* (1963), *Kiss* (1963), *Blow Job* (1964), the screentests, *Poor Little Rich Girl* (1965)), the construction and fragmentation of artificial selves by means of roles appropriated from Hollywood (*Lonesome Cowboys* (1967–68), *Blue Movie* (1968)), and the representation of exhibitionism and spectatorship in feature film that is adjacent to Hollywood (*The Chelsea Girls* (1966), *Flesh* (1968–69), *Trash* (1969)). He suggests that the "photographic apparatus has throughout a double role; on the one hand it is the means of reproduction, and on the other it is the signifier of mass industrial reproduction, both metaphor and metonym for Hollywood, holding out the promise of mass consumption and thus the means of negotiating a private event into a public spectacle. It promises the transformation of an individual into a star."[36] We might apply a similar scheme to Godard's work: the under-

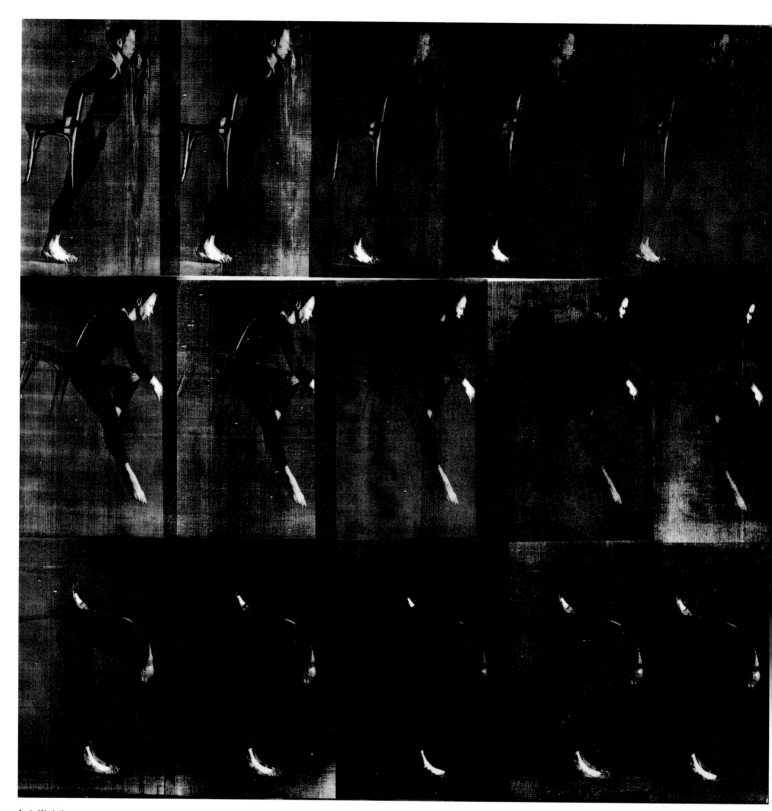

Andy Warhol
Merce Cunningham, 1963
Private Collection

scoring of the voyeuristic aspects of cinema through the convergence of fiction and documentary; the confusion of characters' identities through the use of Hollywood iconography and genre; and the creation of a film structure parallel to the mechanisms of Hollywood — all in the service of foregrounding the film apparatus and re-establishing the relationship between the spectator and the spectacle.

Part II
Cinema Degree Zero: Testing the Limits

Your paintings are like my films — they are about nothing ... with precision.
— Michelangelo Antonioni to Mark Rothko, 1962[37]

The ultimate filmgoer would be a captive of sloth. Sitting constantly in a movie house, among the flickering shadows, his perception would take on a kind of sluggishness. He would be the hermit dwelling among the elsewheres, foregoing the salvation of reality. Films would follow films, until the action of each one would drown in a vast reservoir of pure perception.
— Robert Smithson, 1973[38]

Cinema of Reduction
More than the incorporation of stillness into the temporal dimensions of cinema, more than a send-up of star imagery, Warhol's early films are an integration of the image with the apparatus, an image that could only be derived by allowing the apparatus to function at its most rudimentary level. *Sleep, Kiss, Blow Job, Empire*, or the various "screentests" are "tests" of film's — and the observer's — limits. To fashion such an investigation, Warhol links the concept of a radical gesture of reduction to an elementary application of the apparatus. If *Empire* conjures up Lumière, Warhol's paintings often summon up a related, primordial, cinematic link, that of the chronophotograph. In works such as *Merce Cunningham* (1963), Warhol jars the foundations of painting not only by insisting on

Eadweard Muybridge
Multiple Nude Self-Portrait, n.d.
Collection of Audrey and Sydney Irmas,
Gift of Irmas Intervivos Trust of June 1982,
Los Angeles County Museum of Art

Etienne-Jules Marey
*Chronophotograph of a jump from
a standing still position*, c. 1882

Marcel Duchamp
Nude Descending a Staircase, No. 2, 1912
Philadelphia Museum of Art:
Louise and Walter Arensberg Collection

the pervasive influence of the mechanically reproduced image, but by formally serving up these images in a serialized structure that recalls the motion studies of Eadweard Muybridge, Etienne-Jules Marey, and even Marcel Duchamp, thereby reconnecting painting to the art of simple observation. It is as if painting, cinema, and photography converge in a nexus of indivisible reduction where "Art" disappears into function and content is not yet a possibility. The placement of painting and photography at the origins of cinema reflects backward and forward simultaneously, suggesting a space informed by modernity that projects forward toward the classic cinema as well as a moment when modernism is still entangled in nineteenth-century perceptual investigations and modern history as yet to be written. Like the cinema, Warhol's work becomes a time machine.

In *Writing Degree Zero*, Roland Barthes argues that

> The poetic word is here an act without immediate past, without environment, and which holds forth only the dense shadow of reflexes from all sources which are associated with it. Thus under each Word in modern poetry there lies a sort of existential geology, in which is gathered the total content of the Name, instead of a chosen content as in classical prose and poetry.... It therefore achieves a state which is possible only in the dictionary or in poetry — places where the noun can live without its article — and is reduced to a sort of zero degree, pregnant with all past and future specifications.[39]

Warhol's works of the early sixties mark a point where the dialogue between art and cinema had already fully torn apart the structures of Hollywood and had gotten out from under Hollywood's vast shadow; it had arrived at a zero similar to Barthes's. Now artists and filmmakers would concentrate on the fundamental aspects of the apparatus itself and film would become a material. Testing could now begin on the resiliency of those rudimentary aspects of the cinematic medium.

The work of hyphenated artist-filmmakers associated with the minimalist or "structuralist" movement such as Michael Snow or Tony Conrad, is dominated by an inversion of priorities, the narrative changing places

with the optical, the visual aspects taking priority over actions, and the narrative and characters becoming imbedded in the visual aspects of the film. Little wonder then that these films, along with much of the feature work coming out of Europe by such directors as Michelangelo Antonioni, Alain Resnais, or Ingmar Bergman, were often referred to as "art" films, a term which pejoratively distinguishes them from Hollywood entertainments but also, intentionally or not, underscores their shift away from linear narrative toward abstraction and perceptual phenomena.

Antonioni's work, beginning with *L'Avventura* in 1960, can be described as tending toward the abstract. Narrative, though always present to some extent, is reduced to the simplest of forms, often without beginning, middle, or end, and the visual aspects take on a new weight and importance. Using posed characters that often hug the barren walls of the European industrial landscape, long focal length lenses that reduce depth of field, and restricting his camera movement to slow horizontal pans, Antonioni achieves a sense of flatness that correlates with issues in the visual arts around the same time.[40]

Antonioni has said that he wants "to paint the film as one paints a canvas; I want to invent the colour relationships, and not limit myself by photographing only natural colours."[41] His work forms a close parallel with painting in the late fifties and early sixties as it shifted from Abstract Expressionism's interest in autobiographical gesture and abstract illusionism to impersonal choices based on the structure of the canvas. In discussing *Il deserto rosso*, Angela Dalle Vacche has noted that Antonioni may very well have been influenced by European art informel.[42] Although Antonioni's work does echo the style of postwar abstraction it also looks forward to Minimalism's concerns with monochromatic planes and architectonic systems. If, as Michael Fried suggested, Minimalism had an inherent theatricality, that the subject to object relationship was something that took place in time and

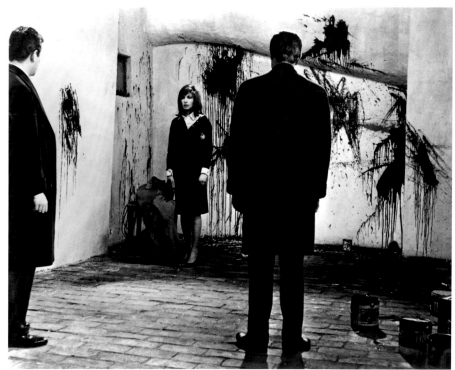

Michelangelo Antonioni
Il deserto rosso (Red Desert), 1964

space,[43] the cinema, with its inherent space-time mechanism, was a readily available medium for Minimalist and structuralist concerns despite its ephemeral nature.

Although Antonioni is often associated with abstract painting, his approach actually might be closer to the work of an artist like Donald Judd. Judd's early work, in which he embedded objects in the textured surfaces of his paintings, and his early sculpture, with its reliance on geometric symmetry and repetition that rejected illusionistic space for a physical presence, has the sense that it is nothing more or less than a literal object, something with no history or associations — perhaps not far from Barthes's idea of zero-degree writing. Both art world Minimalism and Antonioni's films rely on a physicality and presence. The world reveals itself not in quick flashes but in time as we move around an object or through a space.

Antonioni's films exist outside of classic cinematic space and time just as the sculptures of Judd exist outside of fictive and illusionistic space; they require the observer to apply a new sense of time to comprehend them. Antonioni's world is presented by maddeningly slow camera moves which reveal rather than present; his long takes shift classic cinematic time into something closer to real time, and his abandonment of the point of view of a primary character into a freed up multiplicity of perspectives forces the spectator to add together each part to understand the whole. The landscape is not so much a metaphor for the characters or an extension of their mental state, as is often suggested, but a physical construct that gives the character meaning by his or her position in space and his or her relationship with the physical objects of the world, while the physical elements are given presence through the gaze of the characters who wander through and around them. The strange conjoining of vastly incongruous spaces in Antonioni suggests conscious compositions and tableau set up for the camera, while the long takes have the aura of the apparatus hovering around them: it takes too long not to think of the process of the film's own making. For example, the slow motion, fragmented, and repeated images of the explosion in *Zabriskie Point* (1970) not only show Antonioni's search for abstraction in a representational

medium, but also through the use of slow motion and overlapping repetition call attention to that medium itself.

Resnais's *L'Année dernière à Marienbad* (Last Year at Marienbad, 1961) also rejects Hollywood's vocabulary for a new film language based to a great extent on the visual arts, particularly sculpture and architecture. Working from a script by the novelist and painter, Alain Robbe-Grillet, Resnais investigates memory and perception within a palatial hotel in Marienbad. Often freezing the characters in tableau-like positions within the cool spaces of the hotel, Sacha Vierny's fluid camera glides around the characters and through the spaces of the hotel, focusing as much on the ornate architectural details as the characters. No one point of view can be determined, nor is time linear, creating a sense that all this is taking place in shared memory. Resnais's interest in the visual arts dates back to his early documentary films such as *Van Gogh* (1948), in which he used no other material than the artist's paintings. Resnais built on a technique developed by the documentarians Luciano Emmer and Enrico Gras in such films as *Earthly Paradise* (1939) about Hieronymous Bosch. In these films, Emmer and Gras would move the camera "into" the painting, never showing the entire picture, so that the screen became part of the "landscape" of the painting, and the cinema screen's frame was denied.[44]

The nearly frozen characters — perhaps a better term is "figures" — in Antonioni and Resnais's films take on a sense of the inanimate forms that surround them, becoming simply other objects that dot the postwar landscape. But if Antonioni and Resnais were looking to shift cinema into a space between stasis and motion, Chris Marker's *La Jetée* (The Jetty, 1962, released 1964) nudges film back into its origin as still pictures. Made up almost entirely of still photographs (only one second — twenty-four frames — is in motion), *La Jetée* is a science-fiction narrative that unfolds as memory and is shrouded in death. The use of stills runs counter to the "living pictures" aspect of cinema and increases the fatalistic sense of doom and self-destruction in the main character's unwitting search for the moment of his own death. Ingmar Bergman's *Persona* (1966) opens with a pre-title sequence that first announces the

Chris Marker
La Jetée, 1962

 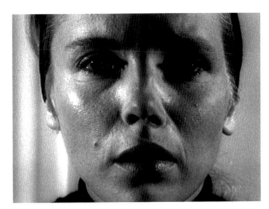

Ingmar Bergman
Persona, 1966

film apparatus itself and its history, then presents the protagonists as large photographic projections examined by a boy who runs his hands over them as if to decode their inner meaning — still images examined by the moving images of cinema. Bergman's notebook suggests the interest the filmmaker had in the apparatus and certain entropic effects: "I imagine a white, washed out strip of film. It runs through the projector and gradually there are words on the sound tape.... Then a face you can barely make out dissolves in all that whiteness."[45] Bergman also relates this self-reflexive sequence to his childhood; as a boy he put film into a strong soda solution, dissolving the emulsion and the images until the film became "white, innocent, transparent. Pictureless."[46] Welles's use of the beam of light and white screen finds its culmination in Bergman's complete obliteration of the cinematic image.

Robert Smithson also saw the postwar motion picture as an entropic entity, as a system that "eventually deteriorates and starts to break apart and there's no way that you can really piece it back together again."[47] In his essay, "A Cinematic Atopia," Smithson concentrates not so much on the images on the screen, as on the effects of cinema-gazing:

> Going to the cinema results in an immobilization of the body. Not much gets in the way of one's perception. All one can do is look and listen. One forgets where one is sitting. The luminous screen spreads a murky light through-out the darkness. Making a film is one thing, viewing a film another. Impassive, mute, still the viewer sits. The outside world fades as the eyes probe the screen.[48]

Smithson suggests that the result of watching so many films is "a state of stupefaction. We are faced with inventories of limbo."[49] He sees this "cinematic atopia" as a "concatenation of the unexpected" where conventional orders and groupings give way to chance reorderings. Robert Sobieszek has pointed out that Smithson's film, *Spiral Jetty* (1970), which is certainly one of the most successful attempts at documenting an earthwork site, "can be viewed as an assemblage of brief, episodic 'takes' of arrested moments and frozen objects — quick glimpses carefully montaged in such a way that even greater cinematic motion is

suggested than actually recorded."[50] Echoing Chris Marker's *La Jetée* and Alain Resnais's *Last Year at Marienbad* in its focus on time and stillness, *Spiral Jetty* serves as a model for the links between past and present, geological time and cinematic time, entropy and eternity, and between physical site and the landscape of the mind:

> The physical confinement of the dark box-like room (of a movie house) indirectly conditions the mind … Time is compressed or stopped inside the movie house, and this in turn provides the viewer with an entropic condition. To spend time in a movie house is to make "a hole" in one's life.[51]

Although it was never realized, Robert Smithson's Cinema Cavern stands as a prime example of the relationship between entropy and film gazing. In a 1971 drawing entitled *Toward the Development of a Cinema Cavern*, Smithson lays out plans for the creation of an underground projection room: the moviegoer would enter into a natural cave to watch a film of the making of the cinema cavern. Bringing together several diverse ideas — the movie theater as temple, the moviegoer as spelunker, Plato's Cave, structuralist self-referentiality, cave painting — Smithson shoves earthwork art into the realm of science fiction by using film to play with time travel.

If any one theme is present in most "structuralist," as P. Adams Sitney terms it[52] or "materialist" cinema, as Peter Gidal calls it,[53] it is the sense of film as a literal object, and the subsequent infringement of film's illusionistic properties. But as we have already seen, this approach is not confined to experimental or "avant-garde" cinema but is found in some feature films and the visual art of the same period; it is an important aspect of Minimalist aesthetics in general. Structuralist film, then, should not be seen in opposition to mainstream cinema nor as a rupture with the more formal art preceding it,

Robert Smithson
Toward the Development of a Cinema Cavern, 1971
John Weber Gallery, New York

Ken Jacobs
Tom, Tom, The Piper's Son, 1969

but must be considered within the broader context of Abstract Expressionism, Minimalism, postminimalism, and Conceptual art practices.

Indeed, when seen as an extension of some of Warhol's artistic practice, which combined elements of Hollywood, Pop, and Minimalism, structuralism is anything but pure. Rather, much of this work could be called exaggerated, even hyperbolic, and actually defined by its lack of purity. In its placement between film and object, its desire for mixing media and movements, its new interest in the body, its perceptual investigations, structuralist filmmaking might be defined as a loose movement that disrupted the codes established by Hollywood practice and embraced the expanding concepts of what art could be — film, performance, installation — and even foreshadowed through the re-presentation of early film footage, the nostalgia for cinema found in the work of the eighties and nineties.

Ken Jacobs's *Tom, Tom, The Piper's Son* (1969) is perhaps the ultimate structuralist deconstruction of cinema. Using a 1905 silent film also entitled *Tom, Tom, The Piper's Son*, Jacobs analyses the film medium by re-photographing it during its projection, sometimes framing it almost in its entirety, sometimes moving in for a detail shot, then using freeze-frame techniques to stop and start the action. The result is a reduction of film to its most "primal" elements: light, shadow, and pictures. Jacobs has said that "Advanced filmmaking leads to Muybridge."[54] Like Cornell, Conner, and Warhol, Jacobs probes film as if it were an object, returning to its early history, to its residue, in an attempt to reframe cinema, to distance it for examination.

Michael Snow's film *Wavelength* (1967) stands as one of the monuments of structural filmmaking, but it is also a film that can be read in a number of different ways: as a perceptual, postminimalist, or even Conceptual art work. Snow described the film as

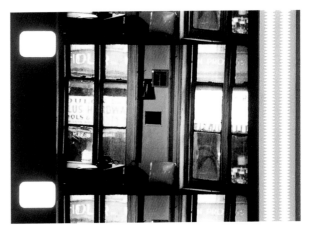

Michael Snow
Wavelength, 1967

a summation of my nervous system, religious inklings and esthetic ideas. I was thinking of, planning for, a time monument in which the beauty and sadness of equivalence would be celebrated, thinking of trying to make a definitive statement of pure film space and time, a balancing of "illusion" and "fact", all about

seeing. The space starts at the camera's (spectator's) eye, is in the air, then is on the screen, then is within the screen (the mind).

The film is a continuous zoom which takes 45 minutes to go from its widest field to its smallest and final field. It was shot with a fixed camera from one end of an 80 foot loft, shooting the other end, a row of windows and the street. This, the setting and the action which takes place there are cosmically equivalent. The room (and the zoom) are interrupted by 4 human events including a death. The sound on these occasions is sync sound, music and speech, occurring simultaneously with an electronic sound, a sine wave, which goes from its lowest (50 cycles per second) note to its highest (12000 c.p.s.) in 40 minutes. It is a total glissando and a dispersed spectrum which attempts to utilize the gifts of both prophecy and memory which only film and music have to offer.[55]

Wavelength is a work about the mixing of abstraction and representation, narrative and pure perception, time and space, far and near, fiction and reality. In the above description of the film, Snow concentrates on only one of its several axes, the one involving the continuity of the zoom and the sine wave that also involves the "formal" and "abstract" language of film flashes, color gels, positive to negative alterations, superimpositions, and changes of film stock. Counterpointed to this, as Annette Michelson pointed out in her essay "Toward Snow," is an axis of "human events," with "their somewhat scattered, random aspect. They take place abruptly, are discrete with respect to one another, are played in a range which runs from the strongly distanced and flat to the conventionally mimetic, linked in some suggestion of causality by only a few lines of dialogue."[56] These human events include the semblance of a narrative: some people move in book shelves, two women listen to a radio, a man is apparently murdered, a woman telephones to report the man is dead. Yet during this "narrative" the camera-eye unblinkingly continues straight ahead into deep space, penetrating all the sheets of time, paying no attention to the "action" and instead continues on to its final resting place within the representational space of a photograph Snow had taken of the ocean. The "characters" and narrative fail to engage the camera/spectator which has placed the perceptual and abstract "events" on the

Michael Snow
Two Sides to Every Story, 1974
National Gallery of Canada, Ottawa

same level as narrative events. Snow uses the notion of "one thing leading to another"[57] to arrive at a new film structure, one that eliminates montage and flips the sense of the narrative line into the deep recesses of space and time.

In his installation *Two Sides to Every Story* (1974), Snow carries his dismantling of cinema further by moving film, or more precisely the screen, into three-dimensions. In *Two Sides* Snow places the screen in the middle of the gallery space, then projects simultaneously two films, one on each side. The viewer is thus forced to move around the screen to view the "narrative," yet can never see both sides at the same time.[58] The narrative is the making of the film, with two stationary cameras set up facing each other. One camera captures Snow, seen sitting in a director's chair, next to the cameraman, directing a walking woman (a reference to Snow's "Walking Woman" series of paintings and sculptures), whose actions are recorded by a second camera on the opposite side of the room. Snow blurs the divisions between screen space in fictive film, the physicality of the reflective screen, and the real space occupied by the viewer. At one point the woman takes an aerosol can and sprays the "screen," a clear sheet of plastic, suggesting that the flat theater screen actually exists as a physical window onto the cinematic world not unlike the illusionistic world within the frame of painting. In Snow's installation, however, the viewer can move behind the screen space, both metaphorically and literally, but ironically he or she can never enter film space.

In his project *Cinema 81* (1981), Dan Graham addresses similar issues surrounding the movie audience and the screen. Using the ground floor of an office building, Graham's model describes how the facade would consist of two-way mirrored glass allowing spectators to see through to whichever side is brighter. When the light levels are roughly equal, according to Graham, viewers "on both sides observe both the opposing space *and* a reflection of their own look within their own space."[59] The screen is placed so that the images are visible from both sides, from the dark recesses of the theater and from the "daylight" of the street, from the perspective of dreams and the perspective of the flaneur.

The desire to break down cinema into its individual components and

Joseph Beuys
Das Schweigen (The Silence), 1973
Walker Art Center, Minneapolis
Alfred and Marie Greisenger Collection
© 1996 Artists Rights Society (ARS),
New York/VG Bild-Kunst, Bonn

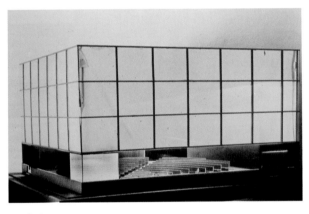

Dan Graham
Cinema 81 (model), 1981
Musée National d'Art Moderne,
Centre Georges Pompidou, Paris

Hollis Frampton and Marion Faller
Sixteen Studies from Vegetable Locomotion, 1975
"Gourds vanishing (var. Mixed Ornamental)"
Walker Art Center
Clinton and Della Walker Acquisition Fund

to make it a concrete object as opposed to an ethereal medium interested not only American experimental filmmakers and European artists such as Joseph Beuys, whose piece *Das Schweigen* (The Silence, 1973) presents Ingmar Bergman's film as a sculptural object, but also conceptually-oriented artists in America. In his early work, John Baldessari, an artist who has maintained a particularly close relationship with cinema throughout his career (his first studio was a movie theater built by his father),[60] reapplied the techniques of the chronophotography of Eadweard Muybridge and Etienne-Jules Marey as well as the stroboscopic photography of Futurists such as Antoni Bragaglia in works such as *Strobe Series/Futurist: Dropping a Cord One Meter Long One Meter (1/4″ Nylon)* (1975). Baldessari had begun to consider cinema as a means of approaching art from a different perspective; he was interested in "the opportunity to explore sequentiality within the single photograph, to apply a 'What will happen if . . .' approach, and to explore some of the ideas of Futurism, essentially idioms of movement."[61] Returning to the very roots of cinema, to the optical devices that prefigured cinema, Baldessari was able to apply concepts of before and after, motion and simultaneity to contemporary photography, not as utopian devices celebrating these cinematic attributes, but as a means of questioning the role of art in a world dominated by film and photography, by the mechanical reproduction of images. Similarly, Hollis Frampton, in works such as *Sixteen Studies from Vegetable Locomotion* (1975) and Allen Ruppersberg, in works such as *Zoetrope* (1980) (which has a European counterpart in Christian Boltanski's "Lanterne Magique" series), use the cinema as a means of seeing the world differently: to see the instant in the passage of time, the freeze frame with its sense of duration, the stilled moment removed from the flow of images, the invisible pulled from the continuous flow of the world. Like Antonioni and Marker, Baldessari, Frampton, and Ruppersberg were searching for ways of breaking the cinema down, of reducing it to its most fundamental component; like Cornell, they returned to the proto-cinema of optical devices to breath new life into contemporary photography.

The reduction of cinema to its irreducible component is extended back out into "narrative" and "context" by another artist also interested in the photographic image, the cinematic apparatus, and issues of time and space. From the early seventies to the present, James Coleman's projects, which have alternated between film, video, and slide projections, have investigated issues of perception, representation, and identity in spaces often falling between painting, photography, cinema, theater, and literature. In *La Tâche Aveugle* (1978–90), Coleman has taken several consecutive frames from James Whale's 1933 film of H.G. Wells's *The Invisible Man*, transferred them from 35mm film to 35mm slide format, and, through a specially-designed dissolve mechanism, projects them in the gallery—only the original half-second of screen time is lengthened to several hours of almost invisible dissolves from one frame to another. Here, Coleman has equated the cinema's reliance on a trick, on the optical illusion of persistence of vision that is manufactured out of invisibility, into a metaphor for the invisible man's desire to be recognized, into a metaphor for the social and economic situations that reinforce invisibility and marginality within the mechanisms of society. The frames are taken from the Whale film just before the invisible man is killed, the only act that can return his visibility and save him from his madness. Yet, ironically, the film apparatus has made the invisible man visible; as Whale pans the camera, placed at a strikingly low angle, we can "follow" the invisible man, a fact subverted by Coleman's presentation. Not only are the projected frames grainy—frame enlargements or freeze-frames invariably have a grainier look still than at twenty-four frames a second—but they are also slightly blurry from the camera pan. Indeed, nothing about the imagery is distinct, everything is barely perceptible, the conventional desire for clarity of image is undercut. The lack of a distinct image, like the lack of an actor to observe, coupled with the highlighting of the apparatus that creates illusion and suspends disbelief, turns the relationship between the spectator and spectacle inside out and forces us to consider our own limited perspective of the world.

James Coleman
La Tâche Aveugle, 1978–90

Allen Ruppersberg
Zoetrope, 1980
The Museum of Contemporary Art,
Los Angeles

Cinema of Expansion

If one tendency in the dialogue between art and film in the sixties and early seventies was the reduction of the moving image toward the still image and objecthood, another trajectory was defined by a group of artists and filmmakers who, although also closely aligned with structuralism, took a more "maximalist" approach to reach ground zero, with an emphasis on perceptual phenomena, visionary abstraction, and the body. Unlike many of the filmmakers who had adopted minimalist strategies, many of these perceptually-oriented filmmakers and artists shifted cinema toward abstraction by maximizing the information in the frame, by pushing the image to such a complex and multi-level state that film was shoved up against its boundary lines of possibility.

For Stan Brakhage, a new age of lyrical abstraction can be found in hypnagogic vision, moving visual thinking, dream vision, and memory feedback.

> Hypnagogic vision is what you see with your eyes closed — at first a field of grainy, shifting, multi-coloured sands that gradually assume various shapes. It's optic feedback: the nervous system projects what you have previously experienced — your visual memories — into the optic nerve endings. It's also called closed-eye vision. Moving visual thinking, on the other hand, occurs deeper in the synapsing of the brain. It's a streaming of shapes that are not nameable — a vast visual 'song' of the cells expressing their internal life. Peripheral vision is what you don't pay close attention to during the day and which surfaces at night in your dreams. And memory feedback consists of the editings of your remembrance. It's like a highly edited movie made from the real.[62]

Brakhage's films retain a sense of intimacy, of the artist's hand, of a personalized vision of the world. On one level they are home movies, but on another they offer a grander, far-reaching, even mythic view of the world.

In Brakhage's monumental, five-part work *Dog Star Man* (1961–64), a silent film like most of Brakhage's works, we are confronted with superimposed planes of images, rushing, leaping, splitting, and dancing, all

Stan Brakhage
The Text of Light, 1974

Tony Conrad
The Flicker, 1966

animated with light flares, pointillistic film grain, and scratches on the celluloid — adding up, in P. Adams Sitney's words, to a film that suggests "the movement of clouds with the flow of the blood in magnification."[63] Brakhage's use of a hand-held camera, distortion lenses, filters, and other devices brings our attention back to film's fundamental properties of light, flicker, and celluloid.

Although the gestural quality, allover composition, and autobiographical dimension of Brakhage links him to Abstract Expressionism — indeed, he was deeply influenced in the early fifties by the works of Clyfford Still, Sidney Peterson, and Mark Rothko[64] — his interest in hypnagogic vision aligns him with the growing interest in perceptual phenomena in the sixties and seventies art world. Brakhage's emphasis on perception goes hand in hand with his freeing of the camera itself; like action painting, Brakhage's hand-held, roving camerawork dissolves the grounded, fixed camera of Hollywood productions, making the camera a fluid, mobile eye more directly related to that of the painter of abstractions. As such, the film frame is "softened," rejecting rigid compositions that relate to perspectival space in favor of flowing, fluid, Pollock-like compositions that constantly shift and transform. The projector light, marks on the celluloid, the developing process, and superimpositions become the subject of Brakhage's work, enveloping the spectator in a cinematic world of pure perception; like a child we seem to be seeing the world for the very first time — disorientated, but in awe. In this respect, Brakhage's works, particularly such films as *The Text of Light* (1974) resemble the work of such "light and space" artists as Robert Irwin, James Turrell, and Doug Wheeler who were simultaneously exploring similar issues of perceptual phenomena.

While Brakhage's work often capitalizes on the stroboscopic effects of cinema by relating the mechanical aspects that drive cinema to the interior vision of the human mind, other artists have used flicker effects to counter the illusionistic and representational aspects of narrative cinema. Perhaps the earliest examples can be found in the films of Peter Kubelka. The filmmaker's *Adebar* (1956–57), *Arnulf Rainer* (1958–60), and *Schwechater* (1957–58) were constructed through compositional

Peter Kubelka
Adebar, 1956–57

Peter Kubelka
Schwechater (1957–58),
Installation, May 1989

Peter Kubelka
Arnulf Rainer, 1958–60

John Whitney
Frames from selected films.

James Whitney
Arabesque, 1975

principles analogous to Webern's music, through juxtapositions of positive and negative, sequence, and intervals.[65] The result are films that could be described as "light-plays" that magnify the material aspects of film itself. Indeed, Kubelka has literally installed them in museums and galleries by pinning the original 35mm filmstrips to the wall. Although these works seem light years from feature film production, Kubelka never saw his work in opposition to Hollywood, but was simply forced by virtue of his desire to invent new forms of cinematic language to work outside of the feature film industry.[66]

Retaining even more of a relationship with Hollywood, Tony Conrad's *The Flicker* (1966) is a kind of "horror" movie, one that goes so far as to carry a warning about the dangers of seizures that can result from watching it. Conrad avoids any image, creating the film instead out of black frames and white (clear) frames, and suggesting narrative through change in frequency.

Nothing at all appears on the screen except the intermittent unobstructed light from the projector.

The Flicker moves gradually from 24 fps to 4 fps and then back out of the flicker range again. The first notable effect is usually a whirling and shattered array of intangible and diffused color patterns, probably a retinal afterimage type of effect. Vision extends into the peripheral areas and actual images may be "hallucinated." Then a hypnotic state commences, and the images become more intense. Fixing the eyes on one point is helpful or necessary in eliciting the fullest effects. The brain itself is directly involved in all of this; it is not coincidental that one of the principal brain-wave frequencies, the so-called alpha-rhythm, lies in the 8 to 16 cycles per second range. Hence the central nervous system itself must here be considered as a kind of sensory mechanism, though its role is not explicitly understood, to my knowledge.[67]

Prior to the work of Brakhage, Kubelka, and Conrad the black or white screen was used only in conjunction with fade-outs and dissolves to denote the passage of time or place. But with works such as *The Flicker* black and white take on new meaning; in Gilles Deleuze's words they

enter "into a dialectical relation between the image and its absence."[68] Conrad's film is a substitute for the narrative film, a compression of the cinematic experience.

In the work of James and John Whitney, flicker is achieved not by the gestural and material approach of Brakhage or the structural device of contrasting frames but by computer generated animation and the optical printer used by the film industry to produce special effects and title sequences. The Whitneys' work marks a transition from the early abstract films developed by such pioneers as Walter Ruttmann and Oskar Fischinger in which pure forms were set in motion as an extension of Kandinsky's search for parallels to music, to work that operates directly on the viewers' perceptual faculty. Working with analogue computers in the fifties and sixties, the two artists produced (they worked separately since the mid-forties) such complex films as *Yantra* (James, 1957), *Lapis* (James, 1963–66), and *Catalogue* (John, 1961) that explored images related to ancient alchemical imagery and Eastern thought. In the meantime, John Whitney's computer techniques found their way into feature filmmaking. Working in collaboration with designer Saul Bass, Whitney developed the geometric Lissajous spirals that come from within the eye in the title sequence to Alfred Hitchcock's *Vertigo* (1958), while special effects wizard Douglas Trumbull built on Whitney's techniques to create what he called the slit-scan computer process that was used to create the Stargate Corridor sequence in Stanley Kubrick's *2001: A Space Odyssey* (1968), a film that is itself a meeting ground for clean minimalist aesthetics, the expansive aspects of wide-screen panoramic composition, and perceptual phenomena.

This pushing of film's capacity for expanding space and time and for abstracting the world is echoed in the film installations, performances, and light shows of the same era by artists such as Carolee Schneemann in her performances such as *Up To And Including Her Limits* (1974–76) and her films such as *Fuses* (1965), Robert Whitman in *Prune Flat* (1965), and Wolf Vostell in *Notstandbordstein* (1969) (in which the streets of Munich became the "screen" for the projection of a film from a moving car); in collaborations by such artists and composers as John

Stanley Kubrick
2001: A Space Odyssey, 1968

Cage and Ronald Nameth in their massive *HPSCHD* (1969) that used fifty-two loudspeakers, seven amplified harpsichords, 8,000 slides, and 100 films; and in the group-created light shows of the Vortex Concerts at Morrison Planetarium in San Francisco and in Los Angeles the innovative light performances of The Single Wing Turquoise Bird.[69]

Although he began as a painter with certain ties to Art Informel, Fabio Mauri turned in the late fifties to projects that would counter the painterly tradition of both European and American action painting, including performance and film. Beginning in 1957, Mauri initiated a series, which continues today, of empty supports that wiped painterly abstraction clean — painting reduced to the zero degree, emptied of all information. These blank surfaces Mauri entitles "Schermi" (screens), referring to the cinema screen, but one that has been reshaped by the pressure of the television. Mauri has a deep commitment to deconstructing media to reveal the ways that all forms of communication are manipulated by those in power. To expose the precarious state of media, particularly cinema, Mauri makes the media "visible," he makes it three-dimensional. In the mid-seventies, Mauri presented a series of film projections which he collectively titled "Senza Ideologia" (Without Ideology). The series began with performances involving the projection of two directors' films, Miklós Jancsó's *Red Psalm* (1972) and Pier Paolo Pasolini's *Il Vangelo Secondo Matteo* (The Gospel According to St. Matthew, 1964), onto the bodies of the directors, and continued the series with the projection of various films onto specific objects: Eisenstein's *Alexander Nevsky* (1938) onto a bucket containing fifty liters of milk, G.W. Pabst's *Westfront* (1918) onto a fan, Carl-Theodor Dreyer's *Gertrud* (1964) onto a scale, an anonymous *Joan of Arc* onto a woman's nude body, and Pasolini's *Hawks and Sparrows* (1964) onto the facade of a building. By projecting onto an object out in the world instead of the screen, Mauri focuses the spectator's attention on the space between the projector and the object, thereby cancelling out the illusionistic aspects of film and the reliance on the suspension of disbelief. In these works, Mauri links each separate component of the cinematic experience into one sculptural unit connected by the cone of light; cinema is turned into

Saul Bass
Title sequence to *Vertigo*, 1958

Fabio Mauri
Senza Ideologia: Pier Paolo Pasolini,
"Vangelo secondo Matteo"
(Without Ideology: Pier Paolo Pasolini,
"The Gospel According to St. Matthew"), 1976
Gallerie Comunale d'Arte Moderna,
Bologna, 1976
(above and right)

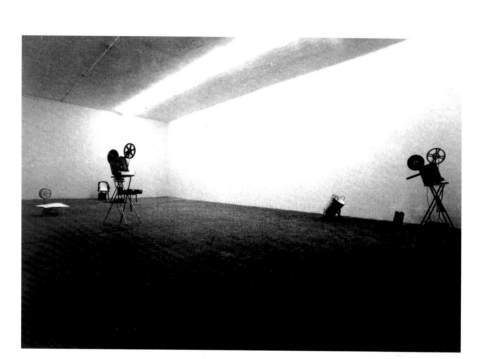

Fabio Mauri
Senza (Without), 1976
Installation view, Galleria Toselli, Milano, 1976

Fabio Mauri
Senza Ideologia: Carl-Theodor Dreyer, "Gertrud"
(Without Ideology: Carl-Theodor Dreyer, "Gertrud"), 1976
Galleria Nazionale d'Arte Moderna, Rome, 1994

a concrete object with physical "weight" and rendered malleable, its monumentality and hypnotic essence, its view of the world, reduced to a tangible state primed for dissection.

The interest in creating new environments for the cinematic experience and in incorporating performance and the body into this context is at the heart of Helio Oiticica's "quasi-cinema" series. Conceived in 1973 in collaboration with the filmmaker Neville D'Almeida, Oiticica's "QUASI-CINEMA, Block-Experiments in Cosmococa," are a meeting ground for a diverse array of issues, including the Brazilian Tropicalismo movement (which reworked modernism while simultaneously reaffirming the character of Brazilian culture),[70] Third World liberation movements, Cinema Novo, American popular culture, Godard's deconstructions of cinema language, the rise of a global culture, performance art, trance states, ritual, and the cinematic relationship of the spectator to the spectacle. Oiticica's desire was to overturn "social preconceptions, group and class barriers" and to accomplish this he devoted himself to "the manipulation of images and not a submission to pre-established models."[71] Like James Coleman, Oiticica's desire to peel away the "social 'layers'" from the image led him to consider the concept of marginality and the relationship between the artist's position and that of marginalized groups in society. Behind Oiticica's interest in samba trance, drugs, rock, "popular" architecture (favelas, markets), and cinema, was the need for "deranging the senses." As Catherine David has pointed out, he "was close to Pasolini in his conception of the marginal and the delinquent ... as vital forces of revolt capable of resisting this one-dimensional world, this repressive, unjust society."[72] In his description of the "quasi-cinema" series, Oiticica refers to a wide spectrum of influences, from Jack Smith's "fragmented narrative" in his performances and films such as *Flaming Creatures* (1963) to Hitchcock's *The Birds* (1963) to Godard's "meta-linguistic questioning of the very quintessence of filmmaking."[73] According to Guy Brett, Oiticica's desire for Cosmococa was to create "something aligned with the supple and joyful lightness he saw in rock ... and in cocaine too ... he saw these as 'similes' for such lightness, to set against the heaviness of academic seriousness, the burden of

Hélio Oiticica and Neville D'Almeida
QUASI-CINEMA, Block Experiments in Cosmococa,CC3 MAILERYN, 1973
Collection Projeto Hélio Oiticica, Rio de Janeiro

'authenticity' in art, and the paralyzing grip of the image and the screen on the film spectator."[74]

Oiticica's Cosmococa installation *CC3 MAILERYN* (1973) uses the image of Marilyn Monroe found on the cover of Norman Mailer's biography as a "pattern" for laying down image-altering cocaine lines. Like the work of James Coleman and Michael Snow and the performances of Carolee Schneemann, Oiticica uses the conditions required for spectatorship — the darkened chamber, the illuminated image — but undermines the normally passive relationship of viewer to spectacle, drawing from what he had seen in the films of Hitchcock, Buñuel, and especially Godard.[75] *CC3 MAILERYN* constitutes a total environment in which the spectator, lying on the floor, becomes actively engaged with the images projected on the walls and ceiling.

In Oiticica's work, like that of Brakhage, Schneemann, and Mauri, the spectator and the spectacle are united in an expanded cinematic experience. In this, it foreshadows the incorporation of film into daily life that is the hallmark of the eighties and nineties.

Part III
Rear Window: Fragments of The Cinematic Past

The death of Hitchcock marks the passage from one era to another.... I believe we are entering an era defined by the suspension of the visual.... I don't think we'll have the strength to make cinema much longer.

— Jean-Luc Godard, 1980[76]

To know the extremes of light

I sit in the darkness

To see the present flashing

in a rearview mirror

— Adrienne Rich, from "Images for Godard," 1977

In Search of the Obelisk,
© 1994 Luxor, Las Vegas, 1994

The Screen as a Mirror

If the expanded cinemas of Brakhage's *The Text of Light*, Kubrick's *2001: A Space Odyssey*, and Antonioni's *Zabriskie Point* were the flip side of structuralism's reductive tendency, exploding out of ground zero, then in the eighties and nineties the shards from these explosive tendencies have settled back down to earth, offering reflections of cinema's history — albeit in severely fragmented form.

Economically, Hollywood seems to have returned in the eighties and nineties to some of the health it enjoyed in the pre-war era. Yet it is a success built not only on movie attendance but on such ancillary forms as video, laser disc, computer games, theme parks, product tie-ins, and the vast foreign market. It is a comeback predicated on cinema's reconfiguration, on the incorporation of the cinema into other facets of daily life.

The last couple of decades, then, have been cinematically schizophrenic. Godard himself stands as a symbol for this ambivalence. In a recent interview he added to his long-running pessimistic outlook for cinema by equating himself with those filmmakers cast aside by the advent of sound in the late twenties: "Now I have that feeling, too — that feeling that I'm being thrown out. Because it's Apple computers that are doing movies today. Not me."[77] Godard's linking of the death of Hitchcock to the demise of cinema suggests the newly emerged situation brought about by the deaths of many of the great masters of cinema in the seventies and eighties including John Ford, Fritz Lang, Jean Renoir, Luis Buñuel, as well as Hitchcock, many of them members of the auteurist pantheon that Godard had helped establish during his years as a critic for *Cahiers du Cinéma*. Yet from that moment Godard suggested he might not be able to make cinema, he has in fact not only continued to make film but has returned to feature filmmaking. While these films are shot with small crews, and are largely improvised, they are nevertheless closer to the feature film work of his early filmmaking years than to the radically reductive and political work of the late sixties and early seventies when Godard turned away from narrative and character to make films such as *Le Gai Savoir*. Thus while Godard suggests, on the one hand, that cinema is over, on the other he is involved once again in making

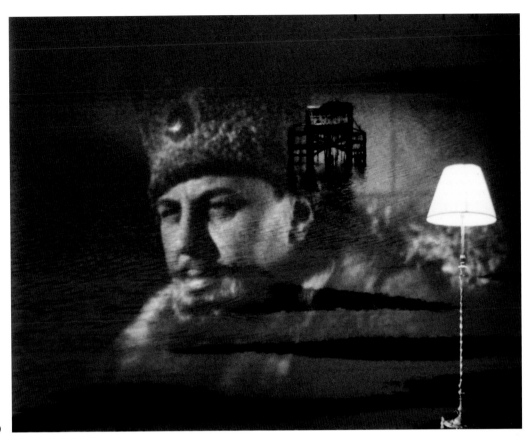

Pat O'Neill
Water and Power, 1989

Pat O'Neill
Water and Power, 1989

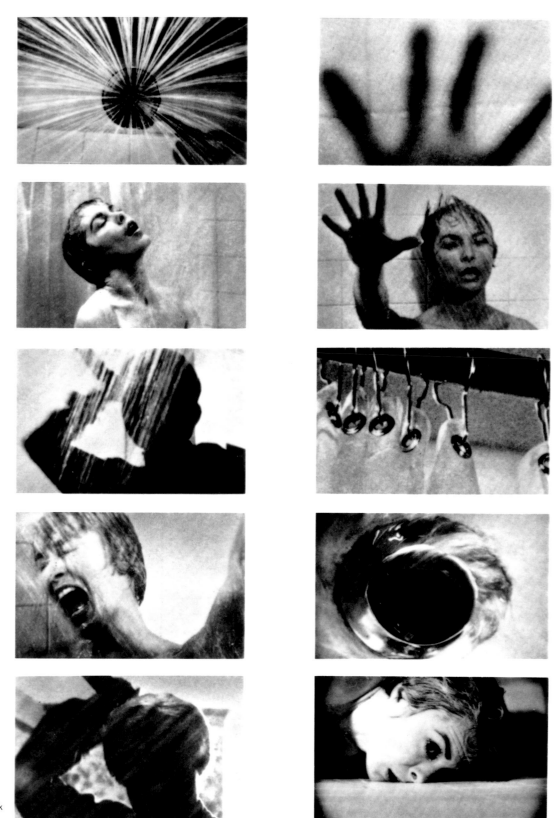

Alfred Hitchcock
Psycho, 1960

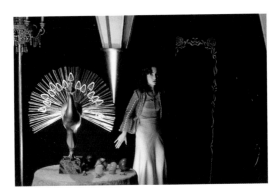

Dario Argento
Suspiria, 1977

Alfred Hitchcock
Spellbound, 1945

David Lynch
Blue Velvet, 1986

feature films that often reconsider his own early work. In *Allemagne année 90 neuf zéro* (1991), for example, Godard revisits *Alphaville* via East Germany.

Our contemporary culture in general seems to be consistently revisiting the cinema as a site, some sort of location that once existed but must now be seen from a distance. Advertisements take on a fashionable "cinematic" appeal, and if Hollywood is no longer the factory of dreams, Las Vegas has creeped into its place as a city that while not actually producing feature films nevertheless locates itself squarely within the "cinematic" through fantasy architecture like the Luxor Hotel with its film presentation, *In Search of the Obelisk*, designed by Douglas Trumbull. In cinema itself, nostalgia has been a primary force since the mid-seventies, from Roman Polanski's *Chinatown* (1974) to Steven Spielberg and George Lucas's "Indiana Jones" series with its echoes of serials from the thirties and forties, to the more ironic use of historical film in Pat O'Neill's *Water and Power* (1989) and *Big Things, Lots of Things* (1995). This codification of classic film genres and vocabulary clearly parallels the way that so-called postmodern art has reinterpreted and re-presented the modernist lexicon.

Reframing historical cinema creates a distance between the moviegoer and the spectacle where the pleasures of self-aware watching override the desire for the loss of self gained from the suspension of disbelief. Going hand in hand with this new self-conscious position of the viewer was the growing influence of European critical theory in the sixties and seventies. Out of this theory came feminist film criticism of the mid and late seventies. In Laura Mulvey's much discussed essay "Visual Pleasure and Narrative Cinema" (1975),[78] the author uses psychoanalysis to address the pleasures of looking and being looked at as they relate to Hollywood screen practice of the forties and fifties. Mulvey uses Hitchcock's interest in voyeurism and Josef von Sternberg's use of the fetish to analyze the identification of women in patriarchal society.

The desire to see oneself seeing unites the cinema and art within the experience of the gaze. Hitchcock is, of course, the well-spring of much of this discussion, and his films, particularly those of the fifties and early

Douglas Gordon
24-Hour Psycho, 1992

Michael Powell
Peeping Tom, 1959

sixties, including *Spellbound* (1945), *Rear Window* (1954), *Vertigo* (1958), *Psycho* (1960), and *Marnie* (1964), with their psychoanalytic or voyeuristic themes and extremely visual style, have supplied not only critics but also filmmakers with a seemingly endless stream of ideas, from Dario Argento's *Suspiria* (1977) to Brian De Palma's *Dressed to Kill* (1980) to David Lynch's *Blue Velvet* (1986), as well as art ranging from Annette Messager's "Chimères" series to Stan Douglas's *Subject to a Film: Marnie* (1989) to Judith Barry's *In the Shadow of the City …Vamp r y* (1982–85) to Douglas Gordon's *24-Hour Psycho* (1992). Barry's piece, for example, uses slide projection and film to create a nocturnal world of voyeuristic probing and vampiristic consumption of narratives constructed through other people's lives, a rear window onto a world of Hitchcockian fantasies.

What makes Hitchcock interesting to other filmmakers, and artists, is not just his themes but the way that he visually intertwines his interest in voyeurism with the cinematic apparatus. Some of Hitchcock's visual strategies may have come from modern art, of which he was quite fond. Salvador Dalí himself was invited to Hollywood by Hitchcock to create the dream sequence for *Spellbound* (1945), the presentation of a half-remembered nightmare complete with a backdrop of floating eyes (recalling Dalí's 1928 collaboration with Luis Buñuel on *Un Chien andalou*), that foreshadows, with its sexual overtones, later Hitchcock projects.

However, the film that most closely aligns issues of voyeurism with the cinematic apparatus is Michael Powell's *Peeping Tom* (1959). A story of looking and violence about a cinematographer traumatized by childhood experiences, *Peeping Tom* engages the spectator like no other film, for in it the spectator becomes guilty by association. Laura Mulvey has written that *Peeping Tom*

is overtly about voyeuristic sadism. Its central character is a young camera-man and thus the story of voyeuristic perversion is, equally overtly, set within the film industry and the cinema itself, foregrounding its mechanisms of looking, and the gender divide that separates the secret observer (male) from the object of his gaze (female). The cinema spectator's own voyeurism is made

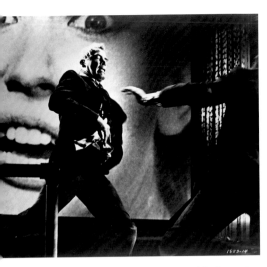

John Boorman
Point Blank, 1967

Cindy Sherman
Untitled Film Still #50, 1979

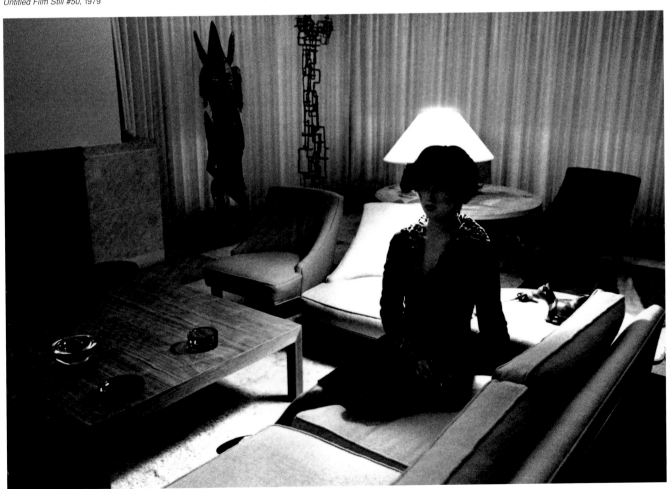

shockingly obvious and even more shockingly, the spectator identifies with the perverted protagonist.[79]

Through the use of point of view, the camera, the victim, and the killer become essentially identical. The film spectator becomes both the looker and the looked at, figure and mirror, occupying fictional space and the real space of the film apparatus simultaneously. In later films, such as Bergman's *Persona* (1966) or John Boorman's *Point Blank* (1967), the characters are caught between the gaze of the audience and the large, still, projections on the screen in fictive space.

This is the same space that Cindy Sherman began to investigate in her "Untitled (Film Stills)" series of 1977 to 1980. In the early seventies, Sherman attended the State University of New York at Buffalo, a city to which a number of experimental filmmakers had gravitated in the late sixties, including Conrad, Sharits, and Frampton. Sherman became familiar with their work and saw in it the possibilities of photographic reproduction as a means of revitalizing art now that painting seemed exhausted.[80] However, Sherman chose not to work in film directly, but to locate her work around cinema much as Warhol had done in his painting and Frampton in his photography. Her use of generic "scenes" recalling American film noir and European art film coupled with the photographing of herself as the generic heroine, draws attention to itself as fiction. Like *Peeping Tom*, Sherman's work addresses the role of the observer and the object of the gaze, and suggests a narrative flow of expectation that arises out of the tension of this configuration: something is about to happen.

Sherman's avoidance of experimental filmmaking in the seventies is a telling sign of that form's crisis. In the seventies, with advances in video technology, artists and filmmakers began to shift to electronic media, leaving avant-garde filmmaking somewhat stranded. Indeed, with the exception of the short-lived New Cinema of the late seventies punk scene in New York, the only major movement in avant-garde film has been one that has shifted the experimental film closer to the feature film by re-introducing narrative. Laura Mulvey and Peter Wollen,

Barbara Bloom
Homage to Jean Seberg, 1981
Collection of Miani Johnson, New York

Annette Messager
Chimères (Chimaeras). Installation view,
Scissors, Scissors, and *Bat*, 1982–83

for example, collaborated on a series of films such as *Penthesilea* (1974) which fused a "formalist" lineage defined by structuralists such as Snow with the political narrative cinema of Godard, Jean-Marie Straub, and Danièle Huillet, fusing Marxism, psychoanalysis, feminism, and semiotics.[81] The interest that Wollen and Mulvey had in feature film, arrived at in part from their semiological and psychoanalytically based writings is paralleled by Sherman's interest in narrative cinema and spectatorship.

With the decline of experimental cinema, the interest in the cinematic apparatus seems to have shifted less into video work than into photography, not only in the work of Sherman, but also in photo works by Baldessari, Jeff Wall, Annette Messager, Barbara Bloom, and Victor Burgin, among others. With their interest in narrative and feature film, these artists mirror Cornell and Warhol, but generally their work is more historical in approach, distanced from their sources by time and the regeneration of images, and has been informed by the psychoanalytic theory and feminist writings of the intervening years. When artists have used film, as in the work of Stan Douglas, it has tended to be found footage and loop installations. In Douglas Gordon's *Hysterical* (1995), found footage showing a male psychiatrist and his male assistant inducing a hysterical fit in a woman patient has been transferred to video and is presented on two screens propped casually in the gallery space. One of the loops has been step-framed into slow motion, causing the two presentations to go out of sync, only occasionally coming together by chance. The slow motion version heightens the already sinister quality of the "normal" version.

Baldessari bridges the work of the structuralist oriented seventies and the more narrative oriented eighties. In works of the seventies such as *A Movie: A Directional Piece Where People are Looking* (1972–73) or

Movie Storyboard: Norma's Story (1974), Baldessari had already begun to deconstruct the language of narrative by using as a structure the juxtaposition of images shot off a television, or the grid of a storyboard.

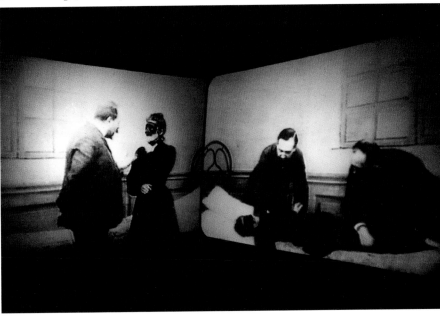

Douglas Gordon
Hysterical, 1995

John Baldessari
Spaces Between, 1986
The Foundation To-Life, Inc. Collection

John Baldessari
Starry Night Balanced on Triangulated Trouble, 1984
Collection of Beatrice and Philip Gersh, Los Angeles

John Baldessari
Black and White Decision, 1984
The Eli Broad Family Foundation Collection,
Santa Monica, California

In his works of the eighties, he has extended these investigations by juxtaposing unidentified film stills into montages that utilize such cinematic devices as directional editing techniques, off-screen space, framing, sequence, and genre to build a narrative framework that nevertheless, somewhat like Cornell's *Rose Hobart* or Bruce Conner's *A Movie*, creates a kind of discontinuity.[82] In *Black and White Decision* (1984), for example, a still of a woman staring over the shoulder of a man, lit in film noirish chiaroscuro, is flanked by flopped "side panels" from a B-western. In Baldessari's world, the bright, shining heroism of the American cowboy can be intercut with the sinister world of the gangster, creating ambiguous meanings that ricochet out of the collision between the "shots."

In a similar manner, Victor Burgin also uses film stills but interweaves them with images drawn from art history to form a passageway between painting and cinema.

> I think of the gallery as the negative of cinema. The room in which the film is shown is in darkness, the room in which my work is shown is light. In the cinema you are still and the images move, in the gallery the images are still and it is you who move. In the cinema you cannot control the sequence or duration of your reception of the images, in the gallery you can. I believe it's through attention to such *differences* between conditions of spectatorship that the work on the walls can release the exhibition space from the *image*-centered nostalgia of the 'picture gallery' — something which always has the musty ordour of ducal palaces about it — and allow it to enter the general arena of sites of contemporary experience; experience which is characterized not so much by the *image*, but rather by the continual *exchange* of one image for another.[83]

In his work *The Bridge*, Burgin combines quotations from John Everett Millais's Pre-Raphaelite painting *Ophelia* (1851–52) with stills from Hitchcock's *Vertigo*. In this work, Burgin forms a "bridge" between Scottie's (James Stewart's) obsession with Madeleine (Kim Novak), Freud's theories of the syndrome of male desire, and watery images of women in Western art.

Douglas Blau
The Conversation Piece
Installation view, Sperone Westwater,
New York, 1993

Douglas Blau
The Conversation Piece (detail), 1993
Installation view, Sperone Westwater,
New York, 1993

Giovanni Pastrone
Cabiria, 1914

Henry Peach Robinson
Fading Away, 1858

Western art history is also highlighted in the work of Douglas Blau. In works such as *The Conversation Piece* (1993–95), Blau brings together hundreds of reproductions: film stills, text book illustrations, art history book plates, postcards, magazine photos, anything that is a picture. Out of this he then creates sequences of images demonstrating thematic and compositional relationships — in this case, with men in conversation. For Blau, art and cinema, high and low, symbolic or illustrative, operate under the same systems of genre painting established in the sixteenth century. Where Burgin seeks out difference, Blau foregrounds instead the consistencies in the vast project of Western Art, a lineage that in the twentieth century was taken up by cinema.

Tableau Vivant

One of the ingredients that separates the photo works of the eighties and nineties from the work that preceded it is its investment in the tradition of painting. Sherman's work, for example, not only brings cinema and photography together, it also resurrects the tableau, that lineage of eighteenth and nineteenth-century painting depicting, in theatrically "staged" scenes, charged dramatic moments.

Tableau painting adopted the theater's frontal composition and melodramatic content to create scenes heavy with "realism" and impregnated with narrative flow, an illusion often enhanced by an almost photographic attention to detail. The result is a kind of palimpsest of still image and motion, and in this the tableau is clearly an antecedent of cinema. From David and Grueze to Alma-Tadema and Paul Delaroche, painting takes on a character that from our perspective today we might refer to as cinematic.[84] And it was only natural that early film directors and production designers would later gravitate toward "cinematic" painting: Giovanni Pastrone's *Cabiria* (1914) recalls Alma-Tadema while D.W. Griffith's *Intolerance* (1916) evokes the panoramic paintings of David Roberts and John Martin. Due to its grounding in Renaissance perspective, its need for architectural spaces built, as Hollis Frampton has put it, "from the ground up,"[85] and its condition of representation, the

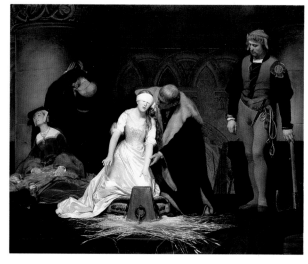

Paul Delaroche
The Execution of Lady Jane Grey, 1833

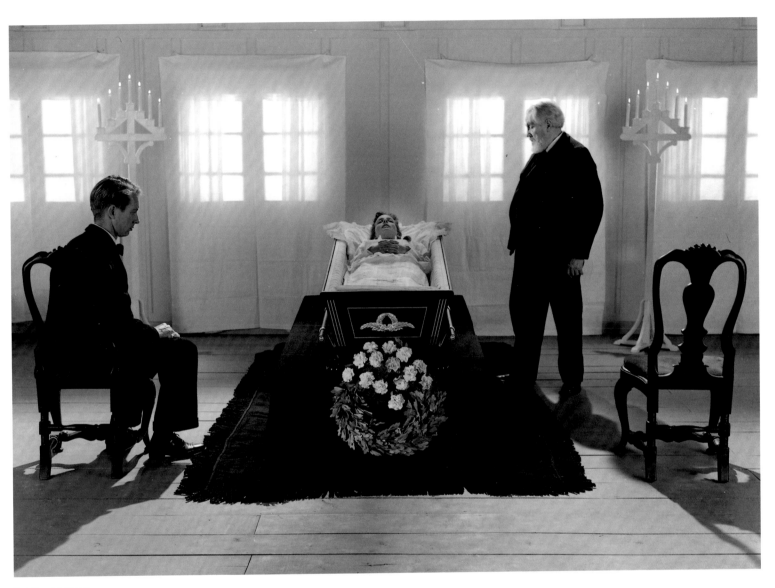

Carl-Theodor Dreyer
Ordet (The Word), 1955

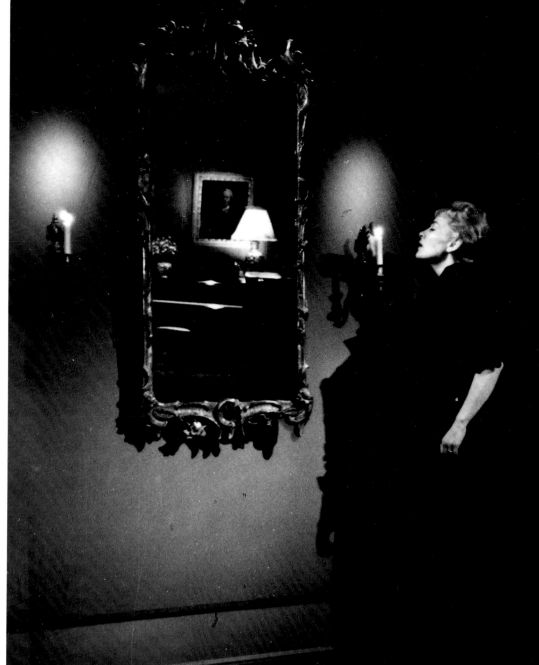

Carl-Theodor Dreyer
Gertrud, 1966

Vilhelm Hammershøi
Interior, 1898
The National Swedish Art Museums,
Moderna Museet, Stockholm

tableau was perhaps better suited to the camera, and subsequently to the motion picture camera, than to painting. In the work of "directorial mode" photographers such as H.G. Rejlander and Henry Peach Robinson, photography assumed painting's goal of bringing fiction and history to life by such "special effects" as staging and collage.

The photo work that emerged in the late seventies draws on this tradition and its inherent mix of painting, theater, cinema, and photography. It is an approach that seems to be foreshadowed in the cinema of the early sixties, particularly the films of Carl-Theodor Dreyer and Pier Paolo Pasolini that self-reflexively mirror their painterly heritage.

Dreyer had been interested in painting, particularly the work of Vilhelm Hammershoi, throughout his career, and as early as 1924 had used obvious tableaux in the film *Michael*. But the pre-war cinema, as noted by Deleuze,[86] was defined by a desire for movement that overrode most attempts at synthesizing still pictures with moving pictures. In his study of Dreyer, David Bordwell discusses this problem:

> The tableau image in painting functions very differently in film. Cinema, especially in the 1920s, seems unwilling to tolerate the stillness and fixity of such a composed totality. More than one theorist at the time identified movement as the very essence of the film medium; stasis became "uncinematic." ... Dreyer's films put a certain pressure on such assumptions. When an alien stylistic element (e.g., the tableau) is introduced into a homogeneous system (e.g., narrative logic's control of cinematic space), the consequences are not peaceful. The alien element, if stressed, can deform others."[87]

Dreyer's last film, *Gertrud* (1966), is a study in the extreme use of tableau vivant, a film dominated by issues of interior space, composition, framing, and above all stillness. Like Antonioni and later filmmakers such as Andrei Tarkovsky, Dreyer utilizes stillness within the context of cinema to create a sense of disparity. *Gertrud* is a film about memory, one in which the past is framed by the present and one in which Dreyer, by slowing down the rhythm and utilizing tableaux, creates a kind of acinema. Bordwell describes the contradiction of tableau within cinema:

Andrei Tarkovsky
Nostalghia (Nostalgia), 1983

The tableau harmonizes the entire frame space as a composed field. Viewed as a long shot, usually from straight-on angle, the tableau presents a unified, closed organization. There are none of the sinuous interlacings of a von Sternberg composition, nor the crisscrossed diagonals of an Eisenstein shot. Here horizontals and verticals dominate, curves tend to be regular and symmetrical, and stability of framing prevails. Objects and figures tend to interact across one plane rather than recessionally; the characters . . . are grouped as if on a frieze.

Within this stable frame space, the figures tend to be caught in carefully poised gestures. "Still lifes with human beings": E.H. Gombrich's description of Vermeer's paintings applies as well to Dreyer's tableaux.[88]

Gertrud is not a film which "moves." Rather it is a series of tableaux that unfold in time, forcing the viewer to read the film not strictly as narrative, but perceptually, to consider every gesture and every object as meaningful.

Other filmmakers of the sixties used the tableau to comment more directly on Western art history and its subject matter. In Pasolini's short film, *La Ricotta* (1962), a film crew (the director is played by Orson Welles) is trying, rather futilely, to shoot a scene in which they have reconstructed Rosso Fiorentino's *Deposition from the Cross* (1521). When Pasolini cuts to the painting, the black and white film changes to color, creating a separation between the "low" art of making a potboiler on the life of Christ and the "high" art of religious painting.

Pascal Bonitzer has observed that whenever a tableau is used in film it creates a blockage in the flow of the film and can never be integrated into the narrative rhythms.[89] The superimposition of tableau and film results, according to Bonitzer, in a kind of enigma. In *L'Hypothèse du tableau volé* (The Hypothesis of the Stolen Painting, 1978), Raúl Ruiz resurrects the tableau in order to give his film just this sort of cryptic aura. Based on a text by Pierre Klossowski, a collector attempts to solve the mystery of a missing painting in an artist's oeuvre by reconstructing the known paintings in tableaux vivants; he invites the viewer to participate in his investigation, which necessitates the careful examination of details in the paintings/tableaux. Ruiz's film plays with the tensions

Raúl Ruiz
L'Hypothèse du tableau volé
(The Hypothesis of the Stolen Painting), 1978

Pier Paolo Pasolini
La Ricotta (episode from *Rogopag*), 1962

Jeff Wall
Eviction Struggle, 1988
Collection of Ydessa Hendeles Art Foundation, Toronto

Jeff Wall
Eviction Struggle, 1988
Collection of Ydessa Hendeles Art Foundation, Toronto

between static and moving images, between the many possible scenarios elicited by a painting against the pre-determined narrative line of a film. Bringing the two art forms together, Ruiz creates a situation in which different rules are overlayed and the truth can thus never be found. Yet out of the recreation of painting in cinema comes new forms of truth. In his book *Poetics of Cinema*, Ruiz suggests that it is "plausible that every image is but the image of an image, that it is translatable through all possible codes, and that this process can only culminate in new codes generating new images, themselves generative and attractive."[90]

The reemergence of the tableau in Ruiz's film and Sherman's photographs in 1977 conveniently marks a moment in contemporary art and film history in which the return of representation and depiction, in harmony with a new nostalgia, use of appropriation, and interest in the pose, overtakes the self-referential conditions of both art and film of the sixties and early seventies while not completely removing the auto-critiques developed by artists and filmmakers in that era. The emphasis shifted from a dialogue about art — the attempts to dismantle and examine the phenomenon of art (and cinema) — back to the image and the problems of making pictures. And in turn, the goal of art has shifted from a radical reductivism that sought a kind of anti-art (and acinematic film) back to images that, like film stills, are fragments of a greater, more socially inclined text.

Jeff Wall's *Eviction Struggle* (1988) is a synthesis of panorama, history painting, and cinematic melodrama (the reverse side utilizes nine monitors presenting moving details/close-ups of the front image). It invests contemporary economic and social conditions with the "importance" of history painting. Like Ruiz and Sherman, Wall "copies" to arrive at a new meaning, a place where history becomes life and life history. Not only does he build on classic painterly composition, but he also incorporates elements that recall moments from films by Godard, Antonioni, and other directors. Wall's use of photography lends to his work the sense of the captured moment, the aura of the past, while the illumination seems to place the imagery squarely within the immediacy of an unfolding cinematic narrative.

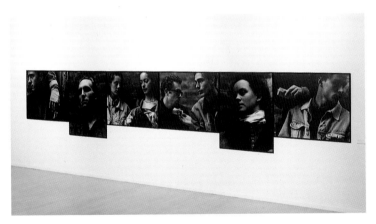

Suzanne Lafont
L'Argent, 1991
F.R.A.C. Franche-Comté, Dole, France

Sharon Lockhart

Audition One, Simone and Max

Audition Two, Darija and Daniel

Audition Three, Amalia and Kirk

Audition Four, Kathleen and Max

Audition Five, Sirushi and Victor

All 1994

Friedrich Petzel Gallery, New York, and
neugerriemschneider, Berlin

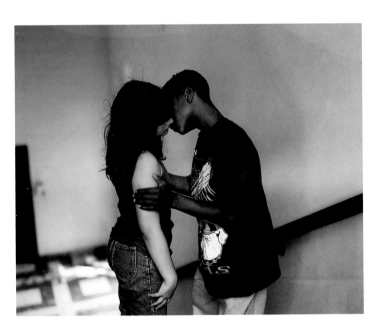 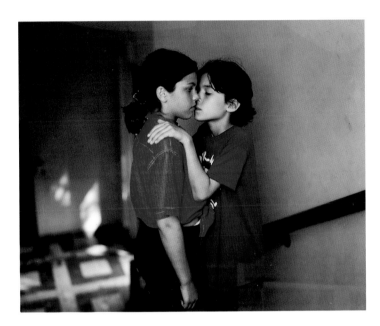

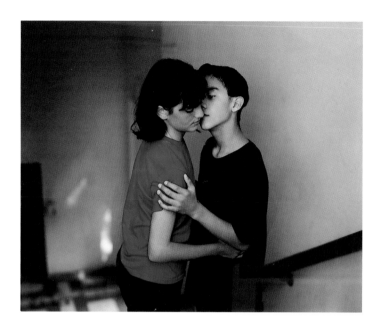

The tableau and staged scene is used by a number of other artists working today. Suzanne Lafont's works, such as *L'Argent* (1991), not only take as their launching point cinema, in this case Robert Bresson's 1983 film of the same title, but use the tableau vivant in order to fuse, like Ruiz and Wall, the spontaneity of cinema with the extended sense of time of painting. Lafont's frieze-like scenes, which are not far from Bresson's own use of relatively flat compositions that emphasize surface and imitate Byzantine iconography,[91] allow the viewer to scrutinize the relationships between the figures/characters and to observe every gesture no matter how minute. This is a condition also at the core of recent video installation work by Bill Viola, such as *The Greeting* (1995), with its tableau vivant based on a Pontormo painting presented in the clarity of 35mm film and extreme slow motion, or in more mainstream narrative cinema, such as Martin Scorsese's restaging of Hieronymus Bosch's *Christ Carrying the Cross* (c. 1515) in the *Last Temptation of Christ* (1988). Sharon Lockhart's "Audition" series combines the staged performance picture with the psychoanalytic dimension of Sherman and Burgin. In these five photographs, the artist duplicates the kiss between children at the end of François Truffaut's *L'Argent de Poche* (Small Change, 1976); however, Lockhart's straight forward documentary approach and concern for detail squeeze some of the cinematic overtones out of the shot, leaving an ambiguous image that hovers between sweet fiction and the harsh realities of directorial control and voyeuristic pleasure that is a necessary ingredient of the production process and the experience of film watching.

The restaging of film scenes finds its mirror image in the use of tableaux vivants in a variety of film directors' work of the eighties and nineties. Godard's most extensive use of tableau, *Passion* (1982), not only explores the relationship of moving to still image, but also the relationship of the act of creation in film to that of painting. If Godard feared Hitchcock's death signaled a new era with no masters to measure oneself by, *Passion* finds Godard stacking himself, and cinema, up against the masters of painting.[92] In *Passion*, Godard "reconstructs" such paintings as Rembrandt's *The Night Watch* and Delacroix's *The Entry of the Crusaders*

into Constantinople by staging tableaux vivants that, like Pasolini's deposition, are themselves the subject of a film crew's work. Cinematographer Raoul Coutard's fluid camera glides around the figures, but seems also to be engaged with the original composition, at times unable to cross certain conceptual boundaries defined by painting as illusionistic space slams up against the "real" space of the painting's surface. Derek Jarman's film *Caravaggio* (1986) uses the recreation of the artist's paintings — with contemporary details sprinkled here and there — to construct the narrative. "If it is fiction," Jarman has written, "it is the fiction of the paintings."[93] Caravaggio's outrage filters through the tableaux to become Jarman's own confrontations with and comments on bigotry and homophobia.

Peter Greenaway's interest in the relationship of film and visual art language has led him into installation work that explores issues of framing, and in the process reconsiders proto-cinematic forms. In his early short films such as *Windows* (1975) and even in his first feature, *The Draughtsman's Contract* (1982), Greenaway built on structuralist film, not so much on its concerns with the material aspects of the film medium as with its use of language and grids as structuring devices. However, for Greenaway, these issues dovetailed with his love of literature and painting, the result being an attempt to merge the history of art with cinema. "The very reasons I became interested in the cinema or television were because of the extraordinary opportunities to play with images, to play with words, to play with their interactions," Greenaway has said. "I started my career as a painter. And I still believe painting is, for me, the supreme visual means of communication. Its freedoms, its attitudes, its history, its potential. And if you look at twentieth-century painting, it's been 10,000 times more radical than the cinema has. Cinema is a grossly conservative medium."[94] Like Ruiz's *Hypothesis* or Antonioni's *Blow-Up*, *The Draughtsman's Contract* is a mystery which integrates art and the cinematic apparatus into its puzzle. The drawings made by the film's main character, the artist Neville, act not only as a possible source of clues, but also as allegorical pictures representing time, place, and memory. Neville's drawings frame the world which is then re-framed by the camera-eye and cinema screen. Like Ruiz and Antonioni, Greenaway

Peter Greenaway
The Draughtsman's Contract, 1982

Louise Lawler
A Movie Without the Picture,
Aero Theater, Santa Monica, California, 1979

leaves the ending a mystery, suggesting that simple attempts to capture topographical details can only frame life, and do not approach the imaginative spirit of art.

Imagination is what Greenaway insists on in his extension of these framing issues in his project *The Stairs or 100 "Intruders" in Geneva* (1994). The Geneva project turns the city into a film. The first in a series of ten exhibitions Greenaway has planned on the theme of film language (location, audience, frame, acting, properties, light, text, time, scale, and illusion),[95] *The Stairs*, like the others planned, does not use film but nevertheless is extremely cinematic. Focusing on location, Greenaway chose 100 sites in Geneva and "framed" each one with a device resembling the camera obscura located at the top of a white staircase. In referring to a previous installation done at the Boymans-van Beuningen museum in Rotterdam, Greenaway discussed how these exhibitions could extend cinema:

> From these exhibitions — all of them enjoyed by a large public — I could find an audience that was not subjected to a sedentary and very largely passive role, sitting in one place in the dark looking at the illusions created of a three-dimensional world by another's subjectivity on a flat screen. Here was an opportunity to make an audience walk and move, be sociable in a way never dreamed of by the rigours of cinema-watching, in circumstances where many differing perspectives could be brought to bear on a series of phenomena associated with the topics under consideration. Yet all the time it was a subjective creation under the auspices of light and sound, dealing with a large slice of the cinema's vocabulary.[96]

The vistas are the "scenes" in an imaginary film, the people of the city its "characters," the spectator its "auteur."

The Absence of Cinema

In 1975, Jack Goldstein made a film entitled *Metro-Goldwyn-Mayer*, a loop playing the famous roaring lion logo, over and over. Goldstein's film plays upon the studio logo as a cinematic code of expectation, the

demarcation of some beginning, a prelude to action. But of course the action never occurs, expectation is undercut, and the narrative film is suspended in an unending beginning. Although Goldstein's film can be seen as a continuation of structuralist strategies, it points forward to the emergence in the late seventies of a new trajectory in the dialogue of art and film, one that is based not merely on deconstruction, but also on absence.

Between Goldstein's film and the end of the seventies, a number of artists had appeared who created projects that, while resurrecting the feature narrative cinema as a subject, were also distanced physically from film. The result is a kind of negation of cinema occasionally coupled with nostalgia. This longing is not necessarily created by using film, but by creating cinematic situations that recall film.

One of the techniques used to undercut the spectacle of cinema is the blank screen. In 1979, Louise Lawler presented *A Movie Without the Picture* at the Aero Theater in Santa Monica. The film *not* screened that evening was John Huston's *The Misfits* (1961). The cinema is suggested but not present. The audience had to imagine Marilyn Monroe and Clark Gable's last screen appearances, the visual pleasure found in watching screen icons having been removed, their deaths, usually supplanted by the cinema, made real. Around the same time, Hiroshi Sugimoto began his ongoing photographs of movie palace interiors. Leaving the shutter open for the duration of the film, the ornate interiors, generally from the twenties and thirties, are bathed in the light from the screen; the film images, however, have vanished, the shadows erased by the light that gives them life and the compression of time back into a moment. All that is left is the empty white screen, filled with so many images that they have become invisible, and the deteriorating palaces, the artifacts from a past era that eased the spectator from reality to illusion. Derek Jarman's film *Blue* (1993) also relies on the blank screen, in this case a monochromatic blue field inspired by Yves Klein. Jarman created a visually nonobjective film but with a voice over about death from AIDS that fills it to the brink with absent images — with destroyed retinas, skies, dead friends, lesions, lightning flickering through a hospital window, men in wheelchairs, blood, refugees from Bosnia, a delphinium — images of the

Hiroshi Sugimoto
Jean Harlow, 1994
Sonnabend Gallery, New York, and
Angles Gallery, Santa Monica, California

Hiroshi Sugimoto
Metropolitan, Los Angeles, 1993
The Museum of Contemporary Art, Los Angeles

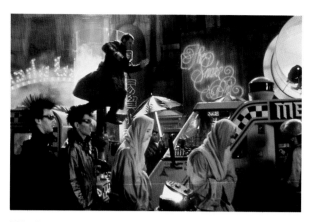

Ridley Scott
Blade Runner, 1982

mind that take the place of the usual cinematic spectacles. The blue screen not only conjures up visions of Klein, but also of Brakhage's experiments with closed-eye vision, of Turner's attempts to paint the sun, of infinity, and ultimately of Jarman himself. Although on the surface both Jarman and Sugimoto have something in common with the "white," clear-leader films of Fluxus participants Nam June Paik and George Maciunas as well as Mauri's *schermi*, the worlds they create with light are not reductive but expansive, not acinematic but overtly cinematic, not avant-garde but nostalgic, not empty but filled with absence.

The sense of loss of the cinema ironically may be due in part to the expansion of the cinematic into other forms, into theme parks, virtual reality rides, music video, and other hyperrealities. Cinema is everywhere; and by being everywhere, it is nowhere. Even in feature film, there are transparent quotations from the past with nostalgic overtones. In films such as Ridley Scott's *Blade Runner* (1982), Terry Gilliam's *Brazil* (1985), Tim Burton's *Batman Returns* (1992), or Robert Longo's *Johnny Mnemonic* (1995), or in the rush of images on MTV, special effects, including matte paintings, models, and digitalization, are used to create worlds that place the past in the future — a past dominated by the look of half-remembered films such as Fritz Lang's *Metropolis* (1927), William Cameron Menzies's *Things to Come* (1936), and Merian C. Cooper and Ernest B. Schoedsack's *King Kong* (1933), fused with Hugh Ferris's imaginary views of Manhattan and with Sentinel Comics.[97] The heavy emphasis on the thirties in these films suggests, as Robert Smithson pointed out years ago, that the "Ultramoderne of the thirties transcends Modernist 'historicistic' realism and naturalism, and avoids the avant-garde categories of 'painting, sculpture, and architecture.'"[98] This longing for the thirties can be equated with a longing for "the film age."

The great storehouse of cinematic images becomes the subject of a number of artist and filmmaker's projects. Echoing his interest in time travel and memory in *La Jetée*, Chris Marker gives us a sequence in his documentary *Sans Soleil* (1982) in which Marker (his presence suggested by a woman narrator reading reports from a traveler) states that he has seen Hitchcock's *Vertigo* nineteen times, and that it is a film

which makes possible "impossible memory, insane memory."[99] Indeed, the memory of Hitchcock's film haunts much of Marker's work; besides reflecting issues surrounding time, loss, and memory, *La Jetée*, for example, indirectly quotes the scene in *Vertigo* in which Kim Novak examines concentric rings on a cut sequoia tree and says: "Here I was born and here I died." One of the few filmmakers other than Godard who has managed to create a new form of cinema existing somewhere between narrative and documentary, Marker's film "essays" often utilize the memory of feature film to create the dreamy, melancholic world of the contemporary traveler; like the cinema spectator, the traveler's world is always receding, his knowledge of the world existing only through its absence. In *Sans Soleil*, San Francisco is seen through the memory of *Vertigo*, the Hitchcock film intercut with Marker's footage, while Tokyo becomes science fiction and horror, "a gigantic collective dream of which the entire city may be a projection," that recalls not only Marker's own *La Jetée* but also Godard's *Alphaville* and Ridley Scott's *Blade Runner*. Near the end of the film, Marker says that the images he has filmed "have substituted themselves for my memory. They are my memory. I wonder how people remember things who don't film."[100] Marker has extended this absence of cinema into "imaginary films." In *America Dreams* (1961) and *Soy Mexico* (1967), for example, Marker has published texts for films existing only in the mind.[101]

Raymond Bellour has observed that *Sans Soleil* has three types of film-images: the "cinema-picture," the cinema-verité-type shots that rush by unaltered; the suspension of movement with the use of freeze frames and shots of motionless images such as photographs, comic strips, paintings, toys, etc.; and the "distorted" image, sections altered by Marker and Hayao Yamaneko on a synthesizer.[102] These last images foreshadow Marker's recent digital works: *Zapping Zone* (1990), *Silent Movie* (1995), and the forthcoming *Level Five* and CD-ROM *Immemory*. Video and computer technology has enabled Marker, as well as other film artists such as Godard in his ongoing *Histoire(s) du Cinema* (begun in 1989), to work as he had always wished, in relative seclusion, creating "cinema" without the heretofore necessary complex industrial and social mechanisms.[103]

Cindy Bernard
Ask the Dust: Vertigo (1958/1990), 1990
Collection of the artist

In *Silent Movie*, which was commissioned by the Wexner Center for the Arts for film's centenary, Marker created an homage to cinema by appropriating and reconstituting film history. Using five monitors stacked in a "tower" recalling the Vesnin brothers designs for the *Pravda* building, Marker uses a computer to call up film segments from the silent and early sound era of cinema. The computer is programmed so the sequence of images will never repeat. Each monitor has a theme: "The Journey," "The Face," "The Gesture," and "The Waltz," with the middle monitor reserved for intertitles both culled from silent film and written by Marker.[104] The result is the past pressed into service by the present and pointing toward the future; the piece continues Marker's theme of memory, loss, and the forward progression of travel, suggesting that cinema is both concluded and in the process of being rejuvenated.

Memory is also at the center of work by other artists such as Cindy Bernard and Christian Marclay. Bernard's "Ask the Dust" (1989–91) consists of twenty-one photographs "recreating" landscape shots from American films between 1954 and 1974, including such classics as *The Searchers* (1956), *Vertigo, North by Northwest* (1959), and *Chinatown*, but also fifties disaster films such as *Them!* (1954) and exploitation films such as *Faster Pussycat! Kill! Kill!* (1965). Using information supplied by the film's directors and production managers, Bernard reconstructs the shot — without the actors — using the same aspect ratio. Colin Gardner has analyzed these works:

> Bernard's strategy entails a two-way deconstruction. By draining the original film's mise-en-scène of all narrative and semiotic connections, Bernard familiarizes the filmic through reprivileging the landscape as a "neutral" site. But landscape isn't a neutral site; it is a constructed representation. We read into it all sorts of mediated, cultural, and ideological connotations, reflecting various frames of historical discourse as well as those of art and popular culture. Thus Bernard's additional filmic parameters act as a paradigm for this tendency to mythify and historicize. The Western mesa landscape is not only a symbol of the wilderness as a frontier of 19th-century migration, it is also a signifier of the John Ford Western.[105]

Cindy Bernard
Ask the Dust: Dirty Harry (1971/1990), 1990
Collection of the artist

Cindy Bernard
Ask the Dust:
Faster Pussycat! Kill! Kill! (1965/1990), 1990
Collection of the artist

Memory is also one of the key ingredients in Christian Marclay's sound work *Vertigo (Soundtrack for an exhibition)* (1990). Hitchcock's film is used as raw material for Marclay's interests in the relationship between objects, images, sound, and silence. Using snippets from the film's dialogue and Bernard Herrmann's score, Marclay creates a richly layered "superimposition" of sounds that are randomly spaced by as much as four minutes. The new "soundtrack," which startles the unaware gallery visitor, conjures up iconic images from the film, but then creates from them a new film of the imagination. The film's absence acts as an opening for new cinematic possibilities.

A sense of nostalgia also crops up in the work of artists whose earlier association with cinema was on a much cooler, more Pop-oriented plane. Edward Ruscha's recent paintings of film frames, in which the scratches and imperfections of celluloid become one with the shadowy images, and Richard Hamilton's *Ghosts of Ufa* (1995), which combines two consecutive frames from a deteriorating German silent film, elicit a new sense of cinema as history and memory, a response at some distance from the artists' earlier, more direct dialogue with contemporary pop culture.

Themes of emptiness and history are also at the core of Raúl Ruiz's installation *All the evil in men...* (1992). The work was inspired by a warning in Blaise Pascal's *Pensées*: "All the evil in men comes from one thing and one thing alone: their inability to remain at rest in a room."[106] In this piece, Ruiz explores the relationship between the concept of entertainment as a diversion from boredom, and the possibility that boredom, or at least a kind of ennui, might be a preferable state. Ruiz uses a space that suggests a church, a darkened room with benches facing an altar; at the altar hangs a scrim on which a film is projected. Off to the sides are a number of cells, each containing objects, tableaux representing individuals who are not present. During the projection of the film, a light fades up, blocking the film out and revealing a blow-up of a cartoon for a tapestry by Rogier van der Wyden, only to disappear and be replaced by the film once again. It is a struggle between a still image requiring quiet contemplation and a moving image which diverts attention. As the religion of modern man, the cinema has created a "world emptied by entertainment."[107]

Edward Ruscha
Asphalt Jungle, 1991
Museum of Fine Arts, Boston,
The Tompkins Collection

Richard Hamilton
Ghosts of Ufa, 1995
Collection of the artist

Raúl Ruiz
All the evil in men..., 1992
Collection of the artist

Raúl Ruiz
All the evil in men..., 1992
Collection of the artist

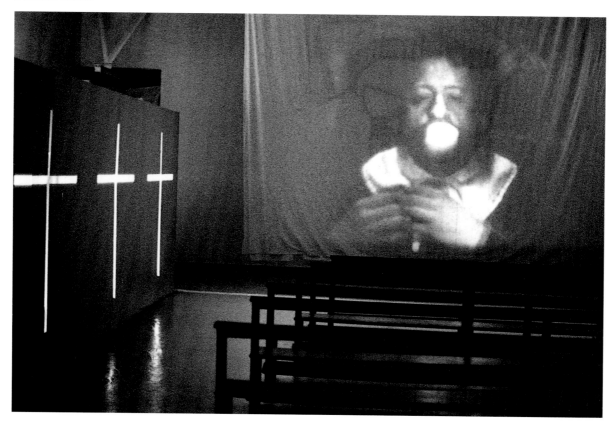

Ruiz's installation investigates the way that cinema has often been used to distract and to replace contemplation with, if not always mindless entertainment, at least with an art form that imposes strict rules of fiction and controls the logic of the imagination. Ruiz's attempt to make transparent the cinema's diversionary tactics seems particularly important as the cinematic is absorbed into the universal audiovisual nexus that is now taking shape at the end this century. While the cinema as a pure art form may be disappearing, the cinematic is alive and well within the various modes of presentation in this vast but homogenous network of images and sounds. Ruiz seems to call for a spirit of openness and inventiveness to be brought to bear on the contemporary cinematic event. But to do this, Ruiz suggests, we must first gain a deeper understanding of the mechanisms of the cinematic experience.

For the last several decades, artists and filmmakers have undertaken this very challenge and have passed through the apparatus itself in an attempt to dissect it. It is a journey that, as we have seen, has often lead back to the origins of film and reflected them back into the present. Indeed, much of the history of the dialogue between art and film after the Second World War is in many ways a reversal of cinema history, kicked off by the dismantling of film just after it had reached its zenith in the thirties, and from there continuing on backward from Warhol's recapitulation of Lumière to the structuralists' interest in chronophotography and optical devices to the more recent generation's interest in tableau vivant and finally to a consideration of cinema before its birth and after its end.

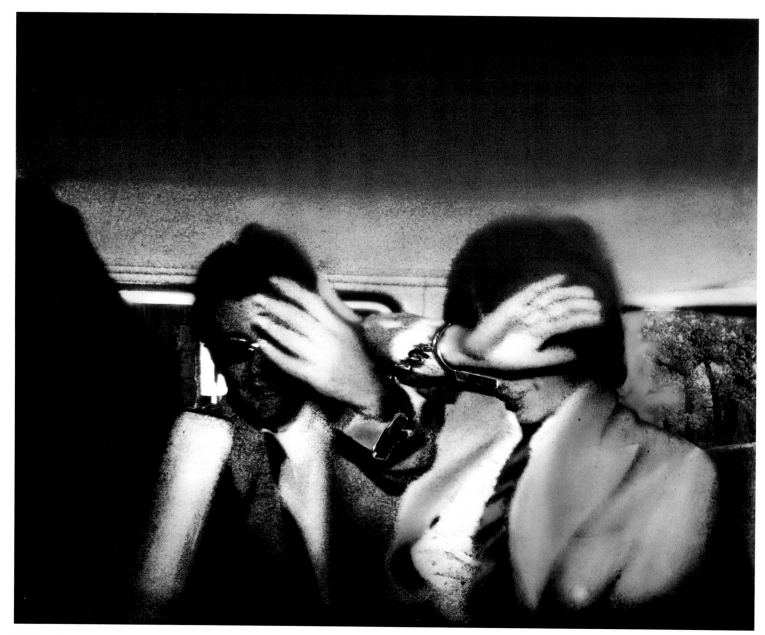

Richard Hamilton
Swingeing London 67 (f), 1968–69
Museum Ludwig, Cologne

Beautiful Moments

Russell Ferguson

A talent scout is struck by a promising face in the subway. Proposition, test photo, test recording. If the tests are conclusive, the young beauty leaves for Hollywood. Immediately put under contract, she is refashioned by the masseurs, the beauticians, the dentists, even the surgeons. She learns to walk, loses her accent, is taught to sing, to dance, to stand, to sit still, to "hold herself."... Her car, her servants, her dogs, her goldfish, her birds are chosen for her.... The studio decides to launch her, and fabricates a fairy tale of which she is the heroine. She provides material for the columnists; her private life is already illuminated by the glare of the projectors. At last she is given the lead in a major film. Apotheosis: the day when her fans tear her clothes: she is a star.

— Edgar Morin, 1960[1]

I've never met a person I couldn't call a beauty.... If everybody's not a beauty then nobody is.

— Andy Warhol, 1975[2]

They were always impressed by the photographs of Jackson Pollock, but didn't particularly think much about his paintings.... The photographs of Pollock were what they thought Pollock was about. And this kind of take wasn't as much a position as an attitude, a feeling that an abstract expressionist, a TV star, a Hollywood celebrity, a president of a country, a baseball great, could easily mix and associate together ... and whatever measurements or speculations that used to separate their value, could now be done away with.

— Richard Prince, 1983[3]

Although the "discovery" of a complete unknown who becomes a great star is one of Hollywood's favorite myths, there was no pretense that such a transformation could be accomplished without the machinery of publicity. The studios had learned how to generate a smooth and continuous stream of new stars, whose celebrity was linked to, but far from

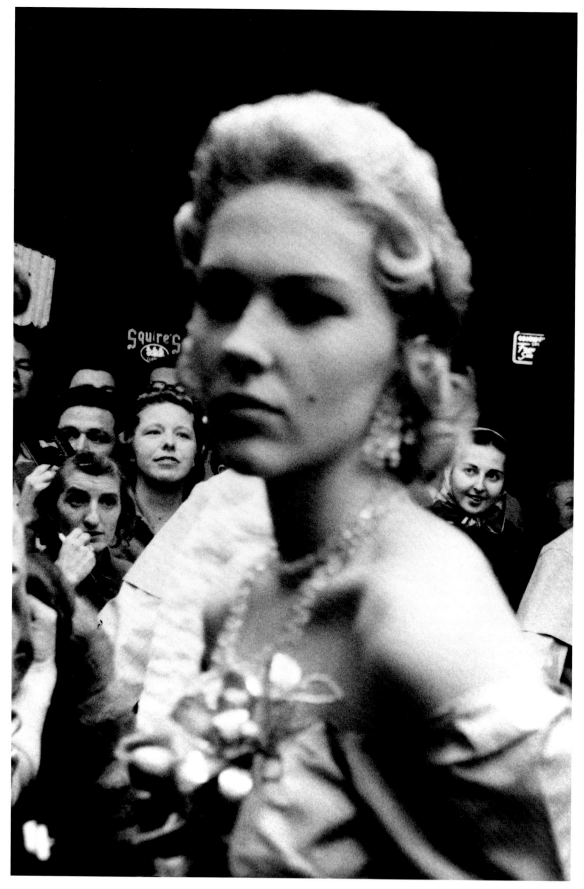

Robert Frank
Movie Premiere, Hollywood, 1955–56
The Museum of Contemporary Art,
Los Angeles

Robert Frank
Untitled (Boy Reading with Movie Star Posters),
n.d.(c. 1950s)
Herbert F. Johnson Museum of Art,
Cornell University, Ithaca, New York
Gift of Andrea D. Branch

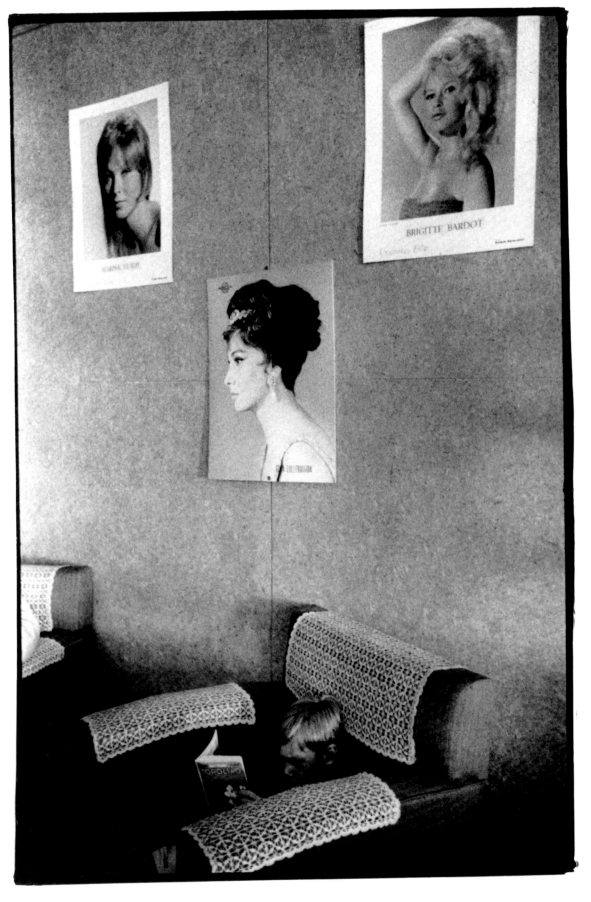

dependent on, their roles as actors. In fact Hollywood's special contribution to the history of fame was its complete professionalization, through an apparatus — of publicists, photographers, fan magazines, and gossip columnists — that was capable of creating fame essentially at will.

In 1948, however, the effective monopoly control that the studios held over movie theaters was broken by the Paramount anti-trust case, and the star system began to crack along with the rest of totalitarian Hollywood. In 1950 Billy Wilder's *Sunset Boulevard* dared to suggest that, once created, stars would still age, and that even the greatest of them might be forgotten. Perhaps there was something nasty floating in the swimming pool. The hovering presence of Erich von Stroheim, the walking epitome of 1920s Hollywood autonomy and excess, here recast as a combination fan and butler, expressed the uneasiness of a studio-driven star culture that for the first time sensed its own vulnerability. With *Sunset Boulevard* the seamless facade that the studio star system had successfully presented to the public throughout the thirties and forties began to crumble. By the mid-1950s the disintegration of the system was well underway. Hollywood would never abandon stars, of course, but the dominance and control exercised by the studios in the thirties, forties, and early fifties would not be regained. It was at this point that stars like Marlon Brando began to assert themselves as working actors in a way that would have been inconceivable in an earlier era, when stars were presented in pseudo-aristocratic terms as simply being themselves (that is, stars), their off-screen activities limited to expensive leisure: travel, parties, and sports such as yachting and polo,[4] in a Hollywood envisioned, in Parker Tyler's words, as "a sort of mundane Olympia where men and women led the 'ideal' lives of gods and goddesses."[5]

Emblematic of the shift away from Olympia was the passage from the impeccable, studio-sponsored images of George Hurrell to the *Naked Hollywood* of Weegee. Weegee's book, published in 1953, made use of the techniques he had developed to shoot gangland rubouts for the New York newspapers. In the tabloid tradition, he sought to give his audience the inside scoop, the dirty details. His goal this time was to debunk the glamour myths of Hollywood. Not only did Weegee print an

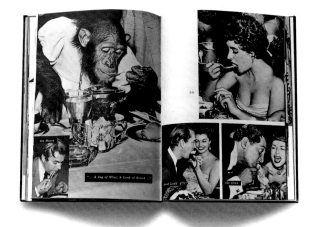

Weegee
Two page spreads from *Naked Hollywood*, 1953

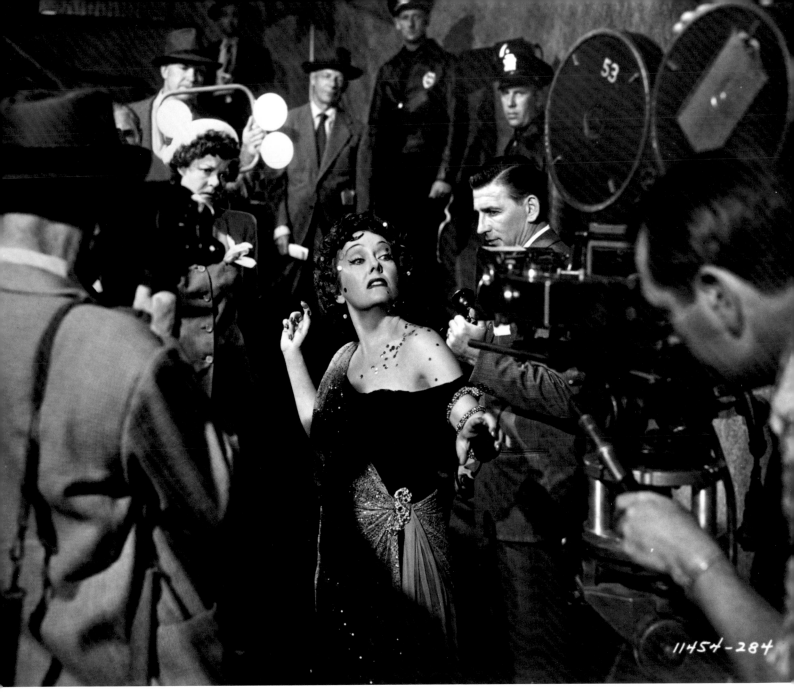

Billy Wilder
Sunset Boulevard, 1950

unflattering photograph of Elizabeth Taylor shoveling a forkful of food into her mouth, he paired it with a similar one featuring a chimpanzee. Shot quickly with a flash, his grainy photos showing Hollywood as a tawdry flesh market could hardly be further from the high elegance of Hurrell's studio portraits.

At the same time that the Hollywood star system was breaking up, however, a broader and more democratic cult of celebrity was on the point of eruption. The field of stardom was about to expand to include pop musicians, fashion photographers, hairdressers, models, artists, and virtually anyone else who could get in front of a camera. Stardom became disengaged from its ties to the Hollywood studios and began to float freely throughout society. This change began to imbue the golden age of the Hollywood star with a nostalgic quality and created disjunctions in the very concept of the star. Spaces opened up in which it became possible for artists to make use of stardom's vocabulary.

The power of the star was breaking up and yet at the same time becoming part of a global language. Even in the United States itself it is easy to find examples of the redefinition of stardom and celebrity. The development can, however, be seen at its most dramatic in England. A new nexus of art, film, fashion, and pop stardom took form in the late 1950s and 1960s in London. British pop culture from the end of the fifties to the late sixties was enthusiastic about the future, emerging from the immediate postwar era with an optimistic vision of a democratic technocracy that welcomed novelty in every area. Dependent as this movement was initially on American movies, comics, advertising, design and music, it quickly took on a life of its own. The shared language contributed to a rapid process of exchange that would culminate in the "British Invasion" of the mid-sixties. The example of London is also striking in that its explosion of American-derived pop culture also produced (or was even preceded by) a sophisticated body of theoretical analysis that as early as the 1950s began to make explicit connections between the broadest field of pop culture and high art as traditionally defined. In addition, a significant group of artists were able to make such connections part of their work. Their innovations were to have a

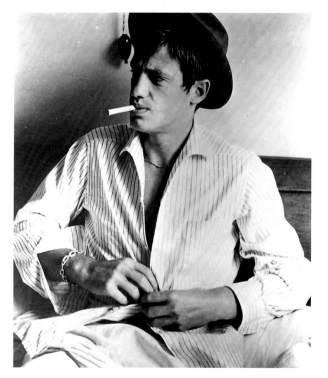

Jean-Luc Godard
A bout de souffle (Breathless), 1960

major impact all over the world, including in the United States from which they had drawn inspiration.

No American artist drew more from the new culture that had developed in London than Andy Warhol (much more so than is usually recognized), although he turned it to quite different ends. Even as Warhol shared with his British counterparts a fascination with the process of star creation, and himself participated in the dramatic broadening of stardom's range, he also returned his gaze to the outmoded glamour of the traditional Hollywood star. Never particularly optimistic, he conducted his radical innovations from the beginning under the melancholy shadow of nostalgia. In the end, therefore, it is possible in thinking about the period from the mid-fifties to the late sixties to trace an arc from a moribund Hollywood, through a hectic and relentlessly forward-looking London, to the New York of Warhol and his attraction to precisely the kind of decaying glamour that London had displaced not so long before.

★　　★　　★

I swore by Elvis and all the saints that this last teenage year of mine was going to be a real rave. Yes, man, come whatever, this last year of the teenage dream I was out for kicks and fantasy.
— Colin MacInnes, *Absolute Beginners*, 1959[6]

There is now a curious cultural community, breathlessly *à la mod*, where Lord Snowdon and the other desperadoes of grainy blow-ups and bled-off layout jostle with commercial-art-school Mersey stars, window-dressers and Carnaby Street pants-peddlers.
— Jonathan Miller, 1964[7]

The roots of what would much later be called "Swinging London" can perhaps be traced to the informal Independent Group that organized lectures and discussions at the Institute of Contemporary Art beginning in 1952. Among the key participants were the writers Reyner Banham and Lawrence Alloway, and the artists Richard Hamilton and Eduardo

Paolozzi. The Independent Group was a loose association of individuals with diverse interests, but almost all the members were united in an enthusiasm for popular culture, including film, science fiction, and advertising. There was a conviction that these forms were worthy of consideration alongside the traditional forms of high art, a sentiment intensified by the absence of any strong British equivalent to Abstract Expressionism.[8] As early as 1954, the same year that wartime rationing finally ended in Britain, visitors to the ICA could hear Alloway lecture on science fiction and Toni del Renzio on fashion. Their discussion of the Western film at this bastion of high European modernism was appropriately titled "Ambush at the Frontier." More such sessions followed, on topics including cars, advertising, product design, sociology, and jazz. The minutes of the ICA annual meeting in 1954 record that "Mr. Richard Hamilton suggested that discussions could be held about the films released to local cinemas, as these had an enormous influence."[9]

The early ICA discussions were still largely devoted simply to spreading the word about the products of American popular culture. But a theoretical re-evaluation soon followed.

"Acceptance of the mass media entails a shift in our notion of 'what culture is,'" Alloway wrote:

> Instead of reserving the word for the highest artifacts and the noblest thoughts of history's top ten, it needs to be used more widely as the description of "what a society does." Then, unique oil paintings and highly personal poems as well as mass-distributed films and group-aimed magazines can be placed within a continuum rather than frozen in layers in a pyramid.[10]

The sense that pop culture and high art occupied a continuum, as Alloway put it, rather than opposite sides of an unbridgeable canyon, marked a significant difference from the conventional wisdom in the United States, where Clement Greenberg's warnings against the dangers of kitsch still dominated. For Alloway, the idea of a continuum of visual culture meant that the difference between high art and pop art (as he used the term, referring to advertising and other purely commercial

manifestations) was a difference of degree rather than of essence. This broadening of the cultural field was combined with a great enthusiasm for new technology of all kinds and a naive belief in its capacity to generate positive change in society. The vocabulary of Futurism was invoked with regularity. Both the Futurists' belief in technology and speed and their desire to break down the traditional boundaries of the fine arts were adopted with enthusiasm.

In the dreary landscape of postwar London, still strewn with bomb sites and living under a government economic policy of the strictest austerity, the United States seemed like a promised land of unlimited consumer-driven plenty, glimpsed primarily at the movies and in the pages of American magazines. At the same time there seemed to be a weakening of the most rigid forms of the class system, and the belief grew that Britain was entering a new, classless, technocratic era. Before the sixties had even arrived, the worlds of celebrity, film, fashion, and art had begun the interpenetration that would gather momentum throughout the next decade.[11] By the late 1950s a new Pop art had emerged in Britain, one that welcomed popular culture as an ally, without giving up its own claims to full artistic validity. In 1957 Alloway wrote that, "When I write about art (published) and movies (unpublished) I assume that both are part of a general field of communication.... The new role of the spectator or consumer, free to move in a society defined by symbols, is what I want to write about."[12] Alloway's identification of freedom in terms of spectacle and consumption marks a sharp difference from contemporary American critics such as Harold Rosenberg, who remained committed to the idea of art as an existential struggle far removed from everyday life.

Hamilton's *Just what is it that makes today's homes so different, so appealing?* (1956) was one of the first works produced in this milieu to capture the sense that the field of cultural possibilities could be greatly expanded, and that consumer society and art could share the same terrain. It even includes an American comic book, blown up, framed, and displayed as a painting on the wall, at least five years before Lichtenstein began his true Pop paintings, as well, of course, as the prominent appearance of the word "POP" itself in the center of the work. Through the

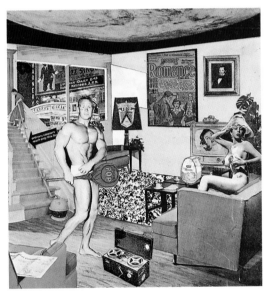

Richard Hamilton
Just what is it that makes today's homes so different, so appealing?, 1956
Kunsthalle Tübingen, Sammlung G.F. Zundel

window, the outside world is represented by a movie theater playing *The Jazz Singer*, the first talkie, and thus representative not just of American movies in general, but also of the onward rush of technological breakthroughs.

Colin MacInnes's critically acclaimed novel *Absolute Beginners* (1959) marked a literary equivalent to Hamilton's prophetic collage. MacInnes's story of a hustling teenage photographer combines elements of a proto-Swinging London with eerie presentiments of Andy Warhol's Factory. Lacking the enthusiasm for technology that inspired Alloway, Banham, and Hamilton, MacInnes focused instead on the culture of images and the emergence of a celebrity free of specific Hollywood connections. The anonymous narrator could be describing Hamilton's collaged environment when he goes to photograph his vaguely sinister client Mickey Ponderoso "striking narcissistic poses" in his "cool and costly" apartment, "you know, with glass-topped white metal furniture, oatmeal-stained woodwork, Yank mags and indoor plants and siphons."[13] At other times he has as his model (and proto-superstar) "the ex-Deb," who "would look sensational when recorded for posterity by my Rolleiflex." She is recruited with heroin, "because the ex-Deb, although you couldn't precisely describe her as a junkie, climbs on the needle when being beautiful is just too much for her." She asks: "If everyone's entire life, every twenty-four hours, was filmed and tape-recorded, who exactly *would* seem normal any more?"[14] MacInnes's Australian TV personality, Call-me-Cobber, announces that "each woman, man and child in the United Kingdom can be made into a personality, a star. Whoever you are — and I repeat, whoever, we can put you in front of cameras and make you live for millions."[15] Perhaps even more uncanny than this early prestatement of Warhol's pithier, "In the future everybody will be world famous for fifteen minutes" is the narrator's pervasive, value-free distance from the events he observes, a quality that Warhol was to make into one of his trademarks.

MacInnes was prophetic in his choice of a photographer as the narrator of *Absolute Beginners*:

Events of the last month had convinced me that the only way I could ever hope to make some swift dinero was by cracking into the top-flight photographic racket — i.e., produce some prints that would be so sensational that I'd make the big time in the papers and magazines, and even (this was my secret dream) succeed in holding a fabulous exhibition somewhere to which all my various contacts would bring their loaded friends.... It seems very fashionable just now to treat photographers like film stars.[16]

MacInnes's fashionable young narrator is a self-confident and highly verbal working-class intruder into the upper-class strongholds of Mayfair and Belgravia, and what gives him the power to assert himself there is his omnipresent camera. "Around my neck hung my Rolleiflex, which I always keep at the ready, night and day, because you never know, a disaster might occur, like a plane crashing into Trafalgar Square … or else a scandal, like a personage seen with the wrong kind of man or woman."[17]

While the desire to photograph something actually newsworthy harks back somewhat to the tabloid tradition of Weegee, the cool interest in disaster for its own sake, and its presumed equivalence to gossip and scandal, "contacts" and "loaded friends," presages the Warhol approach.

The late fifties had seen the beginnings of the photographer as a potentially fashionable figure, a trend that would escalate in the sixties as the process of image creation became steadily more important and overt in fields outside the Hollywood film industry. In London, the most important immediate progenitor of the photographer as star was Anthony Armstrong-Jones, later Lord Snowdon, who had worked for *Vogue* since 1955. It was not until the early 1960s, however, that working-class photographers such as Terence Donovan, Brian Duffy, and, especially, David Bailey became catalysts in the formation of Swinging London. Indeed, when *Absolute Beginners* was published, the fashion photographer John French instantly saw his teenage Cockney assistant, Bailey, in MacInnes's young hero. Like his fictional counterpart, Bailey haunted the jazz clubs of Soho, was always dressed in the height of fashion, and was driven by powerful ambition. Reciprocally, Bailey saw French as

David Bailey
At John Fench's Studio, 1959

Stanley Donen
Funny Face, 1957

Fred Astaire and Richard Avedon on
the set of *Funny Face*, 1957

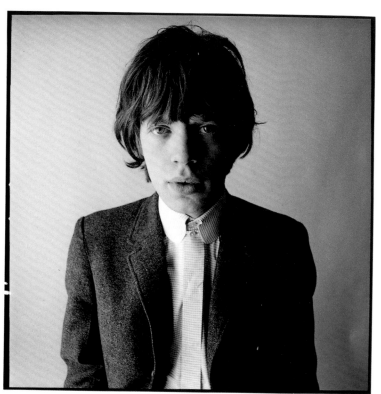

David Bailey
Mick Jagger, 1964

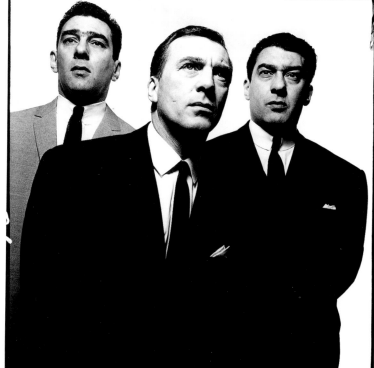

David Bailey
The Kray Brothers, 1965

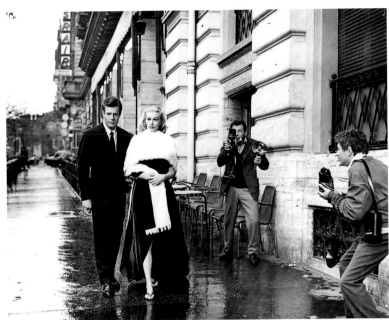

Federico Fellini
La dolce vita, 1960

a version of Fred Astaire's Dick Avery, the photographer modeled on Richard Avedon in Stanley Donen's film *Funny Face* (1957).[18] This international glamorization of the photographer continued with Federico Fellini's *La dolce vita* (1960), whose character Paparazzo gave his name to a new profession.

In 1961 Bailey produced a fourteen-page spread for *Vogue* that featured his first "discovery," Jean Shrimpton, along with other embryonic sixties celebrities (all chosen by Bailey) such as Peter Cook, Kenneth Tynan, and Vidal Sassoon. Only one year after beginning to work for *Vogue*, Bailey was already expanding his role beyond that of photographer to encompass a new identity as star *maker*,[19] and, by implication, celebrity in his own right. Prominent in this spread is a blurring of categories that would become characteristic of the sixties. All that these celebrities have in common is their celebrity: a hairdresser can stand comfortably alongside an eminent theater critic, a comedian, a race-car driver, and a jazz musician. And all of them can be posed next to "the Shrimp" in a fashion magazine.

Bailey would take this hierarchical mixing even further in 1965 with his *Box of Pin-ups*, a boxed set of thirty-six photographs of the "people who in England today seem glamorous to him." Again, emphasis is placed on Bailey's power to select; his subjects are glamorous to *him*, and that, it is implied, is enough to make them glamorous to everyone else. It is his own portrait (by Mick Jagger) that appears on the cover. A scandal erupted as a result of the juxtaposition of royalty (Lord Snowdon, whose wedding to Princess Margaret in 1960 was itself a symbol of the changing status of photographers), with Jagger and other pop stars, various models and photographers, and, most shockingly, the East End gangsters the Kray brothers. The pure white backgrounds stressed that his subjects were indeed "persons without backgrounds," as David Mellor has put it.[20] There was a widespread sentiment that most of Bailey's subjects were not really worth photographing seriously at all. Even those who could accept the images of models and entertainers found his inclusion of "the haircutter and hatmaker, the craftsmen and

David Bailey
Spread from *Vogue*, 15 September 1961

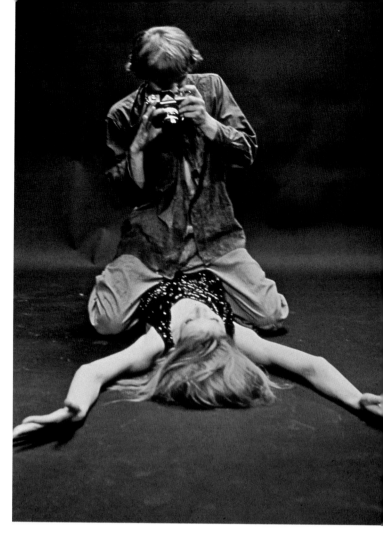

middlemen" too much. "The style of the stars is all right," wrote D.A.N. Jones. "What's depressing is that the middlemen and managers should try to steal their stardust."[21] Bailey's public celebration of his own role as arbiter of taste was clearly difficult for many to swallow. Malcolm Muggeridge wrote that society had seen the birth of "a religion of narcissism, of which photographers like Mr. Bailey are high priests."[22] Four years later, Muggeridge himself would sit for his portrait by Bailey.

By 1966, the energetic fusion of art, Pop, celebrity, and self-promotion had reached the point at which even *Time* magazine took notice of "London, the Swinging City." Its account featured

> Jane Ormsby Gore, 23, daughter of the former British Ambassador to the U.S., and a fashion assistant on British *Vogue*. Clad in a tightly fitted wine-red flared Edwardian jacket over a wildly ruffled white lace blouse, skin-tight, black bell-bottom trousers, silver-buckled patent leather shoes, ghost-white makeup and tons of eyelashes, she pops into a cocktail party, not unlike the one Julie Christie goes to in *Darling*, at Robert Fraser's art gallery on Duke Street. There she sees Fashion Designer Pauline Fordham in a silver metallic coat, Starlet Sue Kingsford in a two-piece pink trouser suit with a lovely stretch of naked tum, Los Angeles-born Pop artist Jann Haworth Blake, Detroit-born Negro Model Donyale Luna.[23]

Time's article shows the worlds of "society," fashion, film, and art engaged in a promiscuous series of overlapping encounters. By this point, of course, the wave was already cresting.

★ ★ ★

> I must tell you, I'd fallen right out of love with England. And even with London, which I'd loved like a mother, in a way. As far as I was concerned, the whole dam group of islands could sink under the sea, and all I wanted was to shake my feet off of them.
> — Colin MacInnes, *Absolute Beginners*, 1959[24]

Michelangelo Antonioni
Blow-Up, 1966

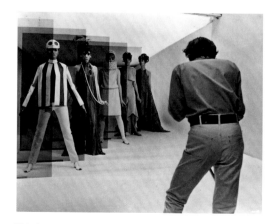

Michelangelo Antonioni
Blow-Up, 1966

In 1966 Michelangelo Antonioni made *Blow-Up* in London. The film's protagonist, the photographer Thomas, played by David Hemmings, was universally assumed to be based on Bailey, who by that time was a major celebrity in his own right (indeed Carlo Ponti, the film's producer, had approached Bailey about playing the lead himself[26]). As George Melly wrote: "The personification of the photographer as pop hero is undoubtedly David Bailey: uneducated but sophisticated; charming and louche; elegant but a bit grubby; the Pygmalion of the walking-talking dolly; foul-mouthed but sensitive."[27] His wedding the previous summer to Catherine Deneuve, at which Mick Jagger was the best man, had been front-page news, with great excitement generated by the fact that the wedding party smoked cigarettes throughout, and that the men did not wear ties. Bailey, like Thomas, drove a Rolls Royce, kept an airplane propeller as a kind of found sculpture, had become involved with an antique store (with the quintessentially sixties name The Carrot on Wheels), and had even published a series of photographs in British *Vogue* of London parks, of exactly the type Thomas is seen taking in the film. Such details made the identification inevitable, although elements of the character are also drawn from other fashionable photographers of the period, such as John Cowan, in whose studio the film was shot and whose work remains visible on the walls.[28]

While Antonioni's film proved to be a timely and commercially successful presentation of Swinging London, or at least of Swinging London as it was popularly perceived (that is, with rock music, casual sex, and lots of drugs), it also stands in contrast to the predominantly upbeat version of modern life represented by English Pop. One of the first products of the sixties to suggest a faltering in the exhilarating rush toward the future, *Blow-Up* in fact recalls Fellini's *La dolce vita* in its tone of blasé disaffection and boredom, expressed through a central figure who is positioned primarily as an observer. The photographer

David Bailey
London Parks, from *Vogue*, 1 October 1962

Thomas is the personification of Lawrence Alloway's ideal "spectator or consumer," roaming freely through the city, aiming his camera at whatever momentarily catches his eye. Rootless and dissatisfied, however, he can find no point of rest. Antonioni's film restates a desire for a stability that is constantly frustrated by a countervailing need to keep moving. As such, *Blow-Up* is also an important film in Antonioni's ongoing investigation of the relationship between the cinema and painting, explored in different terms earlier in *L'Eclisse* (The Eclipse, 1961) and *Il deserto rosso* (Red Desert, 1964). In *Il deserto rosso*, for example, Antonioni had experimented with unnaturalistic uses of color and had made extensive use of telephoto lenses in order to flatten perspective and increase the self-conscious two-dimensionality of his images.

Blow-Up is shot using more conventional techniques, but demonstrates a continuing interest in questions of visual authenticity and in temporality. The entire structure of the film is based on the interplay of the still photographs which seem to reveal a murder and the movement through time represented by the film itself and its protagonists. Thomas is never still. Even when photographing a building, he throws his body from side to side in a frenetic search for the perfect angle, or at least a different angle. He is constantly leaping up, leaving abruptly, breaking into a run. Even as he studies his blown-up photographs, he remains in motion, pacing up and down, back and forth. This tension between the ostensible subject of the film — the intense scrutiny of a series of still, black-and-white images (that is, the experience of painting, or, perhaps more precisely, the experience of art history) — and the endless, dissatisfied movement of Thomas around a relentlessly swinging and intensely chromatic London is what really drives the film: the apparent murder itself turns out to be the most perfunctory of plot devices. The propeller drawn from David Bailey becomes a concrete symbol of propulsive spinning movement brought to a halt and converted into art.

The painter in the studio next door to Thomas paints canvases in which the image breaks up into a grainy kind of Pointillist abstraction, recalling both Thomas's blown-up photographs and — especially — Richard Hamilton's work with enlargements of photographs. Hamilton

Michelangelo Antonioni
Blow-Up, 1966

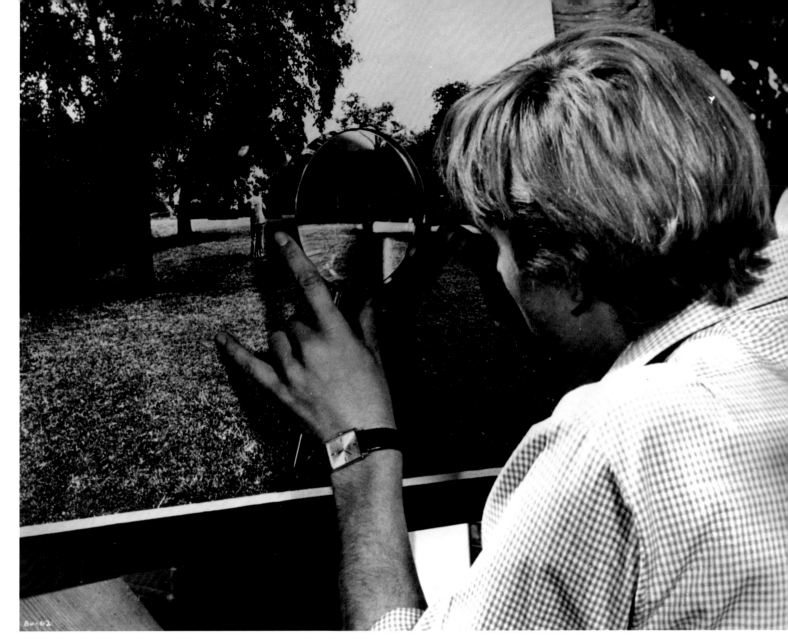

Michelangelo Antonioni
Blow-Up, 1966

Richard Hamilton
People, 1965–66

had used a blown-up photograph by Weegee of the crowded beach at Coney Island to form the carpet in *Today's Homes*, and since the early sixties his work had been increasingly involved with the relationship between photography and painting. *People* (1965–66) is an immediate precursor to some of the issues explored by Antonioni in *Blow-Up*. For this work Hamilton made repeated blow-ups of a postcard photograph of people on a beach, stopping when he reached "the shallow edge between recognition and abstraction."[29] Hamilton's fascination with the manipulation of momentary images fixed by the camera thus forms a corollary to Antonioni's concerns with the authenticity of images and their mutability. For Thomas's neighbor, locating the key to a successful painting is "like finding a clue in a detective story." The remark explicitly links painting to the movie itself, but ambiguously. Thomas finds the clues, but not the solution: is the photographer thus a kind of failed painter? In the antique store he attempts to buy landscape paintings. By the end of the film he has entirely dissolved into a landscape, in this case one painted, literally, by Antonioni. Dissatisfied with the natural color of the grass, the director had had it spray-painted in a different shade.[30]

Large stretches of *Blow-Up* take place in complete silence, as the film seems to seek out an identity as pure visual image. Thomas paces up and down, staring at the photographs, surrounded by his apparatus for fixing the image. Stillness gradually becomes synonymous with disappearance. The body left beneath the trees turns out not to be there on Thomas's return, and Thomas himself, when he finally stops moving, simply vanishes from the screen, ending the film (the movie). Julio Cortázar, in the story of the same name that inspired the film, has his narrator refer to "the air of being twice as quiet that mobile things have when they are not moving." In the end, it proves impossible to fix the enlarged image, and the narrator himself has become fragmented, blown-up. Antonioni starts from here, turning the agitated tumult of sixties London into a meditation on the impossibility of stopping time, on the relationship between the still image and the moving image, the dead and the living.

One of the key scenes in *Blow-Up* features the Yardbirds frenziedly destroying their equipment in the style of The Who, watched by an

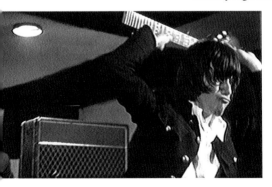

Michelangelo Antonioni
Blow-Up, 1966

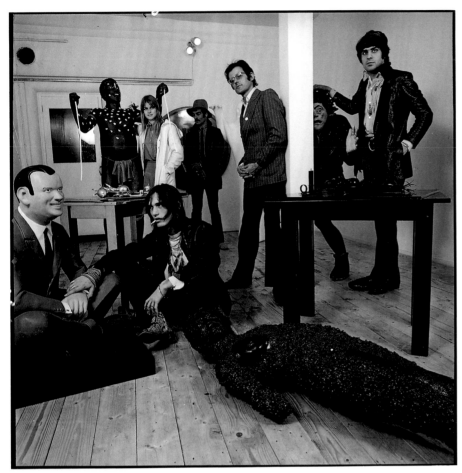

David Bailey
Robert Fraser and Friends, 1968

impassive crowd whose members are energized only by the violent outburst. Among them is Thomas, who leaves the club clutching the neck of a broken guitar — like the propeller, another example of gyrating activity reduced to stasis. On a more documentary level, the appearance of the group emphasizes the importance of rock music in shaping the London scene. Former art-school students such as John Lennon, Keith Richards, Pete Townshend, and Eric Clapton were particularly important.[31] As rock stars, they became key players in the export of Swinging London to the United States, and in the process contributed to the great expansion of stardom beyond the limits of Hollywood. Their training as artists, unparalleled among their American equivalents, paved the way for an unprecedented fusion of art and popular culture. Townshend, who credited The Who's on-stage equipment smashing to the influence of an art-school lecture by the "auto-destructive" artist Gustav Metzger, announced that The Who "stand for pop art clothes, pop art music and pop art behavior . . . we live pop art."[32]

The key figure in the connection between the London art world and the new stars of the pop, film, and fashion worlds was the art dealer Robert Fraser. When Antonioni arrived in London to shoot *Blow-Up*, he announced that the film was to be "everything Robert Fraser, and more."[33] It was Fraser who arranged for Peter Blake and Jann Haworth to design the cover of the Beatles' *Sgt. Pepper's Lonely Hearts' Club Band* (1967), and for Hamilton to design their "White Album" (1968).[34] Fraser was also the main conduit for new American art into London, especially American Pop. He showed Robert Rauschenberg, Jim Dine, Bruce Conner, Claes Oldenburg, Andy Warhol, and Edward Ruscha alongside English Pop artists such as Blake, Hamilton, Paolozzi, and Derek Boshier.[35]

The 1967 diaries of the older society and fashion photographer Cecil Beaton give the flavor of Fraser's milieu. In Marrakesh, Beaton, "came down to dinner very late, and, to my surprise, sitting in the hotel lobby,

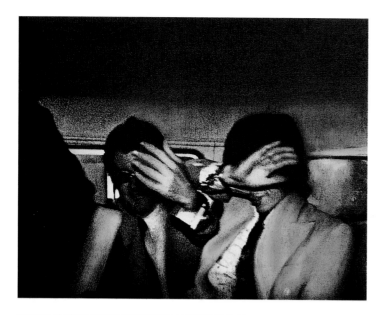

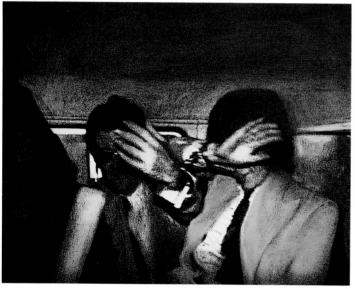

Richard Hamilton
Swingeing London 67 (a), 1968–69
Collection of Rita Donagh, London

Richard Hamilton
Swingeing London 67 (b), 1968–69
Tate Gallery, London

discovered Mick Jagger and a sleepy-looking band of gipsies. Robert Fraser, one of their company, wearing a huge, black felt hat and a bright emerald brocade coat, was coughing by the swimming pool. He ... invited me to join them all for a drink."[36] And later that year, at a dinner party in London, "On arrival I found Jane Ormsby-Gore, with her baby, Saffron, lying in a shopping basket.... In spite of the impediment in his speech, the most articulate person there was Robert Fraser. He has the usual pallor, the five-o'clock shadow, the tie badly in need of a pull up, and hair.... [He] extolled the virtues of Andy Warhol's *Chelsea Girls* film. Wouldn't I like to come and see it? He had it at home."[37] Hamilton recalls of Fraser that, "The feeling I got was that he was interested in 'fame' rather than 'cinema.' It was the glamour of 'movies' he loved. I was introduced to Kenneth Anger, Dennis Hopper and Stacy Keach by him."[38]

In February of 1967, Fraser and Jagger were arrested for drug possession during a police raid on a party at Keith Richards's house. Both were sentenced to prison, with the judge commenting that "There are times when a swingeing sentence can act as a deterrent." Jagger's sentence was commuted on appeal, but Fraser did go to prison. The sensational case produced an immediate response from Hamilton. In his words, he "felt a strong personal indignation at the insanity of legal institutions which could jail anyone for the offence of self-abuse with drugs."[39] While Hamilton participated with other artists from the gallery in organizing its reopening, he also began work on a series of paintings, all entitled *Swingeing London 67* (1968–69). The source image for the paintings was a paparazzo photograph of the kind that MacInnes's narrator in *Absolute Beginners* always hoped to catch with his Rolleiflex. Published in the *Daily Mail*, the photograph, by John Twine, showed Fraser and Jagger in a police van as they were being taken to court.[40] The two men are trying to cover their faces with their hands, which are handcuffed. The literal handcuffing together of the old-Etonian art dealer and the scruffy pop idol was echoed in Hamilton's appropriation for "high" art of a newspaper scandal photograph. His choice as the basis for this major work was not simply a photograph, but an apparently ephemeral,

grainy, uncomposed photograph, shot on the spur of the moment for purely commercial reasons. This "high/low" combination is reiterated in Hamilton's use of both traditional painting techniques and photographic screenprinting one over the other.

Where *Today's Homes* had seized on the freshness and excitement of American popular culture at a time when such qualities in mass culture were still anathema to serious American art, *Swingeing London* was painted when the London scene no longer seemed so fresh, and at a point when assassinations, the escalating war in Vietnam, and the bitterly contested struggle for civil rights had fatally damaged the credibility of the United States as a progressive model. At the same time, it became evident that American artists had caught up with their own mass culture. When Hamilton had visited the United States for the first time in 1963 for the Marcel Duchamp exhibition at the Pasadena Art Museum, he had met Oldenburg and Warhol and saw their work at first hand. Pop art, he discovered, had become "a band wagon which had overrun me."[41] Warhol, in particular, had made works such as *White Burning Car I* in 1963, part of a series using newspaper photographs as the source which showed disturbing rather than affirmative images and which combined silkscreening and painting.

Swingeing London may be read as an elegy for the sixties London scene as it drew to a close. Hamilton had always been an enthusiast of the future. As early as 1955, he had organized the exhibition, "Man, Machine and Motion," consisting of hundreds of photographs of "the mechanical conquest of time and distance." The cover of the catalogue showed a 1912 photograph by Jacques-Henri Lartigue of a speeding race car, its wheels distorted by the photographer's attempt to record it as it passed.[42] In 1961 he had optimistically announced a "philosophy of affirmation" in which the "Pop-Fine-Art standpoint ... is, like Futurism, fundamentally a statement of belief in the changing values of society. Pop-Fine-Art is a profession of approbation of mass culture."[43] But the culture of affirmation had not delivered on its promises. The champion of Pop art as progress now showed the brightest stars of art and pop in handcuffs, futilely trying to hide their faces from the glare of the

photographer's flashbulb. The movement this time is from right to left, backward out of the frame where Lartigue's race car had once rushed forward, and the distortion this time suggests decomposition rather than speed. There is an inescapable sense of slowing down, of the forward momentum which had fueled British Pop culture for ten years grinding to a halt in the courts and in jail. Visible through the left window this time is not the promise of the movie theater in *Today's Homes* but rather a brick wall. Just as in *Blow-Up*, the frenzied milieu of London in the sixties is shown in the process of congealing. The image embodied by Mick Jagger no longer seems that of an exciting new kind of star; instead we see a prisoner. The serial images imply the sequential movement of a film, but in fact we are given the same image each time, the rigidity of black screenprinting imposed on Hamilton's experimental variations of color, medium, and technique. The almost despairing sense of fatigue that pervades Antonioni's film is unmistakably present here too, in the evaporation of the Futurist rhetoric of unlimited forward movement.

★ ★ ★

I'd have the immediacy of a bad movie,

not just a sleeper, but also the big,

overproduced first-run kind. I want to be

at least as alive as the vulgar.

—Frank O'Hara, 1955[44]

The cross-pollination of art and music, film and fashion, which propelled the new pop culture of London did not take place with the same ease in the United States. In part just because American popular culture was so pervasive throughout the world, claims for American art in the 1950s were self-consciously elevated. Its rise to world stature had been marked by a careful resistance to mass culture, Pollock's famous appearance in *Life* magazine notwithstanding. The work's claim to significance, in fact, was based in large part on an explicit rejection of any such

connection. The key figure in maintaining this position was Clement Greenberg. As early as 1939, he had warned against the threat to high art leveled by kitsch: "popular, commercial art and literature with their chromotypes, magazine covers, illustrations, ads, slick and pulp fiction, comics, Tin Pan Alley music, tap dancing, Hollywood movies, etc., etc."[45] Greenberg was aware that such products of mass culture had the capacity to engage the attention of artists whose focus, he was convinced, should be elsewhere:

> Now and then [kitsch] produces something of merit, something that has an authentic folk flavor; and these accidental and isolated instances have fooled people who should know better.... Ambitious writers and artists will modify their work under the pressure of kitsch, if they do not succumb to it entirely.... The net result is always to the detriment of true culture, in any case.[46]

Faced with the threat posed by the power of kitsch, Greenberg stressed that it was essential for art to maintain its autonomy and purity, to protect itself from the taint of mass culture. By the mid-1950s he had built his reductive point of view into a powerful critical position, which he restated with authority in his "Modernist Painting" of 1960: "The essence of Modernism lies, as I see it, in the use of characteristic methods of a discipline to criticize the discipline itself, not in order to subvert it but in order to entrench it more firmly in its area of competence."[47] This position held an unparalleled dominance in the New York art world, which was at the same time supplanting Paris as the capital of contemporary art.[48] Artists who strayed from its inward-looking tenets were condemned to minor status. Stuart Davis, for example, whose work engaged with the iconography of mass culture, "remained a provincial artist."[49]

But the world of American "high" art, like Hollywood, was experiencing a crisis of collapsing aura. The triumph of the New York School was barely complete when its authority — based on the auratic power of the autonomous work of art — was assaulted by a sudden and apparently uncontrollable eruption of trash and kitsch. The noisy breakthrough of

Pop art in 1962 did not just threaten the preeminence of New York School painting; it did so in the most frightening ways: that is, by calling into question art's essential seriousness, and by flirting, at least, with the idea of mechanical reproduction as integral to the work itself. Bad enough that representational content itself was returning so soon after it had been declared dead, but the content in question was shamelessly drawn from the most despised elements in all of visual culture: advertising, comic books, trashy movie magazines ("all the great modern things that the Abstract Expressionists tried so hard not to notice at all," as Warhol put it[50]). All of these forms were dependent on mass reproduction. The sanctity — the aura itself — of the great individual painting was being challenged. Even if the idea of the aura was in fact being extended into the realm of mass culture rather than challenged altogether, that in itself remained unacceptable. Roy Lichtenstein's early Pop works were a conscious attempt to make "despicable" paintings that would push the limits of art-world tolerance. "The one thing everyone hated was commercial art."[51] And indeed many did hate the new painting. Max Kozloff, for example, announced that "the art galleries are being invaded by the pin-headed and contemptible style of gum-chewers, bobby soxers, and, worse, delinquents."[52]

It proved impossible to keep art insulated from mass culture. The poet and curator Frank O'Hara, who organized important one-man exhibitions of Robert Motherwell and Franz Kline at The Museum of Modern Art in New York, who was a champion also of the second generation of Abstract Expressionist painters, and who called the first manifestations of American Pop art "boring and crappy,"[53] had already in his own poetry plunged into the very material that the Abstract Expressionists, with the partial exception of Willem de Kooning, were determined to keep at arm's length. But O'Hara was not simply a poet of everyday life, a tendency which could, after all, have been absorbed into a bohemian tradition going back at least as far as Baudelaire's "The Painter of Modern Life." He was also strongly attracted to the glamour of the movies and their stars:

Hiroshi Sugimoto
Valentino, 1994
Sonnabend Gallery, New York, and
Angles Gallery, Santa Monica, California

In times of crisis we must all decide again and again whom we love.
And give credit where it's due: ...
not to the American Legion, which hates everybody, but to you,
glorious Silver Screen, tragic Technicolor, amorous Cinemascope,
stretching Vistavision and startling Stereophonic Sound, with all
your heavenly dimensions and reverberations and iconoclasms! ...

Long may you illumine space with your marvellous appearances, delays
and enunciations, and may the money of the world glitteringly cover you
as you rest after a long day under the klieg lights with your faces
in packs for our edification, the way the clouds come often at night
but the heavens operate on the star system. It is a divine precedent
you perpetuate! Roll on, reels of celluloid, as the great earth rolls on![54]

O'Hara's gushing enthusiasm for the Hollywood cinema, especially for its stars (most of this poem, "To the Film Industry in Crisis" (1955) is an epic list of the stars he worships: "Rudolph Valentino of the moon, its crushing passions, and moonlike, too, the gentle Norma Shearer,"), marks his poetry as a precursor of the Pop art he was so reluctant to embrace when it made its appearance a few years later.

On September 30, 1955, twenty-four-year-old James Dean died in the crash of his speeding Porsche. O'Hara poured out a series of anguished poems in his memory:

For a young actor I am begging
peace, gods. Alone
in the empty streets of New York
I am its dirty feet and head
and he is dead.[55]

These poems represent the decisive entry of the Hollywood star into the image repertoire of American "high" culture, though still, of course, in the realm of literature rather than art (Joseph Cornell's idiosyncratic homages being an isolated exception). In the late fifties, however, Ray

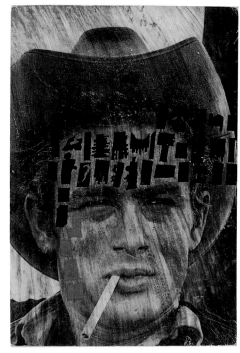

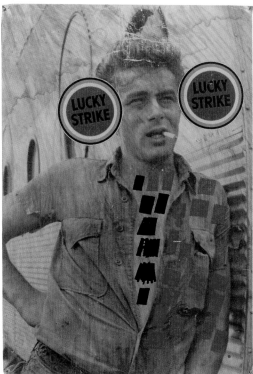

Ray Johnson

James Dean, 1958
Collection of Mr. and Mrs.
Henry Martin, Bolzano, Italy

James Dean (Lucky Strike), 1957
Richard L. Feigen & Co.,
New York and Chicago

Marilyn Monroe, 1958
Richard L. Feigen & Co.,
New York and Chicago

Elvis Presley No. 1, 1956–57
Collection of William S. Wilson,
New York

Johnson began making his collages devoted to Dean, as well as to Elvis Presley and Marilyn Monroe. Andy Warhol, still unknown outside the world of commercial illustration, made a drawing of Dean shortly after the star's death in which he is depicted with a form of crucifix on his neck and with the emblem of his martyrdom — the Porsche — displayed alongside the upturned head. While the pose itself is recreated in the thrown-back head of John Giorno in *Sleep* (1963), and can also be seen in many of Warhol's early drawings of young men asleep, this drawing can also be seen as an early precursor to the series of car crash works Warhol made in 1962 and 1963, images that bear a striking resemblance to newspaper photographs of Dean's fatal wreck. It was to be Warhol, emerging from the credibility wasteland of commercial art, who would decisively re-write art's relationship to the star.

Andy Warhol
Untitled (*James Dean*), c. 1995
The Andy Warhol Foundation for the Visual Arts, Inc.

<div align="center">★ ★ ★</div>

The Hollywood we were driving to that fall of '63 was in limbo. The Old
Hollywood was finished and the New Hollywood hadn't started yet. . . .
But this made Hollywood *more* exciting to me, the idea that it was so vacant.
Vacant, vacuous Hollywood was everything I ever wanted to mold my life into.
— Andy Warhol, 1980[56]

Whatever you may think of *My Hustler*, it has had *exposure*.
— Paul America, 1967[57]

In 1958 Andy Warhol, the successful commercial artist,[58] met Emile de Antonio through Tina Fredericks, art director at *Glamour* magazine.[59] De Antonio is remembered today primarily for his films, but in the late fifties he worked as an agent. "He connected artists with everything from neighborhood movie houses to department stores and large corporations."[60] Warhol credited de Antonio not only with inspiring him to make films, but with convincing him that he could be a "serious" artist and, more importantly, that the distinction itself was irrelevant. "De was the first person I know of to see commercial art as real art and real art as

James Dean's Car

commercial art."[61] This position has much in common with the concept of a continuum promoted by Alloway and others in England at the same period, and was highly unorthodox in New York art discourse. De Antonio, of course, could speak from a position somewhat outside of that discourse. His movement between the worlds of advertising, fashion, film, and art validated Warhol's sense that he could find a new way to operate. "There was nothing wrong with being a commercial artist.... Other people could change their attitudes, but not me — I knew I was right."[62]

Although he is conventionally thought of as a quintessentially American figure, and certainly presented himself as such,[63] Warhol's unabashed fascination with commercial culture has, in some ways, more in common with the contemporary genre-crossing, market-conscious, working-class English pop figures than with the more strictly art-oriented figures of his generation and earlier in New York, from many of whom Warhol felt alienated in any case. Warhol's enthusiasm for pop music, for example, was considered unusual in New York, although it would have been taken for granted in London. When Ivan Karp, then working for the Leo Castelli Gallery, first visited Warhol's studio in 1961, he was surprised to have his entire visit accompanied by rock-and-roll: "There was a record playing on the record player at an incredible volume! ... And during the entire time that I was there, he did not take off the record, and it played over and over again."[64] Walter Hopps had a similar experience:

> What really made an impression was that the floor — I may exaggerate a little — was not a foot deep, but certainly covered wall to wall with every sort of pulp movie magazine, fan magazine, and trade sheet, having to do with popular stars from the movies or rock 'n' roll. Warhol wallowed in it. Pulp just littering the place edge to edge. As we walked in, the popular music of the time was blaring from a cheap hi-fi set-up; there was a mess of cushions, blankets, and maybe a little mattress.[65]

David Bourdon has stated that pop music was part of a deliberate persona that Warhol was creating for himself, and that the records were classical when he was not working on his image as a "gum-chewing,

Andy Warhol
Triple Elvis, 1964
Virginia Museum of Fine Arts, Richmond

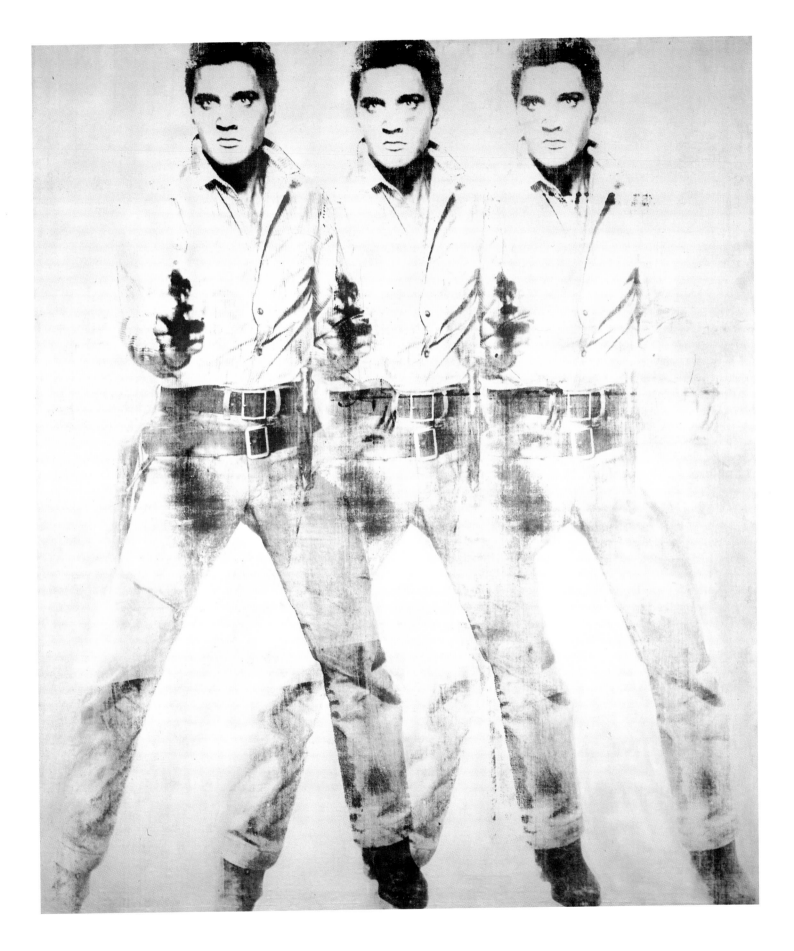

seemingly naive teenybopper, addicted to the lowest forms of pop culture."[66] But Warhol's active engagement with the emerging rock culture only grew, most notably in his sponsorship of the Velvet Underground. His album covers for *The Velvet Underground and Nico* (1966) and for the Rolling Stones's *Sticky Fingers* (1971) were as much landmarks of the genre as Hamilton's and Blake's Beatles' covers.

Warhol's social omnivorousness, along with his enthusiastic embrace of the commercial alongside the avant-garde, made it inevitable that he would connect with the emerging London scene, and in 1963 he did so. Although he was already by this time a famous artist, it is telling that the introductions came not by way of the art world but through fashion magazines. Miki Denhof, of *Glamour*, brought David Bailey to Warhol's firehouse studio on East 87th Street, where the photographer was impressed by Warhol's Elvis paintings. Bailey had first come to New York in January 1962 to photograph Jean Shrimpton. The shoot took place mostly in the streets of the city, and shows the excitement of being in Manhattan, the long-distance source of so much in the London scene. The resulting spread in *Vogue* (April 1962) juxtaposed the fashion shots, themselves loaded with advertising and street signs, with photographs of Coke bottle tops and Lucky Strike packages.

Nicky Haslam, an art director at *Vogue*, was also an important figure for Warhol: "It was from Nicky that we first started hearing about the mod fashion revolution in England that had started in '59 or '60.... He made us aware of the new men's fashions—the short Italian jackets and the pointed shoes ("winklepickers")—and of the way the cockneys now were mingling with the upper classes and things were getting all mixed in and wild and fun."[67]

Haslam introduced Warhol to "Baby" Jane Holzer, when he took him to a dinner party at her Park Avenue apartment. Also present were Bailey and Jagger, whose style Warhol admired: "Bailey all in black, and Mick in light-colored unlined suits with very tight hip trousers and striped T-shirts." And, of course, the former shoe illustrator noted that "Bailey and Mick were both wearing boots by Anello and Davide, the dance shoemaker in London."[68]

David Bailey
Double page spreads from *Vogue*,
April 1962 (pages 118–119 and 122–123)

Richard Hamilton
Fashion-plate (cosmetic study II), 1969
Private Collection

Holzer spent the summer of 1963 in London, where Bailey's photographs of her for *Vogue* made her a star. (These sessions also led indirectly to Holzer's partial appearance in Richard Hamilton's *Fashion-plate (cosmetic study II)* (1969), part of a series that continued his exploration of manipulated photographs and the creation of images in Pop culture. Hamilton used transparencies he obtained from Bailey as the basis of his collages. The visible equipment which forms a frame for these images evokes not just the fashion photographer's studio in *Blow-Up*, but also the apparatus equally visible in Warhol's early films.[69]) "'Bailey is fantastic' says Jane. 'Bailey created four girls that summer. He created Jean Shrimpton, he created me, he created Angela Howard and Susan Murray.'" Through Bailey, Holzer also saw at first hand the breakdown of rigid class divisions: "They're all young, and they're taking over, it's like a whole revolution. I mean, its *exciting*, they're all from the lower classes, East End-sort-of-thing."[70]

Given Warhol's array of potentially marginalizing identities — a gay man; a commercial artist; working-class origins; provincial; painfully self-conscious about his appearance — the heterogeneous, antihierarchical, nonjudgmental aspects of the freewheeling London version of Pop culture must have seemed infinitely more appealing than the dour seriousness with which the New York art world had come to see itself by the early 1960s. David Hockney, also a gay man from a working-class background, whom Warhol had met in New York in 1963, had early on developed a deadpan style with interviewers that had much in common with the approach Warhol made into one of his trademarks. As Peter Wollen has suggested, the role played by Bailey offered another direct potential model for Warhol.[71] Here was a tremendously powerful and glamorous figure who nevertheless exercised his power *behind* the scenes, *behind* the camera — a position which fitted Warhol's distanced, voyeuristic, sensibility perfectly. Bailey too was working-class and operated in a commercial arena which had limited artistic credibility, yet he was able, as Jane Holzer pointed out, to *create* new stars, four in one summer. Like Bailey, Warhol was deeply interested in "the haircutter and hatmaker, the craftsmen and middlemen" of image creation. In 1963, Warhol recalled,

Andy Warhol
Thirteen Most Wanted Men, 1964
© The Andy Warhol Foundation for the Visual Arts, Inc.

"I sat at Le Club one night staring at Jackie Kennedy, who was there in a black chiffon dress down to the floor, with her hair done by Kenneth — thinking how great it was that hairdressers were now going to dinners at the White House."[72] In 1964, his *Thirteen Most Wanted Men* mural at the World's Fair would cause something of the same scandal as Bailey's glamorization of the Kray brothers.[73] Warhol's *Interview* magazine (begun in 1969) would later come to epitomize the culture of heterogenous celebrity.

From his initial devotion as a sickly child to Shirley Temple, Warhol had been a dedicated, even obsessive, fan. Unlike other Pop artists, such as Claes Oldenburg or Jim Dine, whose interest was in the pleasures and politics of the everyday, Warhol was, from the first, explicitly an enthusiast of movies and celebrity. Under the influence of de Antonio his interest in film broadened, and he became a regular at the screenings held by Jonas Mekas at the Film-Makers' Coop.[74] In 1963 he bought his first movie camera, a 16mm Bolex, and rapidly became an important filmmaker as well as a major painter. In a significant departure from what might be called the mainstream of the underground cinema, which defined itself as a director-oriented opposition to everything that Hollywood represented, Warhol created instead his own version of a major studio, adopting from the outset the taboo role of producer.

The context in which Warhol took on that role was that of the *auteur*. The development in the *Cahiers du Cinéma* of the auteur theory had been made widely available in the United States with the publication of Andrew Sarris's "Notes on the *Auteur* Theory in 1962" in *Film Culture*. The development and popularity of auteur theory was itself a marker of the continuing decline of the power and prestige of the Hollywood studios, as well as of the retrospective reinterpretation of Hollywood history from the director's point of view. As Sarris himself acknowledged, "Just a few years ago I would have thought it unthinkable to speak in the same breath of a 'commercial' director like Hitchcock and a 'pure' director like Bresson."[75]

It was in the context of this ongoing rewriting of the importance of the director in the Hollywood cinema that

Dennis Hopper
The Factory (Andy with Camera), 1963
Collection of the artist, Los Angeles

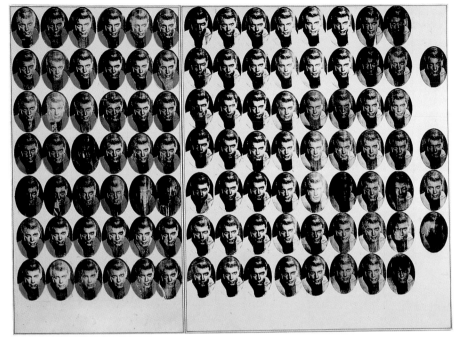

Andy Warhol
Troy Diptych, 1962
Museum of Contemporary Art, Chicago

Warhol declared himself a producer.[76] As a successful artist, Warhol was on one level the quintessential auteur, but in his refusal of overt directorial responsibility and his enthusiastic assumption of the denigrated role of producer, he rewrote the "independent," or "underground" cinema in his own terms. Those terms were based on an unapologetic engagement with Hollywood both as the (already) nostalgic source of the great stars and as a successful commercial enterprise. Even the name "The Factory" emphasizes production rather than art, and may perhaps be linked to Hortense Powdermaker's bestseller *Hollywood the Dream Factory* (1950), an exposé of the mechanics of the studio system. On Warhol's first trip to Hollywood in 1963, Dennis Hopper threw a party that thrilled Warhol with an array of second-tier movie stars: "Dean Stockwell, John Saxon, Robert Walker, Jr., Russ Tamblyn, Sal Mineo, Troy Donahue, and Suzanne Pleshette — everybody in Hollywood I'd wanted to meet was there.... This party was the most exciting thing that had ever happened to me. I only wished I'd brought my Bolex along."[77]

Before Warhol the filmmaker had color, before he had sound, before he had camera movement, before he had anything resembling a script, Warhol had stars. One of the first was Bailey's former model Baby Jane Holzer, who appeared in the "serial," *Kiss* (1963), and then in *Batman Dracula*, *Couch*, *The Thirteen Most Beautiful Women*, and *Soap Opera* (all 1964). For Warhol, his stars became the embodiment both of mainstream glamour as defined by Hollywood and of a critique of that hegemonic system. His choice of potential stars included not just a conventionally beautiful socialite such as Holzer but also, and increasingly, a much more marginal group dominated by transvestites and other self-conscious and performance-oriented outsiders. Their determined assertion of their unique identities within the Warhol version of a studio system lent an ongoing edge to Factory productions. Amateurish acting and knowing acknowledgment of the camera were endemic in the New American Cinema championed by Mekas, but in the films of, say, the

Kuchar brothers, the effect produced is that of an almost cozy version of domestic theatrics. In Warhol's movies, the focus on Hollywood and the self-evident seriousness of many of the performers force disturbing questions on the viewer. Exactly why should these people not be considered stars? They are on screen after all, and they have been chosen by a producer who has declared them to be not just stars but superstars. One of Warhol's most subversive acts was his simple claim to the right of participation in the heart of American popular culture, a claim he made on behalf of himself and, indirectly, on behalf of the beautiful rejects he declared worthy of the same attention he had lavished in his paintings on Elizabeth Taylor and Elvis Presley.

Warhol's Factory was soon making two "features" a month, and, as Stephen Koch has written, "The idea was always to evoke the presence and responses of the superstars. Just as in the balmy Hollywood of old, the screenplays were invariably envisioned as "vehicles" for this or that Factory celebrity. They were never indulged as works of interest in their own right, just as many a major film was written strictly as a pretext to get Joan Crawford back into those wedgies and crying."[78]

And Warhol's project was succeeding. Ronald Tavel, his screenwriter on many of the early films, described the results:

> Audiences now applaud the stars' first second on the screen, their names on the credits. Stars pull star-bits; they come shrieking off the set refusing to carry on when the shooting disturbs them; they become choosey about scripts; they scour movie rags for mentions of their names; they sue publications that use unflattering photos of them. With every passing month, it becomes more difficult to take them seriously — and more and more difficult to deny their existences.[79]

Tavel found that his "scenarios" worked best when they were set up as "groundwork through which the actors would reveal themselves," and to that end he developed the practice of extensive interviews with the stars before writing anything.[80] In the end, whatever his intentions, Tavel's psychological attempts to get the actors to "reveal themselves"

reinforce their status as stars, since simply being themselves is, after all, just what stars are supposed to do. As Paul America put it, offering his highest praise, "James Dean was the *realest* — most *real* — personality I've ever seen. He was . . . James Dean."[81]

In *Sleep* (1963), his first major film, Warhol presented a five-hour series of silent close-ups, roaming over the face and body of the sleeping John Giorno. In the midst of the hyperactive, amphetamine-driven scene that surrounded him, Warhol sought out stasis.[82] Denying even the hint of narrative that might be implicit in scenes of a man sleeping through the night, the film repeats sequences up to twenty times, destroying any conventional sense of structure, or even sequence. Koch has described the effect of this on the audience:

> Its time is utterly dissociated from that of the audience: The Image glows up there, stately and independent. . . . And yet as the minutes tick on, the work seems to insist upon its hallucinated literal time as few other films ever do. Meanwhile the audience's participation in the image is never allowed to fall into the slot of that *other* temporal reality — that acceleration and deceleration of the audience's temporal sense created by narrative fantasy or conventionally edited structure, as in almost any other film one can think of.[83]

The movie actually ends with a freeze-frame, bringing time to an almost literal standstill. The film is silent, although a radio was played on the first two nights that it was shown. More important, Giorno himself, like the great stars of the twenties, is silent. Although Warhol's initial intention was to cast Brigitte Bardot in the role of the sleeper,[84] there is a presumption that whoever is sleeping will be worth watching, even if he or she does absolutely nothing. This is the essence of star quality for Warhol: "The great stars are the ones who are doing something you can watch every second, even if its just a movement inside their eye."[85] Although the use of a man's body as the object of observation clearly derives from a gay context, the film suggests more broadly that the mere presence of a declared star's body is enough to warrant an exceptionally long film. Giorno is not going to communicate anything at all to us, but

Andy Warhol
Frame sequence from *Sleep*, 1963

we may look at him stretched out before us. The audience's role is simply to look on, as fans. Warhol had a precise understanding of how the relationship between star and audience operated. "People usually just go to the movies to see only the star, to eat him up, so here at last is a chance to look only at the star for as long as you like, no matter what he does and to eat him up all you want to."[86]

But the subtext to the presentation of the unknown John Giorno as a star, rather than Brigitte Bardot, is Warhol's implicit assertion that *he* will confer stardom. While Warhol's emphasis on *choosing* as the artist's essential function puts him in the tradition of the avant-garde which runs back to Duchamp's readymades, he saw how close this role was to that of the star-making Hollywood producer, who also simply claimed the right to choose. Warhol told Tavel that his greatest goal was to "make Duchamp's questions stick."[87] Indeed his decisive entry into film in the first place, a move accompanied by repeated assertions that he had given up painting, can convincingly be read as an attempt to take Duchamp's project further, by returning the readymade to its origins in the quotidian without sacrificing its heightened aesthetic status. And Warhol did successfully move beyond the dependence on a meaningful distinction between art and non-art which characterizes the work of almost all his Pop art contemporaries. His shift into the medium of real mass culture brought with it in the process a fundamental redefinition of the aura of the work of art.

The conflation of the roles of artist and producer, unified by the act of choice, is perhaps most visible in *Empire* (1964). The Empire State Building becomes a giant readymade. As Koch unflatteringly describes it, "the camera gazes for a full eight hours of moronic unmoving rapture at New York's venerable 102-story monstrosity while the sun majestically sinks through the afternoon toward darkness in an all-too-literally breathtaking smog."[88] Warhol himself expressed the subject of this film most clearly when he said, "The Empire State Building is a star!"[89] That short sentence also makes clear Warhol's understanding of the star, which is about stasis: the icon only — no action required. Warhol's fixed camera records the presence of a fixed star.

Andy Warhol
Empire, 1964

Andy Warhol
Black and White Disaster, 1962
Los Angeles County Museum of Art

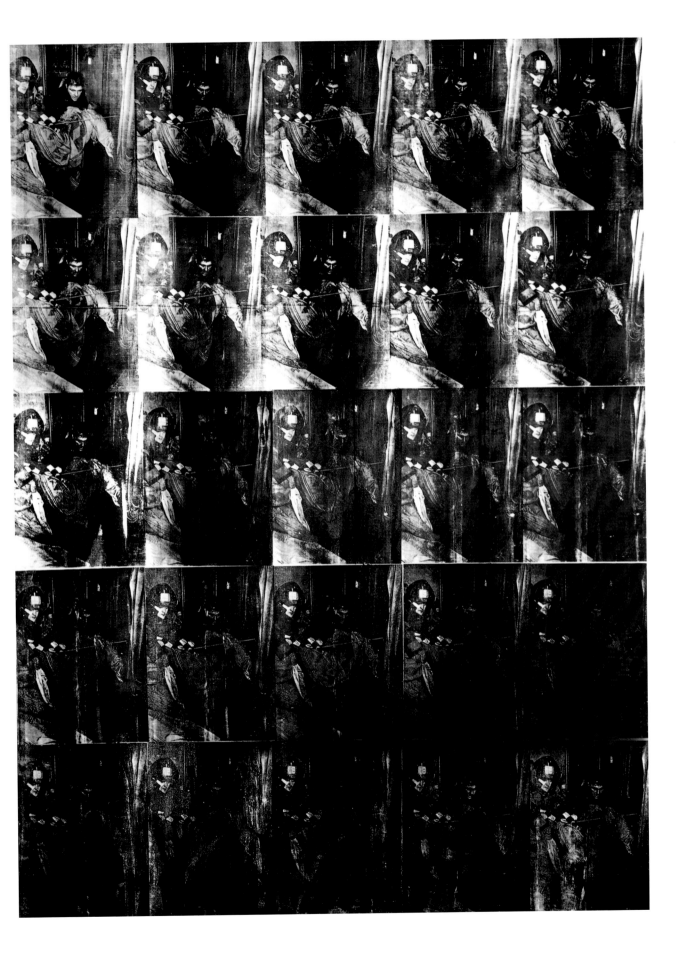

Callie Angell has pointed out that in January of 1964 plans had been announced for the building of the World Trade Center, which would take the Empire State Building's title as the tallest building in the world. It was also in 1964 that the building was floodlit for the first time, not only making nighttime filming possible, but giving the building itself a show-business quality. "Like Elvis at Las Vegas, the Empire State Building returned to public view in a dazzling new act, literally capturing the spotlight as the only floodlit skyscraper in the city skyline."[90] The threat to the building's pre-eminence posed by the World Trade Center and the theatricality of the floodlit comeback combined to give the Empire State Building something of a Norma Desmond quality. This mixture of nostalgia and imminent death was, of course, precisely the combination that Warhol was drawn to in stars. The complete immobility of the building also has the effect of making *Empire* one of the most conventionally painting-like of Warhol's films. He uses the movie camera to make a still image, just as he made it as a sound film that takes place in complete silence. Ironically, given these reversals of expectations, *Empire*, like many of Warhol's early films, is also an almost Greenbergian demonstration of the "essential" qualities of the medium of film itself. The camera is simply turned on and allowed to record what transpires in front of it.

Warhol's interest in stasis and in denial of narrative is as evident in his paintings as in his films. The repetitive grid format of works such as *Marilyn Monroe's Lips*, *Twenty-five Colored Marilyns*, or *Black and White Disaster* (all 1962) indicates not just indifference to narrative, but active resistance to it. The grid format itself is something that Warhol would have seen in the late fifties work of Jasper Johns, and which must have seemed particularly well suited to his interests. In Rosalind Krauss's terms, "The grid announces, among other things, modern art's will to silence, its hostility to literature, to narrative, to discourse."[91] Unlike Johns's work, however, the images that Warhol locked into the fixity of his grid were not determinedly neutral letters or numbers, but powerfully iconic images, often of pre-existing stars, but also of other loaded images such as car crashes or riots. Denying conventional compositional

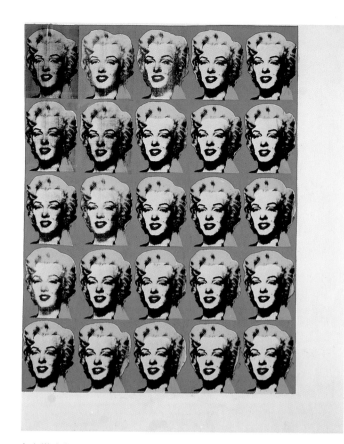

Andy Warhol
Twenty-five Colored Marilyns, 1962
Modern Art Museum of Fort Worth, Texas

dynamics, the iconic image is demonstrated to remain the same as it is repeated over and over again.

In Hollywood, as Laura Mulvey describes it, "Just as an elaborate and highly artificial, dressed-up, made-up, appearance envelops the movie star in 'surface,' so does her surface supply a glossy front for the cinema, holding the eye in fascinated distraction away from its mechanics of production."[92] Warhol was always interested in surface, in appearances. "I see everything that way, the surface of things, a kind of mental Braille, I just pass my hands over the surface of things.... If you want to know all about Andy Warhol, just look at the surface: of my paintings and films and me, and there I am."[93] In his own self-presentation, with his wig and his nose job, he sought a controlled and immutable image that offered nothing but surface to those who beheld it. But in true modernist style, he did not hide the process itself. Although his wig never came off, it was no secret either; he made paintings of the tacky nose job advertisements he must have studied as a potential client.

In Warhol's paintings, as in his films, the mechanics of production always show. There is a quintessentially modernist series of acknowledgments of the signifier qua signifier, the process of manufacture, and of the medium itself. Although the members of Warhol's circle at the time are unanimous that he was completely sincere in his desire for Hollywood success, he certainly did not want to emulate the seamless look of a studio production. If he were to go to Hollywood, it would be with his own style. Tavel recalls, for example, that during the filming of *Horse*,

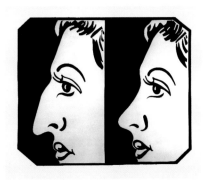

Andy Warhol
Before and After, 3, 1962
Whitney Museum of American Art, New York

> The horse stood in front of a painted Western setting that looked terribly real. That bothered Andy because he kept saying, as he looked through the camera: "I'm telling you, it looks exactly like a Hollywood Western," and he didn't like that. He kept telling me to lower the mike and the boom so we'd have that showing in the picture frame.[94]

Equally, a film's credits were often read aloud as a kind of voice-over, sometimes, as in *Vinyl* (1965), in the middle of the movie. But

for Warhol, the visibility of the apparatus is not simply modernist self-referentiality. It also marks quite specifically the process of star creation by shifting the audience's point of focus from the star as complete entity to the star in the process of emergence. Warhol takes the self-referential strategies of high modernism and recontextualizes them as part of a knowing critique of the artificiality of all identity construction. The high proportion of transvestites among Warhol's stars not only reflects his early connections with the film and performance work of Jack Smith, but also specifically heightens this sense of a highly self-conscious process of image definition.

Even as all the mechanics of construction remain visible, the goal of the process is always the successful establishment of an image. The soundtrack of *Vinyl* features the Rolling Stones's "This Could Be the Last Time," and the title sums up the movie's sense of speed-driven urgency as well as Warhol's constant feeling that time was running out, that the right images must be snatched from the present now, before it was too late. In *Kitchen* (1965), a still photographer periodically interrupts the action, and the actors often freeze to accommodate him. While on one level such interruptions serve as a kind of sub-Brechtian alienation effect, they also emphasize the passage of the stars into the record of history as fixed images rather than as actors engaged with developing characters. The plot of the movie, such as it is, is entirely subordinate to that concern.

In 1969, John Schlesinger's *Midnight Cowboy* achieved great commercial success and went on to win Oscars for Best Picture, Best Director, and Best Screenplay. Its stars, Dustin Hoffman and Jon Voight, were also nominated for Oscars. For Warhol, the key thing about *Midnight Cowboy* was that, in his view, the film was little more than an expanded remake of his own film, *My Hustler* (1965), starring superstar Paul America. The connection was tacitly acknowledged by the inclusion in the later film of a long passage featuring Viva as a Warholesque filmmaker. Schlesinger's film, unlike any of Warhol's, has a strong narrative and highly professional actors.[95] Warhol, however, had long been convinced that such factors were unimportant. The release of *The Chelsea Girls* in 1966 had suggested that Warhol might actually succeed

Andy Warhol
Vinyl, 1965

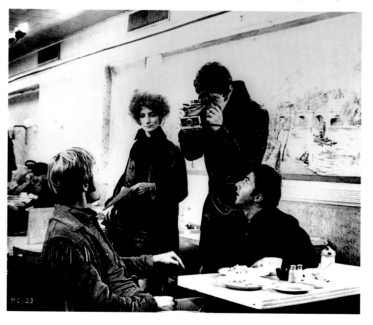

John Schlesinger
Midnight Cowboy, 1969

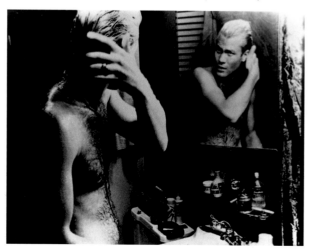

Andy Warhol
My Hustler, 1965

in making commercially viable films. Despite its deliberately sloppy technique and the almost complete absence of professional acting, the film was shown nationally, and people lined up at movie theaters to see it.

The key element that Warhol chose not to take from Hollywood was its insistence on a strong narrative. Narrative is replaced by an almost complete stasis (as in *Sleep* or in the early "portraits") or by a strict seriality (as in the multiple episodes of *Kiss*, which actually was shown as a weekly serial at the Film-Makers Coop). Warhol was quite explicit that, even on those occasions when he had a script, what he wanted from it was "not plot, but incident."[96] The resolute slowing down, even to cessation, of narrative in Warhol's films is driven by his desire, evident also in the paintings, to create images with auratic power, and to make such images out of his own culture, a culture of mass reproduction in which the quality of being unique was no longer central to the power of the image. With the auratic claims of New York School painting already cracked and vulnerable, made so in part by Warhol's own early paintings, and with the golden age of the Hollywood movie star experiencing its own crisis as the great studios crumbled, Warhol was able to put his versions of star and aura into the spaces opening up within and between these previously separate systems of image-making.

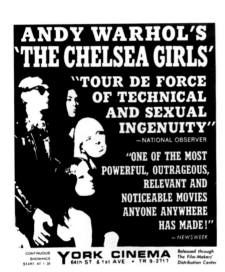

Poster for Andy Warhol,
The Chelsea Girls (1966)
The Andy Warhol Museum, Archives Study Center,
Pittsburgh

<div align="center">★　　　★　　　★</div>

The painting invites the spectator to contemplation; before it the spectator can abandon himself to his associations. Before the movie frame he cannot do so. No sooner has his eye grasped a scene than it is already changed. It cannot be arrested.
— Walter Benjamin, 1936[97]

For Walter Benjamin, a residual element of cult ritual was associated with "authentic" works of art. He recognized that an audience's devotion to a movie star could have some elements that tend towards the ritual, but argued that "The audience's identification with the actor is really an identification with the camera. Consequently the audience takes the position of the camera; its approach is that of testing. This is not the

Andy Warhol
Poor Little Rich Girl, 1965

approach to which cult values may be exposed."[98] In Benjamin's analysis, the apparatus of the cinema serves to bring everything close, for examination, while at the same time the authority of the object is compromised through reproduction. A certain distance remains essential for authority.

> The definition of the aura as a "unique phenomenon of a distance however close it may be" represents nothing but the formulation of the cult value of the work of art in categories of space and time perception. Distance is the opposite of closeness. The essentially distant object is the unapproachable one. Unapproachability is indeed a major quality of the cult image. True to its nature, it remains "distant, however close it may be."[99]

Benjamin associated film with super-objectivity (with "testing"), although it simultaneously "makes the cult value recede into the background not only by putting the public in the position of the critic, but also by the fact that at the movies this position requires no attention. The public is an examiner, but an absent-minded one."[100] This combination of testing and passivity is inimical to auratic experience.

Benjamin's position was challenged as early as 1936 by Theodor Adorno, who wrote to Benjamin that "the autonomy of the work of art, and therefore its material form, is not identical with the magical element in it.... if anything does have an aural character, it is surely the film which possesses it to an extreme and highly suspect degree."[101] It is this suspect aura that Warhol seeks out in his early films. They invite the viewer to contemplation, to abandonment. They reject the assumption that a film will, by its very nature, give off an unending series of new visual images. *Sleep* and *Empire* offer almost completely static images that challenge the audience to enter into a relationship with them undetermined by any sequence of events unfolding on the screen. The long, stationary takes favored by the early Warhol minimize the sequential aspect of film that works against contemplation.

In addition, the star image works against testing, since the star is to be scrutinized but not analyzed. In Warhol's *Poor Little Rich Girl* (1965),

Andy Warhol
Poor Little Rich Girl, 1965

for example, the camera simply stares at the film's star, Edie Sedgwick, as she hangs out aimlessly in her apartment. The fact that the entire first half of the film is profoundly out of focus and proceeds in almost complete silence takes the distancing of the audience from the star to an extreme. The very intangibility of the star, in contrast to the physical presence of the stage actor, can contribute to the creation of an aura comparable to that of an "authentic" object. For Benjamin, however, it is in fact the inherent inferiority of film that leads to the creation of stars. "The film responds to the shriveling of the aura with an artificial build-up of the 'personality' outside the studio. The cult of the movie star, fostered by the money of the film industry, preserves not the unique aura of the person but the 'spell of the personality,' the phony spell of a commodity."[102]

But to whom is the spell "phony"? Perhaps the mediated experience can also be authentic. For Benjamin, "the camera records our likeness without returning our gaze," while, in contrast, "To perceive the aura of an object we look at means to invest it with the ability to look at us in return."[103] But the essence of this relationship is the act of investment. Unless one believes that the auratic object really does return the gaze of its observer, the weight of the experience rests with the viewer. Or, as Warhol put it, "I think 'aura' is something that only somebody else can see, and they only see as much of it as they want to. It's all in the other person's eyes."[104]

★　　★　　★

At the end of my time, when I die, I don't want to leave any leftovers. And I don't want to be a leftover.
— Andy Warhol, 1975[105]

The powerful conservatism which runs as a counterpoint beneath Warhol's innumerable radical innovations marks his work, in the end, as quite different from the relatively uncomplicated positivism and belief in progress of early British Pop art. In Warhol's work, one senses the artist

constantly looking back over his shoulder, anxious to stay ahead, but at the same time unable to suppress a longing for the past that is constantly slipping away behind him. His engagement with celebrity calls for constant novelty, but at the same time the images which attract him most are those of dead stars, stars whose death has conferred on them the possibility of passing into history with their image perfectly and completely formed, of contesting time by becoming part of a timeless canon.

In all Warhol's countless paintings of Marilyn Monroe the image is the same. This relentless repetition makes it clear how little interest he had in development and change, and how much in the iconic and the static. Compare Warhol's use of the image, for example, with Hamilton's treatment of Monroe in *My Marilyn* (1965), for which the readymade starting point was a proof sheet covered in aggressive markings by Monroe herself. The star is presented here as engaged in a violent struggle for control over her own image, even within the very limited frame of the pin-up photograph. This tension is emphasized in Hamilton's work by an ambiguity between painted mark and found photograph, the former in this case being just as readymade as the latter. To read *My Marilyn* the viewer must also participate in a process of moving around the work, evaluating and cross-referencing the similar but different images of the star. Hamilton, like Warhol, is interested in the process of image control, but his concern is precisely with its mutability, whereas Warhol's interest — his obsession — is in where the process leads, in the final, iconic, image. While his own manipulations of that image can take many forms, and reveal his own processes, the image itself remains at some level inviolate, even sacrosanct. Warhol's most vulgar distortions of color, his crudest and most degraded versions of the image, attain their shocking quality only if both the artist and his audience retain some committment to the inherent power of the image itself. For blasphemy to matter there must be believers.

Warhol was fascinated by death, and by the death of stars in particular. He told Gene Swenson in 1963 that he had begun painting Elizabeth Taylor only "when she was so sick and everybody said she was going to die."[106] His first paintings of Monroe were produced immediately following her death. As Mulvey has written about the *Marilyn Diptych* of 1962,

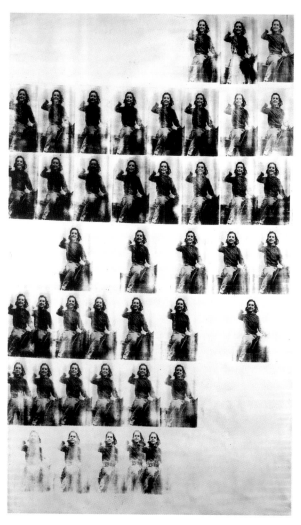

Andy Warhol
National Velvet, 1963
San Francisco Museum of Modern Art

184

Richard Hamilton
My Marilyn, 1965
Ludwig Collection, Ludwig Forum for
International Art, Aachen, Germany

The masquerade is fragile and vulnerable, and the surface starts to crack as the printing process slips and her features distort and decay. The other side of the feminine masquerade seeps through into visibility. In this work, Warhol brings together the mark of the print, the signifier, the subject of modernist discovery and unveiling, with the topography of feminine surface and its underside, which suggests death and decay.[107]

While Warhol on one hand exults in the unveiling of the artificiality of the star, the apparatus of production, and the inevitable decay of glamour, at the same time he continues, like von Stroheim in *Sunset Boulevard*, to worship what once was there. His paintings are suffused with a pre-emptive nostalgia for things that are slipping away, or that came to a sudden and unexpected end. Like Roland Barthes, Warhol understood the death implicit in each photograph from which he worked. "Whether or not the subject is already dead, every photograph is this catastrophe."[108] In *Blow-Up*, Antonioni's photographer-hero is reaching for his camera as he fades away completely in the last scene of the film. Warhol's compulsion was to try to hold his subjects' images fixed in place, even if everything else was about to disappear.

The victim in *White Burning Car I* is literally pinned in place, thrown from his car and impaled on a utility pole.[109] Of the unknown victims shown in such paintings, Warhol said, "I thought that people should think of them sometime.... It's not that I feel sorry for them, it's just that people go by and it doesn't matter to them."[110] And in this image there is indeed a figure walking away. But if the image can be fixed once and for all, then perhaps it will not slip into the flux of the forgotten, as the memory of Norma Desmond is slipping away in *Sunset Boulevard*. As Gilles Deleuze has put it, we, the viewers, are led "from the sad repetitions of habit to the profound repetitions of memory, and then to the ultimate repetitions of death in which our freedom is played out."[111] For Barthes, reiterating all of these repetitions as he looked at a photograph of his parents, it was the anticipated disappearance of the memory of their love that affected him:

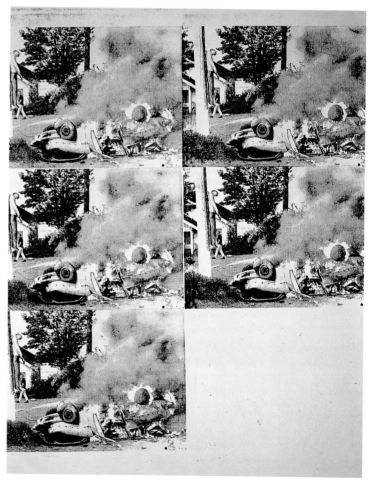

Andy Warhol
White Burning Car I, 1963
The Andy Warhol Foundation for the Visual Arts, Inc.

What is it that will be done away with, along with this photograph which yellows, fades, and will someday be thrown out, if not by me — too superstitious for that — at least when I die?... I realize: it is love-as-treasure which is going to disappear forever; for once I am gone, no one will any longer be able to testify to this: nothing will remain but an indifferent Nature.[112]

For Warhol, himself indifferent, it is only the image itself that might be saved, and it is here that he claims for himself the right to intervene. As artist/producer, he can give a degree of immortality even to an unknown accident victim. "I thought that people should think of them sometime." His attitude to his stars reflects precisely the same sad attraction to people who were about to slip beneath the horizon of visibility. "The people I loved were ... the leftovers of showbusiness, turned down at auditions all over town."[113] Warhol's response was to attempt to fix these "leftovers" at the moment before their moment passed, to save their image, not their souls. His desire to save was limited to a specific image in a moment of specific time, just as his compulsive collecting and hoarding, his "time capsules," were equally devoted to the attempt to bring time to a momentary halt.

But of course, time did not stop, and his stars did often drift on irrevocably over the edge. It was their closeness to going over that had attracted Warhol to them in the first place. When Freddy Herko killed himself by "dancing" out of a window, Warhol's first response was that he wished he could have been there to film it. As Tavel sums up his own response, "I've never heard anyone react to a suicide like that — 'What a shame we didn't have the camera down there and film it.' You cannot like someone who said that, but I don't know if you can hate him either. It's beyond love and hate."[114] It is about stopping time at the perfect point, with the perfect image, while at the same time knowing that the quest is impossible. Everything else is secondary. Or, as Warhol himself put it, "History will remember each person only for their beautiful moments on film — the rest is off the record."[115]

Stanley Kubrick
2001: A Space Odyssey, 1968

The "Other" Cinema:
American Avant-Garde Film of the 1960s

Bruce Jenkins

Here are some memorable moments from the cinema of the 1960s: Jeanne Moreau wanders through a working class neighborhood in Milan; Delphine Seyrig, dressed in Chanel, walks the pristine garden paths of a stately resort; a lateral tracking shot scans an interminable line of traffic along a rural French highway; two bikers encounter New Orleans through an hallucinogenic haze; the faces of Liv Ullmann and Bibi Andersson merge into a single, haunting composite image; a bone tossed skyward by a prehistoric man is transformed into a spacecraft.

Here are some others: a transvestite in a white gown and blonde wig arises from a coffin, clutching a stem of lilies; a series of static shots, eight hours in length, records the upper portion of the Empire State Building; fragments of insect wings, leaves, grass, and twigs cascade across the screen; a brief newsreel image of a passing presidential motorcade cycles through a dozen altered repetitions; imageless alternations of pure black and pure white pulsate in shifting rhythmic patterns; a gradual zoom traverses the spare interior of an artist's loft.

The casual cinephile verifies the significance of the first group of films to the period. They are Michelangelo Antonioni's *La Notte* (1961); Alain Resnais's *L'Année dernière à Marienbad* (Last Year at Marienbad, 1961); Jean-Luc Godard's *Week-end* (1967); Dennis Hopper's *Easy Rider* (1969); Ingmar Bergman's *Persona* (1966); Stanley Kubrick's *2001: A Space Odyssey* (1968). The devotee of experimental cinema recognizes an equivalent canon in the second group: Jack Smith's *Flaming Creatures* (1963); Andy Warhol's *Empire* (1964); Stan Brakhage's *Mothlight* (1963); Bruce Conner's *Report* (1963–67); Tony Conrad's *The Flicker* (1966); and Michael Snow's *Wavelength* (1967).[1]

The extent to which the latter works diverge in style, content, and scale of production from the former has at times provided sufficient grounds to explain their practice. This is the "other" cinema of the 1960s[2] —often given its brief due in the history books by reference to this (or

Michael Snow
Wavelength, 1967

Dennis Hopper
Easy Rider, 1969

Alain Resnais
L'Année dernière à Marienbad (Last Year at Marienbad), 1961

Michelangelo Antonioni
La Notte, 1961

191

another) group of (usually male) filmmakers and defined by the formal distance of its practice from that of the dominant narrative cinema. The period was marked, critically, by devout adherence to the notion of auteurism, but despite the innovations of the concurrent "new waves" emerging across Europe, filmmakers as disparate as Godard, Kubrick, and Antonioni remained aesthetically bound to an image of the cineaste as "the equal of the novelist."[3] The history of "experimental" films of the period, by contrast, is far richer and polyvalent, requiring recourse not only to the history and aesthetics of the cinema proper, but to a broader range of artistic practices — including the novel, but also poetry, painting, dance, and music. They mark this singular period in the moving image arts as a moment of rediscovery by artists, after nearly half a century, of celluloid as a medium for artistic expression. In the brief span of a single decade, a riotous panoply of new forms and competing practices emerged (and as often as not, disappeared) nearly concurrently: among them were underground films, mythopoetic works, flicker films, expanded cinema, and structural films, to name a few.

The 1960s, particularly in the United States, witnessed at least two overlapping artists' cinemas. One comprised first- and second- generation postwar independent filmmakers who well understood the history of cinema and were continuing to develop new modes of personal expression in film. For some of these experimental filmmakers (such as Stan Brakhage, Kenneth Anger, or Bruce Baillie) this meant exploring new visual approaches to mythic expression or autobiography; for others (such as Shirley Clarke or the Mekas brothers) it was a moment to initiate a new kind of narrative feature production.[4] The "other" group can be said to have been made up of an odd array of painters, choreographers, sculptors, photographers, Conceptual artists, and musicians, as well as other (unaffiliated) artists in search of a medium. For these artists picking up their first film cameras, the engagement with film emerged as part of a more global, late-modernist impulse that began to take art off the walls and pedestals and to open itself to the more heterogeneous influence of the world around.[5] And within the complicated web of influences and responses that link these two groups (sometimes in the

form of a single maker, such as a Michael Snow a Hollis Frampton or an Yvonne Rainer), there existed as well an aspiration to purify film's own forms of artistic practice, to ferret out its distinctive formal features in order to define a place for the medium within the larger modernist enterprise.

These multiple experimental cinemas of the 1960s shared a common historical debt to the generation of the 1920s avant-garde in Europe, that critical, though admittedly small, group of visual artists — among them Picabia, Léger, Man Ray, Duchamp, Moholy-Nagy, Richter, and Dalí[6] — whose films maintained a playful relationship to commercial practice while attempting to enlist cinema in the service of advanced forms of artmaking (Cubism, Dada, Surrealism). But the early artists' cinema disappeared with the coming of sound, and the birth of an enduring experimental cinema did not arrive until nearly two decades later, in the mid-1940s, with the work of artists such as Maya Deren and Willard Maas in the United States. By the 1960s this cinema had evolved into a definable practice with an institutional base and a modest complement of infrastructural supports for production, distribution, exhibition, and critical reception.

An ontological account of the origins of this form of experimental cinema was offered by the photographer and filmmaker Hollis Frampton, who wrote in the early 1970s on the relationship between still photography and film and, tacitly, of his own shift from the former to the latter practice. Reformulating the Platonic claim of art's inherent uselessness, Frampton posited that "no activity can become an art until its proper epoch has ended and it has dwindled, as an aid to gut survival, into total obsolescence."[7] One such activity was filmmaking. The motion picture camera became available as an artmaking tool, according to Frampton, only after it was made obsolete by the invention of the next paradigm of moving-image recording. As he put it: "It is customary to mark the end of the Age of Machines at the advent of video. The point in time is imprecise: I prefer radar.... Its introduction coincides quite closely with the making of Maya Deren's *Meshes of the Afternoon*, and Willard Maas's *Geography of the Body* [both 1943]."[8]

Frampton's equation of art with useless activity, of course, bears the distinctive marks of the late high-modernist formalism of its time — a formalism that had called forth Kant's "purposiveness without a purpose" and the "l'art pour l'art" mandate of the nineteenth century as premises for the increasingly self-referential activity of its practice. That Frampton, an admitted admirer of Eisenstein, should willingly banish the whole of cinema prior to 1943 to the realm of "the prehistory of cinematic art" speaks tellingly of his conviction that the new wave of American experimental cinema represented an unprecedented rupture with previous cinematic avant-gardes. The Soviet cinema of the 1920s, the Dadaist film projects of the same period, the various "art" cinemas of the previous fifty years (from *film pur* and German Expressionism to city symphonies and absolute film), for all their usefulness as models of artistic innovation, remained for Frampton cinemas in the service of some form of survival (social, political, ideological). It is only in America in the mid-1940s that he finds a self-committed — that is, in the parlance of the day, a *modern* — cinema.

This first body of film art seemed to emerge simultaneously in the two perennial sites of American film production — New York and Los Angeles. It was in the latter that the Russian-born poet and dancer Maya Deren began her work in film with a modest, black-and-white psychodrama shot by her husband, Czech documentary maker Alexander Hammid. Her *Meshes of the Afternoon* (1943), a tale about a suicidal young woman (played by Deren), showed the marked influence of Surrealism, and, in particular, of Jean Cocteau's early films, in its symbol-laden, dreamlike portrayal of sexual anxiety. A similar partnership between the New York poet Willard Maas and his cinematographer wife Marie Menken led to the making of *Geography of the Body* (1943). Set in counterpoint to a poetic commentary, this short film attempted to portray the "terrors and splendors of the human body" through a series of magnified (and thus ambiguous) biomorphic compositions that were nevertheless sexually redolent.[9]

It was Stan Brakhage, a young admirer of English Romantic poetry and Abstract Expressionist painting earning his living making industrial

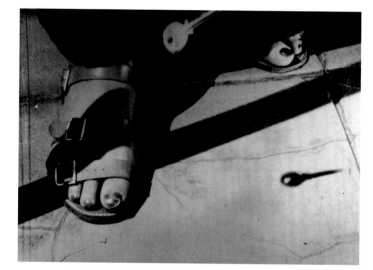

Maya Deren
Meshes of the Afternoon, 1943

films, who, according to the critic Annette Michelson, came to "radical-ize" Deren's and Maas's revisions of filmic form.[10] He was recognized within the world of avant-garde cinema as the "major transitional figure in the turning away of 'experimental' film from literature and surrealist psychodrama and in its subsequent move toward the more purely per-sonal and visual."[11] This he achieved in a series of extraordinary films he made in the late 1950s and early 1960s that used aspects of his daily life to focus on existential anxiety, the dynamics of love and sexuality, and the "fallenness" of the world. What emerged from his series of auto-biographical portraits — from the existential *Anticipation of the Night* (1958) to the mythopoetic *Dog Star Man* (1961–64) and abstract studies such as the cameraless *Mothlight* (1963) — was an understanding of the image no longer simply as a conveyor of representational content and narrative meaning, but rather as the record of an intensive act of seeing. The films, with their gestural camera movements and handcrafted, manipulated surfaces, became (to invoke the title of Brakhage's major treatise on film) "metaphors on vision."[12] In no small way, the films of Brakhage were the cinematic heirs to the prevailing practices of the Abstract Expressionist painters of the previous decade, possessing, in addition to their intense, visceral beauty, an equal measure of self-mythologizing, emotive rhetoric.

Despite the rather private nature of many of his concerns (ironic for an artist working in such an ostensibly public medium) and despite his self-imposed exile in the mountains of Colorado, where he and his wife and artistic collaborator Jane raised a family while creating their impres-sive body of work (jointly signed as "Brakhage" by the early 1960s), Brakhage exerted an enormous influence on a generation of filmmakers as he injected new content and explored new formal approaches to the medium. In legitimizing the distinctly nonprofessional production site of amateur filmmaking — the home ("I studied home movies as diligent-ly as I studied the aesthetics of Sergei Eisenstein")[13] — he also prefigured much of the discourse of avant-garde film practice in the following decade, from the formal strategies of the personal cinema to the "under-ground" form so aptly labeled "pad" films.[14] Brakhage's figure cast a

Stan Brakhage
Mothlight, 1963

Stan Brakhage
Dog Star Man: Part 2
1963

large shadow across the independent and experimental cinemas and represented an exemplary practice that demanded acknowledgment, amplification, and, ultimately, repudiation.

An alternative artists' cinema, independent of the evolving experimental film practice initiated by Brakhage, was concurrently emerging in the late 1950s with the so-called "New York School" — a practice that, despite its name, bore no formal relation to the style of painting more widely associated with this designation. Among the first of the New York School works was *Pull My Daisy* (1959), a collaboration between the painter Alfred Leslie, the photographer Robert Frank, and the writer Jack Kerouac. Based on Kerouac's unproduced play *The Beat Generation*, the film features a cast that includes Beat writers Gregory Corso and Allen Ginsberg, painters Larry Rivers and Alice Neel, and the French actress Delphine Seyrig in her first film role. In striking contrast to the formal ambitions of the Brakhagean school, *Pull My Daisy* was shot in a lucid monochrome, and like Frank's remarkable still photography, masked its extensive preparation and craft. Despite its haphazard look of improvisation and the modest location setting in Leslie's loft, the actors were rehearsed, the sets were dressed, and the film was lensed by Frank on the commercial standard of 35mm stock.

Robert Frank and Alfred Leslie
Pull My Daisy, 1959

The New York School was an evolving hybrid movement that aspired to launch the equivalent of the European new waves in America. While it ultimately failed to create an independent feature movement in the U.S., several significant steps were taken under its influence, including the founding of the Film-Makers' Cooperative by filmmaker Shirley Clarke and critic-filmmaker Jonas Mekas in 1962 as a distribution service and the parallel establishment of the Mekas-run Film-Makers' Cinematheque exhibition program. But the "New Generation of Film-Makers" that Mekas had summoned forth in his writing of the late 1950s and through his organizing activities of the early 1960s turned out to suffer a distinctly more subterranean existence than its European counterparts in the British Free Cinema, the French New Wave, or the new cinemas of Italy and much of Eastern Europe.[15] Carving out a niche for independent production in

Fred McDarrah
Film-Makers' Cinematheque with Jack Smith (left),
Barbara Rubin (center), and Jonas Mekas (right)
hanging plastic drapes, February 18, 1967

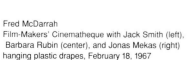

the chasm between the decadence of a declining studio system and the exploitation films of commercial low-budget producers, the New York School created a distinctly American form of post-neorealist practice replete with nonprofessional actors, location shooting, and contemporary narratives.[16]

Among the regulars at the Film-Makers' Cinematheque and the nightly screening of works-in-progress at the Film-Makers' Cooperative was the inconspicuous figure of the artist Andy Warhol. Inspired by the films of Brakhage, as well as the newly emerging "underground" films of Ron Rice and Jack Smith, Warhol began his own filmmaking with a group of serial works — *Eat, Sleep, Kiss* (all 1963) — that derived their deadpan facticity in part from the iconographic residue of his Pop art and in part from his knowingly idiosyncratic rereading of film history. Like Brakhage, he had opted out of the fictions of Hollywood in favor of documenting the homefront. Of course, what constituted the domestic sphere for Warhol was at extraordinary variance with Brakhage's rustic home in the mountains.[17] Despite its seeming distance from the paradigm of new film practices, Jonas Mekas championed the emergence of Warhol's filmmaking and efficiently positioned it within the experimental arena staked out by Brakhage through a simple contrast between those films defined by the "quick" (Brakhage) and those that steeped themselves in the "slow" (Warhol).[18] Other critics were intrigued by Warhol's apparent repudiation of contemporary cinema in these knowing "remakes" of early cinema. The films were shot on black-and-white film stock, used simple fixed-frame compositions and little or no editing, and were projected at "silent speed," which distended motion and increased to perceptibility the medium's signature flicker. But despite its formal resonance with the look of primitive production, Warhol's version of early cinema had a distinctly contemporary character. Updating the Edison Company's early production *The Kiss* (1896), for example, Warhol mixed genders, sexual orientations, and races in his serial couplings (each one lasting approximately one roll of film) and reserved the only significant camera movement (a zoom out) to confirm the gender of the participants in the work's first gay sequence.

Billy Name
Andy Warhol and Ray Johnson, 1964
Billy Name Factory Foto

Warhol's remakes also exhibited a distinct modernity in their reflexive handling of the material aspects of the medium — the fixed stare of the framing foregrounding the camera's presence, the slight flicker referencing the film projector. But Warhol's reflexivity extended beyond the baring of the apparatus and into the sphere of reception as the films' subjects mimed some of the typical activities of their audiences — eating, sleeping, kissing — and occasionally reflected the tedium of spectatorship itself. In such scenes as the finale to *Haircut no. 1* (1963), for example, the performers (one shed of hair; another of attire) stare back into Warhol's camera and rather weakly assume attitudes of boredom and exhaustion.[19]

While Warhol had drawn inspiration from and Mekas had been among the first to call attention to the work of such underground filmmakers as Jack Smith and Ron Rice, it was the writings of the young cultural critic Susan Sontag which had the greatest impact in championing this new experimental practice.[20] Focusing on what she saw as the distinctive feature of the underground — "its willful technical crudity" — Sontag set Smith's work in marked contrast to the technically accomplished practice of his New York School predecessors. She further distinguished his work from the contemporaneous practices of experimental filmmakers like Brakhage and Gregory Markopoulos, who were major figures within the then-current film avant-garde, and acknowledged a consonance in Smith with broader shifts within the arts that ranged from new "aleatory" forms of music and the use of found materials and appropriational techniques in painting and sculpture to environments and Happenings.

Produced on a minuscule budget (estimated pre-lab expenses were $100), *Flaming Creatures* was shot silent on outdated, black-and-white film stock over weekends during a two month period with an assembled cast dressed in thrift-store versions of femininity.[21] The film itself was organized into several sequences (Sontag counted seven; P. Adams Sitney, ten) that are for the most part unconstrained by plot. While spare in narrative action, *Flaming Creatures* exhibited an excessiveness in dress and decor that kept the work on the verge of regressing into precinematic

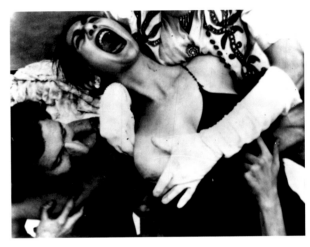

Jack Smith
Flaming Creatures, 1963

tableaux. Its modernity resided not only in Smith's acts of appropriation (a "repertory of fantasy drawn from corny movies," according to Sontag), but also in the work's complex representations of sexuality.[22] Like Barbara Rubin's neglected work *Christmas on Earth* (1963), Smith's film (and much of his subsequent performance work) focused on representations of sexual ambiguity in often ecstatic, celebratory visions. In constructing a liberated representation of the polymorphic nature of sexuality, Smith had —unwittingly or not—crossed the line in censorship. The film and its maker became a cause célèbre from New York to Brussels.

The early 1960s was marked by a wave of avant-garde filmmaking activity as independents abandoned their crossover aspirations and artists joined Warhol and the underground in making movies. One of the most significant instances involved the group of artists connected to Fluxus, who confirmed their roots in Dada through an embrace of the cinema in a manner that attempted both to intervene against high culture and to subvert aspects of then-current film avant-gardes. Much as the Picabia-scripted short *Entr'acte* (1924) used the slapstick structure of the chase film to celebrate popular culture while critiquing the experimental assumptions of *film pur*, the Fluxfilms openly parodied contemporary experimental filmmaking. In Fluxfilm no. 2, for example, the aptly titled *Invocation of Canyons and Boulders for Stan Brakhage* (1963), Dick Higgins effectively lampooned the autobiographic and diaristic aspects and epic proportions of Brakhagean practice through a brief color image in extreme close-up of a moustachioed mouth, presented on a loop for projections of potentially endless duration. Smith's *Flaming Creatures* was the target of another Fluxus parody, by George Landow, titled *The Evil Faerie* (1965), an amateurish, one-shot portrait of a man on a New York rooftop mimicking with his forearms the fluttering motion of wings. The most extensive critical response, however, was reserved for the early Warhol canon. In a series of single, distended actions (the blinking of an eye, striking a match, blowing a smoke-ring) filmed in super-slow-motion, Fluxus managed to hyperbolize both the inherent boredom of Warhol's temporal languor and the banality of his subjects.

While these films amounted to a comic repudiation of the avant-garde, there emerged another Fluxus genre as well, whose reflexive engagement with the medium initiated a formal interest in the apparatus that would assume a central role in experimental practice of the late 1960s and early 1970s. The self-referential temporality of George Maciunas's *End After 9* (1966) which, as its title predicted, concluded after a brief montage of the numbers one to nine; the minimalism of Nam June Paik's imageless *Zen for Film* (1962–64), in which clear leader was run through the projector; and the materialist engagement with the filmstrip in nearly all of Paul Sharits's work, from a simple collage film like *Sears Catalogue 1–3* (1965) to the complex graphic and textual play of his *Word Movie* (1966), had enormous impact on new forms of experimental filmmaking. What became known variously as "structural film" or "structural-materialist film" marked a generational transition within avant-garde cinema and a paradigmatic shift in technique that amounted to a systematic rejection of Brakhagean practice. Its strategies ranged from an eschewal of the handheld camera in favor of fixed-frame cinematography and the use of an optical printer in place of Brakhage's intensive, handcrafted editing, to the jettisoning of explicit autobiographic material in favor of a reflexive engagement with the medium. The apparatus, which had been so severely critiqued, dismantled, manhandled, and reconfigured by Brakhage (who had advocated "deliberately spitting on the lens or wrecking its focal intention"),[23] reemerged in this body of new work like the return of the repressed; and consonant with Roland Barthes's epochal claims for literature, with this return came the implicit "death of the author" and the empowerment of the viewer.

Actively engaging viewer participation in complex image-and-sound relationships was part of a larger cultural practice of the period — the lightshow. This was the era of multiscreen projections, innovative forms of multimedia, and intermedial performances that not only broke the traditional boundaries between disciplines but blurred distinctions between fiction and reality, between spectator and performer, between the work and the world. For the critic Sheldon Renan, who had set out to chart the contours of American underground film (which he regarded as the "third

avant-garde," following the pioneering movement of the 1920s and the postwar generation of Deren, Maas, et al.), the mid-1960s witnessed the emergence of a "fourth avant-garde" of film and filmlike art that he labeled "expanded cinema."[24] At once "more spectacular, more technological, and more diverse in form than that of the avant-garde/experimental/underground film so far," the expanded cinema drew its aesthetic sources and many of its practioners from the other arts.[25]

A catalytic figure of the period was Stan Vanderbeek, who had studied painting and calligraphy at Black Mountain College only to find work as a graphic artist doing backgrounds for the proto-interactive children's television show *Winky Dink and You*. Vanderbeek began working in experimental film with a series of collaged animated shorts in the late 1950s and had actually coined the term "underground film" to describe the irreverent stance of his own satirical films, such as *Achoo Mr. Keroochev* (1959) and *Skullduggery* (1960). By the early 1960s he was a frequent collaborator in the Happenings of Claes Oldenburg and Allan Kaprow, filming these art events and later creating film elements for dance pieces by Merce Cunningham and others. While his collage films prefigured and influenced the form of animation popularized in the 1970s with Terry Gilliam's work for the television series *Monty Python's Flying Circus*, Vanderbeek's major contribution came with experiments in multi-screen projections of his "movie-murals." One such work, *Move-Movies*, presented at the New Cinema Festival at the Film-Makers' Cinematheque in 1965, consisted of a two-screen projection onstage supplemented by five portable projectors carried around the theater and projecting at times on the audience. The culmination of much of this activity for Vanderbeek was the construction in upstate New York of his "Movie-Drome," a planetarium-like screening space in which supine viewers watched hemispheric projections of imagery from magic lantern slides, dance films, computer graphics, and animation.

Film in this period became a sort of lingua franca for the avant-garde, often serving as the site for collaboration among composers, choreographers, and visual artists. This type of expanded performance work, which prefigured the large-scale theater works of the 1970s and

Stan Vanderbeek outside his Movie-Drome, circa 1966

Carolee Schneemann
Fuses, 1965

1980s by Robert Wilson and others, became the provenance of artists such as Robert Whitman, Ronald Nameth, Carolee Schneemann, Robert Rauschenberg, and Andy Warhol, among others, and of multimedia performance groups such as USCO (short for the Us Company) and the Michigan-based ONCE Group. Whitman's work perhaps best exemplified the span of formal options for such intermedial work. It ranged from proscenium-based performances such as *Prune Flat* (1965), in which three women interacted onstage with filmed versions of themselves, to his series of "movie pieces" such as *Sink* and *Shower* (both c. 1964). The latter, which consisted of a film loop of a young woman rear-projected into a shower, so vividly represented its eponymous site that Renan described the embarrassment of "some people seeing it in an art gallery [who] thought they had gone into the wrong room by mistake."[26]

The painter, book artist, and performer Carolee Schneemann merged the screening strategies of Vanderbeek and Whitman with techniques of collaging found footage pioneered by the California assemblage artist and filmmaker Bruce Conner in *A Movie* (1958) — one of the singular achievements of Renan's "third avant-garde" — into the production of moving-image decor for multimedia performances.[27] Beginning with her first work for USCO, she created a number of films for body projection, including *Snows* (1967), which she assembled from vintage newsreel footage, and *Viet Flakes* (1967), which mixed still images from Vietnam with a 1940s newsreel of the Zurich Olympics and her own 8mm footage of driving around New York in a blizzard. Similarly, the artist Robert Rauschenberg, who had maintained a long-term collaboration with Merce Cunningham by designing sets and costumes for his dance performances, began to create his own multimedia performance pieces by the mid-1960s, first by incorporating slide projection with dance in *Spring Training* (1965), then by projecting his found-footage collage film *Canoe* (1966) as a backdrop to the performance work *Linoleum*. He even utilized video in his ambitious stage piece *Open Score* in "An

Carolee Schneemann
Up To And Including Her Limits, 1974–76

Evening: Theatre and Engineering" in the fall 1966.[28] Yvonne Rainer, one of the major figures in postmodern choreography, began in the late 1960s to incorporate film into her performances as well. Her *Volleyball* (1967), in which the camera pursues a rolling ball, was projected during the "Film" section of her celebrated dance piece *The Mind is a Muscle* (1968). After producing a series of such shorts and extensively using slide projections from classic films in her performances, Rainer completed the feature film *Lives of Performers* (1972), which, according to the artist, "integrat[ed] real and fictional aspects of my roles of director and choreographer and the performers' real and fictional roles during the making of previous work and the film itself."[29] By the mid-1970s she had abandoned dance entirely for filmmaking.

Warhol, too, became involved in expanded cinema activity. He had by this time progressed from the early silent "actualities" to making narrative featurettes such as *Vinyl* (1965), an idiosyncratic adaptation of Anthony Burgess's *A Clockwork Orange* that featured Warhol protégé and poet Gerard Malanga in the role of the reprobate youth Alex. *Vinyl* was incorporated by Warhol into a multimedia extravaganza that he mounted in the spring of 1966 at the Dom in the East Village under the title "The Exploding Plastic Inevitable." Essentially a discotheque, it consisted of multiscreen projections (including a silent screening of *Vinyl*), strobe lights, recorded music, and live performance by the Velvet Underground. For Mekas, reporting in his weekly *Village Voice* column, the Plastic Inevitable represented "the loudest and most dynamic exploration platform for this new art."[30] For Warhol scholar Stephen Koch, however, it was a "barnlike, faintly tacky discotheque" that over the course of the evening transformed into "an exploding (more accurately, imploding) environment capable of shattering any conceivable focus on the senses."[31]

The magnum opus of intermedia performances came at the end of the decade with the staging of *HPSCHRD* (1969), a collaboration between the composer John Cage and the intermedia artist and filmmaker Ronald Nameth. First presented in the spring of 1969 at the University of Illinois, this leviathan five-hour work consisted of computer-composed scores

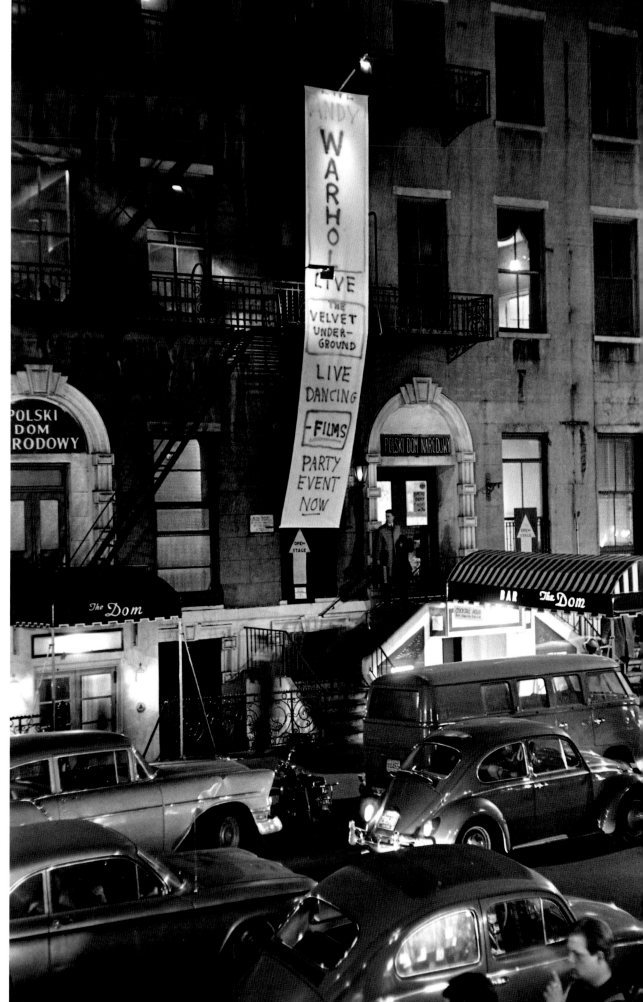

Fred McDarrah
The Dom, April 1, 1966

for amplified harpsichords (hence the title of the work) and computer-generated music on tape played through any of fifty-two loudspeakers (each with its own tape deck), programmed slide projections (involving more than 8,000 slides comprising an encyclopedic tour of models for the cosmos from cave paintings to ancient astronomy to modern science), and multiple film projections on enormous screens that included Georges Méliès's *A Trip to the Moon* (1903), computer animations by John and James Whitney, and NASA footage.[32]

For other artists in the late 1960s, film became, according to the German avant-garde filmmaker Birgit Hein, "a pure medium of documentation."[33] Robert Smithson, for example, recorded the construction of his major earthwork *Spiral Jetty* in a 1970 film of the same name. An exception for Hein was the sculptor Richard Serra, whose films were also cited by one of the leading critics of experimental film, P. Adams Sitney. Sitney noted in a postscript to his influential essay on structural film that "a number of distinguished sculptors have begun to make films in the halfway ground between the subversive 'Fluxus' works and the complex structural films."[34] In contrast to artists engaged in "expanded cinema," the film work of Serra, Robert Morris, and Bruce Nauman (the group to whom Sitney alluded) was resolutely low-tech and understated —the filmic complement to their Minimal and Conceptual art. Serra's films from this period, for example, were brief black-and-white silent studies of his physical encounters with materials in task-oriented situations. The first of these, *Hand Catching Lead* (1968), showed the artist's right hand and forearm framed in close-up during a series of mostly failed attempts to catch pieces of lead dropped from above the frameline. In *Hands Tied* (1968), both of Serra's hands appeared in close-up as he succeeded in loosening a rope that bound them. The most complex of these films, *Frame* (1969), employed manual activity as well, though now focused on an interrogation of an aspect of the film medium. While temporality had been indi-

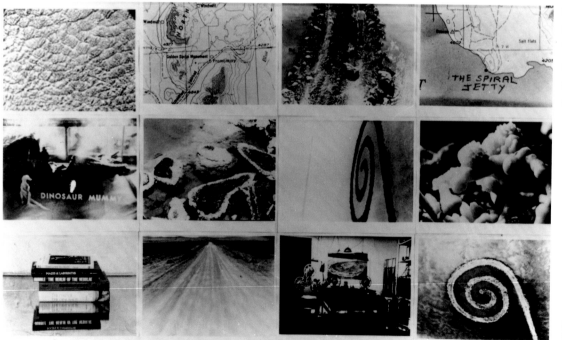

Robert Smithson
Spiral Jetty Film Stills Photo Documentation
John Weber Gallery, New York

rectly invoked in the progression of *Hands Tied* (the film ends when the hands are freed), *Frame* examines the contradictions inherent in the mapping of three-dimensional space onto the two dimensions of the film frame through a series of measurements of the space in front of the lens.[35]

Related to the last of Serra's films, Morris's two-screen *Gas Station* (1969) subjected a quotidian scene (a gas station in Southern California) to two simultaneous filmic depictions. In the first, the station was seen in a long shot that showed nearly the entire width of the facility (a canopied set of pumps, the garage, and office) as well as foreground street traffic and, in the background, a neighborhood and the distant view of the ocean. The second screen presented the same scene, at the same time and from the same angle, but with a zoom lens that isolated and followed details within the scene. Sitney compared the approach to "art historical criticism" while applauding the inadvertent lapses in synchronizing the projection ("details sometimes preceded and sometimes followed the overview"), which "enriched the experience of the film."[36]

Though among the first artists to experiment with video, Bruce Nauman began making films during this watershed period of the "artist's film." From the first, Nauman's work exhibited a marked disregard for both the formal aspects of the medium and current genres of avant-garde practice. Sitney's brief gloss on his films focused solely on their subject matter — "handball, violin-playing, and a loop of a mouth repeating the expression 'lip synch'"[37] — the spareness of description suggesting that the films were, as Hein had implied, no more than straightforward recordings of these activities, marking experimental cinema's version of the "zero degree" of style. While this reading was confirmed by Nauman's modest claims for his films ("I had several performance pieces which no museum or gallery was interested in presenting . . . [s]o I made films of the pieces"),[38] his approaches to the medium were surprisingly varied. His straight forward early films included the short mock documentary *Fishing for Asian Carp* (1966) and the art-process documentary *Span* (1966), both made with the artist William Allan. Four "studio films," which Nauman made by himself the following year, consist of the quotidian movement and repetitive actions that

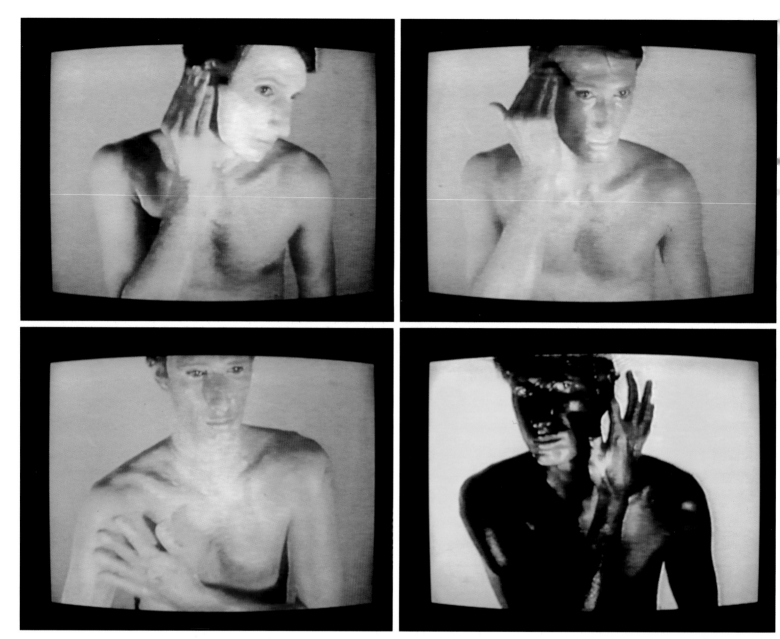

Bruce Nauman
Art Make-Up, no 1: White, 1967
Art Make-Up, no 2: Pink, 1967–68
Art Make-Up, no 3: Green, 1967–68
Art Make-Up, no 4: Black, 1967–68

Sitney had recounted. In each, the artist's intentionally untutored performance technique was matched by his indifference to the craft of filmmaking. These films are marked by a spareness in mise-en-scène and a near absence of cinematic technique (no camera movement, little or no editing). But nowhere in Nauman's work did he as closely approach the "zero degree" than in his four-part series of *Art Make-Up* films (1967–68). These single-long-take self-portraits, in which Nauman is shown applying successive layers of colored makeup (white, pink, green, black) to his bare torso and face, anticipated the present-tense temporality and shallow, haptic space of video as they reconfigured his performance into a sculptural presence.

Despite the nod to the work of visual artists and the trio of sculptors, Sitney's commentary demonstrated a widespread bias within the avant-garde film community toward segregating discussion of these works by "nonfilmmakers" from the detailed descriptions and complex analytical claims made for work by "filmmakers." The correlative tendency to ascribe a singularity of intent to the work of "filmmakers" as varied as the photographer Hollis Frampton; the painter, sculptor, and musician Michael Snow; or the Fluxus artist Paul Sharits (among others) has had the effect of seriously limiting the precise understanding of their individual work while creating false dichotomies between them and an extraordinary wave of other artists similarly aspiring to pursue their artistic activities in film. The so-called "structural filmmakers" were no less eclectic in their sources (Frampton was the highly literate devotee of Ezra Pound, Snow had a background in jazz, Sharits was a painter with a McLuhanesque vision of new forms of media) than nonstructural ones such as Morris, Serra, or Nauman. Even the deployment — by these makers and others — of the signature formal strategies that were believed to define a structural practice (flicker, loop printing, fixed framing, rephotography) resulted in a remarkably broad range of forms. It may be possible only now to begin the historical revisions necessary fully to interpret individual works and to recapture the complexity of attractions, influences and individual aspirations that mark the film work of artists of the mid-to-late 1960s and early 1970s.

A primary text in any such re-examination should be Snow's celebrated work *Wavelength* (1967), a filmic exploration of the phenomenology of space and time that managed to encapsulate both the artist's autobiography and the aesthetic zeitgeist of its era. Given that one of the assumed premises of the form was the stressing of "overall shape," this film has often been reduced to a single, structural description: "one room and one zoom." *Wavelength* is better captured in Snow's early statement:

> I wanted to make a summation of my nervous system, religious inklings, and aesthetic ideas. I was thinking of, planning for a time monument in which the beauty and sadness of equivalence would be celebrated, thinking of trying to make a definitive statement of pure Film space and time, a balancing of "illusion" and "fact," all about seeing.[39]

Despite Snow's aspiration to work with "pure Film space and time" and his assertion that the "film is a continuous zoom," the finished work is all the more remarkable for its spatial and temporal impurity and for the thoroughly discontinuous nature of the central formal conceit. Much as Brakhage recognized the enduring presence of profilmic actuality in even the most abstracted imagery, one finds continual signs of the autobiographic, the personal, the aleatory, and the contingent peering through the seemingly rigid minimalism of *Wavelength*'s procedures and imagery. The work does create a vivid figurative allegory of time-consciousness (the spatial horizon of expectation in the advancing space of the room, the realm of memory in the now invisible background) and a remarkable formal equivalence of sound and image (a tone introduced near the beginning of the film at a low frequency rises as the visual field narrows). But Snow continually embedded into the film an array of cultural detritus (a Beatles song on the soundtrack, store signs that dominate the view from his windows), personal reference (works of art, friends, and his then-wife, the artist-filmmaker Joyce Wieland), and even the traces of a murder mystery cum Manhattan melodrama (with

Hollis Frampton, following a possible break-in, collapsing in the center of the loft and film critic Amy Taubin arriving later to discover the body). While *Wavelength* influenced an entire generation of experimental film-makers and set the terms for nearly all of Snow's subsequent film work, it also opened up a new space within the visual arts that coincided with a significant shift both in visual artmaking and in the evolution of post-modern choreography. The film had reversed the traditional roles of back-ground and foreground, setting and action, and in so doing had effective-ly aestheticized the space of the studio and installed it as the provenance of process, a site in which traces of the trajectories of creative work resided. Snow's "time monument" may well have had its greatest impact in the way its privileging of spatial concerns served as a model for the ensuing wave of post-Minimalist installations and environments.

A similar analysis can be made of Frampton's seminal film *Zorns Lemma* (1970), a work that self-consciously aspired to serve as a mov-ing-image primer for a generation of artists newly engaged by the possi-bilities of cinema. Despite its eponymous scientific reference (the math-ematician Zorn and set theory), the film is also a revival of one of the most venerable of experimental film forms, the "city symphony." Like the classic Paul Strand and Charles Sheeler *Manhatta* (1921), Frampton's film focuses on lower Manhattan cityscapes; but in place of the earlier use of Whitmanesque intertitles, Frampton interpolates single letters of the alphabet glimpsed on shop windows, traffic signs, graffiti, and man-hole covers within his brief, one-second streetscenes. More radical, though, is the film's central section, in whose conceptual scheme these alphabetized images, reminiscent of his photographic series of "word pictures" from the early 1960s, are replaced by a series of quotidian pro-cedures (the artist Robert Huot painting a wall, an egg frying, beans fill-ing a jar, ocean waves breaking).[40] As with *Wavelength*, both the imagery and the formal shifts of *Zorns Lemma* resonate with personal history (Frampton's evolution from poet to photographer to filmmaker) and art-world zeitgeist (from the metricality of new music and the linguistic strategies of Conceptual art to the quotidian vocabulary of the Judson Dance Theater).

Hollis Frampton
Zorns Lemma, 1970

Paul Sharits
Frozen Film Frame: Ray Gun Virus, 1972
Museum Ludwig, Cologne

213

While Frampton and Snow both reflected and influenced concerns of the larger artworld, their filmmaking remained at a physical remove from the arena of the visual arts. Among all the artists working in film during this period, only Paul Sharits managed to create a context for his films to enter the space of the gallery. His "locational film pieces" are multiscreen installation works that effectively formalize and summarize his short experimental films of the mid-1960s. This body of work, produced in the early 1970s, was designed, according to Sharits, "to be displayed in an ongoing, no beginning or ending, constantly variational form, for a gallery-museum context."[41] Meanwhile Sharits had conceived two static versions of the films for gallery exhibition: gridlike drawings that had served originally as "scores" for the films, and the remarkable "Frozen Film Frame" series, in which he arranged strips of the earlier films "side by side from beginning to end, from right to left, between sheets of plexiglass."[42]

While it was conceived with a singular focus on filmic temporality, that earlier work was highly suggestive in its spatial complexity. The shorts that Sharits produced for Fluxus, for example, were included in George Maciunas's ambitious but unrealized plans for multi-image gallery projections that he labeled "Film Wallpaper."[43] And Sharits's flicker films themselves exhibited a singular formal ambition that linked them to that heterogeneous set of filmic and extrafilmic practices of expanded cinema: to enter, activate, and engage the screening space. Sharits's installations, like the three-screen *SYNCHRONOUSOUND-TRACKS* (1973–74), remain among a select few film works that have been exhibited in installation form. Their entrance into the gallery, however, seemed to mark an end rather than a beginning.[44]

By the early 1970s, many artists who had begun making films in the late 1960s were working in video. The poet-turned-performer Vito Acconci made a series of modest Super-8 shorts before launching into a cycle of ambitious works on video. The visual artist William Wegman completed only a single film before beginning his highly successful work in video. Similarly, John Baldessari, who had ended his career as a painter by burning all his canvases, had a brief period of filmmaking

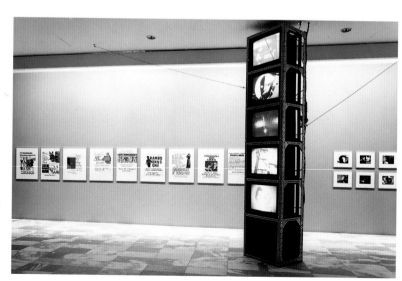

Chris Marker
Silent Movie, 1994–95
In "Video Spaces: Eight Installations", 1995
The Museum of Modern Art, New York

followed by more extensive work in video. The performer Joan Jonas, who had used film initially to record and at times rework her performances, became one of the most accomplished artists to work in video. Richard Serra, too, would shift to video in the early 1970s, creating some of his most powerful work in such tapes as *Television Delivers People* (1973) and *Boomerang* (1974).

Now, more than two decades later, video has become a familiar medium in the gallery, while new forms of crossover practices by both visual artists and filmmakers have emerged. Stan Brakhage continues to make personal films, but now almost exclusively by painting directly onto the celluloid. Film directors ranging from Chris Marker and Raúl Ruiz to Chantal Akerman and Peter Greenaway have initiated installation works for the gallery, which spatialize and extend aspects of their film practice. In contrast, prominent visual artists like Rebecca Horn, Robert Longo, and David Salle have turned to feature film production — with varying degrees of success.

Robert Longo
Johnny Mnemonic, 1995

Meanwhile, a small number of younger artists have continued to work experimentally in the increasingly expensive and technically demanding medium of film, building on the lessons of the poetic and structural practices of previous generations. Filmmakers such as James Benning, Su Friedrich, Bill Brand, Leslie Thornton, Trinh T. Minh-ha and others create work that is marked by an interest in formal innovation and personal expression, but that addresses issues of social critique and narrativity as well. As these filmmakers labor in an arena of shrinking technological and institutional support, however, many predict the "death" of cinema.

Can the promise of film as a site for artistic exploration have played itself out so quickly in this century?[45] Hollis Frampton, toward the end of his life, was becoming more deeply engrossed in his digital arts lab, exploring the interface between new technologies and the very earliest forms of cinema. It may be that he foresaw a more synthetic rapprochement between the various forms of moving-image production than we, in the midst of the chaos, can envision. In his attempts to wed the capabilities of the computer to the rich surfaces of celluloid, perhaps he was imagining the "history of film as it should have been."

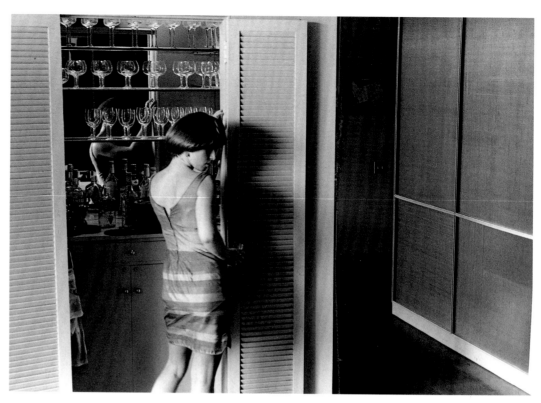

Cindy Sherman
Untitled Film Still #49, 1979

Engaging Perspectives: Film, Feminism, Psychoanalysis, and the Problem of Vision

Kate Linker

It is now twenty years since Laura Mulvey's "Visual Pleasure and Narrative Cinema" appeared in the Autumn, 1975 issue of the film journal *Screen*. If the notion of the watershed is questionable, Mulvey's article is surely a landmark, a text that articulated a specific historical phase within film and its criticism whose repercussions spread quickly to art practice as a whole. Endorsing the use of psychoanalysis as a "political weapon," Mulvey proposed to demonstrate "the way the unconscious of patriarchal society has structured film form," indicating how film reinforces "pre-existing patterns of fascination . . . within the individual subject and the social formations that have moulded him."[1] Mulvey's little "him" posed at the end of her sentence served as a red flag of feminism, marking a perspective but also framing a retort to cultural form. For evident in her article, as well as in the theory and practice that accompanied and followed it, is an approach that holds the *image* responsible for the reproduction of social norms. Reversing the terms of Western esthetics by which society is reflected in its objects, images were accorded a constitutive role. Through the alliance of film, feminism, and psychoanalysis, representation was placed on the agenda of ideological critique.

In an introduction to a survey of recent writing on film, Constance Penley described Mulvey's text as "the first feminist consideration of the play and conflict of psychical forces at work between the spectator and the screen."[2] "Visual Pleasure" articulated a new space of analysis and, within it, interjected a new tool: the Freudian-derived theory of the French psychoanalyst Jacques Lacan, which is specifically a theory of representation. Lacan's quizzical and maddeningly elusive thought has been a central influence on contemporary criticism, and one of Mulvey's major accomplishments may have been to have served as its conduit. My purpose, however is neither to summarize Lacan (although a certain recapitulation is necessary) nor to paraphrase Mulvey, but to indicate

their relevance to work on a paradigm of vision which, over two decades, has been steadily robbed of its innocence.

Mulvey's article, although published in 1975, was presented first as a paper in the French Department at the University of Wisconsin in spring 1973. It thus participates not only in a growing interest in French studies but also in a specific moment in the British film and political community.[3] Claire Johnston published *Woman's Cinema as Counter-Cinema* in 1973, the same year that Yvonne Rainer's *Lives of Performers* and Jackie Raynal's *Deux Fois* were screened in London. That year also saw the beginning of Mary Kelly's *Post-Partum Document* (1973–79), an extended, 163-part visual arts work informed by Lacanian psychoanalysis and semiotics. Juliet Mitchell published *Psychoanalysis and Feminism* in 1974, the year in which *Screen*'s "Psychoanalysis and Cinema" issue appeared, heralding the transformation of the journal into a forum for the deconstruction of the sexual agendas of mainstream film. The Edinburgh Film Festival of 1975, along with the debates organized by and around *Screen* and the Filmmaker's Co-op, offered occasions for intense, rigorous, often heated exchanges on the political structure of illusionistic narrative cinema. On the American West Coast the initial issues of *Camera Obscura* appeared in 1976, published with the declared purpose of working "on cinematic representation and the signifying function of women within this system." Mulvey's radical critique of mainstream images and pleasures was thus in keeping with a broad analysis, not only of patriarchy, but also of the ways in which socio-technological apparatuses including but not confined to film participate in the construction and reproduction of its structures.

The conjunction of film, feminism, and psychoanalysis in this oppositional practice must be placed against the background of a specific event, namely, the internal transformation of semiotics in general and film theory in particular. Throughout the 1960s and early 1970s film theory had been dominated by a specific semiological model informed by Saussurian structural linguistics. According to this perspective (which underlies virtually every variant of analytical structuralism) film, like other "meaningful" structures, was regarded as a self-contained system

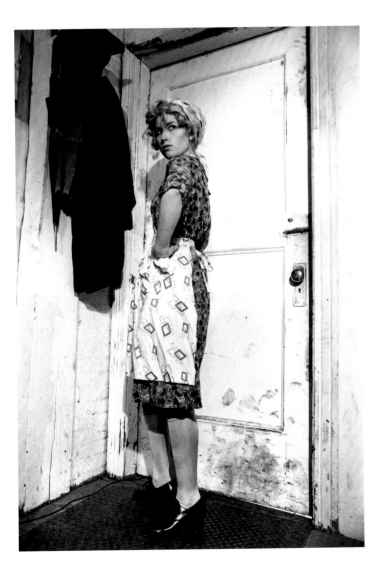

Cindy Sherman
Untitled Film Still #35, 1979

—an independent work—whose signifying capacity was dependent on the interrelationships of its elements. Meaning was made a function of the internal operations of codes that could be deciphered by a literate reader. In the early 1970s, however, the notion of a filmic language with its structures already in place, its viewer firmly positioned outside, ceded to a more complex and imbricated conception that focused on the signifying practices that interact to produce meaning *in and through* a given object. In this "semiotic" approach (which roughly conforms to the imperatives of post-structuralism) the focus is less on structures than on structuring, less on discrete meanings than on the production of meaning. The boundaries surrounding the image elide into surrounding space and critical focus shifts to the discursive formations that cross and contain it. Barthes, through hardly independently,[4] summarized this transformation of the semiological field as a shift from "work" to "text."

The notion of the text introduces into film the social field, now understood as a space of representations that the viewing subject traverses freely. The role of that spectator to "reader-text relations" is central. On one hand, the spectator's active relationship to and with the text confers on the text a multiplicity of meaning excluded from the old "expressive" model, in which the viewer-reader would elucidate the meaning embedded by an author in a work. On the other hand, and most importantly, it introduces a new situation in which the viewing subject is produced through its encounter with the text, and in which the representations pullulating through textual space assume ascendancy *over* the subject. It is this metamorphosis in semiotic study that enabled the political cast of post-structuralist feminist inquiry. In film terms, it became possible to examine the placement of women in commercial film less in terms of camera angle, point-of-view, and other grammatical codes than of the ways in which these and other practices work to produce patriarchal ideology. Viewed in this manner, patriarchy could be examined less as a historical "fact" than as the *effect* of specific arrangements of discourses (and, correspondingly, of the value-structures they introduce) that organize and secure its power. Conceived in this way, film is not an object but an instrument, a machine, an apparatus.

In the early 1970s this shift in semiotic theory allowed cinematic representation to be considered less as a reproduction of a pre-existing, external reality — what is described as the "pro-filmic" — than as one among many social discourses that construct reality and, with it, the viewing subject. As if to illustrate Gilles Deleuze's statement that machines are social before they are technical,[5] cinema was seen in its productive rather than reproductive capacities, not as a mimesis of phenomena but as their constitutive agent. For British film theory, the origin of this idea of the apparatus as a social machine, producing ideological effects, can be traced to the French political philosopher Louis Althusser. Althusser's radical rereading of Marx, informed by Freudian and Lacanian psychoanalysis, was first available in translation in the early 1970s, and it is in this form that both his thought and Lacan's were injected into British cinema studies. Althusser's seminal contributions to the field were his intertwined concepts of the apparatus and the imaginary.

Althusser described ideology, the corpus of naturalized assumptions that we take for common-sense or self-evident truths, as the product of different discourses and signifying practices; a cornerstone of his theory is that social representations are constitutive, producing "real" effects. He described the varied social institutions including religion, government, education, and so forth as so many "ideological state apparatuses" whose function is to construct and reproduce ideology. It is implicit in this aim of reproduction that ideology must produce subjects for its representations. Using a Lacanian paradigm, Althusser described the subject's comprehension by, and constitution through, the social process. In "Ideology and Ideological State Apparatuses (Notes toward an Investigation)," Althusser referred to a reciprocal relation by which "the category of the subject is constitutive of all ideology, but at the same time and immediately . . . the category of the subject is only constitutive of all ideology *insofar as all ideology has the function (which defines it) of 'constituting' concrete individuals as subjects.*"[6] The manner by which ideology constructs subjects is interpellation, defined as a kind of "hailing" or subject address. Althusser's notion of the subject's interpellation by the ideological apparatus was picked up in film theory's attention to

subject "positioning," and found its most elaborate echo in the notion of "suture," introduced by Jean-Pierre Oudart and developed by Stephen Heath, which indicates the way in which the spectator is "bound into" representation by cinematic devices. Inasmuch as representations position their subject so as to secure meaning or make sense, the individual is inherently *subjected* by the signifier, which operates in a legislative manner. "There are no subjects except by and for their subjection."[7] In this way Althusser developed Lacan's startling pronouncement that the condition for the subject's existence is submission to social law.

According to Althusser, ideology is not, as in the Marxist paradigm, false consciousness; instead, it is unconscious. It was Althusser's imperative to recuperate the imaginary in its reality, to place it on a par with material substance, elucidating the material import of "insubstantial" representation. Althusser contrasted his position with Marx's, observing that "in *The German Ideology,* Ideology is conceived as a pure illusion, a dream, i.e. as nothingness. All its reality is external to it. Ideology is thus thought as an imaginary construction whose status is exactly like the theoretical status of the dream among writers before Freud."[8] The comparison is central: Althusser, in Freud's manner, proposes the reality of the illusory, designating the imaginary as *necessary* to the ideological founding of the subject. What is expressed in ideology is not, as Marx would have had it, the real conditions of existence, but rather "the imaginary relation of those individuals to the real relations in which they live." The imaginary, then is a representation of the subject's lived relation to society. Through this relation the subject comes to view as its own, to see itself in, the representations of the social order.[9]

If ideology is illusory, it is because it is literally specular: the subject recognizes itself in ideology *as if in a mirror*. For this inherently narcissistic paradigm Althusser drew on Lacan's concept of the mirror stage. Although the recognition is a misrecognition — the images the subject accepts as its own are those of another, constructed by the Other — what is important is that the relation is foundational for the individual as subject

to the social order. Althusser's imagistic paradigm of the imaginary provides the generative concept of film theory, evident in the work of Jean-Louis Baudry, Christian Metz, Heath, Mulvey, and others, of the screen as a mirror. According to this concept, the illusionary representations on the movie screen are accepted by the subject as its own. In this manner cinema, much like its affiliate, photography, works as an apparatus to construct the misrecognition necessary to produce the ideological subject.

If film theory derived the name and concept from Althusser, the notions Althusser used to elaborate the apparatus are hardly his own; indeed he could be accused — as David Macey has in a recent essay — of "thinking with borrowed concepts."[10] As I have noted, Althusser's "thinking" was a major path of dissemination for French theory. (It is not inconsequential that his essay "Freud and Lacan" was included in *Lenin and Philosophy and Other Essays*.) More important than Althusser's practice of cribbing (which is inherent to the referential structure of philosophical method) are his reasons for turning to psychoanalysis in the first place. Psychoanalysis, after all, is the science that studies subject construction — and it was a theory of the subject's construction that was missing, Althusser inferred, from prior theories of ideology. Equally important, Althusser turned not to any psychoanalysis, but to Freud's

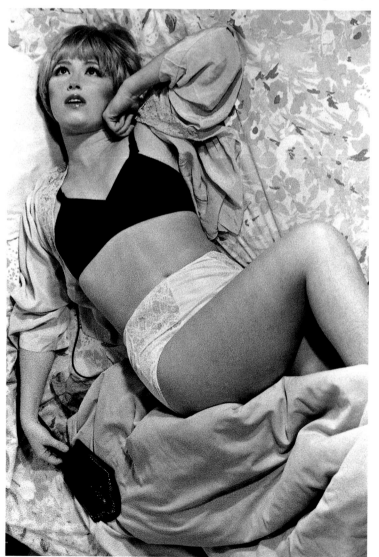

Cindy Sherman
Untitled Film Still #6, 1977

theories as re-read and reinterpreted by Lacan. He credited Freud with the discovery that the human subject is "de-centered, constituted by a structure which has no 'center' either, except in the imaginary misrecognition of the 'ego,' i.e. in the ideological formations in which it 'recognizes' itself."[11] Inherent in Althusser's statement is an attack on ego-psychology, our common-sense view of psychoanalysis, the orthodox version — still dominant in America — that conceives of a potentially unified subject channeled, through analysis, into conformity with society's codes. Freud, in contrast, asserted the predominance of the unconscious (the ego, he noted "is not master in its own house"), alluding to the symptomatic eruptions of the unconscious in the dream-work. It was only through the

illusory workings of imaginary culture that the ego could represent itself as center and master of its world.

Switching registers allows us to turn to Lacan, and to the radical relevance of his work to theories of representation. Lacan's major contribution to feminist circles in the early 1970s was his development of Freud's analysis of the psychosexual structures of sexuality, using the sciences of linguistics and semiotics that were unavailable to Freud. Opposing the prevailing view of the self as an entity with an identity, Lacan stressed the subject's division and incoherence; in his work the human subject is seen, following Freud, as "primordially alienated," as a divided being that will attempt to make itself in culture through a series of provisional and unstable attempts at unity. It is important to Lacan both that these appeals to unity are illusory and that they come from outside. The key role in the construction of the subject is played by representations, which offer the self images of what it might become (operating, in this sense, as the agent of social law). As the artist and writer Victor Burgin has remarked, invoking Lacan, "There is no essential self which precedes the social construction of the self through the agency of representations."[12] This refusal of a pre-existing, essential, or biological self defines subject construction as a historical process, one that, theoretically at least, is open to change through work on dominant social representations. It is from this potential mutability of signifying structures that political feminism derives its impetus. For Lacan was firm in his insistence that the structures of sexuality are not natural and, thus, unchangeable, but rather imposed, arbitrary, and, in consequence, historically variable. As he observed in "Guiding Remarks for a Congress on Feminine Sexuality," "images and symbols *for* the woman cannot be isolated from images and symbols *of* the woman. It is representation, . . . the representation of feminine sexuality. . . , which conditions how it comes into play."[13]

Lacan described sexuality as an assignment, an ordering that is always mediated by signs. This arbitrary disposition functions as a legislative divide, producing and reproducing its categories. Through an elaborate conceit Lacan conflated sexuality with the structure of language, with its

polarities of marked and unmarked terms. Drawing on the illuminations of the linguist Ferdinand de Saussure, who had criticized the notion of language as absolute reference, describing it instead as a "chain" that moves from link to link, producing meaning from the relations between terms,[14] Lacan accorded sexuality a *differential* structure. Within his system, the meaning of sexuality is determined through the relations between the opposed terms of presence and absence, of having or not-having a penis. The structure of "ladies and gentlemen," then, is imposed from outside, through the operation of a law that Lacan terms the Symbolic. In an important gesture Lacan points to the imperiousness of this imposition, noting that the presence or absence of a penis only signifies insofar as it already has a meaning within a given system of difference; it is specific to patriarchy, and to its particular attribution of values. For Lacan, the privileged signifier in the Symbolic order is the phallus. The penis is *only* its physical stand-in.

For all the alleged absolutism of his pronouncements, Lacan was critical of the power of the phallus. Following Freud, he pointed to the arbitrariness by which the initial bisexual drives manifested in child's play were channelled into the polar structures of adult sexuality, indicating the legislative imposition it implied. Indeed, much of his late writing is devoted to unmasking the fraudulence of phallic supremacy, revealing its dependence for power on subjection of the other; as Juliet Mitchell observed, the whole edifice of sexual construction only figures because of what the woman lacks.[15] Castration — as a reality for the woman, as perceived threat for the male — performs the central structuring instance in the Lacanian system. Lacan's late texts indicate the deconstructive thrust of his thought as he demonstrates the fallacy of phallic power: all are castrated; no one has the phallus; subjectivity is inherently partial, divided, by virtue of subjection.

A thematic of separation and loss threads its way through subjectivity. The foundation of Lacan's theory is that subjectivity is formed through divisions whose repressions comprise the unconscious. Another way of formulating this is that meaning, or a "place" in the patriarchal structure, is secured only at the price of loss (a notion that should erode our inherited

Cindy Sherman
Untitled Film Still #21, 1978

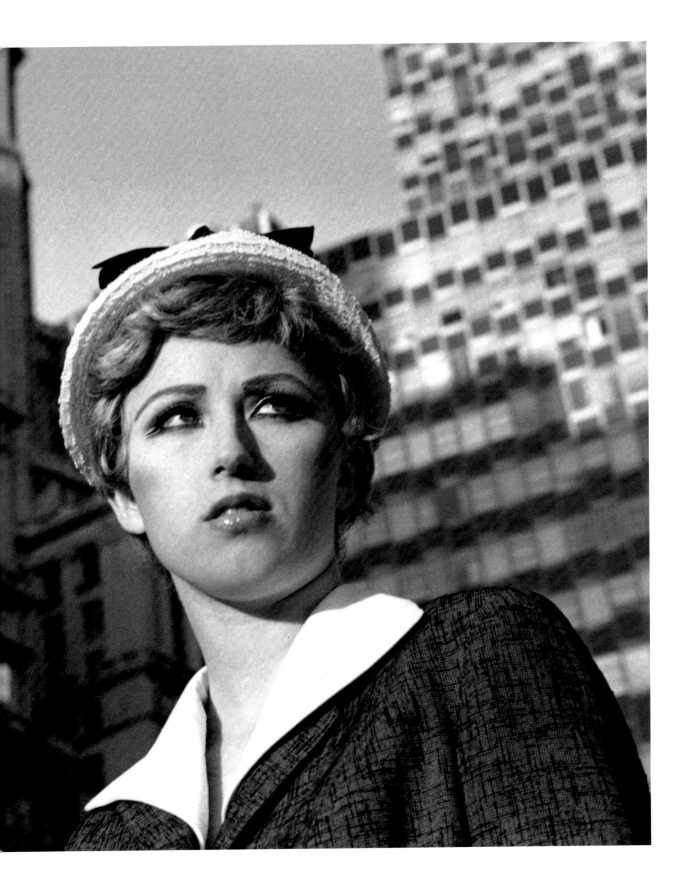

Western faith in the wholeness and self-sufficiency of the individual). All adult life and, most prominently, its fantasies, are a deferred consequence of the repressions instituted by the rule of Symbolic patriarchal law.

Lacan presents the key instances of Symbolic structuring in a series of vignettes. In one, the child discovers the crucial signifier of sexual difference — its mother's castration — through looking. Both Freud and Lacan observed that in a critical moment prior to the Oedipal state, the child's look establishes its mother, or another, as without a penis, as lacking the masculine organ and inherently "less than" the male. As Jane Gallop has observed, the discovery of castration occurs through vision, pointing to its privilege in Western society: "sight of a phallic presence in the boy, sight of a phallic absence in the girl, ultimately sight of a phallic absence in the mother. *Sexual difference takes its decisive significance from a sighting.*"[16] (To which Luce Irigaray has commented, "Rien à voir équivaut à n'avoir rien" — *Nothing to see equals having no thing* — a statement that hints at the eye's ability to master its objects, reducing them to in-significance.[17]) This moment, which "assigns" the child within the sexual order, also divides and displaces the mother (who, prior to this moment, appeared as "phallic," omnipotent, whole). In the later image of the Oedipus complex, paternal Law intercedes to break up the natural dyad of mother and child to insure heterosexual identification. The illusion of sexual completeness characteristic of the child's phallic phase is sundered by the incest prohibition operating in the Name of the Father. According to a successful Oedipal resolution each child will choose as love object a member of the opposite sex and identify with one of the same. Threatened by castration, the boy will transfer his Oedipal love for his mother onto another feminine subject, while the girl will transfer her love to her father, who appears to have the phallus, identifying with her mother, who has not. The girl will struggle to "have" the phallus, instituting the play of heterosexual identity that culminates in the phallic substitute of the child, while the boy will work to "represent" it. Among the desires of the Oedipus complex repressed into the unconscious, the central, recurring one is the phallic mother herself. Thus, sexual identity is assumed only at the price of the lost object

(which, Lacan asserts, indicates that no one has the phallus; every "one" is partial, as a condition of subjection). In lack, the effect of a primordial absence, Lacan bases the instigation of desire, which is distinguished from need in that its satisfaction is never attained. What is at issue is not a physical object, such as the water that would satisfy thirst, but a fantasy object. Desire is deviation; it is constantly "forced away from its aim and into displacements."[18]

Lacan encapsulates the relations structuring subjectivity in a tripartite scheme, designating as the Real the original plentitude that eludes the hold of the Symbolic, the order of language and representation, and whose return is conjured, through phantasy and projection, in the Imaginary. The same division is enjoined on the infant in its acquisition of speech, when it moves from a world of objects to one of objects ordered by words: it is only through absence, through the loss of the "real" object in all its immediacy, that re-presentation can occur. Mimesis, then, is an illusion: in this world in which words never coincide with their meanings, the signifier is a dim, insufficient substitute enjoined on the subject. Representation, then, is loss, is lack, and with it is initiated the play of desire — a tension whose psychic implications are confirmed by the modernist valorization of im-mediacy, of plenitude, of an (impossible) unity of signifier and signified. The maternal body recurs, as it does, Lacan tells us, in innumerable echoes, mirrors, registers of psychic life.

All of which brings us to the mirror stage, the template for the apparatus, the bedrock of film theory. Lacan's description of the "stade du miroir" appears in one of the best-known of his *Ecrits:* the text from 1949 entitled "The Mirror Stage as Formative of the Function of the I." Although Lacan revised his perspective later, eschewing its dependence on optical models, the text has until recently retained its canonical status. In it Lacan addressed the phase, occurring in the infant somewhere between the ages of six and eighteen months, in which the child perceives its reflection in a mirror as an independent and totalized image — as integrated, rather than the bits and pieces that are the substance of its physiological perceptions. This first view of the self as unified will provide the basis for future identifications, furnishing a prototype for the

Jean-Luc Godard
Une Femme mariée (A Married Woman), 1964

images that will be assumed by the self. Lacan treats the self conceived as an identity, or organized entity, as an imitation of the cohesiveness of the mirror stage. As Jane Gallop has written, the mirror stage is a decisive moment, for the subject as for Lacan; underlying all his writing is the sense that the self is an *illusion* done with mirrors.[19] However, this imaginary identification is inherently alienating since the view reflected to the child locates it within a space or field whose dimensions it cannot see. As the art historian Norman Bryson has written, the first image of the self as totalized involves a displacement, an image of it as seen *by* others and *for* others.[20] Furthermore, inasmuch as the coherence achieved in the mirror masks the infant's fragmentation, the Imaginary image is fictional (Lacan: "this form situates the instance of the ego, before its social determinations, in a fictional direction"). The totalized image of our first recognition, then, is a misrecognition, a mis-prision, or mis-take.[21]

Lacan makes much of the child's "jubilation" before its image in the mirror, alluding to the pleasures inherent in looking. The primary narcissism of the mirror stage is one part of what Lacan, following Freud, designates as the scopic drive (the other is the intrinsically sadistic, objectifying, and "mastering" pleasure of voyeurism, which consists of turning persons *into* images). Pleasure, evoking plentitude, and displeasure, associated with anxiety and castration, structure our psychic economy, making the viewer the point of ideological appropriation by the image; it is for this reason that we are subject to the illusions of coherence furnished by the media. Lacan describes the subject's "capture" in the imaginary, designating it as "captivated by the lure of spatial identification," as it misrecognizes itself in depicted scenes. Thus, our "desire to go to the cinema," like other forms of entertainment, is based on a structure of wish-fulfillment.

Burgin has remarked on this process in Althusserian terms, observing that ideology exists in a specular relationship to the subject, offering images of a world "more whole, more free of contradiction" than it is in lived experience.[22] Parenthetically, the media's appeal to unconscious structures of fascination has made them common property for artists drawn toward ideological critique.[23] For example, the video and installation artist Judith Barry has investigated the collective fantasies that

comprise the contemporary unconscious. In her early videotape *Casual Shopper* (1980) she examined the ideologized consumer who seeks personal completeness and satisfaction through the purchase of material objects, much as Dara Birnbaum's *Technology/Transformation: WONDER WOMAN* (1979) may configure, in its treatment of the television spectacle of the same name, the phallic mother, omnipotent, prior to the discovery of castration. Several photographers — Burgin and Sarah Charlesworth among them — have interrogated the specular brilliance implicit in the photograph's glossy sheen. These instances are repetitions in another register of the formative effect of the mirror stage (which, Lacan observes, precipitates the subject, functioning much like a machine: "for the subject captivated by the lure of spatial identification, [it] machinates the succession of fantasies which go ... to the armor finally assumed of an alienating identity ... which will mark with its rigid structure his entire mental development").[24]

Now if film theory ratifies the Imaginary as elucidated by Lacan, it is because the structure of Lacan's machine confirms one long associated with cinema, the structure of the camera obscura. Inherited from Euclidean geometry and constructed around the system of classical perspective, that arrangement defines the picture surface or screen as a slice through a visual pyramid that originates in the viewpoint established by the lens or eye, the geometrical underpinnings of the system guaranteeing the theoretical identity of that point with the vanishing point into which space converges on the horizon.[25] The authority of the system depends on the precise viewing point, that punctum, from which the rays of light originate and, more importantly, from which the information they convey alone makes sense. The spectator of cinema, or of any representation, fills in this position. As Mary Ann Doane has written, the theory of the viewing apparatus depends on the designation of the spectator

as a point in space, a site. Through its reinscription of Renaissance perspective, the apparatus positions the spectator, on this side of the screen, as a mirror of the vanishing point on the other side. Both points stabilize the representational logic, producing its readability, which is coincident with the notions of unity,

Judith Barry
In the Shadow of the City ... Vamp r y,
1982–85

coherency, and mastery.... From the point of view of psychoanalytic theory this is ... an ideologically complicit vision of the 'self.'[26]

By placing the viewer in a position of Imaginary control over space, the perspective system constructs a transcendent subject, the "mastering" subject of consciousness — a fact that has been responsible for perspective's hold over Western representation. As Barthes wrote in an essay that was published in English in 1974 in *Screen*, "there will still be representation for so long as a subject (author, reader, spectator, or voyeur) casts his *gaze* towards a horizon on which he cuts out the base of a triangle, his eye (or his mind) forming the apex."[27] Barthes notes, additionally, that this "Organon of Representation" has "as its dual foundation the act of cutting out (*découpage*) and the unity of the subject in that action." Barthes's reference to the spectator's eye or mind marks the way in which this Western punctual subject is invariably a disembodied subject, an individual whose unity over time and in space masks the division or disunity the body inherently suggests. In fact, the effect of the camera obscura and its geometric paradigm is to *de*corporealize vision — an impact Barry acknowledges in her installation *In the Shadow of the City ... Vamp r y* (1982–85), in which cinematic perspective constitutes the spectator as a simulacrum of the bloodless, disembodied, and insatiable vampire. It has been argued persuasively that the privilege Western esthetic theory accords to vision is a function of its propensity for mastery.[28] It is worth noting as well that the position occupied by the viewer in Barthes's description is the same one occupied by the jailor/panopticon in Foucault's model of the state's system of domination through surveillance (a position that Barry also characterizes as specific to the all-seeing urban voyeur). In each case, the subjective effect of representation is rife with what Lacan described as "that belong-to-me-aspect so reminiscent of property."[29] The unifying gaze

constructs a position of control or possession that is conferred, through identification, onto the spectator. In this manner, the apparatus constructs a pleasurable coherence for the viewer that the reality of the unconscious denies. Or as Bryson remarked of perspective's address, "it is a *personal* construction, where the image recognizes (more accurately, constructs) the viewer as a unitary subject, master of the prospect, unique possessor of the scene."[30]

As if acknowledging the primacy of this visual structure, Christian Metz observed in "The Imaginary Signifier" that "the topographical apparatus of the cinema resembles the conceptual apparatus of phenomenology," with the result that "the main form of idealism in cinematic theory has been phenomenology."[31] The phenomenological valorization of personal experience is played out in the spatio-temporal mise-en-scène of experimental film, as well as in modernist painting; their accounts of the perceptual sensation of this egocentric subject mime the Western paradigm of the self-reflexive consciousness — the subject who "sees itself seeing," reflected in its mirrors. As Constance Penley has remarked, the institution of cinema "replays unconscious wishes, the structures of which are shared by phenomenology: the illusion of perceptual mastery with the effect of the creation of a transcendental subject."[32] However, if film theory acknowledges the apparatus's production of this subject, it would also demonstrate that such mastery is an illusion produced by and for the dominant order. As the product of an idealist patriarchal structure, cinema is a social machine for the reproduction of its ideological subject — a perspective that informs feminist film theory's choice, for its objects of analysis, of the mainstream "texts" made by Hollywood studios in the 1930s through 1950s. Feminist theory has argued that the enjoyment these films offer for mass consumption depends on the skillful manipulation of the grammatical codes of editing, point of view, and so forth, all of which precipitate the spectator's identification with images. The rhetorical strategies of classical narrative cinema frame a pleasurable address that the spectator willingly accepts.

Mulvey's "Visual Pleasure and Narrative Cinema" expresses this view on the apparatus's "satisfaction and reinforcement of the ego," and

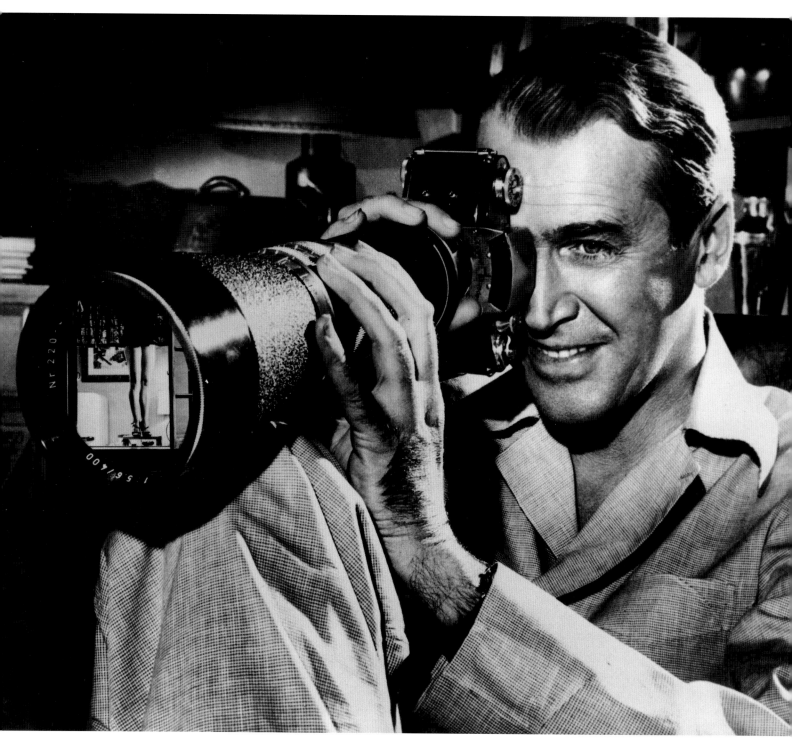

Alfred Hitchcock
Rear Window, 1954

it is not for nothing that the spectator in her article is referred to unfailingly as "he." As an exemplary product of a masculinist ideology, cinema encodes this bias in its topographical system, fashioning an apparatus that reproduces the subject/object dialectics of patriarchal society — the subject male, the object female. Although Mulvey's revisions, like other authors' articles,[33] modify this position, allowing for specific films constructed from a feminine perspective, her text presents the Lacanian view that woman in the patriarchal order does not represent but is, instead, represented; or, more properly, she is invariably positioned as the *object* of the male gaze. As castrated, lacking access to language and representation, woman, Mulvey wrote, is "bound by a symbolic order in which man can live out his phantasies and obsessions through linguistic command by imposing them on the silent image of woman still tied to her place as bearer of meaning, not maker of meaning." While the male finds in film sources of satisfaction and pleasure, the female spectator is excluded from the structure — or forced to participate in her own objectification, by masochistic identification with the masculine position.

"Visual Pleasure" engages both the orthodox theory of the apparatus and an account of the role of filmic devices in implementing patriarchal ideology. According to Mulvey, the active/passive sexual imbalance in the social world is reflected in cinema by the way in which the male spectator is acknowledged and reinforced through the visual coding of the female figure ("The determining male gaze projects its phantasy on to the female figure which is styled accordingly") as well as by the diagesis of the narrative, in which the male figure supports the conventional "active" role of "forwarding the story, making things happen," providing "a main controlling figure with whom the spectator can identify." The functioning of illusionistic narrative film, she observed, revolves around scopophilic pleasures elucidated by Freud — the inherently sadistic practice of voyeurism and the ego-gratifying identifications of narcissism. Through their control of the dimensions of time and space by editing and narrative, Mulvey wrote, "cinematic codes create a gaze, a world, and an object, thereby producing an illusion cut to the measure of desire."

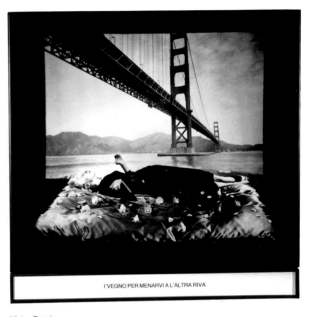

I'VEGNO PER MENARVI A L'ALTRA RIVA

Victor Burgin
The Bridge (detail), 1984
Les Impenitents, F.R.A.C. de Haute
Normandie, Rouen

Mulvey's stress on patterns of visual fascination is borne out by numerous filmic texts. For example, Alfred Hitchcock's *Rear Window* (1954) and *Vertigo* (1958), are structured around a psychoanalytically-informed notion of the look. In *Rear Window* the hero, Jeffries, is a documentary photographer who is confined by an accident to a wheelchair; he occupies himself by observing his neighbors through his apartment window, thereby extending his professional capacities of surveillance. As Jean Fisher has written in an analysis of Burgin's *The Bridge* (1984) — a six-part photoconstruction based on *Vertigo* — Jeffries's voyeurism is expanded through prosthetic devices such as binoculars and telephoto lenses which equate his viewing position with that of the camera. In fact, as Mulvey and others have remarked, *Rear Window* serves as a metaphor for the cinema, in which Jeffries's vision approximates the audience's and the events occurring in the apartment opposite are aligned with those projected on the screen. The object on which Jeffries's voyeurism is ultimately trained is a woman — Lisa — and his desire for her is a function of her distance. Lisa, then, functions as a substitute for a lost object whose recapture is a motor of Jeffries's desire. *Vertigo* engages this active/passive duality in a more complicated plot, employing as its protagonist a male detective similarly in pursuit of a feminine ideal. Hitchcock's blowzy heroine, Madeleine/Judy, played by Kim Novak, serves as an idealized image of woman — woman as image — with whose fantasized conquest the (masculine) viewer is invited to identify.

Barbara Kruger
Untitled (It's A Small World), 1990
The Museum of Contemporary Art,
Los Angeles

Mulvey's paper proposed a radical negation of the ease and plentitude associated with cinematic narrative, arguing that "cinematic codes and their relationship to formative external structures ... must be broken down before mainstream film and the pleasure it provides can be challenged." The effect of this proposal has been both indirect and specific; it is echoed, for example, in the art practice of Barbara Kruger, who has voiced her wish to "welcome the female spectator into the audience of men" in a retort to the obliterating impositions of masculine culture. Kruger's strategies consist in superimposing mass-produced photographs with contradictory verbal texts so as to block the observer's identification with the depicted image; what is important is not only her

work's distance from the art-historical traditions of collage and photomontage but, more importantly, its operation as an interrogation of unwritten assumptions of Western *visual* culture.

Kruger's practice, among others, points to the dissemination of psychoanalytically informed theories in the late 1970s and early 1980s, as psychoanalysis developed broadly as a tool to analyze the spectator's psychic investment in images. This was evident in England and, increasingly, in the United States, where a small but consistently polemical strain of visual arts practices arose. Many of these early efforts were collected in the travelling exhibition, "Difference: On Representation and Sexuality," that was organized by The New Museum of Contemporary Art in New York in late 1984. In retrospect, the exhibition is notable less as a comprehensive survey than as historical testimony of a specific and important moment of confluence between political feminism, psychoanalysis, and visual arts practices. Exemplary among these practices is the work of the American artist Silvia Kolbowski, whose early art examined women's subjection to the controlling male gaze, as well as Burgin's analysis of the psycho-sexual illuminations discernible in texts extending from Freud's writings to Hitchcock's films. In England, Burgin's efforts were redoubled by a group of artists, ranging from Kelly to Ray Barrie to Yve Lomax, who scrutinized and challenged the processes of the social structuring of sexuality, both masculine and feminine. In film, the work produced in the early seventies by Chantal Akerman, Yvonne Rainer, Marguerite Duras, and other women found staggered replies in films by Mulvey and Peter Wollen, Sally Potter, and Candace Reckinger, among others, in which meandering or fissured narratives and interruptions between image and sound provided devices to refute the fixed paradigms of sexual identity imposed through cinematic codes. In this "counter-cinema," as the film writer Claire Johnston called it, women's discourse is shown to be a debate with dominant culture, contesting its arbitrary restriction of feminine sexuality.

Retrospectively, Mulvey's article contributed to what both Burgin

Michael Powell
Peeping Tom, 1959

and Joan Copjec have described as a "Foucauldization" of psychoanalytic theory,[34] a false conflation of the domains of physiological optics and psychological space that we will turn to shortly. Led on by the concept of the apparatus and its corresponding description of the gaze, looking has been equated with objectification, and objectification with domination — a simple formulation that finds its cinematic apogee in Michael Powell's *Peeping Tom* (1959), in which the voyeur/protagonist kills his female victims using a weapon attached to his camera. The result of this panoptic definition of the gaze, as Doane remarked in an article from 1981, is that the mere "gesture of directing a camera toward a woman has become equivalent to a terrorist act,"[35] impelling many to argue (following Doane) that the woman's body should be placed "in quotation marks" — *outside* of representation. But if Mulvey's project contributed to the hypostacization of the gaze as a metapsychological concept, it also described both the conditions and conditioning of woman's visibility under patriarchy, as exemplified by mass media texts. For there is no doubt that our society places the major responsibility on women to produce an image to be seen. Moreover, Mulvey's article encouraged a realization of the impure pleasures of looking that deflate modernism's preoccupation with the purity of vision, therefore eroding its primacy.

While attention has been focused on Mulvey's elucidation of Freud's discovery of the sexual pleasures of voyeurism, the implications of his correlative interest — fetishism — have been less remarked upon. In clinical terms, the fetish is the object with which the traumatized male would "complete" the woman. It is consequent upon the castration complex and, somewhat illogically, serves as its commemoration, marking what would be concealed, abolished; as the analyst Mannoni observed, "the *Verleugnung* of the maternal phallus sketched the first model of all repudiations of reality, and constituted the origin of all those beliefs which survive their contradictions in experience."[36]

Josef von Sternberg
The Scarlet Empress, 1934

Victor Burgin
The Bridge (detail), 1984
Les Impenitents, F.R.A.C. de Haute
Normandie, Rouen

Such disavowal is expressed either through substitution — fixation on a single object that compensates for absence — or, conversely, through building an image into an imaginary unity, an elaborate whole, a fiction satisfying in and of itself. The latter path is taken by mainstream film in its cultish elaboration of the "perfect" beauty of the female star as a kind of substitution/echo of the phallic mother. The idealization of woman functions as a means of allaying anxiety, of making her, as Mulvey suggests, "reassuring rather than dangerous."

That fetishism is a masculine project is questioned in Kelly's *Post-Partum Document*, whose multiple parts incorporate or evoke the substitutes the mother deploys to deny separation from her child. Barbara Bloom has also examined the fetishistic representation of the female body in advertising as well as in domestic environments, pointing to the scope of our erotic investment in objects. Inasmuch as all representation is fetishistic in its claim to compensate for absence, the late critic Craig Owens extended the scope of our visual imagery: Is it not possible, he proposed, that visual culture is "a means, perhaps, of mastering through representation the 'threat' posed by the female?"[37] The image is linked to fetishism through a disavowal that maintains the subject's imaginary unity against the reality of its division. Mulvey has cited the films of Josef von Sternberg for their production of a moment in which "the beauty of the woman as object and the screen space coalesce," resulting in "the image in direct erotic rapport with the spectator."[38] Such fantasized moments of coincidence between seer and seen are foundational for the Western subject of consciousness. A similarly fetishistic motive, however, may underlie our psychological attraction to complex, reticulated, unified objects — images whose coherence impels our delusory identification with them, inviting satisfaction, plentitude, pleasure. Furthermore, it may support our investment in theories that support this ideology of unity, notably the modernist valorization of immediacy, "unified fields," and "good composition" that maintain the subject's transcendent mastery over the visual field.

Lacan rejected this transcendence as delusion: the subject, he said, could be identified only inadequately in an incessant play of images that

Cindy Sherman
Untitled Film Still #54, 1980

concealed a fundamental non-identity. It was because the limit of language was unattainable that the process was interminable. Lacan applied this proposition to sexuality where, he said, there was no sexual relation: the inherent partiality of subjects did not allow them to be synthesized, as in the ideology of sexism, into opposing fields that resolve themselves in the unity of the heterosexual couple (a proposition that Burgin amplifies in *The Bridge*, arguing that no "bridge" or "junction" fuses established sexual poles). Instead, Lacan described a situation in which resolute certainties — clear sexual "positions" — cede to incompleteness, irresolution, *contingency*. Sexuality resulted in masks, covers, appearances, or what he referred to as *donner-à-voir* — "the intervention of an 'appearing' which gets substituted for the 'having' so as to protect it on one side and to mask its lack on the other."[39] Lacan followed Joan Rivière in describing femininity as compensation and cover: "It is in order to be the phallus, that is to say, the signifier of the desire of the Other, that the woman will reject an essential part of her femininity, notably all its attributes, through masquerade."[40] All femininity, then, is representation, display, a form of phallic spectacle (a process that finds an artistic expression in the *Untitled Film Stills* by Cindy Sherman, where multiple images and poses drawn from cinematic referents are interchangeable masks covering a non-identity). However, Lacan indicated the complement of masquerade in the masculine display of the "parade," which consists in the assertion of the phallus to support the *illusion* of having it. The psychoanalyst Eugenie Lemoine-Luccioni has glossed this concept: "If the penis was the phallus, men would have no need of feathers or ties or medals.... Display [*parade*], just like the masquerade, thus betrays a flaw: no one has the phallus."[41] The phallic function thus produces a failure on each side, but no symmetry between them. Lacan observes that as a function of this miming around an absence, the "ideal or typical manifestations of behavior in both sexes . . . are entirely propelled into comedy."[42]

Now in accentuating the fundamental *failure* of sexuality and its consequently interminable production, Lacan presents a view that is radically different from the varied theories of the apparatus and vision that are predicated on the Imaginary pure and simple. For by stressing the

unattainability of the phallus, Lacan opposes attempts to "fix" sexuality according to the established poles of sexual difference, renouncing with them the subject positions that the theory of the apparatus constructs. Indeed, recent writing has looked to Lacan's late seminars to contest what is most problematic in apparatus theory — its unvarying production of the transcendent, masculine subject at the head of the filmic machine.[43] This determinism in the theory has been traced back to its organizing spatial logic which restricts subjectivity to a single site — the gaze of the spectator/camera — excluding the destabilizing, disorganizing force of desire within the perceptual field. In this manner, apparatus theory, while theorizing a specific techno-historical moment, is strangely ahistorical, producing an inflexible eternal subject for the field that it surveys. Its problem, as Doane writes, is its very infallibility.[44] This is its inhering "pessimism," to which is opposed the discursive, differing, identity-deferring practice of film as a psychic process. And, in a related manner, the geometric visual paradigm on which the apparatus relies has been questioned for its replication of the Western subject of consciousness, ignoring the vital role played by fantasy and the unconscious in encounters with images and objects.

Lacan's late writing subtly refutes this presumption of mastery, describing vision as a dialectic between optical and psychical space that results in a conflictual, rather than stable, subject. He titled one chapter of *The Four Fundamental Concepts of Psycho-Analysis* "The Split between the Eye and the Gaze," stressing "the total distinction between the scopic register and the invocatory, vocatory, vocational field"[45] (which, he stated elsewhere, is "simply the mapping of space, not sight"). In this scopic register, in which the visual field is penetrated by desire, the security of the Imaginary is threatened by the phallic function. Lacan remarks on such scopic "fascination" in "What is a Picture?," observing that "it is in so far as all human desire is based on castration that the eye assumes its virulent, aggressive function."[46] The gaze of the Other, which Lacan designates as *objet a*, operates much like an evil eye or *fascinum* (which, in its Latin etymology, means both a "bewitching" and an "amulet in the shape of a phallus"). In the scopic field, then, the

subject's vision is penetrated by a gaze that pre-exists and surrounds it, so that the individual is not so much the subject *of* vision as the subject *in* vision, the subject who is, most properly, vision's object rather than its cause:

> In the scopic field, the gaze is outside, I am looked at, that is to say, I am a picture.... the gaze is the instrument through which light is embodied and through which — if you will allow me to use a word, as I often do, in a fragmented form — I am *photo-graphed*.[47]

This gaze, as has been noted, "is in no way the possession of a subject."[48] Rather, it functions like the lamp of a projector, flooding the viewer with a blinding light — "dazzling, pulsatile," to quote Lacan — that surrounds him or her, and in whose path the viewer serves as an intervening obstacle, casting a shadow on the screen.[49] Inasmuch as the viewer cannot see the source of the light, there is no presumption of mastery; rather, it is the gaze that masters the subject. And, in opposition to the Kantian paradigm, by which vision is disincarnated and, thus, disinterested, vision is made a function of the viewer's bodily location. The viewer becomes a part of the picture, eliding the distance that geometrical perspective maintains between subject and object. Lacan diagrams this visual field as the dialectical interpretation of two pyramids, locating the subject function within them, in the intersection of vision and desire. In this manner, the Western philosopher's subject — the subject presumed to know — is unmasked of his presumptions.

"I am not that punctiform being located at the geometrical point from which the perspective is grasped."[50] If Lacan's mirror stage has been taken as foundational for a theory of vision, his later work revises the image, redefining the mirror as a screen.[51] This, at least, is the position that the image occupies in Lacan's diagram, as it blocks the Other from the subject, occluding the subject's view, and refusing to yield to its desire for Absolute meaning. In this manner, the image functions neither as a mirror, confirming the subject, nor as a transparency (as in the other paradigm of modernism) giving onto meaning. Instead, it registers

our uneasy feeling in every act of looking that there is something beyond, and masked by, what we actually see. Lacan describes the essence of vision as that "slippage" that eludes the grasp of the controlling consciousness:

> In our relation to things, in so far as this relation is constituted by the way of vision, and ordered in the figures of representation, something slips, passes, is transmitted, from stage to stage, and is always to some degree eluded in it — that is what we call the gaze.[52]

It goes without saying that the apparatus cannot theorize this slippage from the vantage of geometrical perspective.

As Copjec has written, Lacan's tale of the sardine can serves as a humorous correction of the mirror-stage vignette, a deflation of the Hegelian mastery that it presumes. In the tale, Lacan is afloat in a boat at sea, searching for some transcendent revelation. Nothing happens, nothing appears on the horizon, except for the materialization of a small, bobbing, glimmering can, an anti-mirror for an anti-hero. "You see it," says one of Lacan's fisherman-companions. "Well, it doesn't see you." There is no transcendence and no transparency, no acknowledgement of the viewing subject; instead, "the horrible truth," Copjec observes, "is that *the gaze does not see you*." Rather than founding and empowering the subject, Lacan's gaze "is located 'behind' the image, as that which fails to appear in it and thus as that which makes all its meanings suspect. And the subject, instead of coinciding with or identifying with the gaze, is rather *cut off from it*."[53]

Lacan's screen represents the materiality of the signifier, of language, as that which is always imperfect and inadequate, an opaque veil separating the subject from its intention, the meaning it would aim at. However, this gap or non-coincidence is not merely spatialized; it is also psychologized, made a function of an invisible and inherently non-spatial limit to language, desire. Here there is no confusion between optical and psychical space, between the visual object that we might apprehend and the psychoanalytical object that eludes our grasp. Moreover, the failure at

Cindy Sherman
Untitled Film Still #65, 1980
The Museum of Contemporary Art, Los Angeles
Purchased with funds provided by the friends of
Marsha Kleinman in her memory

the core of language is not regarded as a loss[54] (the human subject, Lacan says, knows how to isolate the function of the mask and to play with it, a process that leads to literature, culture, sexuality) but rather as the source of its productive logic. It is because the subject is cut off from what would complete it that language devolves into endless substitutions, into verbal and visual multiplicity and identity-deferring change that elude the definitions — sexual and otherwise — of society. Words fail and, with them, all those images by which the subject would represent itself to and for that order. And, similarly, the categories of visibility by which we might define our location within that order are inherently problematized.

In his late work, Lacan abandoned his two-dimensional geometrical models for impossible, complex topologies — spaces that have neither insides nor outsides nor clearly demarcated boundaries. These figurations of the unconscious's dynamism cannot be "mapped," nor, indeed, can they be apprehended through logic; instead, they configure what eludes the complete or secure grasp of rational systems of analysis. Lacan's diagrams frame an injunction to theory to reconsider its totalizing force, by which it constitutes the field that it surveys, instituting order where it is not. They are matched in the contemporary practices of Barry, Kruger, and others who attempt to reinscribe the multiple and illogical dimensions of the body into the visual field. More generally, however, these efforts frame an imperative to us to re-examine the complexity of vision, acknowledging that when we see simply, we simply see. Perhaps that is what it has taken us twenty years to apprehend.

Cindy Sherman
Untitled Film Still #43, 1979

Derek Jarman
Caravaggio, 1986

Notes on Film and Painting

Robert Rosen

In looking at the relationship between film and painting, it might seem logical to look primarily to the experimental avant-garde. It is not by accident that cross-media critical writing on cinema and the fine arts has drawn its examples overwhelmingly from the creative work of independent filmmakers. It is here that one would reasonably expect to find an agenda of formal issues — structural, representational, and self-reflective — common to both art forms. One might also expect to find here evidence of direct mutual influence — the impact on film of artistic movements such as Surrealism, Futurism, and Abstract Expressionism, and, conversely, the impact on painting of cinematic experiments in visual composition, kinesthetics, and the iconography of mass culture.

By contrast, the relative scarcity of analytical writings comparing painting with commercial narrative cinema reflects an underlying doubt that meaningful and productive relationships could possibly be found linking two such fundamentally different media. It might appear at first glance that any attempt to find common ground between such radically different modes of expression would be at best forced, at worst futile. Above all, the chasm that ostensibly separates high and low (popular) culture appears to be unbridgeable. Serious painting, like avant-garde film, is intended to be exhibited to critically aware viewers, often in museum settings; mainstream narrative film is destined to be screened in theatrical settings to a socially heterogeneous paying public. Works of fine art are characteristically created, consumed, and commented upon in integrated arts communities; commercial cinema is more frequently produced in self-sufficient industrial or protoindustrial environments. The term "entertainment" is rarely applied to the fine arts. It is inescapably wedded to the movies.

Why, then, focus on the ostensibly self-defeating area of commercial narrative cinema? This course is based on the fundamental premise that, however problematic and obliquely mediated the relationship may be,

William Wyler
The Best Years of Our Lives, 1946

popular narrative cinema and modern painting are necessarily inter-twined, both historically and aesthetically. In an age of mechanical reproduction of images and rampant commodification of culture, it is virtually unavoidable that widely disparate representational practices should intersect. It would seem reasonable to assume that all forms of artistic expression, be they elite or popular, are necessarily responsive to common cultural, social, and political forces. The omnipresent webs of communication that interlace all sectors of mass society ensure increas-ing interchange among all cultural strata and make it extremely unlikely that any realm of creative endeavor could operate hermetically sealed from outside influence.

What follows are some preliminary reflections on the relationship of film to painting — impressionistic notes of a cinematheque programmer searching for concepts and film titles that would most effectively convey the expressive challenges and aesthetic strategies common to both media.

Representing depth on a two-dimensional plane

Painters and filmmakers face the common challenge of conveying an illusion of depth on a two-dimensional plane. In meeting this challenge both may choose to strive for realistic representations of dimensionality — the painter empowered by the rules of perspective and the filmmaker by appropriate lens selection. To that end, both must strategize the organization of objects across and into the frame and must maximize the expressive uses of internal framing and light and shadow. Conversely, both may choose to willfully distort realistic perspective for expressive purposes — the choice by a filmmaker of a fish-eye lens for surrealistic deformation or a telephoto lens to flatten an object into its background.

Why, then, focus on the ostensibly esthetic purposes and not merely a stylistic adornment? In William Wyler's *The Best Years of Our Lives* (1946), for example, the audience's attention and emotional empathy is torn between two powerful images within the same frame — looming in the foreground, a war veteran whose hands were lost in combat now learning to play piano using his prosthesis, and far in the background, his closest friend in a telephone booth in an emotional break-up with the

woman he loves. The interplay of foreground and background spaces creates an emotional and cognitive dialectic that liberates the spectator from submission to a linear text and instead invites reflection. Wyler's use of composition in depth exemplifies a point of convergence between long-established traditions of Hollywood illusionist cinema and the radical redefinition of spectator to spectacle central to modernism in the fine arts.

Representations of depth in film and painting diverge significantly in several important areas, notably the illusion that a film spectator has of entering into the frame as the result of camera movement or the use of a zoom lens. The allure of vast spaces deep into the frame is experienced by viewers of George Lucas's *Star Wars* (1977) as well as of Alfred Hitchcock's *Vertigo* (1958), in which the impact is viscerally palpable as the camera and the zoom lens move simultaneously in opposite directions.

Difference in the perception of depth also results from the ontology of the photographic image — an unavoidable predisposition toward realistic representation that can be displaced in part by compositional strategies, special effects and lens selection, but never fully eliminated. Totally created images such as animation, however, are free from this limitation. The emergence of UPA cartoons in the 1950s, in their rejection of Walt Disney's strivings for realism, represented an important convergence of commercial filmmaking with currents of modernism in the arts. Instead of imitating Disney's penchant for full-character animation and the studio's vaunted use of the multi-plane camera to achieve illusions of depth, cartoons such as *Gerald McBoing Boing* or *Mr. Magoo* went in the direction of abstraction: an eager embrace of flatness on a two-dimensional plane, minimalist graphics, and a self-reflective turning toward sound and sight as their subject matter.

Working within the limitations of a frame

Paintings and films are circumscribed by frames — clearly defined boundaries, most frequently taking the form of a rectangle, that physically separate a work from its surrounding environment, starting with the exhibition site itself and extending out to the broadest social context.

Robert Cannon
Gerald McBoing Boing, 1950

Alfred Hitchcock
Vertigo, 1958

The inescapable fact of the frame at once establishes the parameters of a creative terrain and serves as a discomfiting limitation — a challenge to fulfill the potential of a pre-established space and a troubling embarrassment that compromises the self-sufficiency of a work.

The artist may choose to minimize a viewer's awareness of the frame. To that end film has certain built-in advantages. Unlike paintings displayed on the walls of a well-lit gallery, films are shown in theatrical settings on larger-than life screens surrounded by darkness. The monumentality of the image situates the edges sufficiently close to the outer limits of peripheral vision as to become operatively invisible. The neutrality and anonymity of the darkness passively cedes hegemony to brightly lit images and booming sounds within the frame. The power of total immersion in the image is accentuated in widescreen formats — the battle scenes in Stanley Kubrick's *Barry Lyndon* (1975) or Akira Kurosawa's *Ran* (1985) are cases in point. In an anticipation of widescreen formats during the silent era, the French director Abel Gance devised a breathtaking panorama using three separate screens.

Surrendering to the frame's inescapable presence, a filmmaker or artist may choose to flaunt rather than deny its existence. Conventional film formats, for example, carry with them associative meanings that can be foregrounded as part of the narrative. The use of the 1 x 1:33 frame ratio by Francis Ford Coppola in *One From the Heart* (1982) evokes nostalgia for the era of classic Hollywood filmmaking. George Miller's insertion of classically formatted black and white segments into the full-color and widescreen *The Road Warrior* (1981) brings associations with the documentary realism of theatrically presented newsreels.

Compositional strategies such as the use of framing within the frame draw viewers' attention into the body of a work, thereby lessening awareness of the outer boundaries. More positively, however, internal framing is also a highly expressive way to evoke feelings and to constitute meaning. The long shot of John Wayne emerging from the desert framed by the door of a homesteader's cottage in *The Searchers* (1956) conveys in its form the narrative opposition of the wilderness and the garden so central to the mythology of the western. The image of a nervous young

Abel Gance
Napoleon, 1929

man being seduced by an "older woman" in Mike Nichols's *The Graduate* (1967) is conceptually as well as cognitively framed by shooting through Mrs. Robinson's arched leg.

Most frequently, however, filmmakers and artists neither negate nor celebrate the existence of the frame but choose instead to create a dialectical interaction between what is inside and outside its boundaries. Offscreen or off-frame space can be recruited into a work through a wide array of techniques suggesting physical extension beyond the limits of the visible image, or by organizing a disturbing compositional imbalance within the frame lines to suggest a satisfying completion beyond its boundaries. Frequently a human off-frame gaze is used to imply the existence of an encompassing world.

Filmmakers can also draw on movement and sound to energize offscreen space. Camera mobility — pans, tilts and traveling shots — and editing practices such as cutting on movement in a uniform direction both serve to interlace on-screen and offscreen space into a seamless continuum. Offscreen sound has the potential to evoke intense empathy for events hidden from sight that we are compelled to imagine. What we see through the camera in a scene from Theo Angelopoulos's *The Traveling Players* (1975) is a static long-take of an empty hallway, but what we hear coming from off-frame are the sounds of a brutal beating.

Narrative

In contrasting painting and popular cinema, the difference that looms largest is the relative centrality of narrative practices in film as opposed to formal or stylistic concerns. To be sure, practitioners in both media have over time created works ranging from the melodrama to the purely abstract. But overall the major currents of artistic modernism have tended to marginalize the importance of storytelling, while cinema has placed it at the center. Filmmakers creating works for theatrical distribution may draw on a broad range of artistic endeavors that include writing, performance, design, musical composition, editing, and cinematography, but in the final analysis it is narrative that creates a whole that is greater than the sum of its parts.

This difference noted, film and painting nevertheless display intriguing points of convergence, among them the inescapability of narrativizing spectators. Even in the face of totally nonrepresentational works, viewers have a powerful urge to uncover or invent narrative — a basic need to normalize the challenge of the unfamiliar by situating it in a comfortably recognizable sequence of events. The "storyline" may be the relationship of the work to the history of the artist or even the vagaries of the art market. But painting, like film, establishes an interactive viewer-object relationship that invites intertextual and contextual elaboration.

Point of View

Both painting and film strive to define and control a spectator's point of view, by means of such elements as the length of viewing time, the sequencing of images, the location of the subject matter in space and time, and the perspectives for subjective participation. Given the attributes specific to each medium, however, the results differ dramatically.

Because narrative film is intrinsically a series of shots sequenced over time, the filmmaker exercises virtually absolute control over the duration of a spectator's involvement with a work and over the sequencing of the spectator's involvement with the images as well. Be it the rapid-fire montage and time distortions of the Odessa Steps sequence in Sergei Eisenstein's *Potemkin* (1925) or the legendary long take that opens Orson Welles's *Touch of Evil* (1958), the nature of narrative requires that a spectator follow a pre-established, subjective trajectory through a work. For the painter, however, the means to control a spectator's involvement in a work are necessarily more oblique — the use of compositional strategies and visual complexities that indirectly coax a viewer through an ideal duration and sequencing of viewing perspectives.

Narrative exposition also requires that the film text provide a spectator with readily readable indicators as to where the diegesis is situated in time and space at every moment of its development. Conventionalized signifiers are used to announce temporal alterations such as flashbacks or flashforwards or to smooth over shifts in geographic location. Editorial

Alfred Hitchcock
Spellbound, 1945

cues and special effects signify shifts in psychological space as well, including dream states, insanity, or drug-induced hallucination. The cautious framing of Salvador Dalí's surrealistic dream sequence in Alfred Hitchcock's otherwise illusionist rendering of *Spellbound* (1945) is a case in point. Luis Buñuel's disarming use of a dream within a dream sequence in *The Discreet Charm of the Bourgeoisie* (1972) playfully subverts and thereby calls attention to established representational practices.

While a painting or film can mediate a spectator's entrance into a work through one or several points of view, it is highly unusual for stories on film to be told through only a single voice. The omnipotently self-willed cameras in Miklós Jancsó's *Red Psalm* (1972) or Hitchcock's *Rope* (1948) are exceptions that prove the rule. More characteristically, the complex requirements of film narrative call for an orchestrated interplay of multiple viewpoints — a voice-over narrator with an ax to grind, a voice-of-god narrator with omniscient objectivity, a neutral fly-on-the-wall camera, an unapologetically biased camera, the subjective viewpoints of one or several of the characters in the story, or the reality constructs covertly built into the plot's structure by its author.

Self-reflexivity

Contemporary painting and film have converged in their frequent expression of modernism's powerful impulse toward self-reflexivity — the turning of an art work's focus back onto itself so as to reveal and comment upon its construction or formal attributes. Debate on whether a medium's concern with exploring itself is an act of radical deconstruction or narcissistic self-indulgence fails to draw distinctions among four basically different representational practices in pursuit of four different and frequently exclusive objectives.

The first practice is at the heart of modernism's subversive agenda — the problematizing of a particular work's formal attributes in a manner

Federico Fellini
8 1/2, 1963

that implicitly challenges the medium's conventional practices. Contemporary painting has called into question virtually every aspect of past practices, notably the realistic or naturalistic representation of color, form, texture, and socially recruited iconography. Given its anchoring in realistic representations of the photographic image, narrative film has necessarily been more circumspect in the scope of its formal auto-critique, tending instead to challenge the hegemonic practices of Hollywood's illusionist cinema — the transparent visual, auditory and performatory strategies intended to establish the credibility of on-screen images as the equivalent of real life.

A second, closely related, self-reflexive practice is to reveal a work as the result of intentioned creative construction — its self-announcement as a subjectively shaped interpretation of experience. Though not incompatible with the goal of problematizing the formal attributes of the media as a whole, an open display of the facts of construction calls into question, more specifically, the relationship of spectator to spectacle. Instead of passive surrender to a work entirely on its own terms, a spectator's awareness of its subjectivity serves as a structurally embedded invitation to critical dialogue.

Alone or in combination, these self-reflexive practices are embodied in a wide array of narrative films. Federico Fellini's *8½* (1963) equates an individual's quest for self-identity with the writing and directing of the film we are seeing. Frank Tashlin's *Will Success Spoil Rock Hunter?* (1957) or Jerry Lewis's *The Nutty Professor* (1963) challenge conventions of Hollywood realism using stylistic strategies imported from cartoon animation. Kurosawa's *Rashomon* (1950) explores the relativism intrinsic to personal narrative and Jean-Luc Godard's *Week-end* (1967) uses the intrusion of written text as a distantiating provocation. The line separating spectator and spectacle is broached in Buster Keaton's *Sherlock Jr.* (1924) as is the boundary between spectatorship and voyeurism in Michael Powell's *Peeping Tom* (1959). Cartoon animation's license to ignore all conventions, even the laws of gravity, frees Chuck Jones to bravely explore the perils of film space in *Duck Amuck* (1953).

Chuck Jones
Duck Amuck, 1953

A third self-reflexive practice particularly applicable to commercial film takes the form of metatextual commentary on generic narrative formulas. The emergence of the "adult western" in the 1950s was an implicit critique of the ideological baggage carried by the classic westerns of the pre-war period. In Stanley Kramer's *High Noon* (1952) there is a breakdown in the formerly taken-for-granted natural harmony between personal and community identity. George Stevens's *Shane* (1953) challenges the myth of the lonesome cowboy; Sam Peckinpah's *The Wild Bunch* (1969), the western's codification of violence, and Robert Altman's *McCabe and Mrs. Miller* (1971), the conventions of generic realism. For the western, like many other genre forms, self-reflexivity takes the form of a provocative interplay of two types of pleasure: the comfort found in the familiar and the excitement resulting form the subversion of expectations.

The three forms of self-reflexivity discussed thus far are all implicitly or explicitly confrontational, the fourth is not. All films are self-reflexive to the extent that they implicitly allude by their example to narrative forms, iconography, or stylistic conventions already established in previous work. Unless it is the first film they have ever seen, spectators necessarily view and "read" a given work within the framework of a film literacy acquired from the sum totality of their past experience with the medium.

Intertextual self-referentiality is intrinsic to a narrative medium that is highly conventionalized, prolific in its output, and easily accessible to its consumers. As a self-reflexive strategy it is as likely to be used to reaffirm conventions as to challenge them. Thus a Hollywood studio-crafted film that takes filmmaking as its subject matter, such as Vincente Minnelli's *The Bad and the Beautiful* (1952), can be self-reflexive without revealing anything of itself. Instead, it self-confidently celebrates and reaffirms the pleasures and sufficiency of the culturally dominant film language and its mode of production.

Vincente Minnelli
The Bad and the Beautiful, 1952

Francis Ford Coppola
One From the Heart, 1982

Color, Texture, Light, and Shadow

The core creative decision on the expressive use of color required of both painters and filmmakers is whether color choices are to be guided by the exigencies of realism, fantasy, emotional resonance, or a quest for symbolic or intellectual signification. The color scheme of Warren Beatty's *Dick Tracy* (1990) relies on supersaturated non-naturalistic colors as an intertextual homage to the graphic boldness of comic book art. Terrence Malick in *Badlands* (1973) uses a far more subtle reliance on primary colors to signal sub-textual semiotic musings on the politics of media that lie discreetly hidden beneath the genre conventions of a violent road movie. The hard-edged colors in Douglas Sirk's *All That Heaven Allows* (1955) are used to contrast the surface tranquility of the 1950s suburban life with the profoundly troubled emotional life of the film's protagonist. The use of flash framed, understated color in Altman's *McCabe and Mrs. Miller* is a rejection of the romanticism associated with the look of Technicolor, while Coppola's use of colored lighting in *One From the Heart* (1982) is intended to evoke it. For symbolic purposes Michelangelo Antonioni used dyes to intensify the green coloring of the grass lawn in *Blow-Up* while Martin Scorsese, for similar reasons, rejected color entirely in *Raging Bull* (1980). Steven Spielberg went for a mixture of the two by strategically inserting bits of life-like color into the midst of the black and white nightmare of *Schindler's List* (1994).

For painters, the representation of light and shadow has always been a major preoccupation; for filmmakers it is the element without which the medium would quite literally not exist. The central challenge for theatrical filmmakers in particular is to use light and shadow evocatively and expressively in the service of narrative. The moral ambiguities at the core of film noir genre films such as Billy Wilder's *Double Indemnity* (1944) and Welles's *Touch of Evil*, or the spiritual angst of Ingmar Bergman's *The Seventh Seal* (1957), are conveyed primarily through interplays of light and dark. The psycho-sexual fears underlying Joseph Losey's *The Servant* (1963) and F.W. Murnau's depiction of the vampire in *Nosferatu* (1922) are evoked by menacing shadows on a stairway wall.

Orson Welles
Touch of Evil, 1958

Martin Scorsese
Raging Bull, 1980

The use of texture would seem to be limited to painting — the physicality of brush strokes evident in the original work that at once shape a viewer's emotional responses and serve as enduring artifacts of the artist's creative presence. Film, by contrast, even in its final form for exhibition, is already a reproduction several generations removed from the original and effectively devoid of tactile presence — a projection of light and shadows on a flat screen that must use visual style to evoke texture inferentially. In *Morocco* (1930), Josef von Sternberg uses soft focus, diffuse lighting, filters, scrims, and rays of light streaming through grated windows to achieve results ranging from romanticized close-ups of Marlene Dietrich to richly textured walls and surfaces. Kurosawa is masterful in using cinematography, lighting, composition and set design to evoke multi-textured realities — the feel of oil painting evoked through extreme close-ups and special effects technologies in *Akira Kurosawa's Dreams* (1990) and the feel of wood, textiles, and natural materials in *The Seven Samurai* (1954).

And More...

A comparison of the formal elements common to film and painting can be complemented by identifying key points of conjuncture that are more strictly historical or thematic. Three areas in particular pose intriguing questions for further inquiry: filmic representation of painting and painters, film's problematizing of modernism and the direct influence that painting has had on film directorial decision-making.

In viewing films that take real painters as their subject matter, such as Minnelli's *Lust for Life* (1956), Altman's *Vincent and Theo* (1990), or Derek Jarman's *Caravaggio* (1986) several questions inevitably follow. Is historical authenticity compatible with the narrative requirements of popular film, and if so, how are the two goals mediated in practice? Can an artistic medium, such as painting, be visually represented through the formal language of another medium, such as film, without compromising the integrity of its aesthetic, and, if so, by means of what formal strategies?

One could also question the depiction of art as a fictional element in a wide array of film genres. Film noir in particular has had a strange

Akira Kurosawa
Akira Kurosawa's Dreams, 1990

dualistic relationship to modernism, on the one hand turning to German Expressionism for its visual aesthetic and to the avant-garde for its form-breaking iconoclasm, and on the other hand vilifying modern painting as deceptive in Fritz Lang's *Scarlet Street* (1945) and downright dangerous in Robert Aldrich's *Kiss Me Deadly* (1955).

Finally, there are questions to be asked about the many instances when painting has had a direct and documentable impact on a film's look or content. How do directors such as Buñuel with a background in the avant-garde integrate their past experiences with the requirements of commercially-based narrative film production? How did German Expressionism come to enter mainstream Hollywood production in the form of film noir? What are the formal attributes of the hybrid forms that result from the self-conscious introduction of painterly styles into film, such as Coppola's use of classical composition and renaissance lighting in *The Godfather* (1972), or Kubrick's homage to eighteenth-century neo-classicism in *Barry Lyndon*?

What relationship does aesthetic delight have to intellectual insight,

emotional gratification, or ideological challenge? To what extent does the monumentality of an image, the viewing context, or the centrality of narrative fundamentally differentiate the meaning of pleasure from one medium to another? These questions and others are implicitly posed by formalistic analysis, but not necessarily answered. The goals of this essay were more modest in scope — to provide audiences with tools for more critically self-conscious viewing experiences.

Robert Aldrich
Kiss Me Deadly, 1955

Dr. Mabuse and Mr. Edison

Jonathan Crary

In a 1988 interview with Serge Daney, Jean-Luc Godard surveys the life span of cinema. For him it is essentially "a nineteenth-century concern resolved in the twentieth."[1] He locates its last flowerings in Italian neo-realism, the Nouvelle Vague, and, finally, in the work of Rainer Werner Fassbinder. With the ubiquity of television, it was no longer a question of how one looked at the world, for television "quickly replaced the world and didn't look at it anymore."[2] Godard is, of course, only one of many in the last decade or two who have insisted that, even though films obviously continue to be made, their effects, their significance, the way they are consumed and produced now occurs amid such qualitatively different conditions that they bear only a depleted formal similarity to film in the first half of the twentieth century. Whether or not one agrees with Godard's historicization here, or with related arguments by others, one of the assumptions of his polemic is the instability and transience of cinema as a cultural form within modernity.

In spite of such reminders we nonetheless have a tendency, even a need, to articulate certain visual practices in terms of enduring formal structures or innate characteristics. Many analyses of film, television, and photography make these phenomenona into essentialized objects of analysis. There is also a persistent, and most often unexamined, Kantian prejudice that perceptual and cognitive capacities are ahistorical; that is, they are unchanging and permanent, and most significantly are independent of an external social/technological milieu that is in constant flux. Thus there are difficult historical problems in any attempt to posit anything more than a temporary subjective identity for a cinematic spectator, a television spectator and so on.

One has only to think of the influential meditations written in the 1970s on the philosophical and semiotic status of the photograph, which seemed so persuasive then, and of how they have been rendered quaintly obsolete by the spread of various digital techniques for image production.

Fritz Lang
The Thousand Eyes of Dr Mabuse, 1960

Omnia

The mimetic dimension of photography (actually challenged from the 1840s on) will perhaps one day seem like a peculiar digression within a larger trajectory of image making in the West. Television, partly because of the immediate physical presence of the TV set, seemed for several decades like a stable object when in fact the institutional relations of which it was a part were changing continuously during that time. But during the past ten years even the possibility of giving television a coherent identity has evaporated as monitors and screens of many kinds proliferate and intersect with a broad range of expanding flows and electronic networks.

Of course critical analyses of practices such as film, video or photography may at times need to work with synchronic assumptions or to pose provisional stable models for explanatory purposes, but a falsification occurs if such practices are treated as autonomous formal structures or independent visual media. They must also be thought of in terms of their inseparability from the intrinsic instability of larger processes of modernization.

More specifically, since the late nineteenth century, and increasingly during the last two decades, one crucial dimension of capitalist modernity has been a constant remaking of the conditions of sensory experience, in what could be called a revolutionizing of the means of perception. For the last hundred years perceptual modalities have been, and continue to be, in a state of perpetual transformation or, some might claim, of crisis. If vision can be said to have any enduring characteristic within twentieth-century modernity, it is that it has no enduring features. Rather, it is embedded in a rhythm of adaptability to new technological relations, social configurations, and economic imperatives. What we familiarly refer to as film, photography, and television are transient elements within an accelerating sequence of displacements and obsolescences, within the delirious logic of modernization. And by modernization I mean a process that is fully distinct from a notion of progress but which is instead a self-perpetuating, directionless creation of new needs and desires, new production, new consumption.

To step back for a moment to the late nineteenth century, it is worth

noting that it is just when the dynamic logic of capital begins to systematically undermine any stable or enduring structure of perception that capital simultaneously attempts to impose a disciplinary regime of attentiveness. The late nineteenth century is also when the human sciences, particularly the emerging field of scientific psychology, suddenly make central the question of *attention*. Attention was a problem whose importance related directly to the emergence of a social, urban, psychic, industrial field increasingly saturated with sensory input. Inattention, especially within the context of new forms of industrialized production and consumerism, begins to be seen as a threat and as a serious problem. It's possible to see one crucial aspect of modernity as a continual crisis of attentiveness: a crisis in which the changing configurations of capitalism push distraction to new limits and thresholds, with unending introduction of new organizations of sensory experience, new sources of stimulation and streams of information, and then respond with new methods of regulating but also productively harnessing perception.

By the late nineteenth century, capitalism in the West begins to spawn arrangements that require attentiveness of a subject in terms of a wide range of new spectacular tasks, but at the same time its internal movement was continually to dissolve the binding cognitive synthesis that was the basis of a disciplinary attentiveness. Part of the cultural logic of capitalism demands that we accept as natural switching our attention rapidly from one thing to another. Capital as high speed exchange and circulation is inseparable from this kind of human perceptual adaptability, and it imposes a regime of reciprocal attentiveness and distraction. The last decade has been a mere taste of the rapidity with which new forms of visual consumption will continue to supplant one another. Whether there are inherent social or psychic or even physiological limits to this acceleration remains to be seen.

One of the places where this particularly "modern" system of perceptual mutation can first be located is in the work of Thomas Edison. Edison stands not simply as a participant in the making of cinema but for a specific swerve that separates earlier nineteenth-century techniques of display, exhibition, and attention from what would follow in the twentieth.

What needs to be identified is not some sequence of optical devices running from the magic lantern, diorama, phenakistiscope, cinemascope, or 3-D movies to contemporary, head-mounted displays, but the emergence, beginning in the 1870s, of a new system of quantification and distribution. For Edison, cinema had no significance in itself—it was simply one of a potentially endless stream of ways in which a space of consumption and circulation could be dynamized, activated. Edison saw the marketplace in terms of how images, sounds, energy, or information could be reshaped into measurable and distributable commodities, and how a social field of individual subjects could be arranged into increasingly separate and specialized units of consumption. Now, the logic that supported the Kinetoscope and the phonograph—that is, the structuring of perceptual experience in terms of a solitary rather than a collective subject—is replayed in the increasing centrality of the VDT screen as the primary vehicle for the distribution and consumption of electronic entertainment commodities.

At the same time, Edison was one of the first to intuit the economic interrelation between hardware and software (i.e., the machines to make movies, the machines with which to view movies, and the movies themselves), establishing as he did enduring patterns of vertical integration of these spheres of production within a single corporation. Edison's first technological product, a hybrid teletype machine-stock ticker of the early 1870s, is paradigmatic for what it foreshadows in subsequent technological setups—the indistinction between information and visual images, and quantifiable flow as the object of consumption. Edison's understanding of some of the key systemic features of capitalism underscores the abstract nature of the products he "invented"; his work was about the continual manufacture of new needs and the consequent restructuring of the network of relations in which such products would be consumed. Steven Jobs, Bill Gates, et al. are simply later participants in this same historical project of perpetual rationalization and modernization. In the late twentieth century, as in the late nineteenth century, the management of attention depends on the capacity of an observer to adjust to continual repatternings of the ways in which a sensory world can be consumed.

Critics such as Siegfried Kracauer and Walter Benjamin brought the notion of "distraction" to the forefront of debates about the effects of cinema in twentieth-century mass culture. In a general way, their work, and much that followed, articulates distraction as a term opposed to the idea of a contemplative perception, a self-conscious apperception. Movies, as products of an incipient culture industry, seemed to signal the transformation of perception into a debased form of mere external stimulation, very different from an older, more sustained, self-aware modality of looking. In the context of music, a related distinction was made by others between "higher" (deeply attentive) and "lower" (distracted) forms of listening. In both cases works of high modernism were cited as examples in which some kind of purified, even ethically superior, perceptual engagement was possible.

But some of those in the nineteenth century who most deplored the "distracted" qualities of an emerging mass culture sought to push their own art in the direction of a kind of attentiveness remarkably close to what popular cinema would claim in the twentieth century, especially after 1930. For example, Richard Wagner's frustrations with the experience of music drama, of theater, in the mid-nineteenth century were in part about the general problem of inattentiveness — of spectators who were given multiple points of attraction, of theaters constructed so that audiences delighted in looking at themselves, at the orchestra, at the diverse social texture around them (which was the case with the variety show formats of early cinema as well).[3]

One aspect of Wagner's "reforms," incarnated in the design of Bayreuth, involved the transformation of the nineteenth-century theater into a protocinematic space.[4] Bayreuth diagrammed a new kind of viewing machine which more rigorously controlled the spectator's perceptual experience. It not only integrated the sightlines of the audience with the orthogonals of scenic space (eliminating the lateral views of older theater design), but also initiated the idea of near complete darkness as a way of heightening the intensity of lighting effects on stage. Wagner's insistence on lowering the orchestra out of sight is another part of the thoroughly "phantsmagoric" character of his work discussed by Theodor

Adorno and others. As many have noted, there was a sizable gap between Wagner's ambitions and the technical resources that were available to him in his lifetime. He never fully reconciled himself to having to work with the clunkiness of mundane stagecraft, with greasepaint on the singer's faces and with how these interfered with the full absorption of an audience into his work. Wagner, despite the archaizing surfaces, stands for a new will to mastery over all aspects of spectacle that would allow for the calculated production of states of regression, fascination, dream — the very kind of attentiveness that would fully belong to cinema half a century later. Nonetheless, his control over emotional response was potent enough to provoke Nietzsche's insistence that Wagner furnished "the first example, only too insidious, only too successful, of hypnotism by means of music ... persuasion by the nerves."[5]

The institutional and technological shifts in the late nineteenth and early twentieth centuries, briefly suggested here, were bound up in new knowledge about perception, cognition, and the subjective experience of vision. For several hundred years up into the nineteenth century, a wide range of ideas about vision had tended to emphasize those features of perception that were stable, predictable and supported the notion of a manifest correspondence between the world and what the eye saw. Vision itself may not have changed in the nineteenth century but what did change dramatically was the development of knowledge and theories that foreground very different features of vision: the unreliability, the internal volatility, and the uncertain temporality of visual perception.

This volatility is evident in many places, for example in the late work of Cézanne. Not only does Cézanne disclose the distractions that are inherent in even the most rapt form of attention, but he heralds the dynamization of perception occurring in many different domains by the late 1890s, including those in which someone like Edison was involved. What Cézanne powerfully describes is not a logic of contemplative distance, or of perceptual autonomy, but rather an account of a nervous system interfacing with a mobile, continually transforming external environment. Contemporary with early cinema, Cézanne's work in the 1890s involves a sweeping destabilization of what previously had

Paul Cézanne
Mont Sainte-Victoire, 1902–1904
Philadelphia Museum of Art,
George W. Elkins Collection

constituted an "image." His work is one of numerous contemporary expressions of the notion that reality can be conceptualized as a dynamic aggregate of sensations. For Cézanne *and* for the emerging industries of the spectacle, a stable punctual model of perception is no longer effective or useful.

Obviously Cézanne's images are static but, like those of Jules-Etienne Marey, they document perceptual experience that is in constant flux and are about the recording of temporal processes, motor responses and rhythms. Part of Cézanne's singularity was the relentlessness with which he was alert to his own perceptual experience. Perhaps as much as any one artist, Cézanne disclosed the paradoxes and the malleability of attentiveness — that looking at any one thing intently, rather than leading to a fuller and fuller grasp of its very presence, its rich immediacy, finally leads to its perceptual disintegration and loss, its breakdown as intelligible form. That is, attention and distraction are not distinct but part of a dynamic continuum in which attention was always of limited duration, inevitably disintegrating into a distracted state. For Cézanne, this dissolution inherent in attentiveness not only allowed his radical desymbolization of the world but also produced an interface with a perpetually modulating set of relations between what had been thought of as "external" events and sensations. Paradoxically, it was through his own immersion in the physiological features of vision (for example the distinction between the foveal and peripheral areas of the retina and the disjunct, non-homogenous visual field that results from that) that he aspired to exceed the corporeal limits of vision in quest of a new mode of inhabiting the material world. Cézanne's late work poses the exhilarating outlines of a new kind of eye that would overcome the monadic nature of embodied human vision and be able to see with an impossible kind of attentiveness, an eye without constraints, cut loose from its physical anchorage.

For example, one key feature of Cézanne's landscapes from the late 1890s is the eradication of any consistent distinction between near and far vision, between what has often been referred to as haptic and optic perception. There is no longer any spatial schema in Cézanne's work

which allows those distinctions to retain their coherence; instead, his surfaces are assembled unpredictably out of the enigmatic palpability of distant forms and the evanescence of seemingly near-at-hand objects. This oscillation between close and distant vision, or between focus and out of focus, parallels montage effects in film which bind dramatically different spatial positions into new kinds of syntheses and adjacencies. For all their differences, Cézanne's work and cinema both posed the possibility of what Gilles Deleuze has described as an acentered ensemble of variable elements which act and react on each other. They are products of a moment at the end of the nineteenth century when, according to Deleuze, it was no longer possible to hold or occupy an unambiguous position and when more and more movement was entering psychic life. [6]

It has long been said of Cézanne that he never acquired the *trucs* or gimmicks of the atelier, that he was relatively free of readymade schema and traditional solutions for pictorial organization (including, for example, much of the historically accumulated practices associated with linear perspective). But if these accounts of Cézanne as a kind of primitive who avoided any premade interpretations of the world are useful, it is because they suggest Cézanne's particular sensitivity to and observation of perceptual experiences that had been ignored, or marginalized, or that had been incompatible (and hence unarticulated) within older (classical) organizations of knowledge about vision. Cézanne's work, then, is less about a tabula rasa than about repeated and varied attempts to achieve a "presuppositionless" engagement with the visible world, to achieve a liquid, groundless space, filled with forces, events, and intensities rather than objects. But it was just such a malleable and tractable visual space that would become subject to endless forms of external restructuring, manipulation, and colonization throughout the twentieth century.

Within modernity the terrain and tools of invention, freedom, and creation are always intertwined with those of domination and control.

★　　★　　★

One of the most extraordinary articulations of the connection between attentiveness and the changing field of institutional and technological modernity can be found in the work of Fritz Lang. The critic Raymond Bellour has written about Lang that there is no other filmmaker for whom vision is so nakedly and so unequivocally the ultimate metaphor: not Sternberg, not Eisenstein, not Hitchcock.[7] I would add that what is crucial about Lang's thought on vision is its relation to shifting and historically determined mechanisms of power.

I want to discuss briefly Lang's great trilogy that spans most of his career, his three Mabuse films: the two-part *Dr. Mabuse the Gambler* of 1921–22, *The Last Testament of Dr. Mabuse* of 1932–33, and *The Thousand Eyes of Dr. Mabuse* of 1960. These films compellingly chart the mobile characteristics of various perceptual technologies and apparatuses of power, culminating in a precocious meditation in the final film on the status of the video screen. What becomes clear is how the name "- Mabuse" does not finally designate a fictional character that Lang returned to several times (let alone a character that fits Kracauer's "Caligari to Hitler" hypothesis). Rather Mabuse is the name of a system — a system of spectacular power whose strategies are continually changing but whose aim of producing "docile" subjects remains relatively constant. On a more biographical level, the three films together also stand for Lang's own turbulent itinerary from work in the German theater and silent film industry in the teens through the era of the big German studios in the early thirties to two decades in the heart of what two of his fellow German neighbors in 1944 Los Angeles, Horkheimer and Adorno, called "the culture industry" and to his final meditations on the hegemony of television.

In the first of these films, *Dr. Mabuse the Gambler*, Lang sketches out a panoply of modern practices of control, persuasion, and coercion. In this silent film Mabuse stands for an array of spectacular techniques of dazzlement, immobilization, and suggestion; that is to say for powerful effects generally describable as

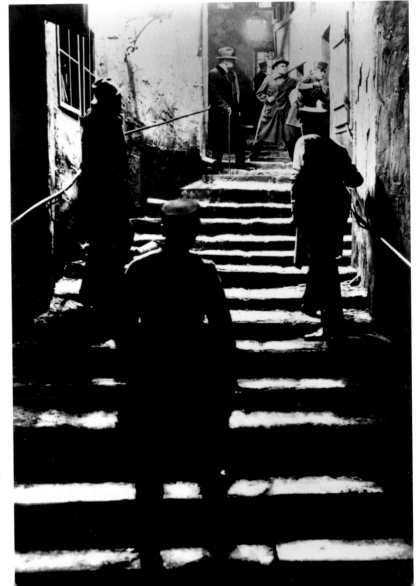

Fritz Lang
Dr. Mabuse der Spieler
(Dr. Mabuse the Gambler), 1921–22

Fritz Lang
Das Testament des Dr. Mabuse
(The Last Testament of Dr. Mabuse), 1932–33

hypnotic. But unlike Freud, whose essay on "Group Psychology" dates from the same year as this film (1921), Lang is less interested in the nature of an emotional tie to a charismatic figure than he is in a diverse technology of influence. The protean Mabuse, in his multiple masks and guises, becomes a principle of flexible and versatile power rather than a figuration of totalitarianism. In *Dr. Mabuse the Gambler* control is exerted within the perceptual fields of cultural and economic space — including the rhythmic attractions of the roulette wheel and the shifting quotes on the wall of the stock exchange.

But by the early 1930s, in *The Last Testament of Dr. Mabuse*, Lang identifies a different arrangement of power effects. It is in this period that a modern perceptual regime of reciprocal attentiveness and distraction takes on some of its paradigmatic modern features. If one follows Guy Debord's own historicization of spectacular culture, it is possible to suggest that it is around 1930 when it becomes structurally implanted in the West — the institutional and technological origins of television, the consolidation of corporate control over both television and radio, the emergence of urbanism as a regime of social control, and the introduction of synchronized sound into films and the first concerted use of sound/image technology by state power in Nazi propaganda. These are just some of the components of the social environment in which Lang was operating and in which Walter Benjamin would soon make a diagnosis of a "crisis in the nature of perception itself." Later in that decade Benjamin presented his interrelated images of the disjunctions of the gambling table, the tempo of the industrial assembly line, and the reel of film; for Benjamin these were equally emblems of the deterioration of experience — experience as an indifferent sequence of stimuli without order. This organization of experience for him was above all the obliteration of a Kantian model of apperception and its replacement by the perceptual fragment or ruin.

In the extraordinary first five minutes of Lang's 1932 film, which opens in an urban industrial zone, we hear nothing but the deafening and finally numbing noise of the monotonous functioning of heavy factory machinery (a kind of *British Sounds* almost forty years before Jean-Luc

Godard's). Established from the start is a milieu fully defamiliarized by processes of modernization in which an older model of sensory integration is deranged and fragmented (precisely the opposite of the institutional claims for the sound film). It is in these circumstances that Lang delineates how arrangements of power around forms of ocular domination give way to tactics of simulation, recording, and tele-communication in which auditory experience is primary. In other words, the Mabuse system cannot be reduced to a visual model, for it deploys a broader range of perceptual management. Sound had of course been part of cinema in various additive forms from the beginning, but clearly the introduction of synchronized sound decisively transformed the nature of attention within a spectacular setup. At the same time, this film does away with the figure of Dr. Mabuse completely, further diffusing and delocalizing the operation of power from some center of control and intentionality. One of the key elements in this film is the procedure by which members of the underworld network receive their orders: they are contacted by a voice emanating from a hidden loudspeaker and recording devices. Like the optical modalities in the earlier film, hypnotic forms of influence here proceed by the isolation of a single sense, in this case hearing rather than vision.

Finally, *The Thousand Eyes of Dr. Mabuse* is significant for the way the cathode ray tube becomes a dominant component of the Mabuse system. Lang hardly presents a homogenous image of television here, specifically differentiating broadcast TV on one hand and the use of closed circuit video for surveillance on the other. The panopticism of the film's title is not inappropriate in that part of the film's formal structure is built around a network of surveillance cameras feeding video images back to a massive bank of monitors. Rather than suggesting Orwellian models of ubiquitous control, Lang situates the television screens within a larger and chaotic spectacular regime of psuedo-events, disinformation, voyeurism, and scopic desire. The cathode ray tube becomes a means for Lang to explore the relation between new abstract perceptual spaces that exceed his own accumulated experience of the cultural conditions of cinema. One of the work's most piercing moments is a slow,

Fritz Lang
Metropolis, 1927

seamless dissolve from a filmed image of a scene to a video screen of the same image. Lang's particular overlapping of these two kinds of screens is an announcement of a specific historical passage to a new arena of techniques of subjectification, when cinema is supplanted or infiltrated in various ways by television.

It should be noted that the technological themes developed in the Mabuse films are also evident in other Lang works — even from the early 1920s Lang was a close observer of the ways in which different technological networks permeated a densely layered social space, whether in *Spies* (1928), *M* (1931), *Metropolis* (1927) or *Fury* (1936). Well before the advent of television Lang was finely attuned to the enigmatic character of a seemingly mundane object such as a typewriter or telephone and how its habitual use incorporated its user within the operations of institutional power.

By the mid-1950s Lang was describing a bleaker landscape. In *While the City Sleeps* (1956) he returns to the theme of *M*, the serial killer, but instead of examining a social space through diverse investigative and juridical practices, the actuality of the murderer and his crimes is fully subsumed within a media-saturated regime of information. The transgressive nature of the Peter Lorre figure in *M*, which mobilized all sectors of society in order to rid itself of the offending presence, gives way here to a world in which a murderer is transformed into a commodity for spectacular consumption. And the film details the corrosive and fatal effects of a world constituted solely as commodifiable spectacle, in this case as newspaper, photograph, and television.

Part of what Lang designated by the name Mabuse was a system that produced and depended on subjects who were "open to influence" or, in Foucault's words, who were reduced as a political force. A work that deliriously explored more recent configurations of the "Mabuse" system was David Cronenberg's 1982 film *Videodrome*. Cronenberg addresses the addictive and hypnotic effects of electronic media and provides a remarkable description of the ways in which large zones of perceptual experience are being reshaped by an ongoing biotechnic modernization within which the nervous system has less and less of an autonomous

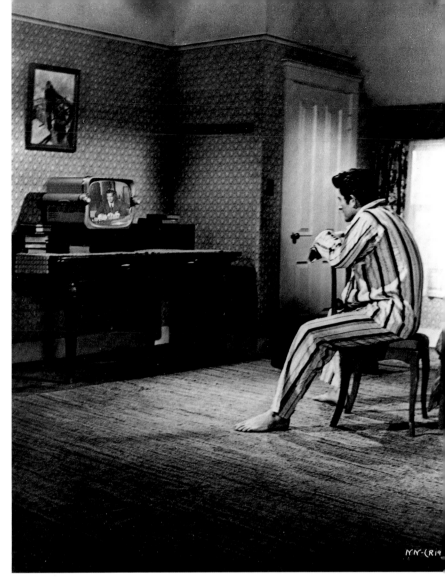

Fritz Lang
While the City Sleeps, 1956

David Cronenberg
Videodrome, 1982

Edward Ruscha
9, 8, 7, 6, 1991
Collection of the artist

have passed into it will, much sooner than we suspect, be reconfigured by the appearance of another set of technological promises and products, obsolescences and derelict spaces, new forms of verisimilitude, reorganizations of social time, of distribution and consumption, into a another seemingly unprecedented epoch. One of the most persistent features of modernity is the potent seductiveness of the phantasmagoria of progress, and among the ranks of the seduced are those who believe that modernity has somehow been exceeded. But if global capitalism continues to consolidate itself we will simply always be in the *same* historical era in relation to the enduring and mundane imperatives of capitalist modernization and rationalization.

Jean-Luc Godard
Allemagne année 90 neuf zéro (Germany Year 90 Nine Zero), 1991

History Without Object

Molly Nesbit

If I negate powdered wigs, I am still left with unpowdered wigs.
— Karl Marx[1]

Try not to think of it as negation.

A maelström is not a death.

Poe described the maelström as a funnel spinning an enormous gulf
down into the sea and sucking all life to its drop. His was a story,
a short one, but made longer by the maelström, which kept everything in
its clutches from a neat, brief fall. For nothing drowned at once. Instead
each thing hung torturously on the side of the infernal hole, circling
down dizzily, starting, Poe observed, and stopping. A fir tree stuck on
the edge; the wreckage of a Dutch merchant ship slid like grease to the
bottom. But was there a bottom? If so, it was not seen. A mist enveloped
it and a rainbow hung there too, "like that narrow and tottering bridge
which Mussulmen say is the only pathway between Time and Eternity."[2]

Try, as Poe did not, to imagine the descent of a word.

Imagine *chew*.

Falling in swings, alone, like an object.

Imagine the word walking that bridge, knowing it was not the gangplank.

Is this academic?

Godard in his films of the past ten years has taken to speaking in mael-
ström, filling his funnels with the voices of others, in voice-overs, in the
dialogues, in the monologues where the words of literature, of philoso-
phy, of Johnny Guitar come back.

> Lie to me. Tell me all these years you've waited.

> All these years I've waited.[3]

> If a blind man were to ask me "Have you got two hands?" I should not make
> sure by looking. If I were to have any doubt of it, then I don't know why I
> should trust my eyes. For why shouldn't I test my *eyes* by looking to find out

whether I see my two hands? *What* is to be tested by *what*? (Who decides *what* stands fast?)

And what does it mean to say that such and such stands fast?[4]
And what of the rest that will not?

It is not only Godard who has been cutting into language and knowledge and certainty like this. There is an abundance of reference, of means, of deliberate and productive confusion in recent art and film. Phantoms gather in different forms. You might think of the work of Cindy Sherman, Bill Viola, Gary Hill, Lawrence Weiner, Louise Bourgeois. More maelström than negation, more word than theory, something that looks like an effect of time. The question is, what time?

Can anyone now hear Walter Benjamin's alarm clock ringing for sixty seconds of every minute?[5] Does it still go off?

No, but time went off.

It would take all kinds of stories with it.

It would be myth.

It would be missed.

Clocks now barely tick.

In 1988 Godard would tell Serge Daney that the feeling of time has changed, "that history is alone, it's far from man, that's it."[6]

Cindy Sherman
Untitled Film Still #63, 1980

＊　　＊　　＊

The departure of organized time is disconcerting. So much is left in the lurch. What of the old historical explanations? What, then, of those master narratives, of scientific progress and political emancipation, which themselves were a kind of history, that Jean-François Lyotard so astutely analyzed and hymned in 1979 when writing *The Postmodern Condition*?[7] He was already pointing out their insufficiency, which was equally, it should be noted, an insufficiency in Hegel. And yet paradoxically this would have the opposite effect of giving the master narratives a new short life, especially for the images of the eighties so

concerned to have a tradition or break with one.

As if tradition were a history.

It was not.

As if history were a story.

Lyotard had only referred to the stories as part of a report on knowledge's postmodern condition in 1979. A condition is not a category. A condition lays out a fundamental contingency, like a physical, temporal starting point, like the edge of a cliff. Lyotard was interested in a widening chasm in discourse that was separating scientific from nonscientific study: techniques of verification, he observed, were taking greater and greater leave from techniques of narrative. He saw the chasm best represented by the computerization of our culture and by the collapse of the legitimation narratives of scientific speculation and political emancipation, those stories that had been most especially tied to and promoted by the nation states. Kinds of progress, now kaput. Or to be differently formulated.

We are left facing this condition, Lyotard continued, with the ability to speak. We still are. We still have voices. We still have our professional and nonprofessional ways. Neither knowledge nor the social fabric has been destroyed; it is only that the terms have changed. Time, says Lyotard, taking his cue from Wittgenstein, to reconsider language games. Because we continue to be born into discourse as children. Speak, says Lyotard, especially when you are spoken to, and do not mind the splintering:

> Nobody speaks all of those languages, they have no universal metalanguage, the project of the system-subject is a failure, the goal of emancipation has nothing to do with science, we are all stuck in the positivism of this or that discipline of learning, the learned scholars have turned into scientists, the diminished tasks of research have become compartmentalized and no one can master them all.
>
> Speculative or humanistic philosophy is forced to relinquish its legitimation duties, which explains why philosophy is facing a crisis wherever it persists in arrogating such functions and is reduced to the study of systems of logic or the history of ideas where it has been realistic enough to surrender them.[8]

Bill Viola
The Greeting, 1995
Video-sound installation

Lyotard's exhibition, *Les Immatériaux*, held in Paris in 1985, was the ostensive corollary of his report.[9] In other words, it showed what he had told. It gave the viewer headphones to receive each room's different radio signal, setting up a physical approximation of an expanding data

base asking for interaction. But discourse would exist elsewhere too.
The exhibition would be laid out on a ground plan of *ma* concepts,
matériau, matériel, matière, maternité, matrice, with each room asking
the body to move from these *mas* toward a language problem, to explore
the new means of communication, all the while recognizing its techno-
logical bases and its relation to the market. It was all very complicated.
The machinery would help project the voice, give it an image sometimes,
or a second skin, screen the vowel sound or the oboe's tone into a trail of
color, question the copy. At the end an image of an Egyptian goddess
giving the soul to King Nectanebo II appeared photographically spun out
into a long wave of stone, a succession of old touches and mute smiles.
Like the culture of the deep directory, the chip, the veil?

Dear goddess, will the computer forward your touch?

Will I ever know my own two hands?

The interactive exhibition drew back from that last question.

It had to.

Its language was only charged with finding another way to tell.
Language games, nay, language itself, was going to save you. The lan-
guage you already know would shake itself up into another order of
representation. But all language really did back then was show you to
the door. It bespoke nostalgia, really nothing more.
Cinema, which is not a language, could have looked like the prototype
for that new order of representation, for it tracked language together

with an image, pushing the parts into increasingly new combinations. Silent films, with their subtitles cutting into the threads of filmed scenes, had put the problem forward as one of a separation; talkies would redefine the relationship as a closer, spoken one, not written. Fifty years of montage theory would come to explore the many ways cutting could tie language or sound to image. And yet this movement between text and image was based on a prior, ostensibly infantile model that everyone already knew even if they did not want to: the little child's model of show and tell. Which was the model Wittgenstein had used in order to define his language-games in the first place.[10]

The idea with show and tell being to split the existing separation between language and image into a difference that would become the source of organized knowledge. Once set, the two were sewn together into a seamless flow. The child was schooled to see them and merge them into one perception: the poodle dog obeys; the binoculars are nouns of vision. The lesson pushed the flow toward action. So that "to imagine a language means to imagine a form of life."[11] Wittgenstein found the initial split worth a life's work, and sought to dismantle the assumptions around it, around the fact that we might agree to see that the dog is pink, around the fact that someone might remember that the devil first appeared as a poodle to Faust. The spaces in the demonstration would grow and open up under Wittgenstein's direction; naming itself would grow, as he said, into a queer, occult process.[12]

Compare knowing and saying:

how many feet high Mont Blanc is —

how the word "game" is used —

how a clarinet sounds.[13]

The ideal, as we think of it, is unshakable. You can never get outside it; you must always turn back. There is no outside; outside you cannot breathe. Where does this idea come from? It is like a pair of glasses on our nose through which we see whatever we look at. It never occurs to us to take them off.[14]

For how can I go so far as to try to use language to get between pain and its expression?[15]

Even inside a mind language will have its uses and its limits. Outside a mind it will have to navigate the spaces between people. Lessons and pages will try to capture that space; so will cinema.

Pages from the notebook of Mauperty, February 7 and 10, 1931. Rouen, Musée National de l'Education

A stretch of breath.

Between scenes.

Between man and dog.

Godard has always filmed those spaces, isolating them through extreme techniques of montage that always did more than cut or tie. In 1956 he explained it as a heartbeat.[16] In 1965 in *Alphaville* he used it to monitor the all-powerful computer named Alpha 60 (actually nothing more than a cheap Phillips fan) that was controlling the human life of the future. The computer told you right away that "sometimes reality is too complex for oral transmission. But legend embodies it in a form which enables it to spread all over the world." Legend would be made in Alphaville by the computer. Life was to be lived within the logic of its strictly verbal definitions. Its dictionary was the Bible; *amour, pourquoi, rougegorge* and *tendresse* had become forbidden words. Language was control. Godard would combat it with montage. It would be the film's cutting as much as the efforts of its hero, secret agent Lemmy Caution, that would free language to do something else besides name the right names. Godard and Lemmy Caution pulled the beautiful Natasha von Braun away from the semantic vampire by means of little fragments of poetry by Paul Eluard. Eluard's lines were not exactly offering her mental shelter, only an openness between the sounds of their parts. She pronounced them as a magic spell, for to her this was a language which as yet had no meaning.

> We live in the oblivion of our metamorphoses

> But this echo which rolls throughout the day

> This echo beyond time, anguish or caress

> Are we near or far from our consciousness[17]

The phrases came with a montage that made the sequence blink like an eye; the lines of dialogue and poem would float apart, not like a rupture, more like a song. She and Lemmy Caution will use mind and body to escape Alpha 60. And love, but love will not conquer all. For love will only function as a disorder, not an order, in the films of Godard. Love will provide another space, this one between people. There will be no model of order, not language, not technology, not love, not even cinema.

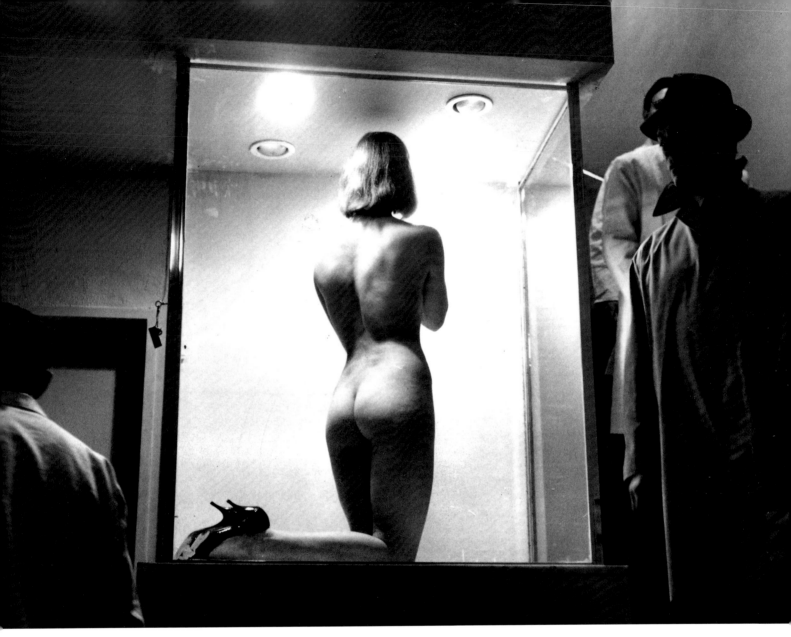

Jean-Luc Godard
Alphaville, 1965

Two do not become one.

Another insufficiency in Hegel.

Do you remember what Pierrot le Fou said to you from the cornfield?

> We have come to the time of double men. We have no need of mirrors to speak
> by ourselves. When Marianne says the weather is nice what does she think of?
> Of her I have only this appearance saying the weather is nice, nothing more.
> What good explaining all that. We are made of dreams and dreams are made of
> us. The weather is nice my love in dreams, in words and death. The weather is
> nice my love, the weather is nice in this life.[18]

Do you remember the end of *Ici et ailleurs* (1974)?

The others that's far from our here.

But perhaps we too are far from our here.

Do you remember Godard's 1980 interview?

> In the end I am at the same time Swiss and French, my situation is that of living
> on both sides of the border, not only to be a frontiersman, but to be a double
> frontiersman, always a foreigner to the one and a foreigner to the other and
> having the need to pass from one side of the border to the other, which is also a
> little bit the cinema, and what I like a lot, I think, is the communication, the
> passing, the not being fixed. Even now today, the human being is someone who
> goes from one place to another and not one who stays in one place and then
> goes in another ... When travelling I've always been surprised by those people
> who count the time of the trip as nothing, whereas for me, that is practically
> the essential part. I consider the time of the trip or two hours at the airport to be
> nothing lost, nothing gained. Finally one lives this much and I am surprised,
> above all today when one communicates a great deal, because for most people
> it's a time which does not exist. Time only exists when solidified, if one might
> say it like that, whether one stays in one place from which one should leave,
> whether one gets there, and between the two, that does not exist. Me, I think that
> which exists is *between*.[19]

Darryl Turner
Jean-Luc Godard, 1995

★　　★　　★

We have been returned to the maelström. This space between, a space
in time and outside it, a space in language and beyond it, a space in
the techniques of cinema and beyond it, a space inside a person and
between people and nature and the weather, a between-many, is not in

fact to be ascribed to a new technology or even a postmodernity:
it predates it and will postdate it. We are no longer speaking simply of
the gap between the word and the thing any more than we are speaking
with the sparks made by the flint and stone of the dialectic. Godard
has lately taken to thinking of this space as history, but this is a history
without a specific object, history spilling outside a discipline or even a
history-concept. One might want to call this the space of philosophy
or its world, except that even with the freest of models, there would be
philosophy's concepts and here ideas exist and help, but they do not
control. Knowledge as it happens is historical material too.

Chew between time and eternity.

A tissue of?

No, a series of observations.

A cinema of asides.

With their accumulation Godard can show time thick and gone off.

Watch it.

This way of treating knowledge as so much historical material, impor-
tant but not omnipotent, needs perhaps more explanation in the English
speaking world where systems in and of themselves have the status of
veritable *a priori*. One of the unintentional effects of the English trans-
lation of Lyotard's book on the postmodern condition was to give the
word postmodern the appearance of a certainty which has now been so
marketed and generalized as to be analytically fairly useless. Another,
perhaps more disastrous, effect of the book has been to encourage
the idea that philosophy could rescue us from facing the problem of our
own historical definition. Godard does not and need not concern him-
self with this, the English speaker's problem; he simply asks continen-
tal philosophy to appear on the continent in his films, not as the star,
but as one of the players along with the famous faces, the songs, the
dialogues from novels, the morsels of film chat and poem and intertitle.
All of this in the service of a passage. All of this trying to come to
terms with the new distance in history, which takes form in his films
as an ocean of thick time and hole.
To see history as thick time, to see thick time as historical material,
starting and stopping, empty and full, is not given to everybody.
It requires the ability to look backwards and forwards at once. In antiq-
uity this point of view would be considered divine. We have lost the

Jean-Luc Godard
Passion, 1982

word for it. Near the beginning of Godard's film *Hélas pour moi* (1992) the narrator asks if the voices of our friends do not from time to time haunt the voices of those who have come before? If the beauty of the women from a former time does not reappear in the faces of our female friends? The past is claiming a redemption. There is a mysterious rendez-vous of the generations. "Our coming was expected on earth," the narrator concludes, quoting without saying so one of Benjamin's theses on the philosophy of history. It was the thesis that reflected upon the place of happiness. It drew from a longer reflection which had at one point led Benjamin to write: "Our life is, as it were, a muscle strong enough to contract the whole of historical time."[20] But for Benjamin this contraction and telescoping of time outside and inside a person, the past moving through the present and the present moving through the past, was very specifically the pursuit of the historical materialist. Benjamin's historical materialist would not use time to pursue the idea of progress, but rather to write a dense demonstration or actualization or materialization of history. It would be, he thought, a matter of images.[21] And he saw their accumulation in a book as a kind of literary montage which would have the added advantage of raising the practice of quoting without quotation marks to the very highest level.[22] So that knowledge would enter the subject subjectively, just like time and voices and eyes.

Godard has taken this so-called literary montage back to cinema, beginning first in the ongoing video series *Histoire(s) du cinéma* (1989–) and in the made-for-television film *Allemagne année 90 neuf zéro* (Germany Year 90 Nine Zero, 1991). Each contemplates a phenomenon vanishing into the distance, in the first case, the cinema, in the second case, the end of the revolution associated with the name of Marx.[23] For Godard is and has long been an historical materialist too. The montage now works the space of spaces with many cuts at many levels at once to amass a history of crack and between. It does not project a direction. And yet it is not abstract. Godard can speak of it quite concretely:

> I will take an example: the tree next to Goethe's summer pavilion, real, filmed
> on site, in its place, so much so that the word real still has a meaning. Then the
> tree at the center of Buchenwald, where the author of the color theory liked,
> so the story goes, to come read, some forty kilometers from Weimar, according
> to the sign. All this emmeshed in the white page of Hegelian history, which
> becomes the intermediary, via the camps, with the white dress of Werther's
> model since Goethe, according to Wittgenstein, did not believe that white was
> an intermediary color. And later, the white rose, Rilke's one unknown. Long
> live then the "speech of the waves."[24]

The funnel is full.

Jean-Luc Godard
Histoire(s) du cinéma, 1989

You can take it with you.

Father, can't you see I'm burning?[25]

Oddly, this was Hegel's idea of what history was before the arrival of
philosophy. For if Hegel saw philosophy as a circle, his philosophy of
history proceeded from ruin. Turn to *The Philosophy of Right*. There
Hegel, sounding like a premonition of Wittgenstein, pointed to the split
in a phrase, "*Here* is the rose, dance *here*," and went on to explain:
"What lies between reason as self-conscious spirit and reason as present
actuality, what separates the former from the latter and prevents it from
finding satisfaction in it, is the fetter of some abstraction or other which
has not been liberated into the concept."[26] Namely, the fetter of histori-
cal material with all its unliberated, greyed matter. If only the concept
would rise from this to form the circle and function like a halo, it
could produce, among other things, an apotheosis of the nation state.
Hegel was not, of course, an historical materialist, but Marx was. Marx
answered Hegel by taking this criticism of heaven, as he called it,
and making of it a criticism of earth. "*Here* is the rose," which Marx
took, turning Hegel's phrase against itself, using philosophy to argue
for political revolution.[27] Historical material contained its own reason,
Marx would argue, the logic of class separations and struggle. Dance
here on earth; it will mean fighting for human freedom.

For Marx this meant physical, political freedom, not an idea.

A material, historical state.

The Berlin Wall, remarked Lemmy Caution, looking back on it, was,
quand même, the triumph of Marx because it actually was an idea that
gripped the masses and became a material force.[28] It had been an answer
to an alarm clock. It was also finished.

So what does it mean to say that such and such stands fast?
Is Hegel now faster than Marx?

Allemagne année 90 neuf zéro pressed Lemmy Caution back into
service in order to consider such questions but it jumped over the line
about the rose. The film opens with a passage from the next page of
The Philosophy of Right. Though first a voice speaks over the long tones
of Gavin Bryars's *After the Requiem*, of the impossibility of ever know-
ing time, fog shimmers on a northern marsh, the tones continue, and
only then do Hegel's lines reply: "When philosophy paints its grey
in grey, a shape of life has grown old, and it cannot be rejuvenated, but

only recognized, by the grey in grey of philosophy. . . ."[29] Hegel had continued, "the owl of Minerva begins its flight only with the onset of dusk." But Godard cut him off. Montage will see to it that no owl, no concept, no saving philosophy will arrive, only a growing rupture in the real. Hegel will appear again right away in the film while Lemmy Caution sits in the kitchen somewhere in East Germany and learns of his reassignment. Hegel's translations will be discussed. But the whistle will be blown on Hegel and his lines will be used against themselves again, this time by Godard, to begin the description of historical material and reassert its force. Like this, subtly, the film will show and tell a position that remains in spite of the collapse of the communist state.

There must be another response besides negation.

Marx, remember, did not negate Hegel, he opposed him; he coquetted, as he said, with the dialectic, and sought to demystify it.[30]
There will always be more wigs.

Godard has Lemmy Caution come out from under cover in the hairdresser's shop to join the West. And two centuries of German language culture will come forward in threads, Hegel, Goethe, Kafka, Freud, to help make this history into a story, a remake of *Alphaville*? No such luck. Here the enemy has no voice. Threads alone will speak.

Read Faust. Speak, Faust, if you must, through Lemmy Caution's mouth.

My name is Faust, in everything your equal.[31]

Citations or voices?

Fictions or pearls?

The references will some of them be credited, others hover like impressions. Benjamin's *Origin of German Tragic Drama* and Dürer's *Melancholia I* and Michel Hannoun's *Nos solitudes*, will be there like Beethoven's Seventh Symphony and Marx, as an undertone, the kind of knowledge that sits in the back of a mind, not a solid pedantic citation, but a support all the same.[32] From there it is ready to travel through a mind in words, in feelings, in the words of others, of fathers, of lovers, of mothers in airports.
Godard makes man a funnel too, a funnel through whom the threads will move and sound. The echos counter-echo. Now and again they sing. Is this so extraordinary? Knowledge is usually held in the mind by threads like this and minds are never alone in themselves once knowl-

Jean-Luc Godard
Allemagne année 90 neuf zéro
(Germany Year 90 Nine Zero), 1991

edge sets in and its threads begin to cross. Call it a documentary touch that makes all the characters in *Allemagne année 90 neuf zéro* have minds that are crossed like that. Lemmy Caution will open himself up to Faust; K. and Quixote will move to Caution; the part played by Claudia Michelsen remains so open that it has no single name. Goethe's sketch of Corona Schröter washes up mute in her wake. Mostly the women speak. But when one of them speaks the Spirit's lines to Faust, is she Gretchen or the devil?

A woman named Delphine will correct Hegel's French translations, accuse governments, and reflect upon the death of Rosa Luxembourg while the film reflects on the images that remain of a camp victim dragged dead and naked to her grave and Eva Braun being walked to her fate. Minds are crossed, of course, by images too. But minds do not become these images, any more than minds become their knowledge or actors become their characters. Minds simply accommodate it all, or, overstimulated, let it go.

And what will be left of the left?

The answer to that question lies in the *betweens* of the montage. If the montage's threads and flashes do not translate or transmute into a line of thought that carries this film forward like an argument or a tale, they do not behave like capital either: they do not reduce themselves to a common form, like money, that allows for the trade to be carried forth in a system.[33] Historical material will not be shown to be, by nature, capital's material. Historical material is not, by nature, capital's material.

Only in English does the word change have a monetary value.

The film remains committed to the old opposition.

To a revolution of retrospect, still a revolution, just gone thick. Rilke will speak like Quixote through Caution as the old chameleon watches windmills creak and sheep flock: "The dragons of our life are only princesses waiting to see us beautiful and brave."[34] Other voices take up their dialogue inside his head:

Hello baby, we're here.

You?

Yes, I've stopped by for a drink on my way.

That's a joke which is going to cost you. What are you doing here?

It's your perfume. I followed it.

You take me for an idiot?... Are you sure that it is *really* to tell me all this that you've come?

Minds crossing as time is stopping, it is not a postmodern condition any more than a special effect. When Baudelaire told Manet that he was the first in the decrepitude of his art, he was describing the exact same ruin, the selfsame *between*.[35] For Manet opened the door to a separated image in the early 1860s by painting a different thick time, a time that appeared through references to Goya prints, current court fashion, and recognizable girls, a time which has been thinned by posterity into a simple modernity, using one of Manet's youthful quips as the premise.[36] Better to say *Il ne faut pas être de son temps*. Better to say that Manet's pictures leave the instant of modernity and cloud it. Cloud it here by putting Mademoiselle V. in boy's clothes, thickening the paint to roll back the space, and scattering an entire universe of emotions over the face of innocence, each of whose parts is at odds with the others. Awkwardness, love's sparkle, deadpan, distress, an excess struggling happily for dignity, a body too physical for the tropes and pants, a psychic minx, a play. This is a woman who, if she could speak, would choose to tilt at bulls.

Her coming was expected on earth.

Two souls, alas, are housed within my breast.[37]

The History of the World is not the theatre of happiness. Periods of happiness are white pages in it....[38]

Fine white holes.

As opposed to lace.

Historical material that will never be understood as knowledge and be for it none the worse off.
Historical material waiting, like the princesses.

Like the dragons.

Lemmy Caution will eventually find himself muttering in West Berlin in what now begins to look like a proper remake of *Alphaville* except that

Edouard Manet
Mademoiselle Victorine in the Costume of an Espada, 1862
The Metropolitan Museum of Art, New York
The H.O. Havemeyer Collection

capital has replaced the computer as the organizing force. In the dusk the birds now gather. It will be, Lemmy says, "a battle of money and blood." And the film will break off in the hotel room just the *Alphaville* cycle begins its repetition in earnest. History is not a circle. Historical material will escape the pure figure. It will ask that space be understood apart from system. It will ask for an altogether different definition of philosophy. It wants to turn toward the future. And it was at this turn that Benjamin saw a new set of revolutionary barricades. For all futures sleep with their pasts.

> Each epoch not only dreams the next, but also, in dreaming, strives toward the moment of waking. It bears its end in itself and unfolds it — as Hegel already saw — with ruse. In the convulsions of the commodity economy we begin to recognize the monuments of the bourgeoisie as ruins even before they have crumbled.[39]

> Fruitless searching is as much a part of this as succeeding, and consequently remembrance must not proceed in the manner of a narrative or still less that of a report, but must, in the strictest epic and rhapsodic manner, assay its spade in ever-new places, and in the old ones delve to ever-deeper layers.[40]

> Business demands seriousness and severity, living demands caprice; business requires consistency, living often requires inconsistency, for that is what makes life agreeable and exhilarating. If you are secure in the one, you can be all the more free in the other; whereas if you confound the two, your freedom uproots and destroys your security.[41]

Imagine knowledge to be for the living.

Knowing being parting, finding.

Try to think of the maelström as a swim.

Edward Ruscha
Triumph, 1994
Collection of Pontus Hulten

296

The End

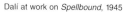

Dalí at work on *Spellbound*, 1945

James and John Whitney in their studio, 1945

Jean Cocteau
Publicity poster for
Orpheus, 1949
British Film Institute

Albert Lewin
Pandora and the Flying Dutchman, 1951

Actors protest against H.U.A.C., 1947

Art and Film:
A Selected Chronology

Mariana Amatullo

1945

Joseph Cornell makes the box construction *Penny Arcade Portrait of Lauren Bacall*, as well as a dossier in homage to the actress (1945–46). The cinematic source for Cornell's tribute to Bacall is Howard Hawks's *To Have and Have Not* (1944).

Cornell also designs and edits the September issue of the *Dance Index* magazine, in which he publishes the ballet scenario "Theater of Hans Christian Andersen," largely conceived as a film script.

Alfred Hitchcock directs *Spellbound*; Salvador Dalí designs the surrealistic dream sequence to Hitchcock's specifications. "I was determined to break with the traditional way of handling dream sequences through a blurred and hazy screen. I asked Selznick if he could get Dalí to work with us and he agreed, though I think he didn't really understand my reasons for wanting Dalí. He probably thought I wanted Dalí for publicity purposes. The real reason was that I wanted to convey the dreams with great visual sharpness and clarity, sharper than the film itself. I wanted Dalí because of the architectural sharpness of his work. My idea was to shoot the Dalí dream scenes in the open air so that the whole thing, photographed in real sunshine, would be terribly sharp. I was very keen on that idea, but the producers were concerned about the expense. So we shot the dream in the studios." [Hitchcock in François Truffaut, *Hitchcock* (New York: Simon and Schuster, 1967), 117–118]

Albert Lewin, *The Picture of Dorian Gray*. Lewin commissions Ivan Albright to paint *The Picture of Dorian Gray* (1943–44) for this screen adaptation of Oscar Wilde's novel. The black-and-white cinematography breaks into Technicolor for the portrait sequence.

Publication of *Naked City*, first book of photographs by Weegee (a.k.a. Arthur Fellig). Weegee later sells the film rights to Mark Hellinger and signs on as "special consultant" for the Jules Dassin film *The Naked City* (1948).

James and John Whitney complete their *Five Film Exercises* (begun in 1943). The short films are developed on their homemade animating and sound composing equipment and represent their first attempt to create "audio-visual music" or "color music" by the synchronization of abstract transformations to electronic sounds. "There is perhaps more personal freedom than is possible in any other motion picture today. Our sound and image technique provide a complete means accessible to one creator. We believe in the future of the abstract film medium as one differing from the others in that it demands none of the large scale collaboration typical in present motion picture fields.

"Our very realm of creative action is implicit in the machine. Emphasis is necessarily upon a more objective approach to creative activity. More universal. Less particular. More so by the inherent impersonal attribute of the machine. We discern a creative advantage here similar to that deliberately sought after by both Mondrian and Duchamp however opposed their respective points of view; Duchamp, an anti-artist, and Mondrian, seeking a purity of plastic means." [James and John Whitney, "Audio-Visual Music," in *Art in Cinema*, Frank Stauffacher, ed. (San Francisco: San Francisco Museum of Art, 1947), 33–34]

1946

Hollywood's most successful year yet at the box office: motion picture attendance receipts reach $1.7 billion. Movie audience numbers decline significantly immediately after this all-time high, affected by transformations in lifestyle and new trends in the leisure and entertainment industries. Television sets go on sale to the public and rapidly become a popular commercial medium (in 1948, one million sets are in use).

Edgar G. Ulmer, *Detour*.

Albert Lewin, *The Private Affairs of Bel Ami*. Based on Guy de Maupassant's novel, the film features the painting *The Temptation of St. Anthony* (1946–47) by Max Ernst. Ernst's work was selected by Marcel Duchamp, Alfred H. Barr and Sidney Janis, jurors of the "Bel Ami International Art Competition," a contest and art exhibition organized as a publicity stunt for the film.

Salvador Dalí designs various sequences for *Destino*, a Walt Disney ballet film combining live-action and animation, never produced (only fifteen seconds of animated film, in Technicolor, was completed).
"Animation enhances art, its possibilities are limitless. One can create effects *magnifique*. Surrealism will be reaching immense numbers of people it never has before!" [Dalí, cited in Leonard Shannon, "When Disney met Dalí," *Modern Maturity* (December-January 1978–79), 51]

Release of Hans Richter's *Dreams that Money Can Buy*. Considered one of the first feature-length avant-garde films produced in America, the film is based on scenarios by Alexander Calder, Marcel Duchamp, Max Ernst, Fernand Léger, and Man Ray.

1947

In Los Angeles, the House Committee on Un-American Activities begins closed hearings on communist tendencies in the motion picture industry. The investigations result in widespread blacklisting.

Oskar Fischinger makes his last major work, the abstract film *Motion Painting No. 1*, using geometric designs to the accompaniment of Bach's Brandenburg Concerto No. 3.

The San Francisco Museum of Art organizes the "Art in Cinema" symposium and film series, an examination of the fifty-year history of "the motion picture as an art form." The catalogue accompanying the series includes contributions by Arthur Miller, Luis Buñuel, Hans Richter, Maya Deren, Oskar Fischinger, and James and John Whitney.

Kenneth Anger makes his first short film, *Fireworks*.

Michael Powell and Emeric Pressburger, *Black Narcissus*.

Weegee leaves New York for Hollywood or "Zombieland," as he refers to it, where he spends the next five years doing small photography assignments for movies and gathering material for his *Naked Hollywood* book. He also joins the Screen Actor's Guild, and plays "bit parts" in a few films. [*Weegee by Weegee*, (New York: Da Capo Press, 1961), 103]

1948

Eastman Kodak introduces acetate film for general industry use; nitrate film becomes obsolete soon thereafter.

Sale by Film Classics of 24 Alexander Korda features to KTLA TV, Los Angeles, is the first major sale of feature films to television.

Supreme Court antitrust rulings force Paramount to divest itself of its single chain of theaters. The other major Hollywood companies follow suit; this loss of monopoly control over movie theaters is a tremendous blow to Hollywood's studio system.

Orson Welles, *The Lady from Shanghai*.

Marilyn Monroe makes her screen debut with bit parts in *Scudda-Hoo! Scudda-Hay!*, *Dangerous Years*, and *Ladies of the Chorus*.

Alain Resnais makes the documentary *Van Gogh*, composing the film solely with the pictorial oeuvre of the Dutch artist. The camera moves across the surface of the canvases without ever revealing their frames. Resnais wished to investigate whether "painting could replace the role of real objects in cinematographic narrative, and, if so, the audience could, almost unaware, substitute the inner world of the artist for the world as revealed in photography." [Resnais in François Porcile, *Défense du Court Métrage Français*, (Paris: Ed. du Cerf, collection 7e art, 1965), n. p.]

1949

RCA announces color television system.

Publication of *Life* magazine article "Jackson Pollock: Is He the Greatest Living Painter in the U.S.?"

William Dieterle, *Portrait of Jennie*, starring Jennifer Jones. Cornell recalled an "enchanting" stroll in Central Park about the set of the film as one of his most precious memories.

1950

U.S. movie theater weekly attendance falls to sixty million. Major Hollywood studios release fewer than three hundred films.

Publication of Hortense Powdermaker's *Hollywood, the Dream Factory: An Anthropologist Looks at the Movie-makers*.

Billy Wilder, *Sunset Boulevard*.

Release in the U.S. of Luis Buñuel's *Los Olvidados* (The Young and the Damned). The film restores Buñuel to international prominence.

Chesley Bonestell, engineer and matte painter, designs the space scenes and lunar landscapes for George Pal's film, *Destination Moon*.

Jean Cocteau makes *Orphée* (Orpheus).
"I am a draughtsman. It is quite natural for me to see and hear what I write, to endow it with plastic form. When I am shooting a film, every scene I direct is for me a moving drawing, a painter's grouping of material." [Cocteau in *Cocteau on Film, Conversations with Jean Cocteau*, recorded by André Fraigneau, (New York: Dover Publications, Inc., 1972), 21]

Akira Kurosawa, *Rashomon*.

1951

Release of the first feature films shot in Eastman Color, which becomes the standard color film.

First color broadcasts by CBS television.

Publication of first issues of the French film journal *Cahiers du Cinéma*, co-edited by André Bazin and Jacques Doniol-Valcroze. The *politique des auteurs* (the *auteur* theory) is formulated and proclaimed in *Cahiers* under Bazin's editorial guidance. The French critics of *Cahiers du Cinéma* focus on the triumph of individual Hollywood directors such as Alfred Hitchcock, Nicholas Ray and Orson Welles, and see them as "authors" of their films. Many of the staff writers of *Cahiers*, such as Jean-Luc Godard, François Truffaut, Claude Chabrol, Jacques Rivette, and Eric Rohmer, go on to make films of their own, providing the nucleus of the French *Nouvelle Vague* (New Wave) movement.

Release of two Lettrist films: Isodore Isou, *Traité de bave et d'éternité* (Treatise on Drivel and Eternity) and Maurice Lemaître, *Le film est déjà commencé?* (Has the Movie Started Yet?). In his "chiseling film," Isou scratches and hand-marks the celluloid and creates a disjunctive combination of visual elements and non-synchronous sound. Lemaître's work is a "performance film" in which he introduces the sounds and reactions of an actual audience as well as criticisms of the film's first screening.

Albert Lewin makes a "deliberately Surrealist film," *Pandora and the Flying Dutchman*. The production design of the film is inspired by the work of Giorgio De Chirico.

Chesley Bonestell collaborates with George Pal in the production design for the science-fiction film *When Worlds Collide*.

Vincente Minnelli, *An American in Paris*.

1952

Wide-screen projection as well as stereophonic sound systems are introduced and soon become a fixture in movie theaters around the world, in part as cinema's response to the increasing competition from television. Cinerama, a three-camera, three-projector system utilizing a large curved screen to create the effect of huge space, makes its public debut in New York with *This is Cinerama*, a spectacular, thrill-filled travelogue. Henry Koster's *The Robe*, the first film in Fox's CinemaScope (a process that uses an anamorphic lens) opens at New York's Roxy Theater in 1953; the commercial success of the film leads to the adoption of the wide-screen process by other major studios as well as the

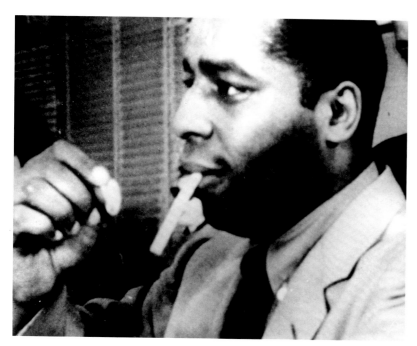

John Cassavetes
Shadows, 1959

Andy Warhol
Empire, 1964

Jean-Luc Godard
Publicity poster for *Alphaville*, 1965
British Film Institute

its images, derived from the lifestyle shown in picture magazines such as *Europeo* and *Oggi*—senseless spectacles featuring shady aristocrats, Fascism, and how those magazines photograph such spectacles and glamorize them on their pages. Those picture magazines were the troubled mirror of a society continually celebrating itself, showing itself off, praising itself." [Fellini in *Federico Fellini: Comments on Film*, Giovanni Grazini, ed. (Rome-Bari: Gius. Laterza & Figli Spa, 1983, and Fresno: The Press at California State University, 1988), 138]

Michelangelo Antonioni, *L'Avventura* (The Adventure).

Godard, *A bout de souffle* (Breathless) (shot in 1959). Godard's breaking away with traditional cinematic syntax and his fascination with Hollywood genres establish him as a leading figure of the French New Wave.
"What I wanted was to take a conventional story and remake, but differently, everything the cinema had done. I also wanted to give the feeling that the techniques of filmmaking had just been discovered or experienced for the first time." [Godard in "An Interview with Jean-Luc Godard, *Cahiers du Cinéma* 138 (December 1962). Reprinted in *Godard on Godard*, Jean Narboni and Tom Milne, ed. and trans. (New York: Da Capo Press, 1986), 173]

Godard's second film, *Le Petit Soldat* (The Little Soldier) is a daring portrait of the Algerian war and is banned from distribution until January 1963.
"To photograph a face is to photograph the soul behind it. Photography is truth. And the cinema is the truth twenty-four times a second." [Godard, from *Le Petit Soldat*]

Fritz Lang, *The Thousand Eyes of Dr. Mabuse*.

1961

Alain Resnais makes *L'Année dernière à Marienbad* (Last Year at Marienbad) based on the screenplay by Alain Robbe-Grillet.
"When I see a film, I am more interested in the play of feelings than in the characters. I think we could arrive at a Cinema without psychologically definite characters, in which the feelings would have free play in the way that, in a contemporary canvas, the play of forms becomes stronger than the anecdote." [Resnais in *Interviews with Film Directors*, Andrew Sarris, ed. (1962), 375]

François Truffaut, *Jules et Jim* (Jules and Jim).

John Huston, *The Misfits*, last screen roles of Marilyn Monroe and Clark Gable.

1962

August 5: Marilyn Monroe found dead in her Los Angeles house.

The exhibition "The New Realists" opens at Sidney Janis Gallery, New York. The group show of twenty-nine artists includes Jim Dine, Roy Lichtenstein, Claes Oldenburg, James Rosenquist, George Segal, Andy Warhol, and Tom Wesselmann.

British television channel BBC showcases Ken Russell's documentary film *Pop Goes the Easel*, featuring artists Peter Blake, Pauline Boty, Peter Philips, and Derek Boshier.

Andy Warhol produces his first silkscreens on canvas, using the technique in his series of iconic images of film stars beginning with Troy Donahue, and followed by those of Marilyn Monroe, Elizabeth Taylor, Elvis Presley, and Marlon Brando.

Founding of the New York Film-Makers' Cooperative, headed by Jonas Mekas. Underground-film screenings organized both by the Film-Makers' Cooperative and the Film-Makers Cinémathèque program, New York, play a dramatically influential role in encouraging visual artists such as Andy Warhol and Michael Snow to undertake filmmaking.

Publication in *Film Culture* of "Notes on the *Auteur* Theory" by Andrew Sarris.

Release of Agnès Varda's *Cléo de 5 à 7* (Cléo from 5 to 7).

Robert Aldrich, *Whatever Happened to Baby Jane?*.
"In *Baby Jane*, we thought that if you made a movie about the

periphery of Hollywood which had something to do with the ancient Hollywood, and you put it in two stars who were getting old, people would read into that picture a secret show-biz mythology, almost a nostalgia. The audience feels that they are privy to real-life secrets about [Joan] Crawford and [Bette] Davis." [Aldrich in *Cinéfantastique*, vol. 3, no. 3 (Fall 1974). Reprinted in Richard Combs, *Robert Aldrich* (London: British Film Institute, 1978), 60]

In *L'eclisse* (Eclipse), Michelangelo Antonioni experiments with frame compositions, camera angles and editing techniques, moving toward an abstract language of visual imagery.
"The visual aspect of film is, for me, strictly linked to its thematic aspect. It is in this sense that, almost always, an idea comes to me through images.... What is ordinarily called 'the dramatic line' does not interest me." [Antonioni in Ned Rifkin, *Antonioni's Visual Language* (Ann Arbor, Michigan: UMI Research Press, 1977), 15]

Pier Paolo Pasolini, *Mama Roma*.

Several artists connected with the Fluxus group begin to turn to filmmaking, producing a varied array of works including Dick Higgins's *Invocation of Canyons and Boulders for Stan Brakhage* (Fluxfilm No. 2) and Nam June Paik's *Zen for Film* (1962–64).

1963

First New York Film Festival.

Bruce Conner, *Report* (1963–67). The film is shot from television footage of the assassination and funeral of President John F. Kennedy.

Kenneth Anger, *Scorpio Rising*.

Jack Smith, *Flaming Creatures*.
"A verdict was passed in the New York Criminal court last Friday that Jack Smith's film *Flaming Creatures* is obscene. A similar decision was passed by the Los Angeles court on Kenneth Anger's film *Scorpio Rising*.... From now on, at least in these two cities, it will be a crime to show either *Flaming Creatures* or *Scorpio Rising*, either publicly or privately. During the trial we had offered ...to explain some of the meanings of *Flaming Creatures* and to give some insight into the meaning of art in general. The court chose to ignore us; it preferred to judge the film by what it called 'the community standards.'" [Jonas Mekas, *Movie Journal: The Rise of the New American Cinema, 1959–1971* (New York: Collier Books, 1972), 141–142. Reprinted in Barbara Haskell, *Blam! The Explosion of Pop, Minimalism, and Performance 1958–1964*, exh. cat. (New York: Whitney Museum of American Art, 1984), 130–131]

Stan Brakhage makes *Mothlight*, a "collage" film realized entirely without a camera, by running moth wings and flora affixed to strips of clear leader through an optical printer. Publication of *Metaphors on Vision*, Brakhage's major treatise on film.

James Whitney makes the abstract animated film *Lapis* (1963–66) using an analog computer.

Godard, *Le Mépris* (Contempt). The film is shot in color and widescreen and features an international cast of stars including Brigitte Bardot, Jack Palance, and Fritz Lang in the role of a movie director, and Godard himself as his assistant.
"In *Le Mépris* I was influenced by modern art: straight color, 'pop' art. I tried to use only the five principal colors." [Godard, Sharits, "Red, Blue, Godard," *Film Quarterly*, vol. 19, (Summer 1966), 24]

Federico Fellini, *8 1/2*.

Andy Warhol moves into his "Factory," in a warehouse on East 47th Street, New York, buys a 16mm Bolex movie camera and begins actively producing films. He makes *Andy Warhol Films Jack Smith Filming "Normal Love"* and stirs controversy with his silent films *Sleep, Kiss, Haircut (no. 1)*, and *Tarzan and Jane Regained...Sort of* (shot in Los Angeles).

Opening of the exhibition *Andy Warhol* at Ferus Gallery in Los Angeles. Dennis Hopper throws a party for Warhol; Troy Donahue, Peter Fonda, and Sal Mineo attend.
"I love Los Angeles. I love Hollywood. They're beautiful. Everybody's plastic. I want to be plastic." [Warhol, 1963, in Rainer

Crone, *Andy Warhol* (New York: Praeger Publishers, 1970), 29]

1964

Hitchcock, *Marnie*.

Warhol makes the films *Eat, Blow Job, Batman Dracula, Couch, Harlot, Soap Opera, The Thirteen Most Beautiful Women* and *Empire*. Begins filming his *Screentests*. Through 1966 Warhol produces over five hundred "film portraits" of Factory regulars, underground luminaries, and counter-culture heroes. An 8mm film loop installation consisting of excerpts from *Eat, Haircut, Kiss*, and *Sleep* projected on viewers (with soundtrack by LaMonte Young) is shown at the New York Film Festival.

Godard, *Bande à part* (Band of Outsiders).

Release of Chris Marker's *La Jetée* (The Jetty) (made in 1962).

The Beatles star in Richard Lester's *A Hard Day's Night*.

Richard Hamilton takes a publicity still from the 1948 "B movie" *Shockproof* (starring Patricia Knight) as a point of departure for the paintings *Interior I* and *Interior II*.

Antonioni makes his first color film, *Il deserto rosso* (Red Desert).
"I want to paint the film as one paints a canvas; I want to invent the color relationships, and not limit myself by photographing only natural colors.... Color is not just a little something extra.... I wanted to use it to help convey states of mind, and it is realistic color—at least to the extent that it communicates this kind of reality." [Antonioni in Seymour Chatman, *Antonioni, or, the Surface of the World* (Berkeley: University of California Press, 1985), 131]

Pier Paolo Pasolini, *Il Vangelo Secondo Matteo* (The Gospel According to St. Matthew).

Carl-Theodor Dreyer makes his last film, *Gertrud*.
"Where does the possibility of an artistic renewal of film lie? I, for my part, can only see one way: abstraction...'abstraction' as an expression for the perception of art which demands that an artist shall abstract from reality to reinforce its spiritual content, whether this is of psychological or purely aesthetic nature. Or said even more succinctly: Art shall represent the *inner* and not the *outer* life." [Dreyer, excerpt from a 1955 lecture. Reprinted in Donald Skoller, *Dreyer in Double Reflection* (New York: Da Capo Press, 1973), 178]

Hiroshi Teshigahara, *Woman in the Dunes*.

Stan Brakhage completes his "mytho-poetic," multi-part film of the creation of the universe, *Dog Star Man* (begun in 1961 with *Prelude: Dog Star Man*).

1965

Godard, *Alphaville*.

Warhol begins making synchronized-sound films featuring his entourage at the Factory: *Screentest #2, The Life of Juanita Castro, Poor Little Rich Girl, Vinyl, Henry Geldzahler, Lupe* (inspired by the account of the 1944 suicide of actress Lupe Velez in Kenneth Anger's *Hollywood Babylon*), *My Hustler, Restaurant, Kitchen, Paul Swan, More Milk Yvette, Horse*, (a parody of the Western movie genre), and *Camp*, an homage to influential underground performers that Warhol admired.
Richard Hamilton develops the painting *My Marilyn* from photographs marked-up by the actress, who typically demanded to see exposures for approval before publication. "The violent obliteration of her own image has a self-destructive implication that made her death all the more poignant. *My Marilyn* starts with her signs and elaborates the possibilities these suggest." [Hamilton, *Collected Words 1953–1982* (London: Thames and Hudson, 1982), 65]

Kenneth Anger, *KKK* (Kustom Kar Kommandos).

Robert Whitman produces the "Theatre Happening" *Prune Flat* using film as one of the main components of the performance (*Prune Flat* is subsequently presented off-Broadway, at the Circle-in-the-Square theatre, from May to August 1966).

Michelangelo Antonioni
Zabriskie Point, 1970

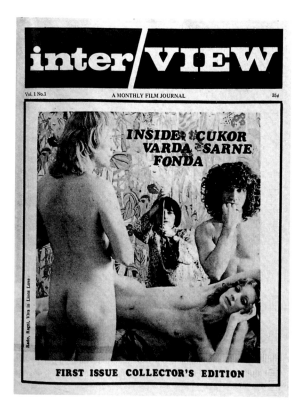

Cover of *Interview* 1, no. 1 (1969)
The Andy Warhol Museum, Archives
Study Center, Pittsburgh

Bruce Conner
Marilyn Times Five, 1969–73

Carolee Schneemann makes her first film, *Fuses*, in which she treats celluloid as a flexible material for experimentation and collage.

"As a painter I had never accepted that any part of the body be subject to visual or tactile taboos. I was free to examine the celluloid itself; burning, baking, cutting, painting, dipping my footage in acid, building dense layers of collage and complex A & B rolls held together with paper clips." [Schneemann, quoted in The Museum of Modern Art, New York, Department of Film flyer]

1966

Godard, *Made in U.S.A.*

Warhol begins producing multi-media presentations called the "Exploding Plastic Inevitable" featuring the Velvet Underground rock group and singer/actress Nico. The first show premieres at the Dom nightclub in the East Village in April 1966.

Warhol makes the film *Hedy* (a.k.a. *The Shoplifter*, *The Fourteen-Year-Old Girl*), conceived as a tabloid-like film exposé based on the detention of actress Hedy Lamarr, caught shoplifting at the end of January 1966 in Los Angeles. *Hedy* is the first film in which Warhol begins experimenting with his "inattentive camera" device. Also makes *The Chelsea Girls*, his first commercially successful feature-length film.

"I didn't expect the movies we were doing to be commercial. It was enough that the art had gone into the stream of commerce, out into the real world. It was very heady to be able to look and see our movie out there in the real world on a marquee instead of in there in the art world." [Warhol, *The Philosophy of Andy Warhol (From A to B & Back Again)* (New York: Harcourt Brace Jovanovich, 1975), 92]

Tony Conrad makes *The Flicker*.

"This is a notorious film; it moves audiences into some space and time in which they may look around and find the movie happening in the room there with them.... It is a library of peculiar visual materials, referenced to the frame-pulse at 24 frames per second." [Conrad in *Film-Makers' Cooperative Catalogue* No. 7 (New York: The New Cinema American Group/Film-Makers' Cooperative, 1989), 116]

Paul Sharits makes his first "color flicker films," which explore the flicker film concept and suggest painting effects of "overtonality": e.g. *Ray Gun Virus*.

George Landow, *Film in which there appear Sprocket Holes, Edge Lettering, Dirt Particles, Etc.*

Antonioni, *Blow-Up*.

Ingmar Bergman, *Persona*.

George Maciunas makes the Fluxus film *Ten Feet*.

1967

Canyon Cinema, Inc., San Francisco, is incorporated to distribute avant-garde films.

Founding of the American Film Institute.

Publication of Guy Debord's *La Société du spectacle* (Society of the Spectacle).

Publication of Robert Smithson's essay "The Monuments of Passaic" (originally entitled "A Tour of the Monuments of Passaic, New Jersey") in *Artforum* (December 1967).

"I should now like to prove the irreversibility of eternity by using a *jejune* experiment for proving entropy. Picture in your mind's eye the sand box divided in half with black sand on one side and white sand on the other. We take a child and have him run hundreds of times clockwise in the box until the sand gets mixed and begins to turn grey; after that we have him run anti-clockwise, but the result will not be a restoration of the original division but a greater degree of greyness and an increase of entropy." [Smithson, "The Monuments of Passaic," reprinted in *The Writings of Robert Smithson: Essays with Illustrations*, Nancy Holt, ed. (New York: New York University Press, 1979) 56–57]

Michael Snow, *Wavelength*.

"I knew I wanted to expand something—a zoom—that normally

happens fast, and to allow myself or the spectator to be sort of inside it for a long period. You'd get to know this device which normally just gets you from one space to another." [Snow in Scott MacDonald, *A Critical Cinema 2: Interviews with Independent Filmmakers* (Berkeley: University of California Press, 1992), 63]

Yoko Ono, *No. 4 (Bottoms)*.

Taka Iimura makes the abstract film *White Calligraphy*, scratching characters from sections of the Japanese epic *The Kojiki* into dark leader.

Warhol shows **** (a.k.a. *Four Stars*) in its original twenty-five hour version at the New Cinema Playhouse. Warhol releases the films *I, a Man*, *Bike Boy*, *Tub Girls* and *Loves of Ondine* (all shown as segments of the long version of ****). Makes the films *The Nude Restaurant* and *Lonesome Cowboys* (1967–68).

Godard, *Deux ou trois choses que je sais d'elle* (Two or Three Things I Know About Her); *La Chinoise*.

John Boorman, *Point Blank*.

Roger Corman, *The Trip*.

Mike Nichols, *The Graduate*.

1968

Stanley Kubrick, *2001: A Space Odyssey*.

"I tried to create a *visual* experience, one that bypasses verbalized pigeonholing and directly penetrates the subconscious with an emotional and philosophical content.... I intended the film to be an intensely subjective experience that reaches the viewer at an inner level of consciousness, just as music does." [Kubrick, "Playboy Interview," (1968) in *The Making of Kubrick's 2001*, Jerome Agel, ed. (New York: New American Library, 1970). Reprinted in Norman Kagan, *The Cinema of Stanley Kubrick* (New York: The Continuum Publishing Company, 1989), 145]

Week-end (Weekend) is Godard's last film before his withdrawal from "traditional" cinema; he increasingly turns his interest into making "revolutionary" films as a collaborative effort, and begins making projects for television such as *Le Gai Savoir* (Joyful Knowledge). Also makes Rolling Stones documentary *One Plus One* (*Sympathy for the Devil*).

Peter Bogdanovich, *Targets*.

June 3: Warhol is shot by actress and factory regular Valerie Solanas; he begins to take a less active role in filmmaking, producing films which Paul Morissey directs, e.g. *Flesh*.

Paul Sharits gives three-dimensional form to his flicker films *N:O:T:H:I:N:G* and *T,O,U,C,H,I,N,G*, by mounting them between Plexiglas as paintings in his series of "Frozen Film Frames."

George Maciunas conceives a visionary plan for a multimedia *Flux Amusement Center* in SoHo, a gallery for multi-image projections which he labels "Flux Film Wallpaper."

Richard Serra makes short films which are a continuation of the concerns that the artist had previously tackled in his sculpture, e.g. *Hand Catching Lead*, *Hands Tied*. Bruce Nauman also embraces film as a complement to his art, e.g. *Art Make-Up* films (1967–68).

1969

Ken Jacobs, *Tom, Tom, The Piper's Son*.

Bruce Conner makes, *Marilyn Times Five*, (through 1973), a tribute to Marilyn Monroe.

"I tell people that while it may or may not have been Marilyn Monroe in the original footage, it's her now. Part of what that film is about is the roles people play, and I think it fits either way. It's her image and her persona." [Conner in "I don't go to the movies anymore," interview by Scott MacDonald, *Afterimage*, vol. 10, no. 1–2, (Summer 1982), 22]

Publication of the first issue of Warhol's *Interview* magazine which begins as "A Monthly Film Journal."

Dennis Hopper's *Easy Rider* becomes the box-office phenomenon of the decade: produced for $375,000, it makes $50 million. John Schlesinger, *Midnight Cowboy*.

Dan Graham makes the films *Sunset to Sunrise* and *Binocular Zoom* (double-projection, 1969–70) using the camera to record both the object of the film as well as the body movements of the subject/filmmaker.

1970

Founding of Anthology Film Archives in New York.

Robert Smithson makes *Spiral Jetty*. The film documents the making of his site-specific sculpture in the Great Salt Lake, Utah.

"The movie began as a set of disconnections, a bramble of stabilized fragments taken from things obscure and fluid, ingredients trapped in a succession of frames, a stream of viscosities both still and moving.... Everything about movies and moviemaking is archaic and crude. One is transported by this Archeozoic medium into the earliest known geological eras. The movieola becomes a 'time machine' that transforms trucks into dinosaurs." [Smithson, "The Spiral Jetty," in *The Writings of Robert Smithson*, 114]

Hollis Frampton, *Zorns Lemma*.

"All that survives entire of an epoch is its typical art form. Film is surely the typical art of our time, whatever time that is." [Frampton in *Film-Makers' Cooperative Catalogue* No. 7 (New York: The New Cinema American Group/Film-Makers' Cooperative, 1989), 451]

Bernardo Bertolucci, *Strategia del ragno* (The Spider's Stratagem) (originally made for Italian television). Bertolucci draws inspiration from the paintings of De Chirico and Magritte.

Dario Argento makes his first horror film, *L'Ucello dalle Piumi di Cristallo* (The Bird with the Crystal Plumage) using unnatural, saturated colors, surreal-like imagery, and bizarre camera angles.

Russ Meyer, *Beyond the Valley of the Dolls*.

Nicolas Roeg and Donald Cammell, *Performance*.

1971

Publication of first issue of the film journal *Screen*.

Michael Snow makes the "landscape" film *La Région Centrale* in which he mounts the "camera-eye" onto a machine capable of rotating 360 degrees around an invisible point to record a desolate area of northern Quebec. The machine designed for the film is subsequently adapted into the projection installation *De La* (1972).

"The camera is an instrument which has expressive possibilities in itself. I want to make a gigantic landscape film equal in terms of film to the great landscape paintings of Cézanne, Poussin, Corot, Monet, Matisse and in Canada the Group of Seven." [Snow, excerpts from a proposal to the Canadian Film Development Corporation (March 1969). Reprinted in *The Michael Snow Project: The Collected Writings of Michael Snow* (Waterloo, Ontario: Wilfred Laurier University Press, 1974), 60 and 73]

Frampton, *Nostalgia* (part one of the film cycle *Hapax Legomena* 1971–72). For *The Nostalgia Portfolio*, Frampton reprints the twelve photographs used to make the film, and reassembles them for exhibition using the text of the film script as captions.

Brakhage, *The Act of Seeing with One's Own Eyes*, part of the series "The Pittsburgh Documents."

Smithson realizes sketches and storyboards for several film proposals, "Movie Treatments," related to earthworks which are never executed. He also conceives drawings for projection sites, e.g. *Toward the Development of a Cinema Cavern* (1971), and writes two essays that include extensive comments on film: "Art Through the Camera's Eye" (ca. 1971–72) and "A Cinematic Atopia" (1971).

Pier Paolo Pasolini casts himself as a disciple of Giotto in *Il Decamerone*, and models the look of the film after Giotto.

Luchino Visconti, *Morte a Venezia* (Death in Venice).

Alain Robbe-Grillet makes his first film in color, *L'Eden et après* (Eden and After), under the influence of pictorial preoccupations

Roman Polanski
Chinatown, 1974

Martin Scorsese
Taxi Driver, 1976

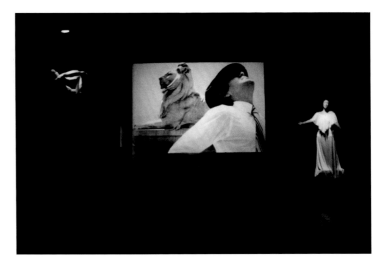

Robert Longo
Sound Distance of a Good Man, 1978

with the work of Piet Mondrian, Marcel Duchamp and Paul Klee.

Dennis Hopper, *The Last Movie*.

1972

First International Festival of Women's Films.

Yvonne Rainer completes her first feature film, *Lives of Performers*.

Chantal Akerman makes her first feature film in New York, *Hôtel Monterey*.

Sharits projects four related films sideways, in a serial manner simulating the look of a strip of film frames in *Soundstrip/Filmstrip* (1971–72). This is the first of a series of "locational" film installations involving continuous projection of multiple film loops with synchronized sound.
"Film can occupy spaces other than that of the theatre, it can become 'locational' (rather than suggesting other locations) by existing in spaces whose shapes and scales of possible sound and image 'sizes' are part of the holistic piece…." [Sharits in *Film as Installation*, exh. cat. (New York: The Clocktower, 1983), 23–24]

John Baldessari begins using film stills in composite photographic pieces, and text-on-canvas works that exploit cinematic montage and narrative strategies.
"I didn't employ them originally because they were movie stills. I went to them simply because they were a cheap source of photographic imagery. But I do realize now that having used stills, I tap into some sort of bank of iconic imagery that most of us tend to realize just having gone to the movies a lot." ["Amy Gerstler Talks with John Baldessari," *Vernacular*, vol. 1, no. 1, (Winter 1994), 14–38]

Luis Buñuel, *Le Charme discret de la Bourgeoisie* (The Discreet Charm of the Bourgeoisie).
"A film is like an involuntary imitation of a dream … the darkness that slowly settles over a movie theater is equivalent to the act of closing the eyes. Then, on the screen, as within the human being, the nocturnal voyage into the unconscious begins. The device of fading allows images to appear and disappear as in a dream; time and space become flexible, shrinking and expanding at will; chronological order and the relative values of time duration no longer correspond to reality, cyclical action can last a few minutes or several centuries; shifts from slow motion to accelerated motion heighten the impact of each. The cinema seems to have been created to express the roots of the subconscious, the roots of which penetrate poetry so deeply." [Buñuel in "Poetry and Cinema" (text of an address delivered at the University of Mexico in 1953). Printed in *The World of Luis Buñuel: Essays in Criticism*, Joan Mellen, ed. (New York: Oxford University Press, 1978), 107]

Rainer Werner Fassbinder, *Die bitteren Tränen der Petra von Kant* (The Bitter Tears of Petra von Kant).

Francis Ford Coppola, *The Godfather*.

Bernardo Bertolucci, *Ultimo Tango a Parigi* (Last Tango in Paris). The look of the film is inspired by Francis Bacon paintings.

1973

The Hollywood industry comes out of the economic crisis of the sixties in part through innovative marketing strategies featuring nationwide distribution of important films.

The first multiplex theater, the Quad Cinema, opens in New York with four separate screening rooms under one roof.

George Lucas, *American Graffiti*.

Martin Scorsese, *Mean Streets*.

Warhol appears in the film *The Driver's Seat* with Elizabeth Taylor. He co-produces the films *Andy Warhol's Dracula* and *Andy Warhol's Frankenstein* (1973–74), both directed by Paul Morrissey.

1974

Carolee Schneemann begins the series of performances (through 1976) entitled *Up To and Including Her Limits*.

Brakhage, *The Text of Light*.

Yvonne Rainer, *Film About a Woman Who…*

Coppola, *The Conversation*.

Roman Polanski, *Chinatown*.

1975

Publication of Warhol's *The Philosophy of Andy Warhol (From A to B & Back Again)*.

Laura Mulvey's landmark article "Visual Pleasure and Narrative Cinema" appears in the fall issue of *Screen*.

Chantal Akerman, *Jeanne Dielman, 23 quai du Commerce, 1080 Bruxelles*, a film about routine and obsession in the daily life of a Belgian housewife and part-time prostitute.

Fabio Mauri realizes projection pieces which emphasize the nature of film as a beam of light through the use of unusual "-screens" such as the human body; in *Intelletuale* he projects Pier Paolo Pasolini's *The Gospel According to St. Matthew* onto the chest of the director himself.

November 2: Pasolini is murdered.

Steven Spielberg's *Jaws* becomes a box-office phenomenon (costs $8.5 million; grosses over $100 million dollars in the U.S.); begins trend of tie-in products such as clothing and toys that turn films into marketing events.

Jack Goldstein makes the film loop *Metro-Goldwyn-Mayer* in which MGM's signature lion roars endlessly.

Edward Ruscha directs the short film, *Miracle*.

1976

Publication of the first issues of *Camera Obscura*.

Martin Scorsese, *Taxi Driver*.

Hiroshi Sugimoto begins his theaters series, a group of black-and-white photographs of movie palace interiors of the 1920s and 1930s (still in progress).
"One night I thought of taking a photographic exposure of a film at a movie theater while the movie was being projected. I imagined how it could be possible to shoot an entire movie with my camera. Then I had the very clear vision that the movie screen would show up on the picture as a white rectangle. If I already have a vision, my work is almost done. The rest is a technical problem." ["Interview with Hiroshi Sugimoto," by Thomas Kellein in *Hiroshi Sugimoto, Time Exposed* (New York: Thames and Hudson, 1995), 91]

Eric Rohmer, *La Marquise d'O* (The Marquise of O).
John Cassavetes, *The Killing of a Chinese Bookie*.

1977

Laura Mulvey and Peter Wollen collaborate on *Riddles of the Sphinx*, a film which they develop in part out of their theoretical writing.
"In those days … the avant-garde thought it could remodel the cinema. I think we all really believed it would be possible. Godard had talked about a return to zero…. We were interested in trying to make a movie in which form and structure were clearly visible but which would also have a space for feeling and emotion, that would open up a cinematic meaning beyond dependence on negating the dominant cinema's conventions and inbred ways of seeing." [Mulvey in Scott MacDonald, *A Critical Cinema 2: Interviews with Independent Filmmakers* (Berkeley: University of California Press, 1992), 334]

Douglas Crimp organizes the exhibition "Pictures" at Artists Space, New York; the show features the new work of Troy Brauntuch, Jack Goldstein, Sherrie Levine, Robert Longo, and Philip Smith.

Cindy Sherman begins her series of *Untitled Film Stills* (through 1980), a sequence of black-and-white photographs in which the artist poses in various stereotypical female roles often styled after movies of the 1950s and early 1960s.

"Part of it could be that I want to see what I look like as a certain character — even though I know that person isn't me. There is also me making fun — making fun of these role models of women from my childhood. And part of it maybe is to show that these women who are playing these characters … maybe these actresses know what they're doing, know they are playing stereotypes … but what can they do?" [Sherman in Gerald Marzorati, "Imitation of Life," *Artnews* (September 1983), 86]

George Lucas, *Star Wars*.

1978

The increase in film and television courses offered in U.S. colleges and universities (over 1,000 schools offer 10,000 courses) reflects the rise of the "Film School Generation" of Hollywood filmmakers.

Robert Longo's multi-media performance *Sound Distance of a Good Man*.

Bruce Conner, *Mongoloid* (music: "Mongoloid" by Devo).

Raúl Ruiz, *L'Hypothèse du tableau volé* (The Hypothesis of the Stolen Painting).

Jeff Wall begins making photographs (cibachrome transparencies lit from behind by fluorescent light) which are carefully staged tableaux indebted both to cinematic and art-historical sources.
"Our pictorial experience of drama was created by painting, drawing, etching, and so on. But the cinema, unlike the forms of performance it canned and played back, is a performance picture. Cinema synthesized the functions of painting and of theatre simultaneously on a technical basis of photographic reproduction. So in that synthesis the mechanics of photography were invested with tremendous meaning, a meaning they will now always have." [Wall in Els Barents *Jeff Wall: Transparencies* (New York: Rizzoli, 1987), 100–101]

1979

Francis Ford Coppola, *Apocalypse Now*.

Derek Jarman makes the film *The Tempest*, and the music video for Marianne Faithful, *Broken English*.

1980

Martin Scorsese, *Raging Bull*.

1981

MTV music video network begins.

Brian De Palma, *Blow Out*.

Dan Graham conceives his *Cinema 81* project, a miniature scale model for a cinema constructed with two-way mirrored glass.

1982

David Cronenberg, *Videodrome*.

Ridley Scott, *Blade Runner*.

Chris Marker pays homage to Hitchcock's *Vertigo*, in the documentary film *Sans Soleil* (Sunless).

Godard constructs tableaux-vivants based on masterpieces by El Greco, Goya, Ingres, Rembrandt, and Delacroix in the film *Passion*. He collaborates with Anne-Marie Miéville in the making of the video film *Scénario du Film Passion*.

Peter Greenaway, *The Draughtsman's Contract*, a film based "upon the art training conundrum of 'draw what you see, not what you know;' the impossibility of only drawing what you see is responsible for all the minutiae of the plot and the narrative … As I have developed a vocabulary for myself — a vocabulary relating to certain phenomena like the static frame, attitudes towards history painting vis-a-vis drama, concerns for the background being the landscape, middle-ground being the portrait, and foreground being regarded as still life, etc. — what I have done is constantly reprise the genres and attitudes we associate with European painting…. I sincerely

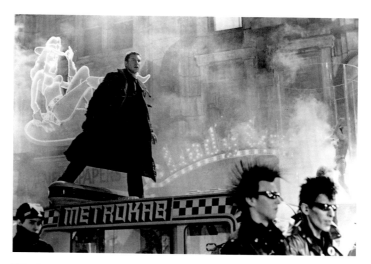

Ridley Scott
Blade Runner, 1982

Raúl Ruiz.
L'expulsion des maures, 1990

Chris Marker
Silent Movie, 1994–95

believe that all the problems that a cineast faces have been faced before in painting. And I want to be able to use that reference, to use it as a sort of thesaurus…. For me an attachment to the tradition of painting, an acknowledgment of that tradition, widens and deepens and enriches the fabric of cinema. [Greenaway in "Cinema and Art: Peter Greenaway," interview by Jacinto Lageira, *Galeries Magazine*, no. 51 (October/November 1992), 101–102]

1983

Godard, *Prénom Carmen* (First Name: Carmen).

Pictorial allusions to René Magritte as well as to Edouard Manet are fundamental to Alain Robbe-Grillet's film *La Belle Captive* (The Beautiful Prisoner).
"What interests me in Magritte is the presence on his canvases of several worlds, often of two worlds, that ought not to communicate but that connect through an opening." [Robbe-Grillet in Anthony N. Fragola and Roch C. Smith, *The Erotic Dream Machine: Interviews with Alain Robbe-Grillet on His Films* (Carbondale and Edwardsville, Illinois: Southern Illinois University Press, 1992), 104]

Publication of Richard Prince's book, *Why I Go to the Movies Alone*.

Publication of Dan Graham's essay "Theater, Cinema, Power" in the summer issue of *Parachute*.
"Hollywood stars, unlike conventional political figures who might be seen as ruthless and scheming to usurp power, are not seen by the public as objects of envy, but resemble more Greek gods, their foibles and personal tragedies magnified by the press and the legend. If they lost stature, their 'star' status was always potentially recoverable." [Graham, *Rock My Religion: Writings and Art Projects, 1965–1990*, Brian Wallis, ed. (Cambridge: MIT Press, 1993), 184]

1984

Brian De Palma, *Body Double*.

Wim Wenders, *Paris, Texas*.
"[In film] everything which is not enclosed in the image frame is nonetheless latently present, it might appear after the next cut or pan. In still photographs, everything which lies outside the frame is locked out forever." [Wenders in interview by Alain Bergala, 22–23]

1985

Terry Gilliam, *Brazil*.

1986

David Lynch, *Blue Velvet*.

Jarman directs his first 35mm film, *Caravaggio*, based on the life and work of the Italian artist. Jarman relies on Caravaggio's paintings for the tableau compositions and chiaroscuro lit scenes of the film but purposely introduces anachronisms such as contemporary dress and objects.

Jarman (with John Maybury and Richard Heslop), *The Queen is Dead* (music video for The Smiths).

Greenaway, *A Zed and Two Noughts*.

Longo directs his first music videos: "Boy (Go)" for the Golden Palominos, "Bizarre Love Triangle" for New Order, and "Peace Sells" for Megadeth.

1987

February 22: Death of Andy Warhol.

Jarman, *The Last of England*.

Wenders, *Der Himmel über Berlin*, (Wings of Desire). The visual text of the film is based on a documentary about Berlin from the German Expressionist period, *Berlin: Symphony of a City* (1927). Cinematographer Henri Alekan photographs the film both in black-and-white and color.

Longo's short film *Arena Brains* premieres at the New York Film Festival.

1988

Greenaway, *Drowning by Numbers*.

Opening of The Museum of the Moving Image, London.

1989

Godard begins the multi-part *Histoire(s) du Cinéma*, for French television. Godard addresses the "splendor and misery" of the twentieth century in a densely layered treatise on the fate of cinema.
"The greatest history is the history of the cinema. It's a nineteenth-century concern resolved in the twentieth. It's greater than the others because it projects, whereas others reduce themselves." [Godard in "Godard Makes [Hi]stories," interview with Serge Daney, *Jean-Luc Godard: Son + Image, 1974–1991*, exh. cat. Raymond Bellour with Mary Lea Bandy, eds. (New York: The Museum of Modern Art, 1992), 159]

1990

More than two-thirds of American households own video casette recorders.

Robert Altman, *Vincent and Theo*.

Akira Kurosawa, *Akira Kurosawa's Dreams*.

Rebecca Horn makes the feature film *Buster's Bedroom*.

Filmmaker Raúl Ruiz realizes his first multi-media installation *The Expulsion of the Moors*, titled after a seventeenth-century painting by Vélasquez mysteriously destroyed by fire in 1734.

Godard, *Nouvelle Vague* (New Wave).

1991

Jacques Rivette, *La Belle Noiseuse*.

Greenaway, *Prospero's Books*.

Greenaway curates "The Physical Self," a thematic exhibition using the resources of the Boymans-van Beuningen collection in Rotterdam to explore his fascination with the human figure.
"I certainly have been aware of a similarity of priorities, where the artifacts of an exhibition are like the props of a film, the lighting of the location and the lighting of a gallery for the presentation of ideas have analogies, and instead of an audience sitting in ordered ranks in the dark before a bright two-dimensional screen, the audience here is permitted, indeed encouraged, to walk around a three-dimensional illuminated space, and … they can look, in some instances, behind the screen to see how the presentation of the material has been arranged." [Greenaway in *Peter Greenaway: The Physical Self*, exh. cat. (Rotterdam: Museum Boymans-van Beuningen, 1991), 16]

Godard, *Allemagne année 90 neuf zéro* (Germany Year 90 Nine Zero).

1992

Sally Potter, *Orlando*.

1993

Jarman dedicates his last film, *Blue*, to "the great master of blue," Yves Klein, "painter of emptiness." The film consists of a soundtrack accompanied by a monochrome blue image projected without interruption for the entire length of the film. A cut-up of music, sound-effects and voices complement the abstract screen with musings on color, art, life, illness, and infinity.
"In the bottom of your heart, you pray to be released from image." [Jarman, from voice-over of the film]

1994

Quentin Tarantino, *Pulp Fiction*.
"One aspect of Godard that I found very liberating — movies commenting on themselves, movies and movie history. To me, Godard did to movies what Bob Dylan did to music: they revolutionized

their forms. There were always movie buffs who understood film and film convention, but now, with the advent of video, almost everybody has become a movie expert even though they don't know it." [Tarantino interviewed by Gavin Smith, *Film Comment* vol. 30, no. 4 (July/August 1994), 42]

Krzysztof Kieslowski, *Red*.

1995

David Salle makes his directorial debut with *Search & Destroy*.

Longo makes the science fiction feature *Johnny Mnemonic*.

Larry Clark, *Kids*.
"I always wanted to make the teenage movie that I felt America never made — the great American teenage movie, like the great American novel…. As far as the look of the film I did what a lot of people do — you think of your favorite films and figure out why you like them visually." [Clark in "Babes in the Hood," interview by Paul Schrader, *Artforum* (May 1995), 77–124]

Chantal Akerman's first museum installation, *Bordering on Fiction: Chantal Akerman's "D'Est,"* is presented at the San Francisco Museum of Modern Art. The film-video installation is based on Akerman's *D'Est* (From the East) (1993) a "film portrait" of Eastern Europe.

Chris Marker conceives the video installation *Silent Movie* as a personal homage to the one-hundredth anniversary of the invention of cinema.
"When I began to play with B&W film clips, and to film in B&W myself for this experiment, I just wanted it to be a light, unpretentious way to celebrate in my manner one hundred years of cinematography, and God forbid I theorize all this in a solemn way: only the pleasure, or is it sweet sorrow, to part with the already doomed glory of that era." [Marker, "The Rest is Silent," in *Silent Movie*, exh. cat. (Columbus: Wexner Center for the Arts, The Ohio State University, 1995), 18]

General Bibliography

Compiled by
John Alan Farmer

Allen, Richard. *Projecting Illusion: Film Spectatorship and the Impression of Reality.* Cambridge: Cambridge University Press, 1995.

Allen, Robert C., and Douglas Gomery. *Film History: Theory and Practice.* New York: Alfred A. Knopf, 1985.

Altman, Rick, ed. *Sound Theory Sound Practice.* New York: Routledge, 1992. Essays by Altman, James Lastra, Steve Wurtzler, Michael Chion, Alan Williams, Nataša Ďurovičová, John Belton, Amy Lawrence, Scott Curtis, Mary Pat Klimek, Jeffrey K. Ruoff, and Andrea Truppin.

___. *Yale French Studies,* no. 60 (1980). Special issue: Cinema/Sound. Essays by Daniel Percheron, Christian Metz, Mary Ann Doane, Alan Williams, Altman, Douglas Gomery, Dudley Andrew, Kristin Thompson, David Bordwell, Philip Rosen, Claudia Gorbman, Annette Insdorf, Michel Marie, Nick Browne, and Marie-Claire Ropars-Wuilleumier.

Andrew, Dudley. *Concepts in Film Theory.* Oxford: Oxford University Press, 1984.

___. *Film in the Aura of Art.* Princeton: Princeton University Press, 1984.

___. *The Major Film Theories: An Introduction.* London: Oxford University Press, 1976.

Arnheim, Rudolf. *Film as Art.* Berkeley: University of California Press, 1957.

The Art of Moving Shadows. Exh. cat. Washington, D.C.: National Gallery of Art, 1989. Essays by Annette Michelson, Patrick Loughney, and Douglas Gomery.

Aubenas, Jacqueline, ed. *Le film sur l'art en Belgique, 1927–1991.* Brussels: Centre du Film sur l'Art, 1992.

Aumont, Jacques. *Du visage du cinéma.* Paris: Editions de l'Etoile, 1992.

___. *L'image.* Paris: Editions Nathan, 1990.

___. *L'oeil interminable: Cinéma et peinture.* Librairie Séguier, 1989.

___, Alain Bergala, Michel Marie, and Marc Vernet. *Aesthetics of Film.* Translated by Richard Neupert. Austin: University of Texas Press, 1992.

Balázs, Béla. *Theory of the Film: Character and Growth of a New Art.* Translated by Edith Bone. New York: Roy Publishers, 1953.

Balio, Tino, ed. *The American Film Industry.* Madison: University of Wisconsin, 1976. Essays by A. R. Fulton, Gordon Hendricks, Robert C. Allen, Russell Merritt, Robert Anderson, Balio, Janet Staiger,

Douglas Gomery, Mae D. Huettig, Cathy Klaprat, Ruth A. Inglis, Ernest Borneman, Thomas H. Guback, John Cogley, Richard S. Randall, Michael Conant, Robert Gustafson, and David J. Londoner.

Barthes, Roland. *Camera Lucida: Reflections on Photography.* Translated by Richard Howard. New York: Hill and Wang, 1981.

___. *Image-Music-Text.* Essays selected and translated by Stephen Heath. New York: Hill and Wang, 1977.

___. *Mythologies.* Translated by Annette Lavers. New York: The Noonday Press, 1993.

Battcock, Gregory, ed. *The New American Cinema: A Critical Anthology.* New York: E. P. Dutton, 1967.

Baudry, Jean-Louis. *L'effet cinéma.* Paris: Editions Albatros, 1978.

Bazin, André. *What Is Cinema?.* Vol. 1. Essays selected and translated by Hugh Gray. Berkeley: University of California Press, 1967. Foreword by Jean Renoir.

___. *What is Cinema?.* Vol. 2. Essays selected and translated by Hugh Gray. Berkeley: University of California Press, 1971. Foreword by François Truffaut.

Bellour, Raymond. *L'entre-images: Photo, cinéma, vidéo.* Paris: La Différence, 1990.

Belton, John. *American Cinema/American Culture.* New York: McGraw-Hill, 1994.

___. *Widescreen Cinema.* Cambridge: Harvard University Press, 1992.

Benjamin, Walter. *Illuminations.* Edited by Hannah Arendt and translated by Harry Zohn. New York: Schocken Books, 1968. Includes "The Work of Art in the Age of Mechanical Reproduction."

Bettetini, Gianfranco. *The Language and Technique of the Film.* The Hague: Mouton, 1973.

Bonitzer, Pascal. *Le champ aveugle: Essais sur le cinéma.* Paris: Cahiers du Cinéma/Editions Gallimard, 1982.

___. *Peinture et cinéma: Décadrages.* Paris: Cahiers du Cinéma/Editions de l'Etoile, 1987.

___. *Le regard et la voix: Essais sur le cinéma.* Paris: Union Générale d'Editions, 1976.

Bordwell, David. *Making Meaning: Inference and Rhetoric in the Interpretation of Cinema.* Cambridge: Harvard University Press, 1989.

___, Janet Staiger, and Kristin Thompson. *The Classical Hollywood Cinema: Film Style and Mode of Production to 1960.* New York: Columbia University Press, 1985.

___, and Kristin Thompson. *Film Art: An Introduction.* New York: Alfred A. Knopf, 1986.

Brakhage, Stan. *Film at Wit's End: Eight Avant-Garde Filmmakers.* Kingston, New York: McPherson and

Co., 1989. Essays on Jerome Hill, Marie Menken, Sidney Peterson, James Broughton, Maya Deren, Christopher MacLaine, Bruce Conner, and Ken Jacobs.

Braudy, Leo, and Morris Dickstein, eds. *Great Film Directors: A Critical Anthology.* New York: Oxford University Press, 1978. Essays on Michelangelo Antonioni, Ingmar Bergman, Robert Bresson, Luis Buñuel, Frank Capra, Charles Chaplin, Carl-Theodor Dreyer, Sergei Eisenstein, Federico Fellini, Robert Flaherty, John Ford, Jean-Luc Godard, D. W. Griffith, Howard Hawks, Alfred Hitchcock, Buster Keaton, Akira Kurosawa, Fritz Lang, Jean Renoir, Roberto Rossellini, Josef von Sternberg, François Truffaut, and Orson Welles.

Bresson, Robert. *Notes on the Cinematographer.* Translated by Jonathan Griffin. New York: Quartet Books, 1986.

Breteau, Gisèle. *Abécédaire des films sur l'art moderne et contemporain, 1905–1984.* Paris: Centre national des arts plastiques, Centre Georges Pompidou, 1985.

Browne, Nick, ed. *Cahiers du Cinéma, 1969–1972: The Politics of Representation.* Cambridge: Harvard University Press, 1990. Anthology of articles published in *Cahiers du cinéma,* 1969–72.

Brunette, Peter, and David Wills. *Screen/Play: Derrida and Film Theory.* Princeton: Princeton University Press, 1989.

Buchloh, Benjamin H. D. "Filmographie: Filme von Künstlern 1960–1974/Filmography: Films by Artists 1960–1974." *Interfunktionen,* no. 12 (1975): 85–95.

Burch, Noël. *Theory of Film Practice.* Translated by Helen R. Lane. Princeton: Princeton University Press, 1981.

Burgin, Victor, James Donald, and Cora Kaplan, eds. *Formations of Fantasy.* London: Routledge, 1989. Essays by Jean Laplanche and Jean-Bertrand Pontalis, Joan Rivière, Stephen Heath, Francette Pacteau, Burgin, John Fletcher, Kaplan, Valerie Walkerdine, and Erica Carter and Chris Turner.

Carroll, John M. *Toward a Structural Psychology of Cinema.* The Hague: Mouton Publishers, 1980.

Casebier, Allan. *Film and Phenomenology: Toward a Realist Theory of Cinematic Representation.* Cambridge: Cambridge University Press, 1991.

Caughie, John, ed. *Theories of Authorship: A Reader.* London: Routledge and Kegan Paul, 1981. Essays by M. H. Abrams, Edward Buscombe, Andrew Sarris, Louis Marcorelles, Lindsay Anderson, Robin Wood, Peter Wollen, Jean-Louis Comolli, Jean Narboni, Claude Lévi-Strauss, Geoffrey Nowell-Smith, Charles Eckert, Brian Henderson, Jean-Pierre Oudart, Pierre Macherey, Roland Barthes, Stephen Heath,

Geoffrey Nowell-Smith, Christian Metz, Sandy Flitterman, Nick Browne, Pam Cook, and Michel Foucault.

Cavell, Stanley. *The World Viewed: Reflections on the Ontology of Film.* New York: Viking Press, 1971.

Ceplair, Larry, and Steven Englund. *The Inquisition in Hollywood: Politics in the Film Community, 1930–1960.* Garden City, New York: Anchor Press/Doubleday, 1980.

Cha, Theresa Hak Kyung, ed. *Cinematographic Apparatus: Selected Writings.* New York: Tanam Press, 1980. Essays by Roland Barthes, Dziga Vertov, Jean-Louis Baudry, Maya Deren, Gregory Woods, Danièle Huillet, Thierry Kuntzel, Bertran Augst, Cha, Huillet and Jean-Marie Straub, Marc Vernet, and Christian Metz.

Chion, Michel. *Audio-Vision: Sound on Screen.* Edited and translated by Claudia Gorbman. New York: Columbia University Press, 1994.

Cocteau, Jean. *The Art of Cinema.* Compiled and edited by André Bernard and Claude Gauteur and translated by Robin Buss. London: Marian Boyers, 1992. Introductory essays by Buss, Bernard, and Gauteur.

___. *On the Film: Conversations with Jean Cocteau.* Recorded by André Fraigneau and translated by Vera Traill. New York: Dover Publications, 1972. Introduction by George Amberg.

Cohen, Keith. *Film and Fiction: The Dynamics of Exchange.* New Haven: Yale University Press, 1979.

Covert, Nadine, ed. *Art on Screen: A Directory of Films and Videos about the Visual Arts.* New York: Program for Art and Film, 1991. Essays by Henriette Montgomery and Covert, Judith Wechsler, Susan Delson, Carrie Rickey, and Covert.

Curtis, David. *Experimental Cinema.* New York: Dell Publishing Co., 1971.

de Haas, Patrick. *Cinéma intégral: De la peinture au cinéma dans les années vingt.* Paris: Transédition, 1985.

de Lauretis, Teresa. *Alice Doesn't: Feminism, Semiotics, Cinema.* Bloomington: Indiana University Press, 1984.

___. *Technologies of Gender: Essays on Theory, Film, and Fiction.* Bloomington: Indiana University Press, 1987.

___, and Stephen Heath, eds. *The Cinematic Apparatus.* London: The Macmillan Press, 1980. Essays by Heath, Peter Wollen, Jeanne Thomas Allen, Douglas Gomery, Mary Ann Doane, Dudley Andrew, Joseph and Barbara Anderson, Bill Nichols and Susan J. Lederman, Kristin Thompson, Jean-Louis Comolli, Maureen Turim, Peter Gidal, Jacqueline Rose, and de Lauretis.

Debord, Guy. *Comments on the Society of the Spectacle.* Translated by Malcolm Imrie. London: Verso, 1990.

___. *Oeuvres cinématographiques complètes, 1952–1978.* Paris: Editions Champ Libre, 1978.

___. *The Society of the Spectacle.* Translated by Donald Nicholson-Smith. New York: Zone Books, 1994.

deCordova, Richard. *Picture Personalities: The Emergence of the Star System in America.* Urbana: University of Illinois Press, 1990.

Deleuze, Gilles. *Cinema 1: The Movement-Image.* Translated by Hugh Tomlinson and Barbara Habberjam. London: The Athlone Press, 1986.

___. *Cinema 2: The Time-Image.* Translated by Hugh Tomlinson and Barbara Habberjam. Minneapolis: University of Minnesota Press, 1989.

Devaux, Frédérique. *Le cinéma lettriste (1951–1991).* Paris: Editions Paris Expérimental, 1992.

Difference: On Representation and Sexuality. Exh. cat. New York: The New Museum of Contemporary Art, 1985. Essays by Craig Owens, Lisa Tickner, Jacqueline Rose, Peter Wollen, and Jane Weinstock.

Doane, Mary Ann. *Femmes Fatales: Feminism, Film Theory, Psycho-analysis.* New York: Routledge, 1991.

___, Patricia Mellencamp, and Linda Williams, eds. *Re-Vision: Essays in Feminist Film Criticism.* Frederick, Maryland: University Publications of America in association with Los Angeles: The American Film Institute, 1984. Essays by Christine Gledhill, Judith Mayne, Doane, Williams, B. Ruby Rich, Kaja Silverman, and Teresa de Lauretis.

Drawing into Film: Directors' Drawings. Exh. cat. New York: Pace Gallery, 1993. Essay by Annette Michelson.

Durgnat, Raymond. *Films and Feelings.* Cambridge: The MIT Press, 1967.

___, and John Kobal. *Greta Garbo.* London: Studio Vista, 1965.

Dyer, Richard. *Heavenly Bodies: Film Stars and Society.* New York: St. Martin's Press, 1986.

___. *Stars.* London: BFI Publishing, 1990.

Ehrlich, Linda C., and David Desser, eds. *Cinematic Landscapes: Observations on the Visual Arts and Cinema of China and Japan.* Austin: University of Texas Press, 1994. Essays by Ehrlich and Desser, Sherman Lee, Douglas Wilkerson, Hảo Dàzhēng, Ní Zhèn, Chris Berry and Mary Ann Farquhar, Ān Jingfū, Jenny Kwok Wah Lau, Thomas Rimer, Donald Richie, Satō Tadao, D. William Davis, Dudley Andrew, Cynthia Contreras, Ehrlich, Kathe Geist, and Desser.

Eidsvik, Charles. *Cineliteracy: Film among the Arts.* New York: Horizon Press, 1978.

Eisenstein, Sergei M. *Cinématisme: Peinture et cinéma.* Brussels: Editions Complexe, 1980.

___. *Film Form.* Edited and translated by Jay Leyda. New York: Harcourt Brace Jovanovich, 1977.

___. *The Film Sense.* Edited and translated by Jay Leyda. New York: Harcourt Brace Jovanovich, 1970.

L'époque, la mode, la morale, la passion: Aspects de l'art d'aujourd'hui, 1977–1987. Exh. cat. Paris: Musée national d'art moderne, Centre Georges Pompidou, 1987. Essays by Bernard Ceysson, Thierry de Duve, Yves Michaud, Johannes Gachnang, Jean-François Chevrier, Serge Daney, Philippe Dubois, and Christine Van Assche; conversation with Bernard Blistène, Catherine David, and Alfred Pacquement.

Farber, Manny. *Movies.* New York: Stonehill Publishing Co., 1971. Original title: *Negative Space.*

Film as Film: Formal Experiment in Film, 1910–1975. Exh. cat. London: Hayward Gallery, 1979. Essays by Phillip Drummond, Al Rees, Birgit Hein, Wulf Herzogenrath, Malcolm Le Grice, Ian Christie, Peter Weibel, Deke Dusinberre, and William Moritz.

Film Culture, no. 62 (1976). Special issue: A Guide to Independent Film and Video. Includes bibliographies on independent film and filmmakers.

Film Stills: Emotions Made in Hollywood. Exh. cat. Zurich: Museum für Gestaltung, 1992. Essays by Alois M. Müller, Gertrud Koch, Max Kozloff, Annemarie Hürlimann, Michel Cieutat, Jörg Huber, Barbara Basting, Alice Kohler-Lechner, Marco Meier, David Streiff, Laura Arici, Martin Schaub, Andreas Isenschmid, Urs Stahel, Lilli Binzegger, Barbara Sichtermann, Martin Schlappner, Rolf Niederer, and Ilma Rakusa.

Flitterman-Lewis, Sandy. *To Desire Differently: Feminism and the French Cinema.* Urbana: University of Illinois Press, 1990.

Friedberg, Anne. *Window Shopping: Cinema and the Postmodern.* Berkeley: University of California Press, 1993.

Gabbard, Krin, and Glen O. Gabbard. *Psychiatry and the Cinema.* Chicago: University of Chicago Press, 1987.

Gardner, Paul. "Light, Canvas, Action! When Artists Go to the Movies!" *ARTnews* 93, no. 10 (December 1994): 124–129.

Gidal, Peter. *Materialist Film.* London: Routledge, 1989.

___, ed. *Structural Film Anthology.* London: British Film Institute, 1976. Essays by Gidal and Malcolm Le Grice; essays on Le Grice, Michael Snow, Kurt Kren, Hollis Frampton, Ken Jacobs, Mike Dunford, Paul Sharits, David Crosswaite, Peter Kubelka, Gidal, Birgit and Wilhelm Hein, Gill Eatherley, George Landow, William Raban, Roger Hammond, Fred Drummond, Mike Leggett, Tony Conrad, John Du Cane, and Joyce Wieland.

Gledhill, Christine, ed. *Stardom: Industry of Desire.* New York: Routledge, 1991.

Gomery, Douglas. *The Hollywood Studio System.* New York: St. Martin's Press, 1986.

Goodman, Ezra. *The Fifty-Year Decline and Fall of Hollywood.* New York: Simon and Schuster, 1961.

Greenberg, Clement. *The Collected Essays and Criticism.* Vol. 1, *Perceptions and Judgments, 1939–1944.* Edited by John O'Brian. Chicago: University of Chicago Press, 1986. Includes "Avant-Garde and Kitsch."

___. *The Collected Essays and Criticism.* Vol. 4, *Modernism with a Vengeance, 1957–1969.* Edited by John O'Brian. Chicago: University of Chicago Press, 1993. Includes "Modernist Painting."

Guiles, Fred Lawrence. *Legend: The Life and Death of Marilyn Monroe.* New York: Stein and Day Publishers, 1984.

Heath, Stephen. *Questions of Cinema.* Bloomington: University of Indiana Press, 1981.

___, and Patricia Mellencamp, eds. *Cinema and Language.* Frederick, Maryland: University Publications of America, 1983. Essays by Heath, Teresa de Lauretis, Mary Ann Doane, Malcolm Le Grice, Mellencamp, Noël Burch, Don Kirihara, David Bordwell, Laura Oswald, Linda Williams, Dudley Andrew, Paul Willemen, and Philip Rosen.

Hedges, Inez. *Breaking the Frame: Film Language and the Experience of Limits.* Bloomington: Indiana University Press, 1991.

Heinich, Nathalie. "Tableaux filmés." *Cahiers du cinéma,* no. 308 (February 1980): 35–40. See also related interviews with Pierre Samson and André S. Labarthe on the filming of paintings, 40–43.

Henderson, Brian. *A Critique of Film Theory.* New York: E. P. Dutton, 1980.

Hillier, Jim, ed. *Cahiers du Cinéma: The 1950s: Neo-Realism, Hollywood, New Wave.* Cambridge: Harvard University Press, 1985. Anthology of articles from *Cahiers du cinéma* published during the 1950s.

___. *Cahiers du Cinéma: 1960–1968: New Wave, New Cinema, Reevaluating Hollywood.* Cambridge: Harvard University Press, 1986. Anthology of articles from *Cahiers du cinéma* published during the 1960s.

Une histoire du cinéma. Exh. cat. Paris: Musée national d'art moderne, 1976. Essays by Peter Kubelka, P. Adams Sitney, Annette Michelson, Dominique Noguez, Jonas Mekas, Claudine Eizykman and Guy Fihman, and Marcel Mazé.

A History of the American Avant-Garde Cinema. Exh. cat. New York: The American Federation of Arts, 1976. Essays by Marilyn Singer, John G. Hanhardt, Lucy Fisher, Stuart Liebman, Paul S. Arthur, Lindley P. Hanlon, Fred Kamper, and Ellen Feldman.

Hollander, Anne. *Moving Pictures.* New York: Alfred A. Knopf, 1989.

Hollywood, Hollywood: Identity under the Guise of Celebrity. Exh. cat. Pasadena, California: Alyce de Roulet Williamson Gallery, Art Center College of Design, 1992. Essays by Fred Fehlau, Anne Friedberg, Michael Lassell, and David Robbins.

Hollywood: Legend and Reality. Edited by Michael Webb. Exh. cat. Washington, D.C.: Smithsonian Institution Traveling Exhibition Service in association with Boston: Little, Brown and Co., 1986.

Houston, Beverle, and Marsha Kinder. *Self and Cinema: A Transformalist Perspective.* Pleasantville, New York: Redgrave Publishing Co., 1980.

Hoy, Anne H. *Fabrications: Staged, Altered, and Appropriated Photographs.* New York: Abbeville Press, 1987.

Image World: Art and Media Culture. Exh. cat. New York: Whitney Museum of American Art, 1989. Essays by Marvin Heiferman, Lisa Phillips, and John G. Hanhardt.

James, David E. *Allegories of Cinema: American Film in the Sixties.* Princeton: Princeton University Press, 1989.

___, ed. *To Free the Cinema: Jonas Mekas and the New York Underground.* Princeton: Princeton University Press, 1992. Essays by James, Paul Arthur, George Kuchar, John Pruitt, Tom Gunning, Marjorie Keller, Rudy Burckhardt, J. Hoberman, Vyt Bakaitis, Richard Foreman, Peter Moore, Maureen Turim, Robert Breer, Michael Renov, Peter Kubelka, Scott Nygren, David Curtis, Stan Brakhage, Lauren Rabinowitz, Nam June Paik, Bob Harris, Richard Leacock, Jeffrey K. Ruoff, and Mekas.

Kahn, Gordon. *Hollywood on Trial: The Story of the 10 Who Were Indicted.* New York: Boni and Gaer, 1948. Reprint. New York: Arno Press and The New York Times, 1972.

Kaplan, E. Ann, ed. *Psychoanalysis and Cinema.* New York: Routledge, 1990. Essays by Kaplan, Laura Mulvey, Anne Friedberg, Mary Ann Doane, Claire Johnston, Deborah Linderman, Raymond Bellour, Kaja Silverman, Janet Walker, Janet Bergstrom, Linda Peckham, Yvonne Rainer, and Bellour and Guy Rosolato.

___. *Women and Film: Both Sides of the Camera.* New York: Methuen, 1983.

Kindem, Gorham, ed. *The American Movie Industry: The Business of Moving Pictures.* Carbondale: Southern Illinois University Press, 1982. Essays by Robert C. Allen; Ralph Cassady, Jr.; Jeanne Thomas Allen; Kindem; Janet Staiger; Douglas Gomery; Simon N. Whitney; Douglas Ayer, Roy E. Bates, and Peter J. Herman; Fredric Stuart; Barry R. Litman; Joseph D. Phillips; Thomas H. Guback; Manjunath Pendakur; and Don R. Le Duc.

Kirby, Lynne. "Painting and Cinema: The Frames of Discourse." *Camera Obscura,* no. 18: 95–105. Review essay of Pascal Bonitzer's *Décadradges: Peinture et cinéma.*

Kracauer, Siegfried. *Theory of Film: The Redemption of Physical Reality.* New York: Oxford University Press, 1960.

Král, Petr. "De l'image au regard: Les peintres de l'imaginaire et ses cinéastes." *Positif,* no. 353–354 (July–August 1990): 68–77.

Lapsley, Robert, and Michael Westlake. *Film Theory: An Introduction.* Manchester: Manchester University Press, 1988.

Le Grice, Malcolm. *Abstract Film and Beyond.* Cambridge: The MIT Press, 1977.

Legrand, Gérard. "De l'espace du tableau à l'espace filmique: Formes symboliques et mouvement du regard." *Positif,* no. 353–354 (July–August 1990): 60–67.

Lemaître, Henri. *Beaux-arts et cinéma.* Paris: Les Editions du Cerf, 1956.

Lotman, Jurij. *Semiotics of Cinema.* Translated by Mark E. Suino. Ann Arbor: University of Michigan, 1976.

MacDonald, Scott. *Avant-Garde Film: Motion Studies.* Cambridge: Cambridge University Press, 1993. Essays on Yoko Ono, Michael Snow, Ernie Gehr, J. J. Murphy, Morgan Fisher, Hollis Frampton, Laura Mulvey and Peter Wollen, James Benning, Su Friedrich, Yervant Gianikian and Angela Ricci Lucchi, Warren Sonbert, Godfrey Reggio, Trinh T. Minh-ha, Yvonne Rainer, and Peter Watkins.

___. *A Critical Cinema: Interviews with Independent Filmmakers.* Berkeley: University of California Press, 1988. Interviews with Hollis Frampton, Larry Gottheim, Robert Huot, Taka Iimura, Carolee Schneemann, Tom Chomont, J. J. Murphy, Vivienne Dick, Beth B and Scott B, John Waters, Bruce Conner, Robert Nelson, Babette Mangolte, George Kuchar, Diana Barrie, Manuel DeLanda, and Morgan Fisher.

___. *A Critical Cinema 2: Interviews with Independent Filmmakers.* Berkeley: University of California Press, 1992. Interviews with Robert Breer, Michael Snow, Jonas Mekas, Bruce Baillie, Yoko Ono, Anthony McCall, Andrew Noren, Anne Robertson, James Benning, Lizzie Borden, Ross McElwee, Su Friedrich, Anne Severson, Laura Mulvey, Yvonne Rainer, Trinh T. Minh-ha, Godfrey Reggio, and Peter Watkins.

Mailer, Norman. *Marilyn: A Biography.* New York: Grosset and Dunlap, 1973.

Masson, Alain. "La geste, en peinture et sur l'écran." *Positif,* no. 353–354 (July–August 1990): 56–59.

Mast, Gerald, and Marshall Cohen, eds. *Film Theory and Criticism: Introductory Readings.* New York: Oxford University Press, 1979. Anthology of essays by Siegfried

Kracauer, André Bazin, Rudolf Arnheim, William Earle, Parker Tyler, Vsevolod Pudovkin, Sergei Eisenstein, Christian Metz, Charles Barr, Erwin Panofsky, Béla Balázs, Robert Warshow, F. E. Sparshott, Hugo Munsterberg, Susan Sontag, George Bluestone, Geoffrey Reeves, Frank Kermode, James Agee, J. Blumenthal, Stanley Cavell, Richard Meran Barsam, Gilbert Seldes, Joe Adamson, Robert Warshow, Pauline Kael, Mast, Annette Michelson, Otis Ferguson, Andrew Sarris, Peter Wollen, Richard Corliss, Richard Koszarski, Roland Barthes, Kenneth Tynan, Gene Youngblood, and Walter Benjamin.

Masters of Starlight: Photographers in Hollywood. Exh. cat. Los Angeles: Los Angeles County Museum of Art, 1987. Essays by David Fahey and Linda Rich.

McLuhan, Marshall. *Understanding Media: The Extensions of Man.* New York: Penguin Books, 1964.

Mekas, Jonas. *Movie Journal: The Rise of the New American Cinema, 1959–1971.* New York: The Macmillan Company, 1972.

Mellencamp, Patricia. *Indiscretions: Avant-Garde Film, Video, and Feminism.* Bloomington: Indiana University Press, 1990.

Metz, Christian. *Film Language: A Semiotics of the Cinema.* Translated by Michael Taylor. New York: Oxford University Press, 1974.

___. *The Imaginary Signifier: Psychoanalysis and the Cinema.* Translated by Celia Britton, Annwyl Williams, Ben Brewster, and Alfred Guzzetti. Bloomington: Indiana University Press, 1982.

___. *Language and Cinema.* Translated by Donna Jean Umiker-Sebeok. The Hague: Mouton, 1974.

Mitry, Jean. *Le cinéma expérimental: Histoire et perspectives.* Paris: Editions Seghers, 1974.

___. *Esthétique et psychologie du cinéma.* Vol. 1, *Les structures.* Paris: Editions Universitaires, 1963.

___. *Esthétique et psychologie du cinéma.* Vol. 2, *Les formes.* Paris: Editions Universitaires, 1965.

Monaco, James. *The New Wave: Truffaut, Godard, Chabrol, Rohmer, Rivette.* New York: Oxford University Press, 1976.

Morin, Edgar. *The Stars.* Translated by Richard Howard. New York: Grove Press, 1960.

Muchnic, Suzanne. "Lights, Camera, Artwork!" *ARTnews* 91, no. 9 (November 1992): 128–133.

Mulvey, Laura. *Visual and Other Pleasures.* Bloomington: Indiana University Press, 1989. Includes "Visual Pleasure and Narrative Cinema."

Murray, Timothy. *Like a Film: Ideological Fantasy on Screen, Camera, and Canvas.* London: Routledge, 1993.

Navasky, Victor S. *Naming Names*. New York: The Viking Press, 1980.

Neale, Stephen. *Cinema and Technology: Image, Sound, Colour*. Bloomington: Indiana University Press, 1985.

Noguez, Dominique. *Le cinéma, autrement*. Paris: Les Editions du Cerf, 1987.

___. *Cinéma: Théorie, lectures*. Paris: Editions Klincksieck, 1973.

___. *Une renaissance du cinéma: Le cinéma « underground » américain: Histoire, économie, esthétique*. Paris: Librairie des Méridiens — Klincksieck et Cie., 1985.

___. *Trente ans de cinéma expérimental en France (1950–1980)*. Paris: A.R.C.E.F., 1982.

Orr, John. *Cinema and Modernity*. Cambridge, Massachusetts: Polity Press, 1993.

Païni, Dominique. "A propos d'un colloque et d'un livre: Le cinéma est la peinture, le cinéma hait la peinture: Entretien avec Jacques Aumont." *Cahiers du cinéma*, no. 421 (June 1989): 60–62.

Passages de l'image. Exh. cat. Paris: Musée nationale d'art moderne, Centre Georges Pompidou, 1990. Essays by Pascal Bonitzer, Jean-François Chevrier and Catherine David, Raymond Bellour, Serge Daney, Jacques Aumont, Christine van Assche, Peter Wollen, Jean-Louis Schefer, Chevrier, Chantal Pontbriand, Sylvain Roumette, Christine Buci-Glucksmann, Alain Bergala, Jacques Derrida, Hervé Guibert and Florence Sébastiani, David, Bellour, Paul Virilio, Anne-Marie Duguet, Louis Marin, and Lucinda Furlong.

Peinture-Cinéma-Peinture. Exh. cat. Marseille: Centre de la Vieille Charité and Paris: Editions Hazan, 1989. Essays by Germain Viatte, Hubert Damisch, Charles-Eric Siméoni, Giovanni Lista, Jean Clair, Patrick de Haas, Sandra Alvarez de Toledo, Christian Derouet, Jean-Claude Marcadé, Krizstina Passuth, Marie-Laure Bernadac, José Vovelle, Sarah Wilson, Annette Michelson, Bernard Blistène, and Alain Fleischer.

Penley, Constance. *The Future of an Illusion: Film, Feminism, and Psychoanalysis*. Minneapolis: University of Minnesota Press, 1989.

___, ed. *Feminism and Film Theory*. New York: Routledge, 1988. Essays by Penley, Pam Cook and Claire Johnston, Laura Mulvey, Janet Bergstrom, Jacquelyn Suter, Elizabeth Cowie, Jacqueline Rose, Mary Ann Doane, Joan Copjec, and Elisabeth Lyon.

Peterson, James. *Dreams of Chaos, Visions of Order: Understanding the American Avant-Garde Cinema*. Detroit: Wayne State University Press, 1994.

Peucker, Brigitte. *Incorporating Images: Film and the Rival Arts*. Princeton: Princeton University Press, 1995.

Picture This: Films Chosen by Artists. Exh. cat. Buffalo: Hallwalls, 1987. Edited by Steve Gallagher. Essays by John Baldessari, Barbara Bloom, John Maggiotto, Barbara Broughel, Ericka Beckman, Tim Maul, John Carson, David Robbins, James Casebere, Daniel Levine, Robert Longo, Dan Graham, Louise Lawler, Peter Nagy, Vito Acconci, Jennifer Bolande, Chris Hill, Barbara Kruger, Lynne Tillman, Silvia Kolbowski, and Andrea Fraser.

"The Pleasure Dome": Amerikansk Experimentfilm 1939–1989/American ExperimentFilm 1939–1979. Exh. cat. Stockholm: Moderna Museet, 1980. Essays by Jonas Mekas and P. Adams Sitney.

Postcards from Alphaville: Jean-Luc Godard in Contemporary Art, 1963–1992. Exh. cat. Long Island City, New York: P. S. 1, Institute of Contemporary Art, 1992. Text by Warren Niesluchowski.

Powdermaker, Hortense. *Hollywood: The Dream Factory: An Anthropologist Looks at the Movie-Makers*. Boston: Little, Brown and Co., 1950.

Prédal, René. *La photo de cinéma, suivi d'un dictionnaire de cent chefs opérateurs*. Paris: Les Editions du Cerf, 1985.

Projected Images. Exh. cat. Minneapolis: Walker Art Center, 1974. Essays by Martin Friedman, Robert Pincus-Witten, Nina Felshin, Annette Michelson, Regina Cornwell, Roberta P. Smith, and Barbara Rose.

Ragghianti, Carlo L. *Le film sur l'art: Répertoire général international des films sur les arts*. Rome: Edizioni dell'Ateneo, 1953.

Renan, Sheldon. *An Introduction to the American Underground Film*. New York: E. P. Dutton and Co., 1967.

Renoir, Jean. *Renoir on Renoir: Interviews, Essays, and Remarks*. Translated by Carol Volk. Cambridge: Cambridge University Press, 1989.

Rollyson, Carl E., Jr. *Marilyn Monroe: A Life of the Actress*. Ann Arbor: UMI Research Press, 1986.

Rosen, Philip, ed. *Narrative, Apparatus, Ideology: A Film Theory Reader*. New York: Columbia University Press, 1986. Essays by David Bordwell, Christian Metz, Raymond Bellour, Nick Browne, Peter Wollen, Kristin Thompson, Deborah Linderman, Roland Barthes, Colin MacCabe, Laura Mulvey, Paul Willemen, Kaja Silverman, Julia Kristeva, Jean-Louis Baudry, Pascal Bonitzer, Mary Anne Doane, Jean-François Lyotard, Teresa de Lauretis, Stephen Heath, Jean-Louis Comolli, editors of *Cahiers du Cinéma*, Noël Burch, Linda Williams, and Thomas Elsaesser.

Rowe, Carel. *The Baudelairean Cinema: A Trend within the American Avant-Garde*. Ann Arbor: UMI Research Press, 1982.

Sarris, Andrew. *The Primal Screen: Essays on Film and Related Subjects*. New York: Simon and Schuster, 1973.

___, ed. *Interviews with Film Directors*. Interviews with Michelangelo Antonioni, Ingmar Bergman, Robert Bresson, Peter Brook, Luis Buñuel, Claude Chabrol, Charles Chaplin, George Cukor, Clive Donner, Carl Th. Dreyer, Sergei Eisenstein, Federico Fellini, John Ford, Jean-Luc Godard, Howard Hawks, Alfred Hitchcock, John Huston, Buster Keaton, Akira Kurosawa, Fritz Lang, David Lean, Joseph Losey (with Nicholas Ray), Ernst Lubitsch, Rouben Mamoulian, Max Ophuls, Pier Paolo Pasolini, Sam Peckinpah, Abraham Polonsky, Otto Preminger, Nicholas Ray (with Joseph Losey), Satyajit Ray, Jean Renoir, Alain Resnais, Leni Riefenstahl, Roberto Rossellini, Josef von Sternberg, Erich von Stroheim, Preston Sturges, François Truffaut, and Orson Welles.

Schrader, Paul. *Trascendental Style in Film: Ozu, Bresson, Dreyer*. New York: Da Capo Press, Inc., 1988.

Screen Reader 2: Cinema and Semiotics. London: The Society for Education in Film and Television, 1981. Anthology of articles from *Screen*.

Silverman, Kaja. *The Acoustic Mirror: The Female Voice in Psychoanalysis and Cinema*. Bloomington: Indiana University Press, 1988.

Sitney, P. Adams. *Modernist Montage: The Obscurity of Vision in Cinema and Literature*. New York: Columbia University Press, 1990.

___. *Visionary Film: The American Avant-Garde*. New York: Oxford University Press, 1979.

___, ed. *The Avant-Garde Film: A Reader of Theory and Criticism*. New York: New York University Press, 1978. Essays by Sitney, Dziga Vertov, Sergei Eisenstein, Hans Richter, Jean Epstein, Germaine Dulac, Antonin Artaud, Joseph Cornell, Maya Deren, Sidney Peterson, James Broughton, John and James Whitney, Harry Smith, Carel Rowe, Stan Brakhage, Peter Kubelka, Stephen Koch, Annette Michelson, Michael Snow, Jonas Mekas, Ernie Gehr, Anthony McCall, Paul Sharits, Tony Conrad, and Hollis Frampton.

___. *The Essential Cinema: Essays on Film in the Collection of Anthology Film Archives*. Vol. 1. New York: Anthology Film Archives and New York University Press, 1975. Essays by Seymour Stern, Ken Kelman, Standish D. Lawder, Sitney, Annette Michelson, and Donald Weinstein.

___. *Film Culture Reader*. New York: Praeger Publishers, 1970. Anthology of articles from *Film Culture*.

Sklar, Robert. *Film: An International History of the Medium*. New York: Harry N. Abrams, Inc., 1993.

Sobchack, Vivian. *The Address of the Eye: A Phenomenology of Film Experience*. Princeton: Princeton University Press, 1992.

Stacey, Jackie. *Star Gazing: Hollywood Cinema and Female Spectatorship*. London: Routledge, 1994.

Staiger, Janet, ed. *The Studio System*. New Brunswick, New Jersey: Rutgers University Press, 1995. Essays by Staiger, Edward Buscombe, Richard B. Jewell, Paul Kerr, Thomas Schatz, David Bordwell, Robert C. Allen, Jeffrey Sconce, Derral Cheatwood, Martin F. Norden, James Lastra, Denise Hartsough, Richard Maltby, Clayton R. Koppes and Gregory D. Black, and Thomas Doherty.

Stam, Robert, Robert Burgoyne, and Sandy Flitterman-Lewis. *New Vocabularies in Film Semiotics: Structuralism, Post-structuralism, and Beyond*. London: Routledge, 1992.

Stauffacher, Frank. *Art in Cinema: A Symposium on the Avantgarde Film Together with Program Notes and References for Series One of Art in Cinema*. San Francisco: Art in Cinema Society, San Francisco Museum of Art, 1947. Reprint. New York: Arno Press, 1968. Texts by Grace L. McAnn Morley, Richard Foster and Stauffacher, Henry Miller, Hans Richter, Elie Faure, Man Ray, Luis Buñuel, John and James Whitney, Erich Pommer, Oskar Fischinger, Maya Deren, George Leite, Paul Velguth; program notes for the films screened in the series.

Touati, Jean-Pierre, and Santiago Amigorena. "Peinture et cinéma: L'épée devant des yeux: Entretien avec Hubert Damisch." *Cahiers du cinéma*, no. 386 (July–August 1986): 26–32.

Turim, Maureen Cheryn. *Abstraction in Avant-Garde Films*. Ann Arbor: UMI Research Press, 1985.

Tyler, Parker. *The Hollywood Hallucination*. New York: Creative Age Press, 1944.

___. *Magic and Myth of the Movies*. New York: Henry Holt and Co., 1947.

___. *The Three Faces of the Film: The Art, the Dream, the Cult*. New York: A. S. Barnes, 1967.

___. *Underground Film: A Critical History*. New York: Grove Press, 1969.

Valkola, Jarmo. *Perceiving the Visual in Cinema: Semantic Approaches to Film Form and Meaning*. Jyväskylä, Finland: Jyväskylän Yliopisto, 1993.

'Vertigo'. Exh. cat. Salzburg: Galerie Thaddaeus Ropac, 1991. Essays by Timothy Greenfield-Sanders, Thaddaeus Ropac, Christian Leigh, Donald Kuspit, Jeanne Silverthorne, Gary Stephan, Anthony Iannacci, Graham McCann, Douglas Blau, Catherine Liu, Buzz Spector, Rosetta Brooks, Michael Kelly, Laura Cottingham, Robert Feintuch, Sarah Morris, Andrew Soloman, Dan Cameron, Octavio Zaya, Jerry Salz, Joshua Decter, Kerry Brougher, James L. Croak, and Herbert Muschamp; interview with James Stewart; conversation between Brian d'Amato and Leigh.

Walker, Alexander. *Stardom: The Hollywood Phenomenon*. New York: Stein and Day, 1970.

Walker, John A. *Art and Artists on Screen*. Manchester: Manchester University Press, 1993.

Wees, William C. *Light Moving in Time: Studies in the Visual Aesthetics of Avant-Garde Film*. Berkeley: University of California Press, 1992.

Weis, Elisabeth, and John Belton, eds. *Film Sound: Theory and Practice*. New York: Columbia University Press, 1985. Essays by Douglas Gomery; Barry Salt; Rick Altman; Mary Ann Doane; Belton; S. M. Eisenstein, V. I. Pudovkin, and G. V. Alexandrov; Pudovkin; René Clair; Basil Wright and B. Vivian Braun; Alberto Cavalcanti; Rudolf Arnheim; Béla Balász; Siegfried Kracauer; Jean Epstein; Robert Bresson; Jean-Marie Straub and Danièle Huillet; Christian Metz; David Bordwell and Kristin Thompson; Noël Burch; Arthur Knight; Ron Mottram; Lucy Fischer; Noël Carroll; Martin Rubin; Penny Mintz; Weis; Michael Litle; Lindley Hanlon; Alan Williams; Charles Schreger; Frank Paine; Marc Mancini; and Fred Camper.

Wollen, Peter. *Signs and Meaning in the Cinema*. Bloomington: Indiana University Press, 1972.

Youngblood, Gene. *Expanded Cinema*. New York: E. P. Dutton and Co., 1970.

Selected Bibliographies for Artists and Filmmakers in the Exhibition

Compiled by John Alan Farmer and Stephanie Emerson

Robert Aldrich

Arnold, Edwin T., and Eugene L. Miller. *The Films and Career of Robert Aldrich.* Knoxville: University of Tennessee Press, 1986.

Piton, Jean-Pierre. *Robert Aldrich.* Paris: Edilig, 1985.

Silver, Alain, and Elizabeth Ward. *Robert Aldrich: A Guide to References and Resources.* Boston: G. K. Hall and Co., 1979.

Kenneth Anger

Anger, Kenneth. *Hollywood Babylon.* New York: Bell Publishing Co., 1975. Originally published as *Hollywood Babylone* (Paris: J. J. Pauvert, 1959).

———. "Interview in *Spider*." In *Film Makers on Film Making: Statements on Their Art by Thirty Directors*, edited by Harry M. Geduld, 288–302.

———. *Kenneth Anger's Hollywood Bablyon II.* New York: Penguin Books, 1984.

Anger Magick Lantern Cycle: A Special Presentation in Celebration of The Equinox Spring 1966. New York: Film-Makers' Cinematheque, 1966.

Haller, Robert A. *Kenneth Anger.* St. Paul: Film in the Cities and Minneapolis: Walker Art Center, 1980.

Landis, Bill. *The Unauthorized Biography of Kenneth Anger.* New York: HarperCollins, 1995.

Schneemann, Carolee. "Kenneth Anger's *Scorpio Rising*. In *Film Culture Reader*, edited by P. Adams Sitney, 277–279. New York: Praeger Publishers, 1970.

Michelangelo Antonioni

Antonioni, Michelangelo. *Blow-Up: A Film.* London: Lorrimer Publishing, 1971. Interview with Antonioni by Pierre Billard; essays by Antonioni and Andrew Sinclair; credits, cast, and script of *Blow-Up*.

———. *Screenplays of Michelangelo Antonioni: Il grido, L'avventura, La notte, L'eclisse.* New York: The Orion Press, 1963.

Arrowsmith, William. *Antonioni: The Poet of Images.* New York: Oxford University Press, 1995.

Chatman, Seymour. *Antonioni, or the Surface of the World.* Berkeley: University of California Press, 1985.

Cuccu, Lorenzo. *Michelangelo Antonioni 1966/1984.* Vol. 2, *L'oeuvre de Michelangelo Antonioni.* Rome: Editions Cinecittà International, 1988.

di Carlo, Carlo. *Michelangelo Antonioni 1942/1965.* Vol. 1, *L'oeuvre de Michelangelo Antonioni.* Rome: Editions Cinecittà International, 1987.

Huss, Roy, ed. *Focus on Blow-Up.* Englewood Cliffs, New Jersey: Prentice-Hall, 1971. Essays by Huss, Charles Thomas Samuels, Kay Hines, and Henry Fernández; reviews by Andrew Sarris, F. A. Macklin, Carey Harrison, Hubert Meeker, Jean Clair, Max Kozloff, Arthur Knight, Stanley Kauffmann, Marsha Kinder, James F. Scott, T. J. Ross, George Slover, and John Freccero; synopsis and outline of *Blow-up*; short story by Julio Cortázar upon which the film is based.

Perry, Ted, and Rene Prieto. *Michelangelo Antonioni: A Guide to References and Resources.* Boston: G. K. Hall and Co., 1986.

Renzo, Renzi. *Album Antonioni: Une biographie impossible.* Vol. 3, *L'oeuvre de Michelangelo Antonioni.* Rome: Editions Cinecittà International, 1987.

Rifkin, Ned. *Antonioni's Visual Language.* Ann Arbor: UMI Research Press, 1982.

Rohdie, Sam. *Antonioni.* London: BFI Publishing, 1990.

Diane Arbus

Armstrong, Carol M. "Biology, Destiny, Photography: Difference According to Diane Arbus." *October*, no. 66 (Fall 1993): 28–54.

Bosworth, Patricia. *Diane Arbus: A Biography.* New York: Alfred A. Knopf, 1984.

Diane Arbus: Magazine Work. Exh. cat. Lawrence, Kansas: Spencer Museum of Art, 1984. Texts by Diane Arbus; essay by Thomas W. Southall.

Hulick, Diana Emery. "Diane Arbus's Women and Transvestites: Separate Selves." *History of Photography* 16, no. 1 (Spring 1992): 34–39.

Monograph. New York: Aperture, 1972.

Untitled: Diane Arbus. New York: Aperture, 1972.

John Baldessari

John Baldessari. Exh. cat. Eindhoven: Stedelijk Van Abbemuseum and Essen: Museum Folkwang, 1981. Text by R. H. Fuchs.

John Baldessari. Exh. cat. Los Angeles: The Museum of Contemporary Art, 1990. Text by Coosje van Bruggen.

John Baldessari. Exh. cat. New York: The New Museum of Contemporary Art and Dayton, Ohio: University Art Galleries, Wright State University, 1981. Essays by Marcia Tucker and Robert Pincus-Witten; interview by Nancy Drew.

Snoddy, Stephen, ed. *This Not That: John Baldessari.* Manchester, England: Cornerhouse, 1995. Essays by Alexandre Melo, Uta Nusser, and Igor Zabel.

Judith Barry

Barry, Judith. *Public Fantasy: An Anthology of Critical Essays, Fictions, and Project Descriptions by Judith Barry.* Edited by Iwona Blazwick. London: Institute of Contemporary Arts, 1991. Includes essay by Johanna Drucker.

Fisher, Jean. *Through the Mirror of Seduction: An Essay on the Work of Judith Barry.* Dublin: Douglas Hyde Gallery, Trinity College, 1988.

The Work of the Forest: Oeuvres récentes, essais critiques. Exh. cat. Brussels: Fondation pour l'architecture à Bruxelles and Dunkerque: Ecole régionale d'art, 1992. Texts by Barry.

Saul Bass

Frolick, Stuart. "Saul Bass," *Graphis* 47, (November/December 1991): 94–105.

Kirkham, Pat. "Looking for the Simple Idea," *Sight and Sound* 4, no. 2 (February 1994): 16–20.

———. "Saul Bass and Billy Wilder: in conversation," *Sight and Sound* 5, no. 6 (June 1995): 18–21.

Moving Introductions. Exh. cat. Los Angeles: Otis Art Institute of Parsons School of Design, 1985. Curated by Sheila Levrant de Bretteville and Barbara Bloom.

Ingmar Bergman

Bergman, Ingmar. *Bergman on Bergman: Interviews with Ingmar Bergman by Stig Björkman, Torsten Manns, and Jonas Sima.* Translated by Paul Britten Austin. New York: Simon and Schuster, 1973.

———. *Images: My Life in Film.* Translated by Marianne Ruuth. New York: Arcade Publishing, 1994.

———. *The Magic Lantern: An Autobiography.* Translated by Joan Tate. New York: Viking Penguin, 1988.

Cowie, Peter. *Ingmar Bergman: A Critical Biography.* New York: Charles Scribner's Sons, 1982.

Kaminsky, Stuart M., ed., with Joseph Hill. *Ingmar Bergman: Essays in Criticism.* London: Oxford University Press, 1975. Essays by Birgitta Steene, Kaminsky, Richard A. Blake, Gene D. Phillips, Robin Wood, Bergman, Charles Thomas Samuels, Erik Ulrichsen, Jorn Donner, Harvey R. Greenberg, Sheldon Bach, Vernon Young, Stanley Kauffmann, Robert H. Adams, Vilgot Sjoman, Carol Brightman, Susan Sontag, Penelope Gilliatt, Philip Strick, Robert E. Lauder, Peter Harcourt, Joan Mellen, and Lester J. Keyser.

Steene, Birgitta. *Ingmar Bergman: A Guide to References and Resources.* Boston: G. K. Hall and Co., 1987.

Cindy Bernard

Cindy Bernard. Exh. cat. Farnham: James Hockey Gallery and Salford: Viewpoint Photography Gallery, 1995. Text by Mark Durden.

Cindy Bernard: Ask the Dust. Exh. brochure. Santa Monica, California:

Richard Kuhlenschmidt Gallery, n.d. [c. 1990]. Text by Benjamin Weissman.

Bernardo Bertolucci

Bertolucci, Bernardo. *Bertolucci by Bertolucci.* Edited by Enzo Ungaro with Donald Ranvaud. Translated from the Italian by Donald Ranvaud. London: Plexus, 1987.

Kline, T. Jefferson. *Bertolucci's Dream Loom: a Psychoanalytic Study of Cinema.* Amherst: University of Massachusetts Press, 1987.

Lagazzi, Paolo. *Reverie e destino.* From the Series Strumenti di studio. Milano: Garzanti, 1993.

Loshitzky, Yosefa. *The Radical Faces of Godard and Bertolucci.* Detroit: Wayne State University Press, 1995.

Joseph Beuys

Adriani, Götz, Winfried Konnertz, and Karin Thomas. *Joseph Beuys: Life and Works.* Translated by Patricia Lech. Woodbury, New York: Barron's Educational Series, 1979.

Joseph Beuys: Arbeiten aus Münchener Sammlungen. Munich: Schirmer/Mosel, 1981. Text by Armin Zweite.

Stachelhaus, Heiner. *Joseph Beuys.* Translated by David Britt. New York: Abbeville Press Publishers, 1987.

Tisdall, Caroline. *Joseph Beuys.* New York: Thames and Hudson, 1979. Includes texts by Beuys.

Douglas Blau

Fictions: A Selection of Pictures from the 18th, 19th, and 20th Centuries. Exh. cat. New York: Kent Fine Art and Curt Marcus Gallery, 1987. Essay by Blau.

Barbara Bloom

Bloom, Barbara. *Ghost Writer/Und wenn Sie nicht gestorben.* Berlin, 1988.

———. *Never Odd or Even.* Edited by Daniela Goldmann. Munich: Verlag Silke Schreiber and Pittsburgh: Carnegie Museum of Art.

———, ed. *The Reign of Narcissism: Guide Book/Führer.* Stuttgart: Württembergischer Kunstverein; Zurich: Kunsthalle; and London: Serpentine Gallery, 1990. Texts by Bloom, Bruce Chatwin, Virginia Woolf, G. W. F. Hegel, Walter Weisbecker, Michael Glasmeier, Walter Benjamin, Louise Vinge, Ernst H. Gombrich, Anna Akhmatova, and Oscar Wilde. Published in conjunction with the artist's installation, *The Reign of Narcissism.*

Mifflin, Margot. "Barbara Bloom: 'My Work Is More Like a Movie Set.'" *ARTnews* 92, no. 2 (February 1993): 102–103.

Rimanelli, David. "Barbara Bloom and Her Art of Entertaining." *Artforum* 23, no. 2 (October 1989): 142–146.

Schleifer, Kirsten Brooke. "Detective Stories: An Interview with Barbara Bloom." *Print Collector's Newsletter* 21 (July–August 1990): 92–96.

Spector, Nancy. "True Fictions: Barbara Bloom." *Artscribe*, no. 76 (Summer 1989): 48–52.

Christian Boltanski

Boltanski. Exh. cat. Paris: Musée national d'art moderne, Centre Georges Pompidou, 1984. Essays by Bernard Blistène, Serge Lemoine, Tadeusz Kantor, Delphine Renard, Günter Metken, Gilbert Lascault, Klaus Honnef, and Dominique Viéville.

Christian Boltanski: Lessons of Darkness. Exh. cat. Chicago: The Museum of Contemporary Art; Los Angeles: The Museum of Contemporary Art; New York: The Museum of Contemporary Art, 1988. Essays by Mary-Jane Jacob, Boltanski, and Lynn Gumpert.

Gumpert, Lynn. *Christian Boltanski.* Paris: Flammarion, 1994.

Stan Brakhage

Barrett, Gerald R., and Wendy Brabner. *Stan Brakhage: A Guide to References and Resources.* Boston: G. K. Hall and Co., 1983.

Brakhage, Stan. *The Brakhage Lectures: Georges Méliès, David Wark Griffith, Carl-Theodor Dreyer, Sergei Eisenstein.* Chicago: The Good Lion, 1972.

———. *The Brakhage Scrapbook: Collected Writings, 1964–1980.* Edited by Robert A. Haller. New York: Documentext, 1982.

———. *Metaphors on Vision.* New York: Film Culture Inc., 1963.

Clark, Dan. *Brakhage.* New York: Film-Makers' Cinematheque, 1966.

Higgins, Gary, Rodrigo García Lopes, and Thomas Connick. "Grisled Roots: An Interview with Stan Brakhage." *Millenium Film Journal*, no. 26 (Fall 1992): 56–66.

Stan Brakhage: An American Independent Film-Maker. Exh. cat. London: Arts Council of Great Britain, c. 1979. Texts by Simon Field and Stan Brakhage.

Luis Buñuel

¿Buñuel!: Auge des Jahrhunderts. Exh. cat. Bonn: Kunst- und Ausstellungshalle der Bundesrepublik Deutschland, 1994. Texts by Octavio Paz; André Breton; Eugen Drewermann; Augustín Sánchez Vidal; Buñuel; Salvador Dalí; Robert Desnos, Georges Bataille, and Marcel Griaule; Henry Miller; Marquis de Sade; Tomás Pérez Turrent; Uwe Scheele; and Mauricio Kagel.

Buñuel, Luis. *My Last Sigh.* Translated by Abigail Israel. New York: Alfred A. Knopf, 1983.

de la Colina, José, and Tomás Pérez Turrent. *Objects of Desire: Conversations with Luis Buñuel.* Edited and translated by Paul Lenti. New York: Marsilio Publishers, 1992.

Durgnat, Raymond. *Luis Buñuel.* Berkeley: University of California Press, 1968.

Edwards, Gwynne. *The Discreet Art of Luis Buñuel: A Reading of His Films.* Boston: Marion Boyars, 1982.

Sánchez Vidal, Agustín. *El mundo de Luis Buñuel.* Zaragoza: Caja de Ahorros de la Inmaculada Aragon, 1993.

Victor Burgin
Burgin, Victor. *Between.* London: Institute of Contemporary Arts and Oxford: Basil Blackwell Ltd., 1986.

___. *The End of Art Theory: Criticism and Postmodernity.* Atlantic Highlands, New Jersey: The Humanities Press International, 1986.

___. *Work and Commentary.* London: New Dimensions, 1973.

Fisher, Jean. "Chasing Dreams: Victor Hitchcock and Alfred Burgin." *Artforum* 22, no. 9 (May 1984): 39–43.

Victor Burgin: Passages. Exh. cat. Villeneuve d'Ascq: Musée d'art moderne de la Communauté Urbaine de Lille, 1991. Essays by Joëlle Pijaudier and Régis Durand; texts by Burgin.

Jean Cocteau
Cocteau, Jean. *Past Tense: The Diaries of Jean Cocteau.* Annotations by Pier Chanel. Translated by Richard Howard. London: Methuen, 1990.

Crowson, Lydia. *The Esthetic of Jean Cocteau.* Hanover, Connecticut: The University Press of New England, 1990.

Emboden, William A. *The Visual Art of Jean Cocteau.* New York: International Archive of Art, 1989. Introduction by Tony Clark.

James Coleman
The Enigma of the Hero in the Work of James Coleman. Exh. cat. Londonderry, Northern Ireland: The Orchard Gallery, 1993. Essay by Jean Fisher.

James Coleman. Exh. cat. Eindhoven: Stedelijk Van Abbemuseum, 1989. Text by Jan Debbaut and Frank Lubbers.

James Coleman. Exh. cat. Lyon: Musée d'art contemporain, 1990. Essay by Lynn Cooke.

James Coleman. Exh. cat. Paris: Musée d'art moderne de la Ville de Paris, 1989.

James Coleman, Projected Images: 1972–1994. Exh. cat. New York: Dia Center for the Arts, 1995. Essays by Lynn Cooke, Jean Fisher and Benjamin H.D. Buchloh.

James Coleman: Selected Works. Exh. cat. Chicago: The Renaissance Society at the University of Chicago, 1985. Essays by Michael Newman and Anne Rorimer.

Bruce Conner
"Bruce Conner: A Discussion at the 1968 Flaherty Film Seminar." *Film Comment* 5, no. 4 (1969): 15–25.

Bruce Conner: Sculpture/ Assemblages/Drawings/Films. Exh. cat. Waltham, Massachusetts: The Rose Art Museum, Brandeis University, 1965.

Grindon, Leger. "Significance Reexamined: A Report on Bruce Conner." *Post Script: Essays in Film and the Humanities* 4, no. 2 (Winter 1985): 32–44.

MacDonald, Scott. "I Don't Go to the Movies Anymore: An Interview with Bruce Conner." *Afterimage* 10, nos. 1–2 (Summer 1982): 20–23.

Mortiz, William, and Beverly O'Neill. "Fallout: Some Notes on the Films of Bruce Conner." *Film Quarterly* 31, no. 4 (Summer 1978): 36–42.

Reveaux, Anthony. *Bruce Conner.* St. Paul: Film in The Cities and Minneapolis: Walker Art Center, 1981.

Tony Conrad
Conrad, Tony. "Tony Conrad on 'The Flicker.'" *Film Culture,* no. 41 (Summer 1966): 1–3.

Le Grice, Malcolm. "Tony Conrad." In *Structural Film: An Anthology,* edited by Peter Gidal, 135–136. London: British Film Institute, 1967.

Mussman, Toby. "An Interview with Tony Conrad." *Film Culture,* no. 41 (Summer 1966).

Renan, Sheldon. "Tony Conrad." In his *An Introduction to the American Underground Film,* 138–140. New York: E. P. Dutton and Co., 1967.

Joseph Cornell
Ashton, Dore. *A Joseph Cornell Album.* New York: The Viking Press, 1974. Includes poems by Octavio Paz, John Ashbery, Stanley Kunitz, and Richard Howard; texts by Cornell, John Bernard Myers, Jonas Mekas, and Peter Bazeley; selections from Cornell's collected readings.

Cornell, Joseph. *Joseph Cornell's Theater of the Mind: Selected Diaries, Letters, and Files.* Edited by Mary Ann Caws. New York: Thames and Hudson, 1993. Foreword by John Ashbery and introduction by Caws.

Joseph Cornell. Exh. cat. New York: The Museum of Modern Art, 1980. Edited by Kynaston McShine. Essays by Dawn Ades, Carter Ratcliff, P. Adams Sitney, and Lynda Roscoe Hartigan.

Joseph Cornell: Collages, 1931–1972. Exh. cat. New York: Leo Castelli Feigen Corcoran, 1978. Texts by Donald Windham and Howard Hussey.

Tashjian, Dickran. *Joseph Cornell: Gifts of Desire.* Miami Beach: Grassfield Press, 1992.

David Cronenberg
Cronenberg, David. *Cronenberg on Cronenberg.* Edited by Chris Rodley. London: Faber and Faber, 1992.

Drew, Wayne, ed. *David Cronenberg.* London: British Film Institute, 1984. Essays by Colin McArthur, Jill McGreal, Drew, Christopher Rodley, Stephen Schiff, Michael Silverman, Julian Petley, Bernard Thomas, Paul Taylor, Kim Newman, Michael O'Pray, and Martin Scorsese.

Grünberg, Serge. *David Cronenberg.* Paris: Cahiers du Cinéma, 1992.

Handling, Piers, ed. *The Shape of Rage: The Films of David Cronenberg.* Toronto: General Publishing Co. Ltd. and New York: New York Zoetrope, 1983. Essays by William Beard, Maurice Yacowar, John Harkness, Handling, Robin Wood, Geoff Pevere, Tim Lucas, and Beard and Handling.

Salvador Dalí
Ades, Dawn. *Dalí.* London: Thames and Hudson, 1982.

Descharnes, Robert. *Salvador Dalí: The Work, the Man.* Translated by Eleanor R. Morse. New York: Harry N. Abrams, 1984.

Maur, Karin v. *Salvador Dalí, 1904–1989.* Stuttgart: Verlag Gerd Hatje, 1989. Includes texts by Rafael Santos Torrella, Marc Lacroix, and Lutz W. Löpsinger.

Salvador Dalí. Exh. cat. London: The Tate Gallery, 1980. Essay by Simon Wilson.

Salvador Dalí. Exh. cat. Montreal: The Montreal Museum of Fine Arts, 1990. Includes texts by Dalí.

Brian De Palma
Bliss, Michael. *Brian De Palma.* Metuchen, New Jersey: The Scarecrow Press, 1983.

Bouzereau, Laurent. *The De Palma Cut: The Films of America's Most Controversial Director.* New York: Dembner Books, 1988.

Dworkin, Susan. *Double De Palma: A Film Study with Brian De Palma.* New York: Newmarket Press, 1984.

MacKinnon, Kenneth. *Misogyny in the Movies: The De Palma Question.* Newark: University of Delaware Press and London: Associated University Presses, 1990.

Stan Douglas
Danzker, Jo-Anne Birnie. "The Beauty of the Weapons: Stan Douglas Does Battle with the Armies of the Modernist Myth." *Canadian Art* 6, no. 3 (Fall 1989): 102–117.

Stan Douglas. Exh. cat. Paris: Musée nationale d'art moderne, Centre Georges Pompidou, 1993.

Stan Douglas: Monodramas and Loops. Exh. cat. Vancouver: UBC Fine Arts Gallery, 1992. Essays by Scott Watson and John Fiske.

Stan Douglas: Perspective 87. Exh. cat. Toronto: Art Gallery of Ontario, 1987.

Carl-Theodor Dreyer
Bordwell, David. *The Films of Carl-Theodor Dreyer.* Berkeley: University of California Press, 1981.

Carl Th. Dreyer. Edited by Jytte Jensen. Exh. cat. New York: The Museum of Modern Art, 1988. Essays by Ib Monty, Jensen, James Schamus, and Carren O. Kaston.

Carney, Raymond. *Speaking the Language of Desire: The Films of Carl Dreyer.* Cambridge: Cambridge University Press, 1989.

Dreyer, Carl-Theodor. *Dreyer in Double Reflection: Translation of Carl Th. Dreyer's Writings "About the Film" ("Om Filmen").* Edited and with accompanying commentary and essays by Donald Skoller. New York: Da Capo Press, 1973.

___. *Four Screenplays.* Translated by Oliver Stallybrass. London: Thames and Hudson, 1970. Texts of *La passion de Jeanne d'Arc, Vampyr, Vredens Dag,* and *Ordet.*

Nash, Mark. *Dreyer.* London: British Film Institute, 1977.

Federico Fellini
Bondanella, Peter E., and Cristina Degli-Esposti, eds. *Perspectives on Federico Fellini.* Toronto: Maxwell Macmillan Canada; New York: Maxwell Macmillan International, 1993.

Bondanella, Peter E. *The Cinema of Federico Fellini.* Princeton, New Jersey: Princeton University Press, 1992.

Fava, Claudio G., and Aldo Vigano. *The Films of Federico Fellini.* Secaucus, New Jersey: Citadel Press, 1981. Translated by Shula Curto.

Fellini, Federico. *Comments on Film.* Fresno, California: Press at California State University, Fresno, 1988. Giovanni Grazzini, ed. Translated by Joseph Henry.

___. *Fellini on Fellini.* New York: Delacorte Press/S. Lawrence, 1976. Translated by Isabel Quigley.

Price, Barabara Anne, and Theodore Price. *Federico Fellini: An Annotated International Bibliography.* Metuchen, New Jersey: Scarecrow Press, 1978.

Tornabuoni, Linda, ed. *Federico Fellini.* Foreword by Martin Scorsese. New York: Rizzoli International Publications, Inc., 1995.

Hollis Frampton
Andre, Carl, and Hollis Frampton. *12 Dialogues, 1962–1963.* Edited by Benjamin H. D. Buchloh. Halifax: The Press of the Nova Scotia College of Art and Design and New York: New York University Press, 1981.

Frampton, Hollis. *Circles of Confusion: Film Photography Video: Texts, 1968–1980.* Rochester: Visual Studies Workshop Press, 1983. Foreword by Annette Michelson.

Hollis Frampton: Recollections/Recreations. Exh. cat. Buffalo: Albright-Knox Art Gallery and Cambridge: The MIT Press, 1984. Texts by Susan Krane and Bruce Jenkins.

October, no. 32 (Spring 1985). Special issue: Hollis Frampton. Essays by Annette Michelson, Barry Goldensohn, Frampton, Christopher Phillips, Bruce Jenkins, Peter Gidal, Allen S. Weiss, and Brian Henderson.

Robert Frank
Alexander, Stuart. *Robert Frank: A Bibliography, Filmography, and Exhibition Chronology, 1946–1985.* Tucson: Center for Creative Photography and Houston: The Museum of Fine Arts, 1986.

Frank, Robert. *The Americans.* Introduction by Jack Kerouac. New York: Scalo Publishers, 1993.

Robert Frank: Moving Out. Exh. cat. Washington, D.C.: National Gallery of Art, 1994. Essays by Sarah Greenough and Philip Brookman, Martin Gasser, Greenough, Brookman, John G. Hanhardt, and W. S. Di Piero.

Robert Frank: New York to Nova Scotia. Exh. cat. Edited by Anne Wilkes Tucker. Houston: The Museum of Fine Arts and Boston: New York Graphic Society, 1986.

Jean-Luc Godard
Bellour, Raymond, with Mary Lea Bandy, eds. *Jean-Luc Godard: Son + Image, 1974–1991.* Exh. cat. New York: The Museum of Modern Art, 1992. Essays by Colin Myles MacCabe, Jean-Louis Leutrat, Gilles Deleuze, Elisabeth Lyon, Constance Penley, Janet Bergstrom, Alain Bergala, Laura Mulvey, Philippe Dubois, Peter Wollen, Jonathan Rosenbaum, Jacques Aumont, and Bellour; interview by Serge Daney.

Cameron, Ian, ed. *The Films of Jean-Luc Godard.* New York: Frederick A. Praeger, 1969. Essays by Cameron, Charles Barr, Richard Winkler, Barry Boys, Edgardo Cozarinsky, V. F. Perkins, José Luis Guarner, Robin Wood, Philip French, Paul Mayersberg, Michael Walker, Stig Björkman, Jim Hillier, Raymond Durgnat, Jean-Louis Comolli, and Jacques Bontemps.

Cerisuelo, Marc. *Jean-Luc Godard.* Paris: Editions des Quatre-Vents, 1989.

Godard, Jean-Luc. *Godard on Godard.* Translated and edited by Jean Narboni and Tom Milne. New York: Da Capo Press, 1986. Foreword by Annette Michelson; introduction by Richard Roud.

___. *Introduction à une véritable histoire du cinéma.* Vol. 1. Paris: Editions Albatros, 1980.

Lesage, Julia. *Jean-Luc Godard: A Guide to References and Resources.* Boston: G. K. Hall and Co., 1979.

MacCabe, Colin. *Godard: Images, Sounds, Politics.* Bloomington: Indiana University Press, 1980. Essays and interviews by MacCabe and Laura Mulvey.

Mussman, Toby, ed. *Jean-Luc Godard: A Critical Anthology.* New York: E. P. Dutton and Co., 1968. Essays by Luc Moullet, Godard, Andrew Sarris, Jean-André Fieschi, Tom Milne, Susan Sontag, Jean Collet, Mussman, Pauline Kael, Robin Wood, John Bragin, Mel Bochner, Michael Benedikt, David Ehrenstein, Raoul Coutard, Richard Roud, Scott Burton, and Michael Kustow; interview by James Blue.

Roud, Richard. *Jean-Luc Godard.* Bloomington: Indiana University Press, 1970.

Douglas Gordon
General Release: Young British Artists at Scuola di San Pasquale, Venice,

1995. Exh. cat. London: The British Council, 1995.

Kingston, Angela. "Douglas Gordon," *Frieze*, no. 21 (March–April 1995): 60.

Newman, Michael. "Screen Memories: The Trauma of Time," *At the Edge of Painting*. Exh. cat. Bern: Kunsthalle, 1995.

Newman, Michael. "Beyond the lost Object: From Sculpture to Film and Video." *Art Press*, no. 202 (May 1995): 45–50.

Obrist, Hans Ulrich. *Take Me (I'm Yours)*. Exh. cat. London: Serpentine Gallery, 1995.

Renton, Andrew. "24 Hour Psycho." *Flash Art*, vol. 26, no. 172 (November/December 1993).

Dan Graham

Buchloh, Benjamin H. D., ed. *Dan Graham: Video-Architecture-Television: Writings on Video and Video Works*. Halifax: The Press of the Nova Scotia College of Art and Design, 1979.

Dan Graham: Public/Private. Exh. cat. Philadelphia: Goldie Paley Gallery, Levy Gallery for the Arts in Philadelphia, Moore College of Art and Design, 1993. Essays by Graham, Mark Francis, and Christina Ritchie.

Dan Graham. Exh. cat. Perth: The Art Gallery of Western Australia, 1985. Essays by Gary Dufour, Graham, and Jeff Wall.

Graham, Dan. *Rock My Religion: Writings and Art Projects, 1965–1990*. Edited by Brian Wallis. Cambridge: The MIT Press, 1993. Includes introduction by Wallis.

Peter Greenaway

Greenaway, Peter. *The Baby of Mâcon*. Paris: Dis Voir, 1994.

___. *Prospero's Books: A Film of Shakespeare's The Tempest*. New York: Four Walls Eight Windows, 1991.

Peter Greenaway: Le bruit des nuages/Flying out of This World. Exh. cat. Paris: Musée du Louvre, Réunion des musées nationaux, 1992. Text by Greenaway.

Peter Greenaway: The Physical Self. Exh. cat. Rotterdam: Museum Boymans-van Beuningen, 1991. Text by Greenaway.

Peter Greenaway: The Stairs—The Location, Geneva/The Stairs—Le Cadrage, Genève. Exh. cat. Geneva: Stairs, 1994. Text by Greenaway.

Peter Greenaway: Watching Water. Exh. cat. Venice: Biennale di Venezia and Milan: Electa, 1993. Texts by Luca Massimo Barbero and Greenaway.

Richard Hamilton

Hamilton, Richard. *Collected Words, 1953–1982*. London: Thames and Hudson, 1982.

Richard Hamilton. Exh. cat. New York: Solomon R. Guggenheim Museum, 1973. Essays by John Russell and Hamilton.

Richard Hamilton. Exh. cat. London: The Tate Gallery, 1992. Essays by Richard Morphet, David Mellor, Sarat Maharaj, and Stephen Snoddy.

Alfred Hitchcock

LaValley, Albert J., ed. *Focus on Hitchcock*. Englewood Cliffs, New Jersey: Prentice-Hall, 1972. Essays by LaValley; Budge Crawley, Fletcher Markle, and Gerald Pratley; Hitchcock; Lindsay Anderson; André Bazin; Robin Wood; Andrew Sarris; Raymond Durgnat; James Agee; Pauline Kael; Raymond Chandler; Ronald Christ; Eric Rohmer and Claude Chabrol; Leo Braudy; John Crosby; and Jack Edmund Nolan; interview by Peter Bogdanovich.

Modleski, Tania. *The Women Who Knew Too Much: Hitchcock and Feminist Film Theory*. New York: Methuen, 1988.

Sloan, Jane E. *Alfred Hitchcock: A Filmography and Bibliography*. Berkeley: University of California Press, 1995.

Spoto, Donald. *The Art of Alfred Hitchcock: Fifty Years of His Motion Pictures*. New York: Hopkinson and Blake, 1976.

Truffaut, François, with the collaboration of Helen G. Scott. *Hitchcock*. New York: Simon and Schuster, 1967.

Žižek, Slavoj, ed. *Everything You Always Wanted to Know about Lacan (But Were Afraid to Ask Hitchcock)*. London: Verso, 1992. Texts by Žižek, Pascal Bonitzer, Mladen Dolar, Fredric Jameson, Alenka Zupančič, Stojan Pelko, Michael Chion, Miran Božovič, and Renata Salecl.

Dennis Hopper

Dennis Hopper: Fotografien von 1961 bis 1967/Photographs from 1961 to 1967. Exh. cat. Basel: Kunsthalle, 1988. Essay by Jean-Christophe Ammann.

Dennis Hopper: Out of the Sixties. Pasadena, California: Twelvetrees Press, 1988. Texts by Hopper, Michael McClure, and Walter Hopps.

Rodriguez, Elena. *Dennis Hopper: A Madness to His Method*. New York: St. Martin's Press, 1988.

Edward Hopper

Edward Hopper: The Art and the Artist. Exh. cat. New York: Whitney Museum of American Art and W. W. Norton and Co., 1980. Text by Gail Levin.

Lyons, Deborah and Adam D. Weinberg. *Edward Hopper and the American Imagination*. Exh. cat. New York and London: Whitney Museum of American Art in collaboration with W.W. Norton & Company, 1995. Julie Grau, ed. Essays by Deborah Lyons, Leonard Michaels, Ann Beattie, Galway Kinnell, Paul Auster, Ann Lauterbach, Walter Mosley, Grace Paley, Thom Gunn, Norman Mailer, Tess Gallagher, James Salter, John Hollander, William Kennedy, and Gail Levin.

Ken Jacobs

Pam, Dorothy S. "The N.Y. Apparition Theatre of Ken Jacobs" in *The Drama Review* (October 1974): 96–109.

Schwartz, David. *Films That Tell Time: A Ken Jacobs Retrospective*. Exh. cat. With interview and contributions by Ken Jacobs, and Tom Gunning. New York: American Museum of the Moving Image, 1989.

Testa, Bart. *Back and Forth: Early Cinema and the Avant-Garde*. Exh. cat. Toronto: Art Gallery of Ontario, 1993.

Wees, William C., *Recycled Images: The Art and Politics of Found Footage Films*. New York: Anthology Film Archives, 1993.

Derek Jarman

Blueprint: Suoni e immagini dal cinema di Derek Jarman. Exh. cat. Rome: Comune di Roma Ripartizione X, Antichità e Belle Arti and London: The British Council, 1993. Texts by Enrico Magrelli, Jarman, Stuart Morgan, Alfred Birnbaum, and Simon Fisher Turner.

Jarman, Derek. *Blue: Text of a Film*. Woodstock, New York: The Overlook Press, 1994.

___. *Chroma: A Book of Color*. Woodstock, New York: The Overlook Press, 1995.

___. *Dancing Ledge*. Edited by Shaun Allen. Woodstock, New York: The Overlook Press, 1993.

___. *Derek Jarman's Caravaggio: The Complete Film Script and Commentaries*. London: Thames and Hudson, 1986.

___. *The Last of England*. Edited by David L. Hirst. London: Constable, 1987.

Ray Johnson

Correspondence: An Exhibition of the Letters of Ray Johnson. Raleigh: North Carolina Museum of Art, 1976. Essay by William S. Wilson; facsimiles of Johnson's letters.

Henry, Gerrit. "Ray Johnson: Collage Jester." *Art in America* 72, no. 11 (December 1984): 138–141.

More Works by Ray Johnson, 1951–1991. Exh. cat. Philadelphia: Goldie Paley Gallery, Moore College of Art and Design, 1991. Essay by Clive Phillpot.

Works by Ray Johnson. Exh. cat. Roslyn Harbor, New York: Nassau County Museum of Fine Art, 1984. Essay by David Bourdon.

Peter Kubelka

Lebrat, Christian, ed. *Kubelka*. Paris: Paris Expérimental Editions, 1990. Texts by Jon Kessler, Kubelka, Lebrat, Stefano Masi, and Hermann Nitsch.

Mekas, Jonas. "Interview with Peter Kubelka." In *Film Culture Reader*, edited by P. Adams Sitney, 285–299. New York: Praeger Publishers, 1970.

Peter Kubelka filmt Arnulf Rainer. Berlin: Günter Brus, n.d.

Simon, Elena Pinto. "The Films of Peter Kubelka." *Artforum* 10, no. 8 (April 1972): 33–39.

Stanley Kubrick

Ciment, Michel. *Kubrick*. Translated by Gilbert Adair. New York: Holt, Rinehart, and Winston, 1988.

Coyle, Wallace. *Stanley Kubrick: A Guide to References and Resources*. Boston: G. K. Hall and Co., 1980.

Falsetto, Mano. *Stanley Kubrick: A Narrative and Stylistic Analysis*. Wesport, Connecticut: Greenwood Press, 1994.

Kagan, Norman. *The Cinema of Stanley Kubrick*. New York: Continuum, 1989.

Nelson, Thomas Allen. *Kubrick: Inside a Film Artist's Maze*. Bloomington: Indiana University Press, 1982.

Akira Kurosawa

Erens, Patricia. *Akira Kurosawa: A Guide to References and Resources*. Boston: G. K. Hall and Co., 1979.

Goodwin, James. *Akira Kurosawa and Intertextual Cinema*. Baltimore: Johns Hopkins University Press, 1994.

___, ed. *Perspectives on Akira Kurosawa*. New York: G. K. Hall and Co., 1994. Essays and interviews by numerous film artists, critics, and scholars.

Kurosawa, Akira. *Something Like an Autobiography*. Translated by Audie E. Block. New York: Alfred A. Knopf, 1982.

___. *Zenshu Kurosawa Akira [Works]*. 6 vols. Tokyo: Iwanami Shoten, 1987.

Suzanne Lafont

Suzanne Lafont. Exh. cat. Paris: Galerie nationale du Jeu de Paume, 1992. Essay by Jean-François Chevrier.

Fritz Lang

Eisner, Lotte H. *Fritz Lang*. New York: Da Capo Press, 1986. First publication, London: Secker and Warburg, 1976.

Humphries, Reynold. *Fritz Lang: Genre and Representation in his American Films*. Baltimore: Johns Hopkins University Press, 1989.

Jenkins, Stephen, ed. *Fritz Lang: The Image and the Look*. London: British Film Institute, 1981.

Kaplan, Anne E. *Fritz Lang: A Guide to References and Resources*. Boston: G.K. Hall, 1981.

Norbert, Jacques. *Dr. Mabuse, der Spieler: Roman, Film, Dokumente*. St. Ingbert: W.J. Rohrig, 1987.

Schnauber, Cornelius. *Fritz Lang in Hollywood*. Vienna: Europaverlag, 1986.

Sharon Lockhart

Aukeman, Anastasia. "Sharon Lockhart at Friedrich Petzel" *Art in America* 83 (April 1995): 112–113.

MacDonald, Daniel. "Sharon Lockhart," *Frieze* (January/February 1995): 63–64.

Meier, Eva. "Sharon Lockhart," *Pakt* (September/October, 1994), 12–13.

Nor Here Neither There. Exh. cat. Los Angeles, LACE, 1994.

Relyea, Lane. "Openings: Sharon Lockhart," *Artforum* 33 (November 1994): 80–81.

David Lynch

David Lynch. Exh. cat. Valencia: Sala Parpalló-Palau dels Scala, 1992. Essays by Artur Heras and Juan Vicente Aliaga; interview by Kristine McKenna.

Kaleta, Kenneth C. *David Lynch*. New York: Twayne Publishers, 1993.

Lynch, David. *Images*. New York: Hyperion, 1994.

Christian Marclay

Block, Ursula, and Michael Glasmeier. *Broken Music: Artists' RecordWorks*. Exh. cat. Berlin: daadgalerie, 1989.

Cooper, Dennis, and Harm Lux. *Christian Marclay*. Exh. cat. Zurich: Shedhalle, 1989.

Cruz, Amada. *Directions: Christian Marclay*. Exh. brochure. Washington D.C.: Hirshhorn Museum and Sculpture Garden, 1990.

Ferguson, Russell. *Amplification*. Exh.cat. Chiesa San Stae, Venice Biennial; Berne: Office fédéral de la culture/éditions Lars Müller, 1995.

Gleismeier, Michael, and Douglas Kahn. *Christian Marclay*. Exh. cat. Berlin: daadgalerie; Fribourg: Fri-Art Kunsthalle, 1994.

Seliger, Jonathan. "An Interview with Christian Marclay," *Journal of Contemporary Art* (Spring 1992).

Chris Marker

Chris Marker: Silent Movie. Exh. cat. Columbus, Ohio: Wexner Center for the Arts, The Ohio State University, 1995. Essays by Bill Horrigan and Marker.

Marker, Chris. *Commentaires 1* and *2*. Paris: Editions du Seuil, 1967.

___. *Le fond de l'air est rouge: Scènes de la troisième guerre mondiale*. Paris: François Maspero, 1976.

___. *La jetée: Ciné-roman*. New York: Zone Books, 1992.

Fabio Mauri

Blouin, René. "Fabio Mauri." *Parachute*, no. 14 (Spring 1979): 24–28. Interview.

Fabio Mauri (1959–1969). Rome: Studio d'Arte Toninelli, n.d. Texts by Emilio Villa, Gillo Dorfles, Guido Ballo, Maurizio Calvesi, Gino Marotta, Pierre Restany, Tommaso Trini, Sandro de Feo, Fabrizio Dentice, Achille Bonito Oliva, and Ennio Flaiano.

Fabio Mauri: Opere e azioni, 1954–1994. Exh. cat. Rome: Galleria Nazionale d'Arte Moderna e Contemporanea and Editoriale Giorgio Mondadori, 1994. Essays by Lea Vergine, Carolyn Christov-Bakargiev, Umberto Silva, Ferdinando Taviani, Marcella Cossu, and Mauri.

Annette Messager

Annette Messager. Exh. cat. Los Angeles: Los Angeles County Museum of Art and New York: The Museum of Modern Art, 1995.

Annette Messager: Comédie tragédie, 1971–1989. Exh. cat. Grenoble: Musée de Grenoble, 1989. Essays by Didier Semin, Klaus Honnef, Catherine Liu, Jules Michelet, Dominique Viéville, Georges Didi-Huberman, and Sigrid Metken; interview by Bernard Marcadé.

Annette Messager: Faire parade, 1971–95. Exh. cat. Paris: Musée d'art moderne de la Ville de Paris, 1995.

Hélio Oiticica

Brett, Guy. "Hélio Oiticica: Reverie and Revolt." *Art in America* 77, no. 1 (January 1989): 110–121, 163, 165.

Hélio Oiticica. Exh. cat. London: Whitechapel Gallery, 1989.

Hélio Oiticica. Exh. cat. Rotterdam: Witte de With, center for contemporary art, 1992. Essays by Oiticica, Guy Brett, Haroldo de Campos, Waly Salomão, and Catherine David.

Pat O'Neill

Hammen, Scott. "Four Films by Pat O'Neill." *Afterimage* (March 1972): 2–4.

Sitney, P. Adams. "Saugus Series." *Millenium Film Journal*, no. 16–18 (Fall–Winter 1986–87): 158–161.

Weinbren, Grahame, and Christine Noll Brinckmann. "Selective Transparencies: Pat O'Neill's Recent Films." *Millenium Film Journal*, no. 6 (Spring 1980): 51–71.

Weinbren, Grahame, and C. Noll Brinckmann. *Pat O'Neill.* Saint Paul, Minnesota: Film in the Cities, 1980.

Pier Paolo Pasolini

Greene, Naomi. *Pier Paolo Pasolini: Cinema as Heresy.* Princeton: Princeton University Press, 1990.

Pasolini, Pier Paolo. *Pasolini on Pasolini: Interviews with Oswald Stack.* Bloomington: Indiana University Press, 1969.

Pier Paolo Pasolini: Figuratività e figurazione. Exh. cat. Rome: Comune di Roma, Assessorato alla Cultura, Palazzo delle Esposizioni and Edizione Carte Serrani, 1991. Texts by Enzo Serrani, Costantino Dardi, Duccio Trombadori, and Pasolini.

Schwarz, Barth David. *Pasolini Requiem.* New York: Pantheon Books, 1992.

Viano, Maurizio. *A Certain Realism: Making Use of Pasolini's Film Theory and Practice.* Berkeley: University of California Press, 1993.

Roman Polanski

Bisplinghoff, Gretchen. *Roman Polanski: A Guide to References and Resources.* Boston: G.K. Hall, 1989.

Butler, Ivan. *The Cinema of Roman Polanski.* New York: A.S. Barnes, 1970.

Leaming, Barbara. *Polanski, the Filmmaker as Voyeur: A Biography.* New York: Simon and Schuster, 1981.

Polanski, Roman. *Roman/by Polanski.* New York: Morrow, 1984.

Wexman, Virginia Wright. *Roman Polanski.* Boston: Twayne Publishers, 1985.

Michael Powell

Christie, Ian. *Arrows of Desire: The Films of Michael Powell and Emeric Pressburger.* London: Waterstone, 1985.

Christie, Ian. *Powell, Pressburger, and Others.* London: British Film Institute, 1975.

Powell, Michael. *A Life in the Movies: An Autobiography.* New York: Alfred A. Knopf, 1987.

Alain Resnais

Kreidl, John Francis. *Alain Resnais.* Boston: Twayne Publishers, 1977.

Monaco, James. *Alain Resnais.* New York: Oxford University Press, 1979.

Oms, Marcel. *Alain Resnais.* Paris: Editions Rivages, 1988.

Robbe-Grillet, Alain. *L'année dernière à Marienbad.* Paris: Les Editions de Minuit, 1961. Illustrated with photographs from the film.

Sweet, Freddy. *The Film Narratives of Alain Resnais.* Ann Arbor: UMI Research Press, 1981.

Ward, Alain. *Alain Resnais; or the Themes of Time.* Garden City, New York: Doubleday, 1968.

Nicolas Roeg

Feineman, Neil. *Nicolas Roeg.* Boston: Twayne Publishers, 1978.

Izod, John. *The Films of Nicolas Roeg: Myth and Mind.* New York: St. Martin's Press, 1992.

Lanza, Joseph. *Fragile Geometry: The Films, Philosophy, and Misadventures of Nicolas Roeg.* New York: PAJ Publications, 1989.

Salwolke, Scott. *Nicolas Roeg Film by Film.* Jefferson, North Carolina: McFarland and Co., 1993.

Mimmo Rotella

Hunter, Sam. *Rotella: Décollages, 1954–1964.* Milan: Electa, 1986. Excerpts from previously published texts on Rotella.

Rotella, Mimmo. *Autorotella.* Milan: Edizioni Apollinaire, 1963.

Trini, Tommaso. *Rotella.* Milan: Giampaulo Prearo Editore, 1974. Includes foreword by Pierre Restany.

Verzotti, Giorgio. "Interview with Rotella." *Flash Art*, no. 139 (March–April 1988): 73–76.

Raúl Ruiz

Buci-Glucksmann, Christine, and Fabrice Revault d'Allonnes. *Raúl Ruiz.* Paris: Dis Voir, 1987. Includes interview with Ruiz.

Cahiers du cinéma, no. 345 (March 1983). Special issue: Raúl Ruiz. Includes interviews by Pascal Bonitzer and Serge Toubiana; articles by Bonitzer, Serge Daney, Yann Lardeau, Danièle Dubroux, Louis Skorecki, and

Michel Chion; bio-filmography by Charles Tasson.

Farassino, Alberto, and M. Alessandro Visinoni. *Raúl Ruiz catalogo.* Italy: Centro Ricerche Spettacolo il Labirinto, Centro Cinematografico e Audiovisivo, 1988.

Ruiz, Raúl. *Poetics of Cinema.* Paris: Dis Voir, 1995.

Allen Ruppersberg

Allen Ruppersberg: The Secret Life and Death, Volume 1: 1969–1984. Edited by Julia Brown. Exh. cat. Los Angeles: The Museum of Contemporary Art and Santa Barbara: Black Sparrow Press, 1985. Essay by Howard Singerman; documentation of works.

Levine, Daniel. "Allen Ruppersberg." *The Journal of Contemporary Art* (Fall 1992). Interview.

Edward Ruscha

Edward Ruscha: Paintings/Schilderijen. Exh. cat. Rotterdam: Museum Boymans-van Beuningen and Paris: Musée nationale d'art moderne, Centre Georges Pompidou, 1989. Essays by Dan Cameron and Pontus Hulten; interview by Bernard Blistène.

The Works of Edward Ruscha. Exh. cat. San Francisco: San Francisco Museum of Modern Art and New York: Hudson Hills Press, 1982. Introduction by Anne Livet; essays by Dave Hickey and Peter Plagens.

Edward Ruscha: The End. Essay by Robert Mahoney.

Carolee Schneemann

Carolee Schneemann: I. Early Work, 1960/1970. Exh. cat. New York: Max Hutchinson Gallery and New Paltz, New York: Documentext, 1983.

Birringer, Johannes. "Imprints and Revisions: Carolee Schneemann's Visual Archeology." *Performance Art Journal*, no. 44 (June 1993): 31–46.

Coe, Robert. *Post Shock: The Emergence of the American Avant-Garde.* New York: W.W. Norton, 1993.

Schneemann, Carolee. *More Than Meat Joy: Complete Performance Works and Selected Writings.* Edited by Bruce McPherson. New Paltz, New York: Documentext, 1979.

Schneider, Rebecca. *The Explicit Body.* New York: Routledge Press, 1996.

Martin Scorsese

Connelly, Marie Katheryn. *Martin Scorsese: An Analysis of His Feature Films, with a Filmography of His Entire Directorial Career.* Jefferson, North Carolina: McFarland and Co., 1991.

Kelly, Mary Pat. *Martin Scorsese: A Journey.* New York: Thunder's Mouth Press, 1991. Forewords by Steven Spielberg and Michael Powell.

Keyser, Les. *Martin Scorsese.* New York: Twayne Publishers, 1992.

Scorsese, Martin. *Scorsese on*

Scorsese. Edited by David Thompson and Ian Christie. London: Faber and Faber, 1989.

Weiss, Marion. *Martin Scorsese: A Guide to References and Resources.* New York: G. K. Hall and Co., 1987.

Ridley Scott

Bruno, Giuliana. "Ramble City: Postmodernism and Blade Runner," *October* no.41 (Summer 1987): 61–74.

Goldberg, Lee. *Science Fiction Filmmaking in the 1980s: Interviews with Actors, Directors, Producers, and Writers.* Foreword by David McDonnell. Jefferson, North Carolina: McFarland & Co., 1995.

Kerman, Judith B. *Retrofitting Blade Runner: Issues in Ridely Scott's Blade Runner and Philip K. Dick's Do Androids Dream of Electric Sheep?* Bowling Green, Ohio: Bowling Green State University Popular Press, 1991.

Ruppert, Peter. "Blade Runner: the Utopian Dialectics of Science Fiction Films," *Cineaste* 17, no. 2 (1989): 8–13.

Scroggy, David. *Blade Runner Sketchbook.* San Diego: Blue Dolphin Enterprises, 1982. Artwork by Syd Mead.

Paul Sharits

Cornwell, Regina. "Paul Sharits: Illusion and Object." *Artforum* (September 1971): 56–62.

Film Culture, no. 65–66 (1978). Special issue: Paul Sharits. Essays by Sharits, Annette Michelson, and Rosalind Krauss; interview by Linda Cathcart.

Krauss, Rosalind. "Paul Sharits: Stop Time." *Artforum* 11, no. 8 (April 1973): 60–61.

Michelson, Annette. "Paul Sharits and the Critique of Illusionism: An Introduction." In *Projected Images.* Exh. cat. Minneapolis: Walker Art Center, 1974.

Paul Sharits: Dream Displacement and Other Projects. Exh. cat. Buffalo: Albright-Knox Art Gallery, 1976. Essays by Linda Cathcart and Rosalind Krauss.

Liebman, Stuart. *Paul Sharits.* St. Paul: Film in the Cities and Minneapolis: Walker Art Center, 1981.

Cindy Sherman

Cindy Sherman. Exh. cat. New York: Whitney Museum of American Art, 1987. Essays by Peter Schjeldahl and Lisa Phillips.

Krauss, Rosalind. *Cindy Sherman, 1975–1993.* New York: Rizzoli International Publications, 1993. Includes essay by Norman Bryson.

Sherman, Cindy. *Untitled Film Stills.* New York: Rizzoli International Publications, 1990. Includes essay by Arthur C. Danto.

Michael Snow

Cornwell, Regina. *Snow Seen: The Films and Photographs of Michael Snow.* Toronto: Peter Martin Associates, 1980.

The Michael Snow Project: Visual Art, 1951–1993. Exh. cat. Toronto: Art Gallery of Ontario, The Power Plant, and Alfred A. Knopf Canada, 1994. Essays by Dennis Reid, Philip Monk, Louise Dompierre, Richard Rhodes, and Derrick de Kerckhove.

Michael Snow: Werke 1969–1978 Filme 1964–1976/Works 1969–1978 Films 1964–1976. Exh. cat. Lucerne: Kunstmuseum Luzern, 1979. Essays by Pierre Théberge, Regina Cornwell, Dominique Noguez, and Snow.

Snow, Michael. *The Michael Snow Project: The Collected Writings of Michael Snow.* Waterloo, Ontario: Wilfred Lurier University Press, 1994.

___, ed. *The Michael Snow Project: Music/Sound, 1948–1993.* Toronto: Art Gallery of Ontario, The Power Plant, and Alfred A. Knopf Canada, 1994. Essays by Snow; David Lancashire; Nubota Kubota, Alan Mattes, and Snow; Paul Dutton; John Kamevaar; Raymond Gervais; and Bruce Elder and Snow.

Hiroshi Sugimoto

Halpert, Peter Hay. "The Blank Screens of Hiroshi Sugimoto." *Art Press*, no. 196 (November 1994): 51–53.

Hiroshi Sugimoto. Exh. cat. New York: Sonnabend Gallery and Tokyo: Sagacho Exhibit Space and Zeito Photo Salon, 1988.

Kellein, Thomas. *Hiroshi Sugimoto: Time Exposed.* London: Thames and Hudson, 1995.

Sugimoto. Exh. cat. Los Angeles: The Museum of Contemporary Art, 1993. Essay by Kerry Brougher.

Yau, John. "Hiroshi Sugimoto: No Such Thing as Time." *Artforum* 22, no. 8 (April 1984): 48–52.

Andrei Tarkovsky

Johnson, Vida T., and Graham Petrie. *The Films of Andrei Tarkovsky: A Visual Fugue.* Bloomington: Indiana University Press, 1994.

Le Fanu, Mark. *The Cinema of Andrei Tarkovsky.* London: The British Film Institute, 1987.

Tarkovsky, Andrei. *Sculpting in Time: Reflections on the Cinema.* Translated by Kitty Hunter-Blair, 1987.

___. *Time within Time: The Diaries, 1970–1986.* Translated by Kitty Hunter-Blair. Calcutta: Seagull Books, 1991.

Turavskaya, Maya. *Tarkovsky: Cinema as Poetry.* London: Faber and Faber, 1989.

Frank Tashlin

Garcia, Roger, ed. *Frank Tashlin.* Locarno: Editions du Festival Internationale du Film de Locarno and London: British Film Institute, 1994.

François Truffaut

Bonaffons, Elisabeth. *François Truffaut: la figure inachevée.* Lausanne: Editions L'Age d'homme, 1981.

Fanne, Dominique. *L'univers de François Truffaut*. Avant propos de Jeanne Moreau. Paris: Editions de Cerf, 1972.

Gillain, Anne. *François Truffaut: le secret perdu*. Preface de Jean Guault. Paris: Hatier, 1992

Shoot the Piano Player: François Truffaut. Edited by Peter Brunette. New Brunswick, New Jersey: Rutgers University Press, 1993.

Truffaut, François . *Hitchcock*. With the collaboration of Helen G. Scott. New York: Simon & Schuster, 1985.

Jeff Wall

Barents, Elie. *Jeff Wall: Transparencies*. New York: Rizzoli International Publications, 1987. Includes interview.

Crow, Thomas. "Profane Illuminations: Social History and the Art of Jeff Wall." *Artforum* 31, no. 6 (February 1993): 62–69.

Jeff Wall: Dead Troops Talk. Exh. cat. Lucerne: Kunstmuseum Luzern, 1993. Essays by Martin Schwander, Declan McGonagle, and Zdenek Felix and by Terry Atkinson.

Jeff Wall: Restoration. Exh. cat. Lucerne: Kunstmuseum Luzerne and Düsseldorf: Kunsthalle, 1994. Essays by Martin Schwander and Jürgen Harten, Schwander, and Arielle Pélenc; interview with Wall by Schwander.

Jeff Wall 1990. Exh. cat. Vancouver: Vancouver Art Gallery, 1990. Essays by Gary Dufour and Jerry Zaslove.

Jeff Wall: Transparencies. Exh. cat. London: Institute of Contemporary Arts, 1984. Essays by Jean-Christophe Ammann and Ian Wallace.

Andy Warhol

Andy Warhol: Death and Disasters. Exh. cat. Houston: The Menil Collection and Houston Fine Arts Press, 1988. Essays by Neil Printz and Remo Guidieri.

Andy Warhol: A Retrospective. Exh. cat. New York: The Museum of Modern Art, 1989. Essays by Kynaston McShine, Robert Rosenblum, Benjamin H. D. Buchloh, and Marco Livingstone.

Bourdon, David. *Warhol*. New York: Harry N. Abrams, 1989.

The Films of Andy Warhol: Part II. Exh. cat. New York: Whitney Museum of American Art, 1994. Essay by Callie Angell.

Gidal, Peter. *Andy Warhol: Films and Paintings: The Factory Years*. New York: Da Capo Press, 1991.

Koch, Stephen. *Star-Gazer: Andy Warhol's World and His Films*. New York: Praeger, 1973.

Name, Billy. *Billy Name: Stills From the Warhol Films*. New York and Munich: Prestel-Verlag, 1994. Foreword by John G. Hanhardt.

O'Pray, Michael, ed. *Andy Warhol: Film Factory*. London: British Film Institute, 1989. Essays by O'Pray,

Peter Wollen, Jonas Mekas, Gregory Battcock, Kathy Acker, Parker Tyler, Stephen Koch, Mark Finch, Peter Gidal, A. L. Rees, David James, Paul Arthur, Vivienne Dick, Tony Rayns, Margia Kramer, Gary Indiana; text by Ronald Tavel; interview by Gretchen Berg.

Smith, Patrick. *Andy Warhol's Art and Films*. Ann Arbor: UMI Research Press, 1986.

Warhol, Andy. *The Philosophy of Andy Warhol (From A to B and Back Again)*. New York: Harcourt Brace Jovanovich, 1975.

Weegee

Kaiser, Reinhard. *Weegee's New York: 335 Photographien, 1935–1969*. Munich: Schirmer/Mosel, 1982.

Stettner, Louis, ed. *Weegee*. New York: Alfred A. Knopf, 1977.

Weegee. *Naked City*. New York: Duell, Sloane, and Pearce, 1945.

Weegee. *Weegee: An Autobiography*. New York: Ziff-Davis Publishing Co., 1961. Reprint. New York: Da Capo Press, 1975.

Weegee and Mel Harris. *Naked Hollywood*. New York: Farrar, Straus and Giroux, 1953. Reprint. New York: Da Capo Press, 1976.

Weegee. Millerton, New York: Aperture, 1978. Essay by Allene Talmey.

Orson Welles

Bazin, André. *Orson Welles: A Critical View*. Translated by Jonathan Rosenbaum. New York: Harper and Row, 1978. Foreword by François Truffaut; profile by Jean Cocteau.

Brady, Frank. *Citizen Welles: A Biography of Orson Welles*. New York: Charles Scribner's Sons, 1989.

Cowie, Peter. *A Ribbon of Dreams: The Cinema of Orson Welles*. New York: A. S. Barnes and Co., 1973.

Gottesman, Ronald, ed. *Focus on Orson Welles*. Englewood Cliffs, New Jersey: Prentice-Hall, 1976. Essays by Gottesman, Kenneth Tynan, Peter Bogdanovich, Charlton Heston, Richard T. Jameson, Phyllis Gioldfarb, Joseph McBride, David Bordwell, Stephen Farber, James Naremore, Michael Mullin, Jack Jorgens, Terry Comito, Peter Cowie, Charles Silver, and John Russell Taylor; interview by Charles Champlin.

Howard, John. *The Complete Films of Orson Welles*. New York: Carol Publishing Group, 1991.

Welles, Orson, and Peter Bogdanovich. *This Is Orson Welles*. Edited by Jonathan Rosenbaum. New York: HarperCollins Publishers, 1992. Interviews.

Wim Wenders

Geist, Kathe. *The Cinema of Wim Wenders: From Paris, France to Paris, Texas*. Ann Arbor, Michigan, UMI Research Press, 1988.

Kolker, Robert. *The Films of Wim Wenders: Cinema as Vision and*

Desire. New York: Cambridge University Press, 1993.

Wenders, Wim. *Emotion Pictures: Reflections on the Cinema*. Translated by Shaun Whiteside in collaboration with Michael Hofman. London: Faber and Faber Limited, 1991.

Wenders, Wim. *The Logic of Images: Essays and Conversations*. Translated by Michael Hofman. London: Faber and Faber Limited, 1991.

John and James Whitney

Film Culture, no. 53–54–55 (Spring 1972). Include special section on John Whitney with interview by Richard Brick and texts by Whitney.

Lamont, Austin. "An Interview with John Whitney." *Film Comment* 6, no. 3 (Fall 11970): 28–33.

Whitney, John. *Digital Harmony: On the Complimentary of Music and Visual Art*. Peterborough, New Hampshire: Byte Books, 1980.

Billy Wilder

Madsen, Axel. *Billy Wilder*. Bloomington: Indiana University Press, 1969.

Positif, no. 269–270 (July–August 1983). Includes special section on Wilder with articles by Michel Ciment, Wilder, Sandro Bernardi, Gérard Legrand, Christian Viviani, and Olivier Eyquem.

Positif, no. 271 (September 1983). Includes special section on Wilder with articles by Michel Cieutat, Jean-Pierre Jeancolas, Vincent Amiel, Yves Hersant, Jean-Loup Bourget, Yann Tobin, and Adrian Turner and Neil Sinyard.

Seidman, Steve. *The Film Career of Billy Wilder*. Boston: G. K. Hall and Co., 1977.

Sinyard, Neil, and Adrian Turner. *Journey down Sunset Boulevard: The Films of Billy Wilder*. Ryde, Isle of Wight: BCW Publishing, 1979.

Zolotow, Maurice. *Billy Wilder in Hollywood*. New York: G. P. Putnam's Sons, 1977.

Checklist of the Exhibition

Robert Aldrich
Kiss Me Deadly
1955
35mm, 105 min., b&w

Whatever Happened to Baby Jane?
1962
35mm, 132 min., b&w
(Excerpt)

Kenneth Anger
Scorpio Rising
1963
16mm, 31 min., color
Courtesy of the artist

Michelangelo Antonioni
Il deserto rosso (Red Desert)
1964
35mm, 120 min., color
(Excerpt)

Blow-Up
1966
35mm, 110 min., color
(Excerpt)

Zabriskie Point
1970
35mm, 112 min., color
(Excerpt)

Diane Arbus
Audience in the Loge and Balcony, N.Y.C.
1958
Gelatin-silver print
14 x 11 inches
© 1995 The Estate of Diane Arbus
Courtesy of Robert Miller Gallery, New York

Audience Projection Booth, N.Y.C.
1958
Gelatin-silver print
11 x 14 inches
Collection of Richard Gere, New York

Dead Gangster from "New York Confidential"
1958
Gelatin-silver print
11 x 14 inches
© 1995 The Estate of Diane Arbus
Courtesy of Robert Miller Gallery, New York

Eyeball from "The Man Without a Body"
1958
Gelatin-silver print
11 x 14 inches
Ydessa Hendeles Art Foundation, Toronto

Frankenstein's Daughter
1958
Gelatin-silver print
11 x 14 inches
Ydessa Hendeles Art Foundation, Toronto

Kiss from "Baby Doll"
1958
Gelatin-silver print
11 x 14 inches
Collection of John Cheim, New York

Man in the Audience, N.Y.C.
1958
Gelatin-silver print
11 x 14 inches
Collection of Richard Gere, New York

Murder Witness, "New York Confidential"
1958
Gelatin-silver print
11 x 14 inches
Collection of Robert Morton, New York

View of Audience from Balcony, Riviera Theater, 97th & Broadway, N.Y.C.
1958
Gelatin-silver print
14 x 11 inches
© 1958 The Estate of Diane Arbus
Courtesy of Robert Miller Gallery, New York

A House on a Hill, Hollywood, California
1963
Gelatin-silver print
20 x 16 inches
The Museum of Contemporary Art, Los Angeles
Purchased with funds provided in part by the Collectors Committee

John Baldessari
A Movie: Directional Piece Where People Are Looking
1972–73
Twenty-eight black-and-white photographs with acrylic, mounted on board
3½ x 5 inches each
Jedermann Collection, N.A.

Movie Storyboard: Norma's Story
1974
Six panels of black-and-white photographs and ink on storyboard layout paper
41½ x 29⅞ inches overall
Five at 8½ x 29⅞ inches each;
One at 8½ x 20¾ inches
Courtesy of Sonnabend Gallery, New York

Strobe Series/Futurist: Dropping a Cord One Meter Long One Meter (1/4˝ Nylon)
1975
Eight black-and-white photographs
11 x 11 inches
Courtesy of Sonnabend Gallery, New York

Thaumatrope Series: Two Gangsters (One a Military Man)
1975
Black-and-white photographs
Two panels: 16 x 20 inches each
Courtesy of Sonnabend Gallery, New York

Black and White Decision
1984
Four black-and-white photographs mounted on board
64 x 70¾ inches overall
The Eli Broad Family Foundation Collection, Santa Monica, California

Kiss/Panic
1984
Twelve black-and-white photographs with oil tint mounted on board
81 x 72¾ inches overall
Collection of Martin and Toni Sosnoff, New York

Starry Night Balanced on Triangulated Trouble
1984
Two black-and-white photographs with oil tint mounted on board
50¾ x 40 inches overall
Collection of Beatrice and Philip Gersh, Los Angeles

Various Shadows
1984
Black-and-white photographs
61¼ x 49¼ inches overall
Collection of the Capital Group
Companies, Inc., Los Angeles

Light and Dark
1986
Two black-and-white photographs
64⅜ x 95⅝ inches overall
Collection of Dr. Lieven Declerck-
Verstraete, Belgium

Spaces Between
1986
Black-and-white photographs
37¾ x 48 inches
The Foundation To-Life, Inc. Collection

Judith Barry
In the Shadow of the City. . . Vamp r y
1982–85
Mixed media installation
35mm slide projectors with dissolve
units, screen, lcd projectors, cassette
player, amplifier, speakers
Dimensions variable
Courtesy of the artist; Rena Bransten
Gallery, San Francisco; and Nicole
Klagsbrun, New York

**Saul Bass (in collaboration with
John Whitney)**
Title sequence to Alfred Hitchcock's
Vertigo
1958
35mm, color

Ingmar Bergman
Persona
1966
35mm, 81 min., b&w
(Excerpt)

Cindy Bernard
Ask the Dust: Easy Rider (1969/1989)
1989
Color photograph
12½ x 23 inches

Ask the Dust: The Searchers (1956/1989)
1989
Cibachrome
12½ x 23 inches

*Ask the Dust: Cheyenne Autumn
(1964/1990)*
1990
Color photograph
10⅜ x 23 inches

Ask the Dust: Chinatown (1974/1990)
1990
Color photograph
11½ x 23 inches

Ask the Dust: Dirty Harry (1971/1990)
1990
Color photograph
11½ x 23 inches

*Ask the Dust: Electra Glide in Blue
(1973/1990)*
1990
Color photograph
11½ x 23 inches

*Ask the Dust: Faster Pussycat Kill!
Kill! (1965/1990)*
1990
Black-and-white photograph
13⅞ x 23 inches

*Ask the Dust: North by Northwest
(1959/1990)*
1990
Color photograph
12½ x 23 inches

*Ask the Dust: Splendor in the Grass
(1961/1990)*
1990
Color photograph
12½ x 23 inches

*Ask the Dust: The Godfather
(1972/1990)*
1990
Color photograph
12½ x 23 inches

Ask the Dust: Vertigo (1958/1990)
1990
Color photograph
12½ x 23 inches

*Ask the Dust: 3:10 to Yuma
(1957/1991)*
1991
Black-and-white photograph
14½ x 23 inches

*Ask the Dust: Bonnie and Clyde
(1967/1991)*
1991
Color photograph
12½ x 23 inches

*Ask the Dust: Five Easy Pieces
(1970/1991)*
1991
Color photograph
12½ x 23 inches

*Ask the Dust: It's a Mad, Mad, Mad
World (1963/1991)*
1991
Color photograph
9¾ x 23 inches

*Ask the Dust: Ride the High Country
(1962/1991)*
1991
Color photograph
11½ x 23 inches

Ask the Dust: The Alamo (1960/1991)
1991
Color photograph
10⅜ x 23 inches

*Ask the Dust: The Far Country
(1955/1991)*
1991
Color photograph
14½ x 23 inches

Ask the Dust: Them (1954/1991)
1991
Black-and-white photograph
14½ x 23 inches

*Ask the Dust: Once Upon a Time in
the West (1968/1990)*
1992
Color photograph
9½ x 23 inches

*Ask the Dust: The Wild Angels
(1966/1992)*
1992
Color photograph
11½ x 23 inches

All works courtesy of the artist

Bernardo Bertolucci
Ultimo Tango a Parigi (Last Tango in
Paris)
1972
35mm, 129 min., color
(Excerpt)

Joseph Beuys
Das Schweigen (The Silence)
1973
Five reels and one film carton
Reels: 14 inches diameter
Carton: 8⅝ x 16¾ x 16¾ inches
Collection of Francis and Eleanor
Coppola

Douglas Blau
The Conversation Piece (CP 2.1)
1993/95
Mixed media assemblage
3 x 15 feet

The Conversation Piece (CP 2.2)
1993/95
Mixed media assemblage
3 x 15 feet

The Conversation Piece (CP 2.3)
1993/95
Mixed media assemblage
3 x 15 feet

All courtesy of the artist

Barbara Bloom
Homage to Jean Seberg
1981
Two rolls photographer's backdrop
paper, black butterfly chair,
blue-and-white striped long-sleeved
shirt, fake "Herald Tribune" newspaper
138 x 60 x 62 inches
Collection of Miani Johnson, New York

Christian Boltanski
Lanterne magique (Magic Lantern)
1981
Slide installation
Dimensions variable
Courtesy of the artist, and Marian
Goodman Gallery, New York

Stan Brakhage
The Text of Light
1974
16mm, 70½ min., color, silent
Courtesy of the artist

Luis Buñuel
La Charme discret de la bourgeoisie 12
(The Discreet Charm of the Bourgeoisie)
1972
35mm, 105 min., color

Victor Burgin
The Bridge
1984
Black-and-white photographs and text
Six parts: two at 36 x 60 inches;
one at 35 x 34 inches; two at 30 x 61
inches; one at 30 x 75 inches and
one introductory panel
Les Impenitents, F.R.A.C. de Haute
Normandie, Rouen, France

Jean Cocteau
La Belle et la bête (Beauty and the
Beast)
1946
35mm, 96 min., b&w
(Excerpt)

James Coleman
La Tâche Aveugle
1978–90
Projected black-and-white images;
continuous projection
Dimensions variable
Courtesy of the artist

Bruce Conner
A Movie
1958
16mm, 12 min. b&w
Courtesy of the artist

Homage to Minnie Mouse
1959
Assemblage
56 x 40¾ x 6½ inches
Norton Simon Museum, Pasadena,
California. Museum Purchase, 1963

*St. Valentine's Day Massacre/Homage
to Erroll Flynn*
1960
Assemblage
19 x 14½ x 3½ inches
San Francisco Museum of Modern Art
Gift of Dr. and Mrs. William Gardner

Homage to Mae West
1961
Assemblage
22 x 35 x 9½ inches
Courtesy of Galerie Patrice Trigano,
Paris

Homage to Jean Harlow
1963
Assemblage
61¾ x 18 x 3 inches
Collection Onnasch, Berlin

Son of the Sheik
1963
Assemblage
66 x 22 x 11 inches
Collection of Lannan Foundation,
Los Angeles

Tony Conrad
The Flicker
1966
16mm, 30 min., b&w
Courtesy of the artist

Joseph Cornell
*Penny Arcade Portrait of Lauren
Bacall (Dossier)*
1946
(added to after 1946)
Paperboard folder containing photo-
graphs and various paper materials
Folder: ¾ x 12 x 8¹¹⁄₁₆ inches
Collection of the Bergman Family,
Chicago

Untitled (Compartmented Box)
1954–56
Mixed media box construction
15⁵⁄₁₆ x 10¼ x 2⁷⁄₁₆ inches
The National Swedish Art Museums
Moderna Museet, Stockholm

Rose Hobart
c. 1936
16mm, 19 min., b&w projected at
16 fps through blue filter
Richard L. Feigen, New York

Greta Garbo
c. 1939
Mixed media box construction
13½ x 9½ x 3 inches
Richard L. Feigen, New York

David Cronenberg
Videodrome
1982
35mm, 89 min., color
(Excerpt)

Salvador Dalí
Backdrop for dream sequence in
Alfred Hitchcock's *Spellbound*
1945
Paint on muslin
204¼ x 456 inches
Collection of Marius Olbrychowski,
Los Angeles

Brian De Palma
Body Double
1984
35mm, 114 min., color
(Excerpt)

Stan Douglas
Overture
1986
Black-and-white 16mm film loop
installation with sound
Duration of each rotation: 7 minutes
Collection of Eileen and Michael
Cohen, New York
Courtesy of David Zwirner, New York

Carl-Theodor Dreyer
Gertrud
1966
35mm, 115 min., b&w
(Excerpt)

Federico Fellini
8½
1963
35mm, 138 min., b&w
(Excerpt)

Hollis Frampton and Marion Faller
*Sixteen Studies from Vegetable
Locomotion*
*Gourds vanishing (var. "Mixed
Ornamental")*
*Zucchini squash encountering saw-
horse (var. "Dread")*
*Sunflower reclining (var. "Mammoth
Russian")*
*Scallop squash revolving (var. "Patty
Pan")*
Savoy cabbage flying (var. "Chieftain")
*Summer squash undergoing surgery
(var. "Yellow Straightneck")*
*Mature radishes bathing (var. "Black
Spanish")*
Pumpkin emptying (var. "Cinderella")
*Winter squash vacillating (var. "True
Hubbard")*
*Tomatoes descending a ramp (var.
"Roma")*
*Watermelon falling (var. "New
Hampshire Midget")*
*Sweet corn disrobing (var. "Early
Sunglow)*
Dill bundling (var. "Rural Splendor")
*Beets assembling (var. "Detroit Dark
Red")*
Carrot ejaculating (var. "Chantenay")
Apple advancing (var. "Northern Spy")
1975
Series of sixteen black-and-white
photographs
11 x 14 inches each
Walker Art Center, Minneapolis
Clinton and Della Walker Acquisition
Fund, 1993

Robert Frank
Stationery Store, Hollywood
1955
Gelatin-silver print
13 x 8⅝ inches
The Sandor Family Collection,
New York

Drive-in Movie, Detroit
1955–56
Gelatin-silver print
18¾ x 12¼ inches
The Museum of Contemporary Art,
Los Angeles
Purchased with funds provided in part
by the Collectors Committee

Movie Premiere, Hollywood
1955–56
Gelatin-silver print
12½ x 8⅜ inches
The Museum of Contemporary Art,
Los Angeles
Purchased with funds provided in part
by the Collectors Committee

Movie Premiere, Hollywood
1955–56
Gelatin-silver print
13¹⁵⁄₁₁ x 11 inches
The Museum of Contemporary Art,
Los Angeles
Purchased with funds provided in part
by the Collectors Committee

Detroit (Joan Crawford)
1956
Gelatin-silver print
12¹⁵⁄₁₆ x 8½ inches
Stanford University Museum of Art
1984.492.12
Gift of Raymond B. Gary

H for Hollywood Sign
1956
Gelatin-silver print
14 x 11 inches
Stanford University Museum of Art
1964.493.70
Gift of Bowen H. McCoy

*Untitled (Boy Reading with Movie Star
Posters)*
n.d. (c. 1950s)
Gelatin-silver print
13¾ x 9¼ inches
Herbert F. Johnson Museum of Art,
Cornell University, Ithaca, New York
Gift of Dr. Andrea D. Branch

Jean-Luc Godard
A bout de souffle (Breathless)
1960
35mm, 90 min., b&w
(Excerpt)

*One Plus One (Sympathy for the
Devil)*
1968
35mm, 99 min., color
(Excerpt)

Passion
1982
35mm, 87 min., color

Douglas Gordon
Hysterical
1995
Video installation
Dimensions variable
Courtesy of Lisson Gallery, London

Dan Graham
Cinema 81
1981
Foamcore, wood, mirror and transpar-
ent Plexiglas with projected Super-8
film loop
28 x 25 x 24 inches
Musée National d'Art Moderne
Centre Georges Pompidou, Paris
(1990)

Peter Greenaway
The Draughtsman's Contract
1982
16mm, 108 min., color

Prospero's Books
1991
35mm, 123 min., color
(Excerpt)

Richard Hamilton
*Portrait of Hugh Gaitskell as a
Famous Monster of Filmland*
1964
Oil and collage on photograph on
panel
24 x 24 inches
Hayward Gallery, Arts Council
Collection, South Bank Centre,
London

My Marilyn
1965
Oil and collage on photograph on
panel
40¼ x 48 inches
Ludwig Collection, Ludwig Forum for
International Art, Aachen, Germany

Swingeing London 67(a)
1968–69
Oil on canvas and screenprint
26½ x 33½ inches
Collection of Rita Donagh, London

Swingeing London 67(b)
1968–69
Oil on canvas and screenprint
26½ x 33½ inches
Museum Ludwig, Cologne

Swingeing London 67(f)
1968–69
Acrylic, collage and aluminum relief on
silkscreen of acrylic on canvas
26½ x 33½ inches
Tate Gallery, purchased 1969

Ghosts of Ufa
1995
Cibachrome on canvas
59 x 78¾ inches
Collection of the artist
Courtesy of Anthony d'Offay Gallery,
London

Alfred Hitchcock
Spellbound
1945
35mm, 111 min., b&w
(Excerpt)

Rear Window
1954
35mm, 112 min., color
(Excerpt)

Vertigo
1958
35mm, 128 min., color
(Excerpt)

Psycho
1960
35mm, 109 min., b&w
(Excerpt)

Dennis Hopper
Brooke Hayward (with Doll)
1962
Black-and-white photograph
24 x 16 inches

Curtis Harrington
1962
Black-and-white photograph
16 x 24 inches

Dean Stockwell
1962
Black-and-white photograph
16 x 24 inches

John Wayne and Dean Martin
1962
Black-and-white photograph
16 x 24 inches

Andy Warhol (with Flower)
1963
Black-and-white photograph
24 x 16 inches

The Factory
1963
Black-and-white photograph
16 x 24 inches

The Factory (Andy with Camera)
1963
Black-and-white photograph
24 x 16 inches

The Factory (Woman with Bubble)
1963
Black-and-white photograph
24 x 16 inches

Paul Newman
1964
Black-and-white photograph
24 x 16 inches

"The Trip"
1964
Black-and-white photograph
24 x 16 inches

George Segal and Sandy Dennis
1965
Black-and-white photograph
16 x 24 inches

Jane Fonda and Roger Vadim
1965
Black-and-white photograph
24 x 16 inches

Peter Fonda (with Robinson Billboard)
1965
Black-and-white photograph
24 x 16 inches

All collection of the artist, Los Angeles

Edward Hopper
New York Movie
1939
Oil on canvas
32¼ x 40⅛ inches
The Museum of Modern Art, New York
Given anonymously, 1941

Ken Jacobs
Tom, Tom, The Piper's Son
1969
16mm, 115 min., b&w and color, silent
Courtesy of the artist

Derek Jarman
Caravaggio
1986
35mm, 93 min., color

Blue
1993
Multi-media installation
75 minutes
A Basilisk Communications produc-
tion, written and directed by Derek
Jarman, produced by James MacKay,
composer Simon Fisher Turner, sound

design by Marvin Black, with John
Quentin, Nigel Terry, Derek Jarman,
and Tilda Swinton, © Basilisk
Communications
Courtesy of Zeitgeist Films, Ltd.

Ray Johnson
Elvis Presley No. 1
1956–57
Collage, ink wash, paint, and photo-
graph, mounted on board
11½ x 14½ inches
Collection of William S. Wilson,
New York

James Dean (Lucky Strike)
1957
Collage of ink, paint, part of cigarette
packs, and ink wash on photograph
14⅞ x 11⁷⁄₁₆ inches
The Estate of Ray Johnson
Courtesy of Richard L. Feigen and
Company, New York and Chicago

Hand Marilyn Monroe
1958
Collage with ink wash on board
16⅞ x 13⅛ inches
The Estate of Ray Johnson
Courtesy of Richard L. Feigen and
Company, New York and Chicago

James Dean
1958
Ink, collage, and paper on cardboard
10½ x 7½ inches
Collection of Mr. and Mrs. Henry
Martin, Bolzano, Italy

Shirley Temple
1958
Ink, collage, and paper on cardboard
9¾ x 7½ inches
Collection of Mr. and Mrs. Henry
Martin, Bolzano, Italy

Untitled
1958
Collage
11 x 7½ inches
Collection of Jasper Johns

Peter Kubelka
Adebar
1956–57
35mm, 69 seconds, b&w
Courtesy of the artist, Vienna

Adebar
1956–57
35mm film installation on wall
Dimensions variable
Courtesy of the artist, Vienna

Schwechater
1957–58
35mm film installation on wall
Dimensions variable
Collection of the artist, Vienna

Schwechater
1957–58
35mm, 1 min., b&w
Courtesy of the artist, Vienna

Arnulf Rainer
1958–60
35mm film installation on wall
Dimensions variable
Collection of the artist, Vienna

Arnulf Rainer
1958–60
35mm, 6 min. 24 seconds, b&w
Collection of the artist, Vienna

Arnulf Rainer
1958–60
Scores and preliminary sketches
Dimensions variable
Collection of the artist, Vienna

Stanley Kubrick
2001: A Space Odyssey
1968
35mm, 141 min., color
(Excerpt)

A Clockwork Orange
1971
35mm, 136 min., color

Akira Kurosawa
Ran
1985
35mm, 161 min., color
(Excerpt)

Akira Kurosawa's Dreams
1990
35mm, 119 min., color
(Excerpt)

Suzanne Lafont
L'Argent
1991
Black-and-white photographs
Six elements: 47¼ x 39⅜ inches
each; 47¼ x 236¼ inches overall
F.R.A.C. Franche-Comté, Dole,
France

Fritz Lang
Scarlet Street
1945
35mm, 103 min., b&w

The Thousand Eyes of Dr. Mabuse
1960
35mm, 103 min., b&w
(Excerpt)

Sharon Lockhart
Audition One, Simone and Max
1994
Ektacolor print
48 x 60 inches

Audition Two, Darija and Daniel
1994
Ektacolor print
48 x 60 inches

Audition Three, Amalia and Kirk
1994
Ektacolor print
48 x 60 inches

Audition Four, Kathleen and Max
1994
Ektacolor print
48 x 60 inches

Audition Five, Sirushi and Victor
1994
Ektacolor print
48 x 60 inches

All courtesy of the artist; Friedrich
Petzel Gallery, New York; and
neugerriemschneider, Berlin

David Lynch
Blue Velvet
1986
35mm, 120 min., color
(Excerpt)

Christian Marclay
Vertigo (Soundtrack for an exhibition)
1990
Compact disc recording, CD player, speakers
Musicians:
Tom Cora, cello
Catherine Jauniaux, voice
Christian Marclay, turntable and CD player
Zeena Parkins, electric and acoustic harp
Bobby Previte, drums
Laura Seaton, violin
Elliott Sharp, bass clarinet
David Weinstein, sampling keyboard
Recorded in October 1990 at Baby Monster Studios, New York City, engineered by Bruce Goggin and Steve McAllister. Additional recording at Harmonic Ranch, New York City, engineered by Bao Morales. Produced and directed by Christian Marclay.
Courtesy of the artist

Chris Marker
La Jetée
1962 (released in 1964)
35mm, 28min., b&w

Silent Movie
1994–95
Modular tower of Tennsco slotted angle steel post;
steel airplane cable, ¹⁄₁₆ inches diameter; computer interface box; five 27˝ video monitors; five laser disc players; five laser discs (20 minutes each);
Top monitor: "The Journey"
Second monitor: "The Face"
Middle monitor: Captions
Fourth monitor: "The Gesture"
Bottom monitor: "The Waltz"
Collection of the artist and courtesy of the Wexner Center for the Arts, The Ohio State University, Columbus, Ohio

Fabio Mauri
Vangolo Secondo Matteo di/su Pier Paolo Pasolini,
(The Gospel According to St. Matthew by Pier Paolo Pasolini)
1975
Documentation of a performance at Civic Museum, Bologna, Italy
Photographs by Antonio Masotti
Fifteen photographs at 27½ x 23¼ inches
Collection of the artist

Senza Ideologia: Pier Paolo Pasolini, "Vangolo Secondo Matteo"
(Without Ideology: Pier Paolo Pasolini, "The Gospel According to St. Matthew")
1976
16mm film projection on Pasolini's coat, shirt, and chair
Dimensions variable
Collection of the artist

Senza Ideologia: Sergei Eisenstein, "Alexander Nevskji"
(Without Ideology: Sergei Eisenstein, "Alexander Nevskji")
1976
16mm film projection on 50 liters of milk in a bucket
Dimensions variable
Collection of the artist

Senza Ideologia: Carl-Theodor Dreyer, "Gertrud"
(Without Ideology: Carl-Theodor Dreyer, "Gertrud")
1976
16mm film projection on a measuring scale
Dimensions variable
Collection of the artist

Senza Ideologia: G.W. Pabst "Westfront"
(Without Ideology: G.W. Pabst "Westfront")
1976
16mm film projection on a fan in motion
Dimensions variable
Courtesy of the artist
Collection of Elisabetta Catalano

Annette Messager
Chimères (Chimaeras), "Scissors"
1982
Acrylic and oil on black-and-white photograph on canvas
119⅝ x 60¼ inches

Chimères (Chimaeras), "Bat"
1983
Acrylic and oil on black-and-white photograph on canvas
72⅜ x 191¾ inches

Chimères (Chimaeras), "Scissors"
1983
Acrylic and oil on black-and-white photograph on canvas
126 x 63 inches
All courtesy of the artist, Paris

Pat O'Neill
Water and Power
1989
16mm, 55 min., color
Courtesy of the artist

Hélio Oiticica and Neville d'Almeida
QUASI-CINEMA, Block Experiments in Cosmococa, CC3 MAILERYN
1973
Multi-media installation
Dimensions variable
Collection Projeto Hélio Oiticica, Rio de Janeiro

Pier Paolo Pasolini
La Ricotta (episode from Rogopag)
1962
35mm, 35 min., b&w and color
(Excerpt)

Roman Polanski
Repulsion
1965
35mm, 105 min., b&w
(Excerpt)

Michael Powell
Peeping Tom,
1959
35mm, 109 min., color
(Excerpt)

Alain Resnais
L'Année dernière à Marienbad
(Last Year at Marienbad)
1961
35mm, 94 min., b&w

Nicolas Roeg
Performance
1970
35mm, 105 min., color
(Excerpt)

Mimmo Rotella
Il Mostro Immortale (Caltiki)
1961
Décollage
77½ x 55¼ inches
Collection of the artist, Courtesy of Giò Marconi Gallery, Milan

Eastmancolor
1962
Décollage
39⅜ x 36⅝ inches
Courtesy of Galerie Reckermann, Cologne

La dolce vita
1962
Décollage
63 x 52½ inches
Private Collection, Rome

Cinecittà
1963
Décollage
71¼ x 54 inches
Private Collection, Rome

Marilyn Monroe
1963
Décollage
78¾ x 55¼ inches
Courtesy of Galerie Reckermann, Cologne

Marilyn Monroe
1963
Décollage
55¼ x 39⅜ inches
Courtesy of Galerie Reckermann, Cologne

Raúl Ruiz
L'Hypothèse du tableau volé
(The Hypothesis of the Stolen Painting)
1978
35mm, 70 min., b&w
(Excerpt)

All the evil in men…
1992
Multi-media installation
Dimensions variable
Collection of the artist

Allen Ruppersberg
Zoetrope
1980
Approximately 6 feet diameter x 6 feet high
The Museum of Contemporary Art, Los Angeles
Gift of Stuart and Judy Spence

Edward Ruscha
The Back of Hollywood
1977
Oil on canvas
22 x 80 inches
Collection Musée d'Art Contemporain de Lyon

Exit
1990
Acrylic on canvas
62 x 90 inches
Collection of Gilbert B. Friesen, Los Angeles

9,8,7,6
1991
Acrylic on canvas
28 x 48 inches
Courtesy of the artist

Asphalt Jungle
1991
Acrylic on canvas
82 x 104 inches
Museum of Fine Arts, Boston
The Tompkins Collection

Fear Not
1991
Acrylic on canvas
82 x 104 inches
Collection of Castelli Gallery, New York

Western
1991
Acrylic on canvas
72 x 96 inches
Collection of Castelli Gallery, New York

Triumph
1994
Acrylic on canvas
32 x 120 inches
Collection of Pontus Hulten

Carolee Schneemann
Fuses
1965
16mm, 22 min., color
Courtesy of the artist

Up To And Including Her Limits
1974–76
Multi-media installation
Dimensions variable
Courtesy of the artist

Martin Scorsese
The Last Temptation of Christ
1988
35mm, 163 min., color
(Excerpt)

Ridley Scott
Blade Runner
1982
35mm, 117 min., color
(Excerpt)

Paul Sharits
Ray Gun Virus
1966
16mm, 14 min, color

Frozen Film Frame: N,O,T,H,I,N,G
1968
16mm film strips and Plexiglas
Three panels: 61¼ x 85¼ inches each
Collection Galerie Rolf Ricke, Cologne

Frozen Film Frame: Ray Gun Virus
1972
16mm film strips and Plexiglas
38½ x 95½ inches
Museum Ludwig, Cologne

Cindy Sherman
Untitled Film Still #2
1977
Black-and-white photograph
10 x 8 inches

Untitled Film Still #4
1977
Black-and-white photograph
8 x 10 inches

Untitled Film Still #6
1977
Black-and-white photograph
10 x 8 inches

Untitled Film Still #7
1978
Black-and-white photograph
10 x 8 inches

Untitled Film Still #14
1978
Black-and-white photograph
10 x 8 inches

Untitled Film Still #21
1978
Black-and-white photograph
8 x 10 inches

Untitled Film Still #25
1978
Black-and-white photograph
8 x 10 inches

Untitled Film Still #32
1979
Black-and-white photograph
8 x 10 inches

Untitled Film Still #34
1979
Black-and-white photograph
10 x 8 inches

Untitled Film Still #35
1979
Black-and-white photograph
10 x 8 inches

Untitled Film Still #43
1979
Black-and-white photograph
8 x 10 inches

Untitled Film Still #48
1979
Black-and-white photograph
8 x 10 inches

Untitled Film Still #49
1979
Black-and-white photograph
8 x 10 inches

Untitled Film Still #50
1979
Black-and-white photograph
8 x 10 inches

Untitled Film Still #52
1979
Black-and-white photograph
8 x 10 inches

Untitled Film Still #53
1980
Black-and-white photograph
8 x 10 inches

Untitled Film Still #54
1980
Black-and-white photograph
8 x 10 inches

Untitled Film Still #56
1980
Black-and-white photograph
8 x 10 inches

Untitled Film Still #63
1980
Black-and-white photograph
8 x 10 inches

All courtesy of the artist and Metro Pictures, New York

Untitled Film Still #65
1980
Black-and-white photograph
10 x 8 inches
The Museum of Contemporary Art,
Los Angeles
Purchase with funds provided by the
friends of Marsha Kleinman in her
memory

Michael Snow
Wavelength
1967
16mm, 45 min., color
Courtesy of the artist

Two Sides to Every Story
1974
16mm film loop, two projectors,
switching device, and aluminum
screen
Dimensions variable
National Gallery of Canada, Ottawa

Hiroshi Sugimoto
Sam Eric, Pennsylvania
1978
Black-and-white photograph
20 x 24 inches
Collection of Cliff and Mandy Einstein,
Los Angeles

Avalon, Catalina Island
1993
Black-and-white photograph
20 x 24 inches
Collection of Patrick and Abby Adams,
Santa Monica, California

Cinerama Dome, Hollywood
1993
Black-and-white photograph
20 x 24 inches
The Museum of Contemporary Art,
Los Angeles
Gift of the artist and Angles Gallery,
Santa Monica, California

Metropolitan, Los Angeles
1993
Black-and-white photograph
20 x 24 inches
The Museum of Contemporary Art,
Los Angeles
Purchased with funds provided by
Mandy and Cliff Einstein, Linda and
Bob Gersh, Linda and Jerry Janger,
Marc Selwyn, Marjorie and Leonard
Vernon, and the Curators' Council

Orange Drive-In, Orange
1993
Black-and-white photograph
20 x 24 inches
Collection of Cecilia and Michael A. K.
Dan, Malibu, California

Studio Drive-In, Culver City
1993
Black-and-white photograph
20 x 24 inches
The Museum of Contemporary Art,
Los Angeles
Purchased with funds provided by
Mandy and Cliff Einstein, Linda and
Bob Gersh, Linda and Jerry Janger,
Marc Selwyn, Marjorie and Leonard
Vernon, and the Curators' Council

Elizabeth Taylor
1994
Black-and-white photograph
20 x 24 inches
Courtesy of Sonnabend Gallery,
New York and Angles Gallery,
Santa Monica, California

Jean Harlow
1994
Black-and-white photograph
20 x 24 inches
Courtesy of Sonnabend Gallery,
New York and Angles Gallery,
Santa Monica, California

Mae West
1994
Black-and-white photograph
20 x 24 inches
Courtesy of Sonnabend Gallery,
New York and Angles Gallery,
Santa Monica, California

Norma Shearer
1994
Black-and-white photograph
20 x 24 inches
Courtesy of Sonnabend Gallery,
New York and Angles Gallery,
Santa Monica, California

Sophia Loren
1994
Black-and-white photograph
20 x 24 inches
Courtesy of Sonnabend Gallery,
New York and Angles Gallery,
Santa Monica, California

Valentino
1994
Black-and-white photograph
20 x 24 inches
Courtesy of Sonnabend Gallery,
New York and Angles Gallery,
Santa Monica, California

Andrei Tarkovsky
Andrei Rublev
1966
35mm, 181 min., color
(Excerpt)

Nostalghia (Nostalgia)
1983
35mm, 126 min., color
(Excerpt)

Frank Tashlin
Will Success Spoil Rock Hunter?
1957
35mm, 95 min., color

François Truffaut
La Nuit américaine (Day for Night)
1973
35mm, 116 min., color
(Excerpt)

Jeff Wall
Eviction Struggle
1988
Cibachrome transparency, fluorescent
light, display case, video,
Nine 19″ monitors, nine VHS players
90 x 163 inches
Ydessa Hendeles Art Foundation,
Toronto

Andy Warhol
Black and White Disaster
1962
Acrylic and silkscreen on canvas
96 x 72 inches
The Los Angeles County Museum of
Art, Gift of Leo Castelli Gallery
and Ferus Gallery through the
Contemporary Art Council (M.65.13)

Marilyn Monroe's Lips
1962
Synthetic polymer, enamel, and pencil
on canvas
Two panels: 82¾ x 80¾ inches
and 82¾ x 82⅜ inches
Hirshhorn Museum and Sculpture
Garden, Smithsonian Institution,
Washington, D.C.
Gift of Joseph H. Hirshhorn, 1972

Troy Diptych
1962
Silkscreen ink on synthetic polymer
paint on canvas
Two panels: 81 x 43 inches and
81 x 67¾ inches
Museum of Contemporary Art,
Chicago
Gift of Mrs. Robert B. Mayer

Twenty-Five Colored Marilyns
1962
Acrylic on canvas
82¼ x 66¾ inches
Collection of the Modern Art Museum
of Fort Worth, Texas
The Benjamin J. Tillar Trust, Acquired
from the Collection Vernon Nikkel,
Clovis, New Mexico, 1983

Merce Cunningham
1963
Synthetic polymer paint and silkscreen
ink on canvas
82 x 82 inches
Private Collection

National Velvet
1963
Silkscreen ink on synthetic polymer
paint on canvas
136⅜ x 83½ inches
San Francisco Museum of Modern Art
Accessions Committee Fund, Albert
M. Bender Fund, Tishler Trust, Victor
Bergeron Fund, Members' Accessions
Fund, and gift of the Warhol
Foundation for the Visual Arts, Inc.

Orange Disaster
1963
Acrylic and silkscreen enamel on
canvas
106 x 81½ inches
The Solomon R. Guggenheim
Museum, New York
Gift of Harry N. Abrams Family
Collection, 1974

Empire
1964
16mm, 8 hours and 5 min. at 16fps,
b&w, silent
Courtesy of The Andy Warhol
Foundation for the Visual Arts,
New York

Double Marlon
1966
Silkscreen ink on canvas
84 x 95¾ inches
Private Collection

Selected *Screentests*
c. 1966
16mm, b&w
Courtesy of The Andy Warhol
Foundation for the Visual Arts,
New York

Weegee
At the Movies (Sleeping Vendor)
c. 1940
Gelatin-silver print
10⁵⁄₁₆ x 13⁵⁄₁₆ inches
Collection of the J. Paul Getty
Museum, Malibu, California

*Hollywood Star Veronica Lake, Los
Angeles*
c. 1940
Gelatin-silver print
14 x 10¾ inches
Collection of Galerie Berinson, Berlin

*Lovers at the Movies, Times Square,
N.Y.*
c. 1940
Gelatin-silver print
10⁵⁄₁₆ x 13⁵⁄₁₆ inches
Collection of the J. Paul Getty
Museum, Malibu, California

At the Palace Theater (5)
1945
Gelatin-silver print
10⁵⁄₁₆ x 13⁵⁄₁₆ inches
Collection of the J. Paul Getty
Museum, Malibu, California

H. Fonda and Friend
1953
Gelatin-silver print
14 x 11 inches
Collection of Galerie Berinson, Berlin

Hedda Hopper
1953
Gelatin-silver print
8¼ x 10 inches
Collection of Galerie Berinson, Berlin

Jerry Lewis
1953
Gelatin-silver print
10 x 8¼ inches
Collection of Galerie Berinson, Berlin

*Louella Parsons (Hollywood
Columnist)*
1953
Gelatin-silver print
10 x 8¼ inches
Collection of Galerie Berinson, Berlin

Ann
c. 1953
Gelatin-silver print
14 x 11¼ inches
Collection of Galerie Berinson, Berlin

Cheeta Before the Movie Camera
c. 1953
Gelatin-silver print
9½ x 7⅝ inches
Courtesy of Vision Gallery,
San Francisco

Jack Benny
c. 1953
Gelatin-silver print
9⅞ x 7⅝ inches
Courtesy of Vision Gallery,
San Francisco

Jerry Lewis
c. 1953
Gelatin-silver print
9 x 7⅞ inches
Courtesy of Vision Gallery,
San Francisco

Marilyn Monroe on an Elephant
c. 1953
Gelatin-silver print
9½ x 7½ inches
Courtesy of Vision Gallery,
San Francisco

No Autograph (Woman Crying)
c. 1953
Gelatin-silver print
9⁷⁄₁₆ x 7⁹⁄₁₆ inches
Courtesy of Vision Gallery,
San Francisco

*Stanley Kubrick on the Set of
Dr. Strangelove*
1963
Gelatin-silver print
10 x 12 inches
Collection of Galerie Berinson, Berlin

Orson Welles
Citizen Kane
1941
35mm, 119 min., b&w
(Excerpt)

Touch of Evil
1958
35mm, 114 min., b&w

Wim Wenders
Der amerikanische Freund
(The American Friend)
1977
35mm, 127 min., color
(Excerpt)

James Whitney
Lapis
1963–66
16 mm, 10 min., color

John Whitney
Catalog
1961
16 mm, 7 min., color

Billy Wilder
Sunset Boulevard
1950
35mm, 110 min., b&w
(Excerpt)

Photo Credits

All photographs courtesy of the artist and/or lender with the following exceptions:

Michelangelo Antonioni. *Zabriskie Point*, 1970. Courtesy Magnum Photos, Inc. Photo by Bruce Davidson.

Michelangelo Antonioni. *La Notte*, 1960 and *Blow-Up*, 1966; Raúl Ruiz, *L'Hypothèse du tableau volé* (The Hypothesis of the Stolen Painting), 1978. Courtesy Cahiers du Cinéma.

Michelangelo Antonioni, *Blow-Up*, 1966; Stanley Kubrick, *2001: A Space Odyssey*, 1968. Courtesy Turner Entertainment Company.

David Bailey, *London Parks*, shot from *Vogue*, October 1, 1962 (no. 13, vol. 119); Shot from *Vogue*, September 15, 1961 (pages 108–109); Shot from *Vogue*, April, 1962 (pages 118–199 and pages 122–123); Weegee, Shot from *Naked Hollywood*. Photos by Paula Goldman.

Barker cross-section from Stephan Oettermann, *Das Panorama: Die Geschiche eines Massenmediums* (Frankfurt am Main: Syndikat, 1980).

Joseph Beuys. *Das Schweigen* (The Silence), 1973. Walker Art Center, Minneapolis. Alfred and Marie Greisenger Collection, Walker Art Center, T.B. Walker Acquisition Fund, 1992. © 1996 Artists Rights Society, New York/VG Bild-Kunst, Bonn.

Douglas Blau. *Genre: The Conversation* (details), 1993. Courtesy Sperone Westwater, New York. Photo Adam Reich.

Barbara Bloom. *Homage to Jean Seberg*, 1981. Courtesy Jay Gorney Modern Art, New York.

Victor Burgin, *The Bridge*, 1984; Robert Smithson, *Toward the Development of a Cinema Cavern*, 1971; *Underground Projection Room*, 1971; *Spiral Jetty Film Stills Photo Documentation*. Courtesy John Weber Gallery, New York.

Paul Cézanne. *Mont Sainte-Victoire*, 1902–1904. Courtesy Philadelphia Museum of Art, George W. Elkins Collection.

Bruce Conner. *Son of the Sheik*, 1963. Photo by Susan Einstein.

Bruce Conner. *Marilyn Times Five*, 1972. Courtesy Canyon Cinema, San Francisco.

Joseph Cornell. *Greta Garbo*, c. 1939. Photo by Eric Pollitzer.

Joseph Cornell, *Untitled (Penny Arcade Portrait of Lauren Bacall)* Dossier, 1945–46; Ivan Le Lorraine Albright, *The Picture of Dorian Gray*, 1943–44. Gift of Ivan Albright, 1977.21. Courtesy Art Institute of Chicago.

Unidentified Photographer. Joseph Cornell with "Legendary Portrait of Greta Garbo." Courtesy National Museum of American Art, Smithsonian Institution, Joseph Cornell Study Center. Gift of Mr. and Mrs. John A. Benton.

Stanley Donen. *Funny Face*, 1957. Courtesy University of California, Los Angeles, OID Photographic Services.

Stan Douglas. *Overture*, 1986. Installation view, Witte de With, Center for Contemporary Art, Rotterdam, September 1994. Courtesy David Zwirner Gallery, New York.

Carl-Theodor Dreyer. *Gertrud*, 1966 and *Ordet/The World*, 1955. Courtesy Det Danske Filmmuseum, Copenhagen.

Marcel Duchamp. *Nude Descending a Staircase, No. 2*, 1912. Courtesy the Philadelphia Museum of Art: Louise and Walter Arensberg Collection.

Oskar Fischinger. *Motion Painting No. 1*, 1947. Courtesy of Elfrieda Fischinger.

Hollis Frampton and Marion Faller. *Gourds Vanishing*, 1975. Courtesy Marion Faller.

Jean-Luc Godard. *Allemagne année 90 neuf zéro*, 1991. Courtesy Drift Releasing, New York.

Dan Graham. *Cinema 81* (model), 1981. Courtesy Marian Goodman Gallery, New York.

Richard Hamilton. *Interior II*, 1964. Courtesy Tate Gallery, London/Art Resource, New York

Richard Hamilton. *My Marilyn*, 1965. Courtesy of Anne Gold Photografin, Aachen, Germany.

Richard Hamilton. *Just what is it that makes today's homes so different, so appealing?*, 1956. Courtesy Kunsthalle Tübingen, Sammlung G.F. Zundel.

Vilhelm Hammershøi. *Interior*, 1898. Courtesy Statens Konstmuseer, The National Swedish Art Museums.

Edward Hopper, *Night Windows*, 1928. Gift of John Hay Whitney; and Andy Warhol, *Gold Marilyn Monroe*, 1962. Gift of Philip Johnson. The Museum of Modern Art, New York. Photographs © 1996 The Museum of Modern Art, New York.

In Search of the Obelisk, 1994. © 1994 Luxor Las Vegas. Courtesy of Ridefilm Corporation, South Lee, Massachusetts.

Ray Johnson. *Marilyn Monroe*, 1958. Courtesy Jasper Johns.

Ray Johnson. *Shirley Temple*, 1958 and *James Dean*, 1958. Photos Prisma-Bolzano.

Chuck Jones. *Duck Amuck*, 1953. Courtesy Chuck Jones Enterprises.

Barbara Kruger. *Untitled (It's a Small World)*, 1990. The Museum of Contemporary Art, Los Angeles. Purchased with funds provided by the NEA and Douglas S. Cramer.

Louise Lawler. *Movie Without a Picture*, Aero Theater, Santa Monica, 1979. Courtesy Metro Pictures, New York.

Chris Marker. View of "Video Spaces: Eight Installations." The Museum of Modern Art, New York, June 21, 1995 through September 12, 1995. Photograph © 1995 The Museum of Modern Art, New York.

Edouard Manet. *Mademoiselle Victorine in the Costume of the Espada*, 1862. The Metropolitan Museum of Art, Bequest of Mrs. H.O. Havemeyer, 1929. The H.O. Havemeyer Collection. (29.100.53).

Fabio Mauri. *Without Ideology: Pier Paolo Pasolini, "The Gospel According to Matthew,"* 1975. Galleria Comunale d'Arte Moderna, Bologna, 1975. Photo by Antonio Masotti.

Fabio Mauri. *Without Ideology: Carl-Theodor Dreyer, "Gertrud,"* 1976. Galleria Nazionale d'Arte Moderna, Rome, 1994. Photo by Antonio Garbasso.

Fred McDarrah. "Filmmakers Cinematheque" and "The Dom." © Fred McDarrah. Courtesy of Fred McDarrah.

Eadweard Muybridge. *Multiple Nude Self-Portrait*, n.d. Courtesy Los Angeles County Museum of Art. Collection of Audrey and Sydney Irmas, Gift of Irmas Intervivos Trust of June 1982, Los Angeles County Museum of Art.

Billy Name. *Andy Warhol and Ray Johnson*, 1964. Billy Name Factory Foto. Courtesy of Billy Name.

Bruce Nauman. *Art Make-Up, no 1: White; Art Make-Up, no 2: Pink; Art Make-Up, no 3: Green; Art Make-Up, no 4: Black*, 1967–68. Courtesy Stedelijk Museum, Amsterdam.

Henry Peach Robinson. *Fading Away*, 1858. Courtesy of The Royal Photographic Society, Bath.

Raúl Ruiz. *L'expulsion des maures*, 1990. Courtesy Galerie nationale du Jeu de Paume, Paris.

Raúl Ruiz. *139 Vous Etes Ici*, 1992. Courtesy le crédac. Photo by Laurent Ardhuin.

Edward Ruscha. *9, 8, 7, 6*, 1991. Photo Paul Ruscha.

Edward Ruscha. *The Back of Hollywood*, 1977. Photo by J.B. Rodde.

Carolee Schneemann. *Up to and Including Her Limits*, 1976. Photo by Shelley Jarhas.

Michael Snow. *Two Sides to Every Story*, 1974. Photo Susan Campbell.

Hiroshi Sugimoto. *Metropolitan, Los Angeles*, 1993 and *Studio Drive-In, Culver City*, 1993. Courtesy Sonnabend Gallery, New York.

Bill Viola. *The Greeting* (detail), 1995. Courtesy Bill Viola Studio. Photo by Kira Perov.

Andy Warhol. *Thirteen Most Wanted Men*, 1964. © 1995 The Andy Warhol Foundation for the Visual Arts, Inc. Photo by Eric Pollitzer.

Andy Warhol. *Before and After, 3*, 1962. Collection of Whitney Museum of American Art, New York. Purchase, with funds from Charles Simon. Photo by Geoffrey Clements.

Andy Warhol. *National Velvet*, 1963. Photo by Ben Blackwell.

Andy Warhol. *Marilyn Monroe's Lips*, 1962. Photo Lee Stalsworth.

Andy Warhol. *Marilyn Diptych*, 1962. Tate Gallery, London/Art Resource, New York.

Andy Warhol. *Triple Elvis*, 1964. Virginia Museum of Fine Arts, Richmond. Gift of Sydney and Frances Lewis. Photo Ann Hutchinson. © Virginia Museum of Fine Arts.

Andy Warhol. *Untitled (James Dean)*, c. 1955; *White Burning Car I*, 1963; *White Burning Car III*, 1963. © 1995 The Andy Warhol Foundation for the Visual Arts, Inc.

Andy Warhol. *The Chelsea Girls*, 1966; *The Pope Ondine Story*, 1966; *Poor Little Rich Girl*, 1965; *Sleep*, 1963. Film still reproduced with the permission of The Andy Warhol Foundation for the Visual Arts, Inc. Still courtesy of Andy Warhol Film Project, Whitney Museum of American Art.

Andy Warhol. *My Hustler*, 1965; *Vinyl*, 1965; *Empire*, 1964. © 1989 The Estate and Foundation of Andy Warhol. Courtesy The Andy Warhol Foundation for the Visual Arts.

"Actress Shoots Andy Warhol." *New York Daily News*, 4 June 1968; Cover of *Interview* 1, no. 1 (1969); Poster for Andy Warhol, *The Chelsea Girls* (1966). Courtesy The Archives of the Andy Warhol Museum, Pittsburgh; Founding Collection, Contribution The Andy Warhol Foundation for the Visual Arts, Inc.

John and James Whitney in their studio. Courtesy John Whitney. Photo by Bob Woelfer.

Courtesy of the Academy of Motion Picture Arts and Sciences:

Robert Aldrich, *What Ever Happened to Baby Jane?*, 1962; Dario Argento, *Suspiria*, 1977; John Cassavetes, *Shadows*, 1959; Francis Ford Coppola, *One from the Heart*, 1982; David Cronenberg, *Videodrome*, 1982; Stanley Donen, *Funny Face*, 1957; Federico Fellini, *La dolce vita*, 1960; Abel Gance, *Napoleon*, 1929; Jean-Luc Godard, *Passion*, 1982; Jean-Luc Godard, *Pierrot le Fou*, 1965; Jean-Luc Godard, *Le Mépris* (Contempt), 1963; Jean-Luc Godard, *Une Femme Mariee* (A Married Woman), 1964; Alfred Hitchcock, *Rear Window*, 1954; Alfred Hitchcock, *Vertigo*, 1958; Dennis Hopper, *The Last Movie*, 1971; Dennis Hopper, *Easy Rider*, 1969; Stanley Kubrick, *2001: A Space Odyssey*, 1968; Akira Kurosawa, *Akira Kurosawa's Dreams*, 1990; Fritz Lang, *While the City Sleeps*, 1956; Fritz Lang, *Metropolis*, 1927; David Lynch, *Blue Velvet*, 1986; Vincente Minnelli, *The Bad and the Beautiful*, 1952; George Pal, *Destination Moon*, 1950; John Schlesinger, *Midnight Cowboy*, 1969; Martin Scorsese, *Raging Bull*, 1980; Ridley Scott, *Blade Runner*, 1982; Douglas Sirk, *Shockproof*, 1949; Frank Tashlin, *Will Success Spoil Rock Hunter?*, 1957; Andrei Tarkovsky, *Nostalghia* (Nostalgia), 1983; Orson Welles, *The Lady from Shanghai*, 1948; Orson Welles, *Touch of Evil*, 1958; Orson Welles, *Citizen Kane*, 1941; Robert Wien, *The Cabinet of Dr.

Caligari, 1919; William Wyler, *The Best Years of Our Lives*, 1946; Publicity still for *This is Cinerama*, 1952.

Courtesy of The Museum of Modern Art Film Stills Archive, New York:

Michelangelo Antonioni, *Il deserto rosso* (Red Desert), 1964; Michelangelo Antonioni, *Blow-Up*, 1966; Peter Bogdanovich, *Targets*, 1968; John Boorman, *Point Blank*, 1967; Luis Buñuel, *Viridiana*, 1961; Roger Corman, *The Wild Angels*, 1966; Salvador Dalí, *Spellbound*, 1945; Jules Dassin, *The Naked City*, 1948; Federico Fellini, *Le Notte di Cabiria* (The Nights of Cabiria), 1957; Federico Fellini, *8½*, 1963; Jean-Luc Godard, *Histoire(s) du Cinema*, 1989; Jean-Luc Godard, *A bout de souffle* (Breathless), 1960; Jean-Luc Godard, *La Chinoise*, 1967; Jean-Luc Godard, *Passion*, 1982; Peter Greenaway, *The Draughtsman's Contract*, 1982; Alfred Hitchcock, *Spellbound*, 1945; Alfred Hitchcock, *Psycho*, 1960; Fritz Lang, *Das Testament des Dr. Mabuse* (The Last Testament of Dr. Mabuse), 1933; Fritz Lang, *Dr. Mabuse der Spieler* (Dr. Mabuse the Gambler/Dr. Mabuse the Fatal Passions), 1921–22; Albert Lewin, *Pandora and the Flying Dutchman*, 1951; Lumiere Brothers, *L'Arrivee d'un Train en Gare de la Ciotat* (Arrival of a Train at La Ciotat), 1896; Alain Resnais, *Last Year at Marienbad*, 1961; Billy Wilder, *Sunset Boulevard*, 1950.

Courtesy Anthology Film Archives, New York:

Kenneth Anger, *Fireworks*, 1947; Kenneth Anger, *Scorpio Rising*, 1963; Stan Brakhage, *The Text of Light*, 1974, Photo by A. Kulikauskas; Stan Brakhage, *Mothlight*, 1963; Joseph Cornell, *Rose Hobart*, c.1936; Maya Deren, *Meshes in the Afternoon*, 1943; Carl-Theodor Dreyer, *Mikael/Chained*, 1924; Cover of first issue of *Film Culture*, 1955; Hollis Frampton, *Zorns's Lemma*, 1970; Robert Frank, *Pull My Daisy*, 1959; Harry Smith, *Heaven and Earth Magic*, n.d. (c. 1940s); Jack Smith, *Flaming Creatures*, 1963; Stan Vanderbeek outside his Movie-Drome.

Courtesy the British Film Institute, Stills, Posters and Designs:

Derek Jarman, *Caravaggio*, 1986; Pier Paolo Pasolini, *La Ricotta* (episode from *Rogopag*), 1962; Michael Powell, *Peeping Tom*, 1959; Publicity poster for *Alphaville*, 1965; Publicity poster for *The Four Hundred Blows*, 1959; Publicity poster for *Orphee*, 1949; Publicity poster for *Peeping Tom*, 1959; Publicity poster for *The Robe*, 1953.

Courtesy Photofest, New York:

Robert Aldrich, *Kiss Me Deadly*, 1955; Edward Dmytryk, *Murder, My Sweet*, 1944; Jean-Luc Godard, *Alphaville*, 1965; James Dean's car; Martin Scorsese, *Taxi Driver*, 1976; Orson Welles, *Touch of Evil*, 1958; Billy Wilder, *Sunset Boulevard*, 1950.

Notes

Introduction

1 Erwin Panofsky, "Style and Medium in the Motion Pictures," reprinted in *Film Theory and Criticism: Introductory Readings*, edited by Gerald Mast and Marshall Cohen (London and Toronto: Oxford University Press, 1974), 152.

2 Raymond Durgnat, "The Mongrel Muse," in *Films and Feelings*. (Cambridge, Massachusetts: The M.I.T. Press, 1971), 19–30.

Brougher

1 From Godard's film *La Chinoise* (1967), quoted in Colin MacCabe, *Godard: Images, Sounds, Politics* (Bloomington: Indiana University Press, 1980), 108.

2 Stan Brakhage, "George Méliès," from *The Brakhage Lectures*, The Good Lion, at The School of the Art Institute of Chicago, 1972, 23.

3 Raúl Ruiz, "Miroirs du cinéma," *Parachute* 67 (July–August–September, 1992), 18.

4 Quoted in *Stan Douglas: Monodramas and Loops* (Vancouver: University of British Columbia, UBC Fine Arts Gallery, 1992), 34.

5 See, for example, Arnold Hauser, *Naturalism, Impressionism, the Film Age*, vol. 4 of *The Social History of Art*, (New York: Vintage Books, 1958).

6 Athanasius Kircher, *Ars magna lucis et umbrae* (Rome, 1646), 173–184.

7 See Charles Musser, *The Emergence of Cinema: The American Screen to 1907* (Berkeley: University of California Press, 1990).

8 Quoted in Ben Hecht, *A Child of the Century* (New York: Ballantine, 1970), 467.

9 Kenneth Anger in an interview in *Spider I*, no. 3 (April 15, 1965), reprinted in *Film Masters and Film Mentors*, 291.

10 See Otto Friedrich, *City of Nets: A Portrait of Hollywood in the 1940s* (New York: Perennial Library, 1987), xi.

11 Robert Sklar, *Film: An International History of the Medium* (New York: Harry N. Abrams, 1993), 302–303.

12 Richard Roud, "Introduction" to *Godard on Godard*, ed. Tom Milne (New York: Da Capo Press, 1972), 9.

13 Roland Barthes, "The Face of Garbo," *Mythologies* (New York: Hill and Wang, 1982), 56.

14 Quoted in P. Adams Sitney, "The Cinematic Gaze of Joseph Cornell," *Joseph Cornell* (New York: Museum of Modern Art, 1980), 73.

15 See Annette Michelson, "Rose Hobart and Monsieur Phot: Early Films from Utopia Parkway," *Artforum* (June, 1973), 51.

16 Marc Holthof, "Die Hopper-Methode. Vom >narrative< zum >abstrakten< Realismus" in *Edward Hopper: 1882–1967*, exhibition catalogue (Frankfurt: Schirn Kunsthalle Frankfurt, 1992), 19–27.

17 David Anfam, *Abstract Expressionism* (London: Thames and Hudson, 1990), 131.

18 Raymond Chandler, *Trouble is My Business* (New York: Vintage Crime/Black Lizard Editions, 1992), vii.

19 For a discussion of this last element, see Serge Guilbaut, *How New York Stole the Idea of Modern Art: Abstract Expressionism, Freedom, and the Cold War* (Chicago: The University of Chicago Press, 1983). See also Mike Davis, *City of Quartz: Excavating the Future in Los Angeles* (New York: Vintage Books, 1992), particularly chapter one, "Sunshine or Noir?"

20 Quoted in Bill Landis, *Anger: The Unauthorized Biography of Kenneth Anger* (New York: HarperCollins, 1995), 18.

21 Landis, 112.

22 See John Belton, *Widescreen Cinema* (Cambridge: Harvard University Press, 1992), 2.

23 Rudolf Arnheim, *Film as Art*, originally published by the University of California Press, reprinted in *Film Theory and Criticism: Introductory Readings*, ed. by Gerald Mast and Marshall Cohen (New York: Oxford University Press, Inc., 1974), 29.

24 Donald Spoto, *The Dark Side of Genius: The Life of Alfred Hitchcock* (Boston and Toronto: Little, Brown and Company, 1983), 399.

25 Peter Plagens, "Ed Ruscha, Seriously," *The Works of Edward Ruscha*, exhibition catalog (San Francisco Museum of Modern Art, 1982), 40.

26 Lawrence Alloway, "The Development of British Pop," in Lucy R. Lippard, ed. (London: Thames and Hudson, 1970), 27.

27 See Michael O'Pray, ed., *Andy Warhol Film Factory* (London: British Film Institute, 1989), 14.

28 Richard Hamilton. Lecture presented in Newcastle, the ICA, Cambridge, and the Royal College. Published in *Collected Words 1953–1982* (London and New York: Thames and Hudson, 1982).

29 David Mellor, "The Pleasures and Sorrows of Modernity: Vision, Space and the Social Body in Richard Hamilton," in *Richard Hamilton*, exhibition catalogue (London: Tate Gallery, 1992), 32.

30 Quoted in *Richard Hamilton*, exhibition catalogue (London: Tate Gallery, 1992), 158, originally published in *Paintings 1956–1964*, exhibition catalogue (London: Hanover Gallery), which included notes by Hamilton.

31 Roud, *Jean-Luc Godard* (Bloomington: Indiana University Press, 1967), 8. See also Roud discussion, 7–12.

32 Quoted in Richard Roud, "Introduction" to *Godard on Godard*, 9.

33 Jean-Luc Godard, "My Approach in Four Movements," in *Godard on Godard*, 242.

34 Roud, 75–82.

35 Godard, "Bergmanorama," reprinted in *Godard on Godard*, op. cit., 77.

36 David James, *Allegories of Cinema* (Princeton: Princeton University Press, 1989), 68.

37 Quoted in Seymour Chatman, *Antonioni, or the Surface of the World*

(Berkeley: University of California Press, 1985), 54 with reference note on 249.

38 Robert Smithson, "A Cinematic Atopia," *Artforum* (September 1971), 53.

39 Roland Barthes, *Writing Degree Zero* (New York: Hill and Wang, 1953), 47–48.

40 See Chatman, *Antonioni or, the Surface of the World*, 119–122.

41 Ibid., 131.

42 Angela Dalle Vacche, "Michelangelo Antonioni's *Red Desert*: Painting as Ventriloquism and Color as Movement." Publication forthcoming.

43 Michael Fried, "Art and Objecthood," *Artforum* (June 1967).

44 Film series catalogue, *100 Annees Lumière*, 64–65.

45 Ingmar Bergman, *Images: My Life in Film*. Trans. by Marianne Ruuth (New York: Arcade Publishing, 1994), 55.

46 Ibid., 55.

47 Robert Smithson, quoted in Robert A. Sobieszek, *Robert Smithson: Photo Works* (Los Angeles: Los Angeles County Museum of Art; Albuquerque: University of New Mexico Press, 1993), 27.

48 Robert Smithson, "A Cinematic Atopia," 53.

49 Ibid.

50 Robert Sobieszek, *Robert Smithson: photo-works*, op.cit., 39.

51 Robert Smithson, "Entropy and the New Monuments," *Artforum* (June 1966), in Nancy Holt, ed., *The Writings of Robert Smithson: Essays with Illustrations* (New York: New York University Press, 1979), 15

52 P. Adams Sitney, *Visionary Film: The American Avant-Garde, 1943–78* (New York: Oxford University Press, 1979), 369–70.

53 Peter Gidal, *Materialist Film* (London: Routledge Press, 1989).

54 In Ken Jacobs, "The Nervous System," project description.

55 Quoted in Annette Michelson, "Toward Snow," *Artforum* (June 1971), 31.

56 Ibid., 30.

57 Letter from Michael Snow to author, September 15, 1995.

58 Regina Cornwell, "Michael Snow," in *Projected Images*, exhibition catalogue (Minneapolis: Walker Art Center, 1974), 26.

59 Dan Graham, *CINEMA 81*, reprinted in *Art After Modernism*, op. cit., 364.

60 Coosje van Bruggen, *John Baldessari*, exhibition catalogue (The Museum of Contemporary Art, Los Angeles; New York: Rizzoli, 1990), 54.

61 Bruggen, op.cit., 53.

62 Interview with Stan Brakhage by Suranjan Ganguly, "All that is Light: Brakhage at 60," *Sight & Sound* (October 1993), 21.

63 P. Adams Sitney, *Visionary Cinema*, op. cit., 179.

64 Conversation between Stan Brakhage and author, Valencia, California, May, 1994.

65 See Peter Weibel, "The Viennese Formal Film," in *Film as Film*, exhibition catalogue (The Arts Council of Great Britain, 1979), 106–112.

66 Conversation with the artist, June 1995, in Venice, Italy.

67 Tony Conrad, letter to Henry Romney, November 11, 1965, reproduced in *Film Culture* 41 (Summer 1966), 2.

68 Gilles Deleuze, *Cinema 2*, op. cit., 200.

69 See Gene Youngblood, *Expanded Cinema* (New York: E.P. Dutton, 1970).

70 See Catherine David, "The Great Labyrinth," in *Helio Oiticica*, exhibition catalogue (Minneapolis: Walker Art Center; Rotterdam: Witte de With, 1992).

71 Ibid., 256.

72 Ibid., 258.

73 Ibid., 174–175 and 180.

74 Ibid.

75 See Oiticica, op. cit., 177.

76 Quoted in Alain Bergala, "The Other Side of the Bouquet," in *Jean-Luc Godard: Son+Image*, edited by Raymond Bellour with Mary Lea Bandy (New York: Museum of Modern Art, 1992), 57.

77 Godard quoted in Scott Kraft, "The Forgotten Legend," *Los Angeles Times Magazine* (April 2, 1995), 26.

78 Laura Mulvey, "Visual Pleasure and Narrative Cinema," *Screen* 16:3 (Autumn 1975).

79 Mulvey, jacket notes for The Criterion Collection laserdisc edition of Michael Powell's *Peeping Tom*.

80 Conversation with the artist, April, 1995.

81 See Peter Wollen, "The Two Avant-Gardes," and Laura Mulvey and Maria Insell, "Independent Film After Structuralism," in *The Vancouver Anthology: the Institutional Politics of Art*, ed. by Stan Douglas (Vancouver: Talonbooks, 19), 113–114.

82 See Colin Gardner, "A Systematic Bewildering," *Artforum* (December 1989), 106–112.

83 Victor Burgin, *Between*, exhibition catalogue (London: Institute of Contemporary Art, 1986), 174.

84 See Anne Hollander, *Moving Pictures* (New York: Alfred A. Knopf, Inc., 1986), 281–291.

85 Hollis Frampton, "Digressions on the Photographic Agony," *Artforum* (November 1972), 51.

86 Gilles Deleuze, *Cinema 1: The Movement-Image*, trans. by Hugh Tomlinson and Barbara Habberjam (Minneapolis: University of Minnesota Press, 1986).

87 David Bordwell, *The Films of Carl-Theodor Dreyer* (Berkeley: University of California Press, 1981), 42–43.

88 Ibid., 43.

89 See Pascal Bonitzer, *Décadrages: Peinture et Cinéma* (Paris: Editions de l'Etoile, 1987), particularly "Le plan-tableau."

90 Raúl Ruiz, *Poetics of Cinema 1: Miscellanies*, trans. by Brian Holmes (Paris: Editions Dis Voir, 1995), 53.

91 See Paul Schrader, *Transcendental Style In Film: Ozu, Bresson, Dreyer* (Berkeley: University of California Press, 1972; New York: Da Capo Press), 62 and 98–103.

92 For a discussion of *Passion*, see Alain Bergala, "The Other Side of the Bouquet," 60–66.

93 Derek Jarman, *Derek Jarman's Caravaggio* (London: Thames and Hudson, 1986), 75.

94 Quoted in Howard Rodman, "Anatomy of a Wizard," *American Film* 16:10 (November/December 1991), 37.

95 Dominique Astrid Lévy and Simon Studer, "The Stairs or 100 'Intruders' in Geneva," in exhibition catalogue *The Stairs: Geneva: Location* (London: Merrell Holberton Publishers, 1994).

96 Peter Greenaway, "Six Exhibitions," in *The Stairs*.

97 See Peter Wollen, "Delirious Projections," *Sight and Sound*, Volume 2, issue 4, 24–27.

98 Smithson, "Ultramoderne," 5–7.

99 See Chris Petit, "Insane Memory," *Sight and Sound* (July 1994).

100 Chris Marker, *Sunless*, Semiotexte, vol. 4, no. 3.

101 Terrence Rafferty, "Chris Marker," *Sight and Sound* (Autumn 1984), reprinted in *The Thing Happens: Ten Years of Writing About the Movies* (New York: Grove Press, 1993), 70.

102 Raymond Bellour, "The Double Helix," in exhibition catalogue *Passages de l'image* (Paris: Musée national d'art moderne, Centre Georges Pompidou; reprinted in Spanish and English in *Passage de l'image*, Barcelona: Centre Cultural de la Fundacio Caixa de Pensions), 66.

103 Conversation with the artist, June, 1995, Paris.

104 For a discussion of *Silent Movie*, see Bill Horrigan, "Another Likeness," in exhibition catalogue *Chris Marker: Silent Movie* (Columbus: Wexner Center for the Arts, 1995).

105 Colin Gardner, "Cindy Bernard," review, *Artforum* (December 1990), 147.

106 Quoted in Raúl Ruiz, *Poetics of Cinema*, 13.

107 Ruiz, 13.

Ferguson

1 Edgar Morin, *The Stars* (New York: Grove Press, 1960), 54–55. Morin's book has been followed by an ever-growing body of works on the star system, a field of study that is now immense. See Daniel J. Boorstin, *The Image* (New York: Athenaeum, 1961); Leo Braudy, *The Frenzy of Renown* (New York: Oxford University Press, 1986); Richard Dyer, *Stars* (London: British Film Institute, 1979) and *Heavenly Bodies: Film Stars and Society* (London: British Film Institute, 1986); Fred Fehlau, ed. *Hollywood Hollywood: Identity under the Guise of Celebrity* (Pasadena: Pasadena Art Alliance, 1992); Christine Gledhill, ed., *Stardom: Industry of Desire* (London: Routledge, 1991); and Jackie Stacey, *Star Gazing* (New York: Routledge, 1994).

2 Andy Warhol, *The Philosophy of Andy Warhol (From A to B and Back Again)* (New York: Harcourt Brace Jovanovich, 1975), 61, 62.

3 Richard Prince, *Why I Go to the Movies Alone* (New York: Tanam Press, 1983), 69.

4 See Dyer, *Stars*, 39–49. "Activities such as sport or the arts are not pursued for health or enlightenment but for the sake of displaying the leisure time and money at one's disposal. Thus a man's athletic body may be much admired, but only on condition that it has been acquired through sports, not labour." (43)

5 Parker Tyler, *Underground Film: A Critical History* (New York: Grove, 1969), 10.

6 Colin MacInnes, *Absolute Beginners* (New York: MacMillan, 1960), 11.

7 Miller, "à la Mod" (*New Statesman*, 29 May 1964), 853.

8 "Bacon was the only British painter of an earlier generation who was regarded with respect by younger artists in London. Moore, Nicholson, Pasmore, Sutherland (the equivalent in age of de Kooning, Newman, Pollock, Still) were considered to be irrelevant to any new art in the 1950's." (Lawrence Alloway, "The Development of British Pop" in Lucy Lippard, *Pop Art* (London: Thames and Hudson, 1966), 29.)

9 See Graham Whitman, "Chronology" in David Robbins, ed. *The Independent Group: Postwar Britain and the Aesthetics of Plenty* (Cambridge: The MIT Press, 1990), 26–33. Del Renzio had worked as an art editor for fashion magazines before joining the staff of the ICA, and returned to *Harper's Bazaar* in 1958 (178).

10 Alloway, "The Long Front of Culture" (*Cambridge Opinion*, 17, 1959), reprinted in *The Independent Group*, 165. A somewhat parallel course could be traced in French thinking. Roland Barthes's *Mythologies* was published in 1957, although not available in English until much later. Edgar Morin's *The Stars* was unusual in being translated as early as 1960. The work of Alloway and his colleagues is of particular interest here, however, because of the explicit relationship of their analyses to practice in the visual arts.

11 Dick Hebdige's essay "Towards a Cartography of Taste 1935–1962" (in *Hiding in the Light* (London: Routledge, 1988), 45–76) gives an invaluable analysis and vivid account of the period. See also David Mellor's essential *The Sixties Art Scene in London* (London: Phaidon, 1993).

12 Alloway, "Personal Statement" (*Ark* 19, Spring 1957), reprinted in *The Independent Group*, 165.

13 *Absolute Beginners*, 22–23.

14 Ibid., 120, 124. As early as 1956, Hamilton had put an image of a tape recorder in the foreground of his *Just what is it that makes today's homes so different, so appealing?*

15 *Absolute Beginners*, 73.

16 Ibid., 119.

17 Ibid., 20. Although MacInnes's narrator is prowling the streets of London in search of something newsworthy, his camera is not the street photographer's 35mm Leica, but rather the larger-format Rolleiflex. According to Jane Livingston, the Rolleiflex was regarded as "the exclusive tool of the fashion photographer"

until 1962, when Diane Arbus began to work with one (*The New York School: Photographs, 1936–1963* (New York: Stewart, Tabori and Chang, 1992), 349). In London, Nigel Henderson had been using a Rolleiflex for street photography as early as the late forties (see James Lingwood, "Nigel Henderson" in *The Independent Group*, 76). Henderson collaborated with Eduardo Paolozzi and Alison and Peter Smithson on an installation for the "This is Tomorrow" exhibition in 1956.

18 David Bailey, *Black and White Memories: Photographs 1948–1969.* Text by Martin Harrison (London: J. M. Dent, 1983), 6. See also Harrison's *Appearances* (New York: Rizzoli, 1991). Bailey did not actually read *Absolute Beginners* himself until the late sixties, when he first met MacInnes (telephone conversation, 6 July 1995).

19 "I sometimes hate what I'm doing to girls. It turns them from human beings into objects. They come to believe they actually are like I photograph them and it gives me a terrific feeling of power. Power and destruction." Bailey quoted in David Mellor, "David Bailey, 1961–66" in *David Bailey: Black and White Memories* (London: Victoria and Albert Museum, 1983), 5.

20 Ibid., 9.

21 Jones, "D for Dolls" in *The New Statesman*, 10 December, 1965, 944.

22 Quoted in *Black and White Memories: Photographs 1948–1969*, 51.

23 *Time*, 15 April, 1966, 31–32. Donyale Luna was the first black model to appear on the cover of English *Vogue* (1 March 1966, in a photograph by Bailey).

24 *Absolute Beginners*, 217.

25 Nadine Liber, "Michelangelo Antonioni Talks about His Work" (*Life*, January, 1967), quoted in William Arrowsmith, *Antonioni: The Poet of Images* (Oxford: Oxford University Press, 1995), 121.

26 Bailey, telephone conversation, 6 July 1995.

27 George Melly, *Revolt Into Style* (London: Allen Lane, 1970), 143.

28 Many of the details used in *Blow-Up* were derived from two hundred pages of notes given to Antonioni by Francis Wyndham, Bailey's collaborator on *Box of Pin-ups*. Bailey was amazed to see in the film not only his purchase of the propeller, but the exact price he had paid for it: eight pounds. In general, Bailey found *Blow-Up* "a bit silly. I didn't think much of it, and I still don't." (telephone conversation, 6 July 1995).

Bailey himself made a film in 1966, *G.G. Passion*, now lost, which was funded by Roman Polanski and co-written by Bailey and Gerard Brach (*Repulsion*). It seems more a precursor of Nicolas Roeg and Donald Cammell's *Performance* (1970) than an echo of *Blow-Up*. Originally titled *The Assassination of Mick Jagger*, it is "the story of a fading pop-star who is hounded to his death." Bailey described the film as "a dream of an inner dream, a Kafka fairy-tale but

modern." See *Black and White Memories: Photographs 1948–1969*, 52, 55, 57.

29 Richard Hamilton, "Notes on photographs" in *Collected Words 1953–1982* (London: Thames and Hudson, 1982), 68.

30 See Arrowsmith, *Antonioni: The Poet of Images*, 107, for this point, and for an extended and subtle discussion of Antonioni's work in general.

31 See Simon Frith and Howard Horne, *Art Into Pop* (London: Methuen, 1987). Frith and Horne's book is an indispensable survey of the relationships between pop music and art.

32 *Art Into Pop*, 100, 101. Somewhat later, Bryan Ferry, an art school student of Richard Hamilton's, applied the Pop art approach to Roxy Music. The lyrics to the group's first single, "Virginia Plain" were based on Ferry's dreams of "New York, Andy Warhol's studio, Baby Jane Holzer" (*Art Into Pop*, 115).

33 Quoted in John McEwen, "Report from London" (*Art in America*, July 1986), 27.

34 The influence could also flow directly from music into film. Wim Wenders writes, for example, that, "When I first began making films — shorts — my starting point was music…. I can remember loads of record sleeves, the ones I liked best were the ones that featured pictures of the groups, standing together in some arrangement…. What was on the covers, with the Kinks for instance, corresponded to my idea of cinema: filming people head on, with a fixed camera, and keeping a certain distance." ("Le Souffle de l'Ange" in *The Logic of Images* (London: Faber and Faber, 1991), 89.)

35 See *Art and Artists* vol. 2 no. 5 (August 1967), 12–13. Fraser is described as having a "fervent belief in smashing down barriers between pop culture and the hermetic arena of 'fine art.'" His interest continued through punk, when he is said to have hung Jamie Reid's Sex Pistols posters in his house and to have urged the Victoria and Albert Museum to collect them (*Art Into Pop*, 131).

36 *Self Portrait with Friends: The Selected Diaries of Cecil Beaton, 1926–1974* (London: Weidenfield and Nicholson, 1979), 381.

37 Ibid., 387–88.

38 Hamilton, letter, 5 February 1995.

39 Hamilton, "The Swinging Sixties" in *Collected Words*, 104.

40 See *Richard Hamilton* (London: Tate Gallery, 1992), 104–107, 166–168.

41 Hamilton, "NYC, NY, and LA, Cal. USA" in *Collected Words*, 55.

42 See *The Independent Group*, 131–133.

43 Hamilton, "For the Finest Art try — POP" in *Collected Words*, 43.

44 O'Hara, "My Heart," in *Selected Poems* (New York: Vintage, 1974), 99.

45 Greenberg, "Avant-Garde and Kitsch" in *Art and Culture* (Boston: Beacon Press, 1961), 9. In 1967, Andy Warhol said: "I never wanted to be a painter. I wanted to be a tap dancer."

(Gretchen Berg, "Nothing to Lose: An Interview with Andy Warhol" in Michael O'Pray, ed., *Andy Warhol Film Factory* (London: British Film Institute, 1989), 56.)

46 Greenberg, "Avant-Garde and Kitsch", 11–12.

47 Greenberg, "Modernist Painting" in *The Collected Essays and Criticism*, vol. 4 (John O'Brian, ed.) (Chicago: University of Chicago Press, 1993), 85.

48 See Irving Sandler, *The Triumph of American Painting* (New York: Praeger, 1970) and *The New York School* (New York: Harper & Row, 1978); Dore Ashton, *The New York School: A Cultural Reckoning* (New York: Viking, 1973); and Serge Guilbaut, *How New York Stole the Idea of Modern Art* (Chicago: University of Chicago Press, 1983).

49 Greenberg, "After Abstract Expressionism," in *The Collected Essays and Criticism*, 122.

50 Andy Warhol and Pat Hackett, *POPism: The Warhol '60s* (New York: Harper & Row, 1980), 3.

51 G. R. Swenson, "What Is Pop Art?" *Art News* vol. 62, no. 7, Feb., 1963, 25

52 Max Kozloff, "Pop Culture, Metaphysical Disgust, and the New Vulgarians" (1962), in *Renderings: Critical Essays on a Century of Modern Art* (New York: Simon and Schuster, 1968), 221.

53 O'Hara, letter to Joan Mitchell, quoted in Brad Gooch, *City Poet: The Life and Times of Frank O'Hara* (New York: Knopf, 1993), 394.

54 O'Hara, "To the Film Industry in Crisis" in *Selected Poems*, 99–100.

55 O'Hara, "For James Dean" in *Selected Poems*, 96.

56 *POPism*, 40.

57 Quoted in Guy Flatley, "How to Become a Superstar — And Get Paid, Too" (*New York Times*, December 31, 1967, D9).

58 See Donna De Salvo, ed. *"Success is a Job in New York…": The Early Art and Business of Andy Warhol* (New York: Grey Art Gallery, New York University, 1989). Warhol is said to have been making $65,000 a year by 1959 (see Benjamin Buchloh, "Andy Warhol's One-Dimensional Art: 1956–1966" in Kynaston McShine, ed. *Andy Warhol: A Retrospective* (New York: The Museum of Modern Art, 1989), 39.)

59 In 1949, Fredericks had given Warhol his first illustration assignments. See De Salvo, *"Success is a job in New York …"*, 3–4.

60 *POPism*, 3–4. See also Emile de Antonio and Mitch Tuchman, *Painters Painting* (New York: Abbeville Press, 1984), 26–28.

61 *POPism*, 4.

62 Ibid., 12.

63 "America was the place where everything was happening…. I didn't ever want to live anyplace where you couldn't drive down the road and see drive-ins and giant ice cream cones and walk-in hot dogs and motel signs flashing!" (*POPism*, 40.) Warhol echoes Frank O'Hara here, from "Meditations in an Emergency" (*Selected Poems*, 87):

"I can't even enjoy a blade of grass unless I know there's a subway handy, or a record store or some other sign that people do not totally regret life."

64 Karp, in Patrick S. Smith, *Andy Warhol's Art and Films* (Ann Arbor: UMI Research Press, 1986), 351. This anecdote shows not just Warhol's interest in pop music, but also his fascination with repetition at the expense of development. The record was "I Saw Linda Yesterday" by Dickie Lee.

65 Hopps, in Jean Stein, *Edie: An American Biography* (New York: Knopf, 1982), 192.

66 Bourdon, in "Andy Warhol 1928–87" (*Art in America*, May 1987), 139.

67 *POPism*, 28. Along with his Rolleiflex, MacInnes's narrator in *Absolute Beginners* wears his "new Roman suit, which was a pioneering exploit in Belgravia, where they still wore jackets hanging down over what tailors call the seat." (*Absolute Beginners*, 20.)

68 *POPism*, 59. The admiration was mutual. "Warhol meant so much to me; everything became important, a can of soup, a car, had a life of its own … he opened my eyes," Bailey said later (in Mellor, "David Bailey, 1961–66," 7).

69 See *Richard Hamilton* (London: Tate Gallery, 1992), 110, 170, and Hamilton, "Printmaking" in *Collected Words*, 92.

70 Tom Wolfe, "The Girl of the Year" in *The Kandy-Kolored Tangerine-Flake Streamline Baby* (New York: Farrar, Straus and Giroux, 1965), 216, 207.

71 See Wollen, "Notes From the Underground" in *Raiding the Icebox* (Bloomington: Indiana University Press, 1993) 174, n42. Like Warhol, Bailey was also an obsessive collector, whose house was "crammed with antiques, tribal masks and other ethnic art, … paintings, animals and birds. Many of these objects were packed into corners rather like miniature shrines." (*Black and White Memories: Photographs 1948–1969*, 52.) In 1971, Bailey filmed Warhol for a documentary for British TV, in which the two men appeared in bed together (fully clothed). Bailey's reputation as a heterosexual playboy has been central to his public image from the beginning of his career. Warhol's identity as a gay man has more recently become the subject of increasing scholarly attention.

72 *POPism*, 36–37.

73 Warhol's work, which was censored, was perhaps more shocking because of its very public context and because of its barely concealed gay subtext. See Richard Meyer, "Warhol's Clones" (*The Yale Journal of Criticism*, 7, no. 1, 1994, 79–109). The artist certainly understood how this work fit with the ongoing redefinition of stardom: "Nowadays if you're a crook you're still considered up there. You can write books, go on TV, give interviews — you're a big celebrity and nobody even looks down on you because you're a crook. You're still

really up there. This is because more than anything people just want stars." (Warhol, *The Philosophy of Andy Warhol (From A to B and Back Again)*, 85.)

74 See Sally Banes, *Greenwich Village 1963: Avant-Garde Performance and the Effervescent Body* (Durham: Duke University Press, 1993).

75 Andrew Sarris, "Notes on the *Auteur* Theory in 1962" in Gerald Mast and Marshall Cohen, eds., *Film Theory and Criticism* (New York: Oxford University Press, 1974), 510. Sarris was himself the subject of a Warhol screen test. Others screentested included Dali, Duchamp, Dennis Hopper, Jonas Mekas, and Jack Smith. See the list in Callie Angell, "Andy Warhol, Filmmaker" in *The Andy Warhol Museum* (Pittsburgh: The Andy Warhol Museum, 1994), 143.

76 See David James, "Andy Warhol: The Producer as Author" in his *Allegories of Cinema: American Film in the Sixties* (Princeton: Princeton University Press, 1989), 58–84.

77 *POPism*, 41, 42. Hopper was one of Warhol's earliest collectors, and participated in Warhol's attempts to make his *Tarzan* movie while he was in California. Hopper recalls that Warhol had very little idea even of how to operate the camera, but that the experience was galvanizing anyway (conversation, 28 July 1995).

78 Stephen Koch, *Stargazer: Andy Warhol's World and his Films* (New York: Praeger, 1973), 64.

79 Ronald Tavel, "The Banana Diary: The Story of Andy Warhol's *Harlot*" in O'Pray, ed., *Andy Warhol Film Factory*, 79 (originally published in *Film Culture* 40, Spring 1966).

80 Tavel, at a Film Forum panel held at the Pacific Design Center, Los Angeles, 6 November 1994. To this extent, Warhol literalized the complaint of William Holden's screenwriter in *Sunset Boulevard* that movie audiences don't realize that films have writers: "they think the actors make it up as they go along." In the case of Warhol's films, they did.

81 "How to Become a Superstar," D9. Mario Montez agreed:
"Gary: Who are your heroes? Who do you most admire?
Mario: Maria Montez; Marilyn Monroe because she's always sweet. Ginger Rogers, Fred Astaire, James Dean, Michael Parks, and John Lennon.
Gary: Why James Dean?
Mario: Because he was always himself."
(Gary McColgan, "Superstar: an Interview with Mario Montez" in *Film Culture* 45, Summer 1967), 19.

82 A stasis already tied to nostalgia, even if fliply: "Seeing everybody up all the time made me think that sleep was becoming pretty obsolete, so I decided I'd better quickly do a movie of a person sleeping." (*POPism*, 33.)

83 Koch, *Stargazer*, 39.

84 See Callie Angell, *The Films of Andy Warhol: Part II* (New York:

Whitney Museum of American Art, 1994), 10–11.

85 *POPism*, 110.

86 Berg, "Nothing to Lose," 57.

87 Tavel, at Art Center, Pasadena, 7 November, 1994.

88 Koch, *Stargazer*, 59–60. Shooting actually began at about 8:10 pm. See Angell, *The Films of Andy Warhol, Part II*, 18.

89 Quoted in Jonas Mekas, *Movie Journal: The Rise of the New American Cinema* (New York: Macmillan, 1972), (July 30, 1964), 151.

90 Angell, *The Films of Andy Warhol: Part II*, 16.

91 Rosalind Krauss, "Grids" in *The Originality of the Avant-Garde and Other Modernist Myths* (Cambridge: The MIT Press, 1985), 9.

92 Laura Mulvey, "Some Thoughts on Theories of Fetishism in the Context of Contemporary Culture" (*October* 65, Summer 1993, 3–20), 13.

93 Berg, "Nothing to Lose," 54, 56.

94 Tavel, in *Edie*, 238.

95 Schlesinger did have to resist the more outré of the studio suggestions: "MGM suggested Elvis Presley would be good for *Midnight Cowboy* if it were turned into a musical. And someone at United Artists, for whom I did the picture, seriously said, Make Ratzo Sammy Davis Jr., and you have a hit." ("John Schlesinger," *American Film*, January 1991, 20.)

96 Quoted (by Tavel) in Koch, *Stargazer*, 63. Tavel told me (7 November 1994) that Warhol "adamantly stopped" him from introducing conventional narrative. Tavel associates this with Warhol's desire to avoid the autobiographical, to avoid telling *his* story.

97 Benjamin, "The Work of Art in the Age of Mechanical Reproduction" in *Illuminations* (New York: Schocken, 1969), 238.

98 Ibid., 228–229.

99 Ibid., 243.

100 Ibid., 240–241.

101 Adorno, "Letter to Walter Benjamin" in *Aesthetics and Politics* (London: New Left Books, 1977), 122–23; reprinted in Francis Frascina and Jonathan Harris, eds., *Art in Modern Culture* (New York: HarperCollins, 1992), 74–75.

102 Benjamin, "The Work of Art in the Age of Mechanical Reproduction," 231.

103 Benjamin, "On Some Motifs in Baudelaire" in *Illuminations*, 188.

104 Warhol, *The Philosophy of Andy Warhol (From A to B and Back Again)*, 77.

105 Ibid., 112.

106 Swenson, "What Is Pop Art?" 60. See also Trevor Fairbrother, "Skulls," in Gary Garrels, ed., *The Work of Andy Warhol* (Seattle: Bay Press, 1989).

107 Mulvey, "Some Thoughts on Theories of Fetishism," 14. This passage also brings to mind Jack Smith's fantasies of Maria Montez: the star as corpse, or vice versa: "Maria Montez was propped up beside the pool which reflected her ravishing beauty. A chunk fell off her face showing the grey under her rouge. How can we get to it? We must retrieve it or else

scrape off all her flesh and start all over." ("The Memoirs of Maria Montez" in *Film Culture* 31, Winter 1963–64, 3.)

108 Barthes, *Camera Lucida* (New York: Hill and Wang, 1981), 96.

109 See *Andy Warhol: Death and Disasters* (Houston: The Menil Collection and Houston Fine Art Press, 1988), 62. The victim was being pursued by a Washington state trooper following a hit-and-run accident. The photograph was taken by John Whitehead, and it appeared in *Newsweek*, 3 June 1963, 20.

110 Berg, "Nothing to Lose," 60.

111 Deleuze, *Difference and Repetition* (New York: Columbia University Press, 1994), 293. See also Thomas Crow, "Saturday Disasters: Trace and Reference in Early Warhol," in Serge Guilbaut, ed. *Reconstructing Modernism: Art in New York, Paris, and Montreal 1945–1964* (Cambridge: The MIT Press, 1990), 311–331.

112 *Camera Lucida*, 94.

113 *POPism*, 56. Ironically, although Warhol himself became by far the most famous artist of his generation, in the broader field of celebrity he remained a relatively minor figure, a curiosity rather than a major star, a Sal Mineo rather than a James Dean.

114 Tavel in Smith, *Andy Warhol's Art and Films*, 487. David Bourdon has written that Warhol called him from the hospital after being shot and complained that his own shooting had not been filmed (in "Andy Warhol 1928–87" *Art in America*, May 1987, 140.)

115 Warhol, *The Philosophy of Andy Warhol (From A to B and Back Again)*, 68.

Jenkins

1 The strategy of contrasting such distinctive practices of 1960s filmmaking is employed (though to a different end) by the film scholar David Bordwell in his incisive essay on "art cinema." See "The Art Cinema as a Mode of Film Practice," *Film Criticism* 4:1 (Fall 1979), 56–64.

2 While this essay barely does justice to its chief area of study, the American avant-garde cinema of the 1960s, it is guilty of huge omissions with respect to contemporaneous experimental film practice in countries such as England, Germany, Austria, Canada, and Japan. My approach toward describing the social and artistic history of the "other" cinema owes a debt to the critic and theorist Nöel Carroll, whose former film column for the *Soho Weekly News* is referenced by the title of this essay.

3 The reference is to a seminal passage in the proto-auteurist writings of the influential French film theorist André Bazin. See the concluding line of Bazin's "The Evolution of the Language of Cinema" in *What is Cinema?*, ed. and trans. Hugh Gray (Berkeley: University of California Press, 1971), Vol. 1, 40: "The filmmaker is no longer the competitor of the painter and the playwright, he is, at last, the equal of the novelist."

4 A helpful introduction to this first wave of independent feature filmmak-

ing in this country is *The American New Wave: 1958–1967* (Minneapolis: Walker Art Center, 1982), a catalogue that accompanied the touring film series of the same name.

5 One of the first and only attempts to describe the "artists' film" is Regina Cornwell's essay "Films By American Artists: One Medium Among Many," in *Films By American Artists: One Medium Among Many* (London: The Arts Council of Great Britain, 1981), 5–16.

6 Two invaluable guides to this period are Birgit Hein's *Film als Film: 1910 bis heute* (Cologne: Kunstverein, 1978) and its English-language counterpart, Phillip Drummond's *Film as Film* (London: The Arts Council of Great Britain, 1979).

7 "For a Metahistory of Film: Commonplace Notes and Hypotheses," originally published in *Artforum* (September 1971) and reprinted in Hollis Frampton, *Circles of Confusion: Film, Photography, Video, Texts 1968–1980* (Rochester, New York: Visual Studies Workshop Press, 1983), 112.

8 Ibid., 113.

9 Willard Maas's statement appears under the rental listing for the film in *Film-Makers' Cooperative Catalogue No. 7* (New York: The New American Cinema Group, 1989), 347.

10 "Camera Lucida/Camera Obscura," *Artforum* 11, no. 5, (January 1973), 37.

11 Sheldon Renan, *An Introduction to the American Underground Film* (New York: E.P. Dutton, 1967), 118.

12 Published in *Film Culture*, no. 30 (Fall 1963) in a striking issue that was edited by P. Adams Sitney and designed by George Maciunas.

13 Suranjan Ganguly, "Stan Brakhage — The 60th Birthday Interview," *Film Culture*, no. 78 (Summer 1994), 22.

14 See Parker Tyler, *Underground Film: A Critical History* (New York: Grove Press, Inc., 1969), 51 ff.

15 Mekas's seminal article appeared as "A Call for a New Generation of Film-Makers" in *Film Culture*, no. 19 (1959) and is reprinted in P. Adams Sitney, ed. *Film Culture Reader* (New York: Praeger, 1970), 73–75.

16 One of the clearest expressions of this aesthetic appeared in "The First Statement of the New American Cinema Group" in *Film Culture*, nos. 22–23 (Summer 1961) and reprinted in *Film Culture Reader*, 79–83.

17 See David James's canny comparison of these two filmmakers in relationship to their respective homes in his insightful study, *Allegories of Cinema: American Film in the Sixties* (Princeton: Princeton University Press, 1989), 57 ff.

18 See Jonas Mekas's *Village Voice* column from August 1964, reprinted in his *Movie Journal: The Rise of a New American Cinema, 1959–1971* (New York: Collier, 1972), 158. It is also worth noting that earlier that summer Mekas had become an artistic collaborator, having shot Warhol's epic *Empire*.

19 This oddly reflexive scene prefigures a textual insertion in George Landow's experimental film *Remedial Reading Comprehension* (1971) that proclaims "This Is A Film About You," as well as Nam June Paik's segment of the omnibus television show *The Medium is the Medium* (1969), in which two of his cast members complain in voice-over about the tedium of the program they are making and we are watching.

20 Susan Sontag, "Jack Smith's *Flaming Creatures*," in *Against Interpretation* (New York: Dell, 1966), 226–231.

21 Gregory Markopoulos, "Innocent Revels," *Film Culture*, no. 33 (Summer 1964), 43.

22 Sontag, "Jack Smith's *Flaming Creatures*," 230–231.

23 Brakhage, "Metaphors on Vision," supra, note 12, n.p.

24 See Renan, *American Underground Film*, 103–104. The most systematic account of this form remains Gene Youngblood's McLuhanesque study of advanced forms of experimental film and television ("nothing less than the nervous system of mankind"), *Expanded Cinema* (New York: Dutton, 1970).

25 Renan, 227.

26 Renan, 240. A similar account can be found in Jonas Mekas's "The Expanded Cinema of Robert Whitman," in *Movie Journal*, 189.

27 Bruce Conner had by the mid-1960s nearly abandoned the collage film — sparingly employing the mode for his *Ten Second Film* (1965), commissioned by the New York Film Festival — and worked instead as a collaborator on the nightly multimedia lightshow at San Francisco's Avalon Ballroom. For Conner's description of this work, see Scott MacDonald's *A Critical Cinema: Interviews with Independent Filmmakers* (Berkeley: University of California Press, 1988), 252–253.

28 A detailed description of this work appeared in Jonas Mekas, "On the Theater and Engineering Show," in *Movie Journal*, 261–262.

29 See Yvonne Rainer, "Lives of Performers," in *Works 1961–73* (Halifax: Press of the Nova Scotia College of Art and Design, 1974), 213.

30 Mekas, *Movie Journal*, 242.

31 Stephen Koch, *Stargazer: Andy Warhol's World and his Films* (New York and Washington: Praeger, 1973), 71.

32 For a more detailed account, see Youngblood, *Expanded Cinema*, 374–378.

33 Birgit Hein, "The Structural Film," in *Film as Film*, 103.

34 P. Adams Sitney, "Structural Film," in Sitney, *Film Culture Reader*, 346.

35 An invaluable guide to these films by Serra and those of the other artists discussed below is the rental catalogue *Castelli-Sonnabend Videotapes and Films* 1, no. 1 (New York: Castelli-Sonnabend Tapes and Films, 1974).

36 P. Adams Sitney, "Structural Film," in Sitney, *Film Culture Reader*, 346.

37 Ibid.

38 Willoughby Sharp, "Nauman Interview," *Arts Magazine* (March 1970), 26.

39 Regina Cornwell, *Snow Seen: The Films and Photographs of Michael Snow* (Toronto: Peter Martin Associates, 1980), 66–67.

40 The list of "replacement images" from *Zorns Lemma* has recently been published, along with Frampton's production notes for the film, in Scott MacDonald's *Screen Writings: Scripts and Texts by Independent Filmmakers* (Berkeley: University of California Press, 1995), 61–66.

41 Paul Sharits, "Exhibition/Frozen Frames," in *Film Culture*, nos. 65–66 (1978), 82.

42 Ibid., 81.

43 Information about creating such expanded works was published in Maciunas's Fluxus newsletters of January and December 1968 and in an announcement for Flux Fest Kits of December 1969. See Jon Hendricks, ed., *Fluxus Codex* (Detroit and New York: The Gilbert and Lila Silverman Fluxus Collection, in conjunction with Harry N. Abrams, 1988), 64–65.

44 This is not to suggest that no film installation works have been produced by artists or exhibited by museums over the past two decades, but rather that the major shift to single-channel video production ensured that future installations would likely be realized on tape (and later on laserdisc) rather than film. Exceptions to this include James Coleman's *Box (Ahhareturnabout)* from 1977 as well as Michael Snow's only film installation to date, the 1974 *Two Sides to Every Story*.

45 In an unpublished 1993 interview by this author with filmmaker James Benning and his daughter, the video artist Sadie Benning, the former commented on this aspect of the evolution of the "other" cinema:

"The other day I was thinking about how film, and video certainly, has grown up too quickly compared to the other arts. Painting and sculpture stayed pure for thousands and thousands of years before people started making intermedia kinds of pieces. But sound was added to film after thirty years, or forty years at the most, of working. Because of that, we've gone so quickly I think we really haven't exhausted the possibilities of what one can do with an image on film or video."

Linker

1 Laura Mulvey, "Visual Pleasure and Narrative Cinema," *Screen*, 16, no. 3 (Autumn 1975), 6. All further quotations from Mulvey in the present article are taken from this version of the essay.

2 Constance Penley, "Introduction — The Lady Doesn't Vanish: Feminism and Film Theory," in Penley, ed. *Feminism and Film Theory* (New York: Routledge, 1988), 6.

3 Much of my information here is drawn from one of the best general accounts of the context of this period, Peter Wollen's "Counter-Cinema

Sexual Difference" in Kate Linker, ed. *Difference: On Representation and Sexuality* (New York: The New Museum of Contemporary Art, 1984), 35–39.

4 Victor Burgin has summarized well the importance of Barthes's notions of the text and intertextuality for recent theory. See, for example, his "Re-reading *Camera Lucida*" in *The End of Art Theory: Criticism and Postmodernity* (Atlantic Highlands, New Jersey: Humanities Press International, 1986), 72–74.

5 Gilles Deleuze, *Foucault*, trans. Sean Hand (Minneapolis: University of Minnesota Press, 1988), 13.

6 Louis Althusser, "Ideology and Ideological State Apparatuses (Notes towards an Investigation)", in *Lenin and Philosophy and Other Essays*, trans. Ben Brewster (London: New Left Books, 1971), 160. While there are many good discussions of Althusser's work, one of the best is Paul Ricoeur, "Althusser's Theory of Ideology," in Gregory Elliott, ed. *Althusser: A Critical Reader* (Oxford: Blackwell, 1994), 44–72.

7 Althusser, 169.

8 Althusser, 150.

9 My formulation is derived from Joan Copjec's in her *Read My Desire: Lacan Against the Historicists* (Cambridge: The MIT Press, 1994). Copjec's book is one of the most incisive and well-argued treatments of Lacan's accomplishments and of the failings of apparatus theory in film studies. See, for example, her examination of the origins of the notion of the apparatus in Althusser's thought, 20–26, to which my reading is indebted.

10 David Macey, "Thinking with Borrowed Concepts: Althusser and Lacan," in Elliott, ed. *Althusser*, 142–158.

11 Althusser, "Freud and Lacan," in *Lenin and Philosophy and Other Essays*, 201.

12 Burgin, "The Absence of Presence," in *The End of Art Theory*, 41.

13 Jacques Lacan, "Guiding Remarks for a Congress on Feminine Sexuality" (1958), in Juliet Mitchell and Jacqueline Rose, eds., *Feminine Sexuality: Jacques Lacan and the école freudienne* (New York: Norton, 1982), 90.

14 For a discussion of this concept see Jacqueline Rose, "Sexuality in the Field of Vision" in Linker, ed. *Difference: On Representation and Sexuality*, 32.

15 Juliet Mitchell in "Feminine Sexuality: Interview — 1982," *m/f*, no.8 (1983), 7.

16 Jane Gallop, *The Daughter's Seduction: Feminism and Psychoanalysis* (Ithaca: Cornell University Press, 1982), 27.

17 Luce Irigaray, *Speculum of the Other Woman*, trans. Gillian C. Gill (Ithaca: Cornell University Press, 1985), 48.

18 For a further discussion of this ordering of sexual identity, see my "Representation and Sexuality" in Brian Wallis, ed., *Art After Modernism: Rethinking Representation* (New York:

The New Museum of Contemporary Art and Boston: David R. Godine, 1984), 391–415, and "Eluding Definition," *Artforum*, 23, no.4, December 1984), 61–67.

19 Jane Gallop, *Reading Lacan* (Ithaca: Cornell University Press, 1985).

20 Bryson's reading is a powerful elucidation of vision as intersected by the sign. See his *Tradition and Desire: From David to Delacroix* (Cambridge: Cambridge University Press, 1984), 107–110 and *passim*.

21 The notion of the "misrecognition" of the self is standard fare in apparatus reading, as in Althusserian ideology. The terms of misrecognition and recognition alternate, suggesting the same (mis)perception.

22 Burgin, "Modernism in the Work of Art," in *The End of Art Theory*, 17.

23 For discussion of the practices of different artists engaged in this terrain, see Craig Owens, "The Discourse of Others: Feminists and Postmodernism" in Owens, *Beyond Recognition: Representation, Power, and Culture*, eds. Scott Bryson, Barbara Kruger, Lynne Tillman, and Jane Weinstock (Berkeley: University of California Press, 1992), 166–190, and "Representation and Sexuality."

24 Lacan, "The Mirror Stage as Formative of the Function of the I" in Alan Sheridan, trans., *Ecrits: A Selection* (New York: W.W. Norton, 1977), 4.

25 Among the good accounts of the ideological assumptions of the perspective system see, for example, Rosalind E. Krauss, *The Optical Unconscious* (Cambridge: The MIT Press, 1993); Norman Bryson, *Vision and Painting: The Logic of the Gaze* (New Haven: Yale University Press, 1983) and *Tradition and Desire*; Burgin, *The End of Art Theory*; and Copjec, *Read My Desire*.

26 Mary Ann Doane, "Remembering Women: Psychical and Historical Constructions in Film Theory," in *Psychoanalysis and Cinema*, E. Ann Kaplan, ed. (New York: Routledge, 1990), 51.

27 Roland Barthes, "Diderot, Brecht, Eisenstein," *Screen*, 15, no. 2 (1974), 33. Reprinted in *Image-Music-Text*. (New York: Hill and Wang, 1977), 69–70.

28 An excellent formulation of this argument is found in Owens, "The Discourse of Others: Feminists and Postmodernism," in *Beyond Recognition*.

29 Lacan, *The Four Fundamental Concepts of Psycho-Analysis*, as discussed in Copjec, 21.

30 Bryson, *Tradition and Desire*, 77.

31 Christian Metz, "The Imaginary Signifier," *Screen*, 16, no. 2 (Summer 1975), 55, as detailed in Constance Penley, "The Avant Garde. Histories and Theories," *Screen*, 19, no. 3 (Autumn 1978), 118.

32 Penley, ibid., 118.

33 Mulvey, "Afterthoughts on 'Visual Pleasure and Narrative Cinema' Inspired by *Duel in the Sun*" in *Psychoanalysis and Cinema*, ed. E.

Ann Kaplan, 24–35. See also the work on the films made by Dorothy Arzner, notably the writings of Pam Cook and Claire Johnston.

34 Burgin, "Geometry and Abjection," *AA Files*, no. 15 (Summer 1987), 35–41, and "Perverse Space," in *Sexuality and Space*, Beatriz Colomina, ed. (New York: Princeton Architectural Press, 1992), 220–240; Copjec, *Read My Desire*, 1–38.

35 Doane, "Women's Stake: Filming the Female Body," *October*, no. 17 (Summer 1981), 15.

36 Octave Mannoni, "Je sais bien, mais quand même," in *Clefs pour l'imaginaire ou l'autre scène* (Paris: Seuil, 1969), 12, as cited in Burgin, *Thinking Photography*, 190.

37 Owens, "The Discourse of Others: Feminists and Postmodernism," in *Beyond Recognition*, 180.

38 Mulvey, "Visual Pleasure," 14. Mulvey also cites Sternberg's wish to have his films "projected upside down." As if to confirm the ideological assumptions of modernism, this practice, which furthers "the spectator's undiluted appreciation of the screen image," was also endorsed by Abstract Expressionist painters as a means of gauging the value of the visual field.

39 Lacan, "The Meaning of the Phallus," in Mitchell and Rose, eds. *Feminine Sexuality*, 84.

40 Lacan, ibid.

41 "[S]i le pénis était le phallus, less hommes n'auraient besoin ni de plumes, ni de cravates, ni de médailles…. La parade, tout comme la mascarade, trahit donc un défaut: le phallus, personne ne l'a." Eugenie Lemoine-Luccioni, *La robe: Essai psychanalytique sur le vêtement* (Paris: Seuil, 1983), 34.

42 Lacan, "The Meaning of the Phallus," in Mitchell and Rose, eds., *Feminine Sexuality*, 84.

43 My discussion of this failing in the theorization of the apparatus is indebted to the treatment of the topic in both Copjec's *Read My Desire* and Doane's "Remembering Women."

44 Doane, ibid., 52, from a passage in which she glosses the perspective voiced by Copjec in her article "The Delirium of Clinical Perfection," *Oxford Literary Review*, 8, nos. 1–2 (1986).

45 Lacan, "What is a picture?," in *The Four Fundamental Concepts of Psycho-Analysis*, ed. Jacques-Alain Miller and trans. Alan Sheridan (New York: W.W. Norton and Co., 1981), 118.

46 Ibid.

47 Ibid., 106.

48 Copjec, 21–22, 34–35.

49 See, for example, the discussions of the topography of Lacan's visual paradigm in Krauss, *The Optical Unconscious*, 87–88, and Mark Wigley, "Untitled: The Housing of Gender," in *Sexuality and Space*, 382–388. Wigley's article offers an interesting indication of the need for alternative visual and spatial paradigms in architecture.

50 Lacan, *Encore* (Paris, Seuil, 1975), 13.

51 This is the gist of Copjec's argument as she points to the relevance of a more accurate reading of Lacan's texts to contemporary theorization of film.

52 Lacan, *The Four Fundamental Concepts of Psycho-Analysis*, as cited in Doane, 53.

53 Copjec, 36. For Copjec's reading of the sardine can tale, see 30–31.

54 Copjec, *passim*. See also Wigley, "Untitled: The Housing of Gender," in *Sexuality and Space*, 382–384, for the operation of this "limit" in architectural space.

Crary

1 "Godard Makes [Hi]stories," in *Jean-Luc Godard: Son + Image* (New York: The Museum of Modern Art, 1992), 159.

2 Ibid., 164.

3 The work of Tom Gunning has been particularly important in reconsidering the question of distraction in early cinema. See, for example, his "The Cinema of Attractions: Early Film, Its Spectator, and the Avant-Garde," in *Early Cinema: Space, Frame, Narrative*, Thomas Elsaesser, ed. (London: British Film Institute, 1990), 56–62.

4 See, for example, Beat Wyss, "*Ragnarök* of Illusion: Richard Wagner's 'Mystical Abyss' at Bayreuth," *October* 54 (Fall 1990), 57–58.

5 Friedrich Nietzsche, *The Case of Wagner* [1888], trans. Walter Kaufmann (New York: Random House, 1967), 171.

6 Gilles Deleuze, *Cinema 1: The Movement-Image*, trans. Hugh Tomlinson and Barbara Habberjam (Minneapolis: University of Minnesota Press, 1986), 61.

7 Raymond Bellour, "On Fritz Lang," in *Fritz Lang: The Image and the Look*, Stephen Jenkins, ed., (London: British Film Institute, 1981), 28.

8 It should be noted that Cronenberg presents a differentiated global arrangement in which the ideological model for control of the Third World is still that of eyeglasses, produced by the multinational conglomerate, Spectacular Optical.

Nesbit

1 Karl Marx, "A Contribution to the Critique of Hegel's Philosophy of Right. Introduction," in *Early Writings*, trans. Rodney Livingstone and Gregor Benton (London: New Left Review, 1975), 245.

2 Edgar Allan Poe, "A Descent into the Maelström," *Poetry and Tales* (New York: Library of America, 1984), 445.

3 Nicholas Ray, *Johnny Guitar* (1954). This and the following citation are used by Godard in *JLG par JLG* (1994), a film commissioned by Gaumont on the occasion of its hundredth anniversary celebration. On Godard's late work see especially: Raymond Bellour, with Mary Lea Bandy, eds. *Jean-Luc Godard: Son + Image 1974–1991* (New York: Museum

of Modern Art, 1992), particularly Bellour's essay, "(Not) Just Another Filmmaker," and that by Philippe Dubois, "Video Thinks What Cinema Creates," 215–231 and 169–185 respectively; J. Hoberman, "Winter Light," *Village Voice* (January 24, 1995), 49; Laurence Giavarini, "A l'ouest, le crépuscule," *Cahiers du Cinéma*, no. 449 (November 1991).

4 Ludwig Wittgenstein, *On Certainty*, ed. G.E.M. Anscombe and G. H. von Wright, trans. Denis Paul and G. E. M. Anscombe (New York: Harper & Row, 1969), 18e–19e.

5 Walter Benjamin, "Surrealism," in *Reflections*, ed. Peter Demetz, trans. Edmund Jephcott (New York: Harcourt Brace Jovanovich, 1978), 192.

6 "Godard Makes [Hi]stories: Interview with Serge Daney," in *Jean-Luc Godard: Son + Image*, 161.

7 Jean-François Lyotard, *The Postmodern Condition: a Report on Knowledge*, trans. Geoff Bennington and Brian Massumi (Minneapolis: University of Minnesota Press, 1984).

8 Ibid., 41.

9 *Les immatériaux*, Centre du Création industrielle, Centre Georges Pompidou, Paris, 1985.

10 *Ludwig Wittgenstein, Philosophical Investigations*, trans. G. E. M. Anscombe (Oxford: Basil Blackwell, 1968), 5.

11 Ibid., 8.

12 Ibid., 19.

13 Ibid., 36.

14 Ibid., 45.

15 Ibid., 89.

16 "Montage my fine care," *Cahiers du Cinéma*, no. 65 (December 1956), reprinted and translated by Jean Narboni and Tom Milne, *Godard on Godard* (London: Secker & Warburg, 1972), 39: "If direction is a look, montage is a heart-beat. To foresee is the characteristic of both: but what one seeks to foresee in space, the other seeks in time."

17 Paul Eluard, "Notre Mouvement," *Le dur désir de durer*, reprinted in *Oeuvres Complètes*, t. II, ed. Marcelle Dumas et Lucien Scheler, (Paris: Gallimard, 1968), 83.

Jean-Louis Leutrat has pointed out that the poems quoted in *Alphaville* do not all come from *Capitale de la Douleur*. See his essay "The Declension" in *Jean-Luc Godard: Son + Image*, 26.

18 *Pierrot le Fou* (1965)

19 Jean-Luc Godard, "Propos Rompus," *Cahiers du Cinéma*, no. 316 (October 1980) 10. Gilles Deleuze has taken the idea of the between into his assessment of Godard's montage of incommensurate parts. See *Cinema 2: the Time-Image*, trans. Hugh Tomlinson and Robert Galeta (Minneapolis: University of Minnesota Press, 1989), 179ff. See also his earlier formulations in "Trois Questions sur *Six Fois Deux* (Godard)(1976)," *Pourparlers* (Paris: Minuit, 1990), 55–66 and in English translation in *Jean-Luc Godard: Son + Image*, 35–41.

20 Walter Benjamin, "N 13a, 1", in "N [Re the Theory of Knowledge, Theory of Progress", trans. Leigh Hafrey and Richard Sieburth, *Benjamin: Philosophy, History, Aesthetics*, ed. Gary Smith (Chicago: University of Chicago, 1989), 71.

21 "N 1a, 7," "N 2, 1," "N 2, 2," "N 2, 6," and "N 3, 1," *Benjamin: Philosophy, History, Aesthetics*, 47–48 and 50–51.

22 "N 1, 10," *Benjamin: Philosophy, History, Aesthetics*, 45.

23 See "Godard Makes [Hi]stories: Interview with Serge Daney," in *Jean-Luc Godard: Son + Image*, 159. A portion of this interview appears in segment 2A of the *Histoire(s)*.

24 *La Quinzaine littéraire*, no. 591 (16 décembre 1991), as quoted by Nicole Brenez, "Le Film Abymé: Jean-Luc Godard et les Philosophies Byzantines de l'Image," in *Jean-Luc Godard: au-delà de l'image*, ed. Marc Cerisuelo (Paris: Lettres Modernes, 1993), 147.

25 Sigmund Freud, as quoted in *Histoire(s) du cinéma (1A).*, from Freud's *Interpretation of Dreams*, ed. and trans. by James Strachey (New York: Avon, 1965), 546–548.

26 G. W. F. Hegel, *Elements of the Philosphy of Right*, ed. Allen W. Wood, trans. H. B. Nisbet (Cambridge: Cambridge University Press, 1991), 22.

27 Karl Marx, *The Eighteenth Brumaire of Louis Bonaparte* (New York: International Publishers, 1963), 19.

28 Karl Marx, "A Contribution to the Critique of Hegel's Philosophy of Right. Introduction," in *Early Writings*, trans. Rodney Livingstone and Gregor Benton (London: New Left Review, 1975), 251.

29 Hegel, *Philosophy of Right*, 23. Hegel had begun the thought in 1816 in his *Lectures on the History of Philosophy*, trans. E. S. Haldane, v. 1 (London: Routledge & Kegan Paul, 1955), 52: "It may be said that Philosophy first commences when a race for the most part has left its concrete life, when separation and change of class have begun, and the people approach toward their fall; when a gulf has arisen between inward strivings and external reality, and the old forms of Religion, &c., are no longer satisfying; when Mind manifests indifference to its living existence or rests unsatisfied therein, and moral life becomes dissolved. Then it is that Mind takes refuge in the clear space of thought to create for itself a kingdom of thought in opposition to the world of actuality, and Philosophy is the reconciliation following upon the destruction of that real world which thought has begun. When Philosophy with its abstractions paints grey in grey, the freshness and life of youth has gone, the reconciliation is not a reconciliation in the actual, but in the ideal world."

30 With Hegel, Marx noted, the dialectic is standing on its head and needs to be inverted "in order to discover the rational kernel within the mystical shell." Postface to the second edition of *Capital*, v. 1, trans. Ben Fowkes (London: New Left Review, 1976), 103.

31 Ibid., 48.

32 Walter Benjamin, *The Origin of German Tragic Drama*, trans. John Osborne (London: NLB, 1977). Michel Hannoun, *Nos solitudes: enquête sur un sentiment* (Paris: Seuil, 1991).

33 Marx, "Economic and Philosophical Manuscripts," *Early Writings*, 361 and 375. See especially 361: "Everything which the political economist takes from you in terms of life and humanity, he restores to you in the form of *money* and *wealth*, and everything which you are unable to do, your money can do for you: it can eat, drink, go dancing, go to the theatre, it can appropriate art, learning, historical curiosities, political power, it can travel, it is *capable* of doing all those things for you; it can buy everything; it is genuine *wealth*, genuine *ability*. But for all that, it only likes to create itself, to buy itself, for after all everything else is its servant." Though this is all prelude to the formulations in *Capital*, see especially v. I, chapters 3 and 4.

34 Rainer Maria Rilke, *Letters to a Young Poet*, trans. M.D. Herter Norton (Revised edition. London: Norton, 1954), 69.

35 Baudelaire's letter to Manet, 11 mai 1865, cited by A. Tabarant, *Manet et ses oeuvres* (Paris: Gallimard, 1947), 110.

36 As the young man at the Collège Rollin, reading Diderot, he is supposed to have cried "Voilà qui est fort sot … il faut être de son temps, faire ce que l'on voit, sans s'inquiéter de la mode." As quoted by Antonin Proust, *Edouard Manet Souvenirs* (Paris: L'Echoppe, 1988), 10. First edition 1897.

37 Goethe, Faust, part I, trans. Philip Wayne (Harmondsworth: Penguin, 1949), 67.

38 Hegel, *The Philosophy of History*, trans. J. Sibree (Buffalo: Promethus, 1991), 26. I have changed the blank pages to read white as they do in the French translation used by Godard. See *La raison dans l'histoire*, ed. Kostas Papaioannou (Paris), 19 for the passage from the editor's introduction used by Godard in *Allemagne année 90 neuf zéro*.

39 Walter Benjamin, "Haussmann, or the Barricades," in *Reflections*, 162.

40 Walter Benjamin, "A Berlin Chronicle," in *Reflections*, 26.

41 Goethe, *Elective Affinities*, trans. R. J. Hollingdale (London: Penguin, 1971), 46.

Stan Douglas
Overture, 1986